Food and Fashion

Food and Fashion

Edited by
Melissa Marra-Alvarez and Elizabeth Way

BLOOMSBURY VISUAL ARTS
LONDON • NEW YORK • OXFORD • NEW DELHI • SYDNEY

BLOOMSBURY VISUAL ARTS
Bloomsbury Publishing Plc
50 Bedford Square, London, WC1B 3DP, UK
1385 Broadway, New York, NY 10018, USA
29 Earlsfort Terrace, Dublin 2, Ireland

BLOOMSBURY, BLOOMSBURY VISUAL ARTS and the Diana
logo are trademarks of Bloomsbury Publishing Plc

First published in Great Britain 2022

Cover design: Adriana Brioso
Cover image: Joan Smalls for Moschino, Milan Fashion Week Fall/Winter 2020–21, Italy.
(© Daniele Venturelli/Getty Images)

A catalogue record for this book is available from the British Library.

A catalog record for this book is available from the Library of Congress.

ISBN: HB: 978-1-3501-6434-5
 ePDF: 978-1-3501-6435-2
 eBook: 978-1-3501-6436-9

Typeset by Lachina Creative, Inc.
Printed and bound in India

To find out more about our authors and books visit
www.bloomsbury.com and sign up for our newsletters.

For Javier Alvarez

Contents

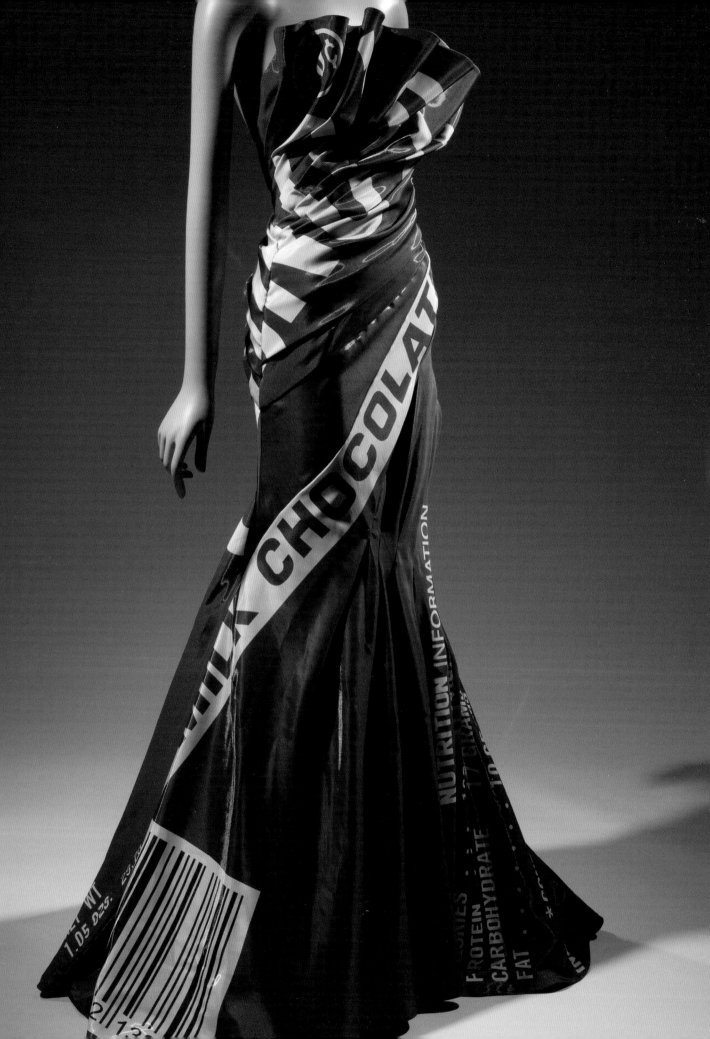

Foreword by Valerie Steele

"One cannot fully understand cultural practices unless 'culture', in the restricted, normative sense of ordinary usage, is brought back into 'culture' in the anthropological sense, and the elaborated taste for the most refined objects is reconnected with the elementary taste for the flavours of food."[1]

Pierre Bourdieu, *Distinction*

What do food and fashion have in common? They are both cultural practices, not only in the restricted sense of "high culture" (the arts) but also in the anthropological sense of "culture" (i.e., the way human beings do things). For tens of thousands of years, humans have eaten food cooked with fire and used needles to sew garments. Today also, people around the world prepare their food and dress their bodies in particular ways. But although dress and food are cultural universals, within any given culture, there are levels of refinement and distinction. Some people eat fast food and wear fast fashion, whereas others savor haute cuisine and haute couture. This is obviously, in part, a question of money, but it is also partly a question of taste.

Taste is not just a metaphor referring to arbitrary individual preferences. One way that power is exercised is through distinctive cultural consumption. It is not by accident that people with greater economic capital consume objects that are associated with elite cultural tastes. So called "good taste" tends to be identified with traditional elite status and "old money," whereas the *nouveaux riches* are criticized for their vulgar, flashy tastes, which are perceived as revealing their "lower" origins. This phenomenon, first observed in Europe and North America, has considerable validity across a range of cultures. Specifics change, but it is clear that people have to learn to acquire a taste for one thing rather than another. Some people who could easily afford caviar might still prefer the familiar taste of peanut butter, and others whose families could gift them a sable fur coat might recoil in disgust, preferring a second-hand denim jacket. Taste involves flavor, but also experience and knowledge about cultures, lifestyles, and ideologies.

The global development of capitalism in the years following the Second World War has further complicated the evolution of taste. By the 1960s, the coexistence of elite and popular taste was manifested in a range of cultural phenomena, such as the trend toward pop art. Traditional class hierarchies continued to exist, of course, as evident in the continued emphasis on "classical" styles, but other factors also exerted an influence on taste. Urban elites increasingly adopted cosmopolitan tastes drawn from other cultures. During the 1980s, for example, young, hip westerners, who would

Figure F.1
Jeremy Scott for Moschino, evening gown, fall 2014, Italy. © The Museum at FIT

9

not have grown up eating raw fish, became enthusiastic consumers of sushi. Perhaps not coincidentally, the 1980s witnessed the so-called "Japanese fashion revolution," with the global rise of avant-garde designers such as Issey Miyake, Rei Kawakubo of Comme des Garçons, and Yohji Yamamoto. Everything Japanese was suddenly cool.

"Fashion shapes our taste in food almost as surely as it does in dress, and in much the same way," observes the great food critic Mimi Sheraton. We usually define fashion as the current style in dress. But fashion—in the sense of the way we do things *at this time*—applies to almost every aspect of modern life: There are fashions in music, sports, places to go on vacation, and even fashions in the names that we give our children. Mildred and Wilber have long been out of fashion, Zoe and Christopher were fashionable more recently, and Olivia and Liam are currently trending. Clearly, fashion is not simply the result of industry propaganda; there are no advertising agencies urging parents to choose this name and not that. But tastes in names do change, and so do tastes in dress and food.[2] Recent decades have seen a greater multiplicity of tastes coexisting, perhaps because fashion trendsetters have become both more diverse and more open to new experiences.

Food and clothing are basic needs that can be raised to the heights of luxury and artistry. Across world history, the ruling class has monopolized consumption of the most rare and valuable products, including meat, wine, spices, dyes, silk, fur, and precious jewels. With the Industrial Revolution, the production and consumption of both food and fashionable dress became transformed into multinational systems, encompassing both elite and mass markets. Fashion has been described as "capitalism's favorite child," but food may be even more profitable. Both are also terribly wasteful. One of the most important issues today is the negative environmental impact of the food and fashion industries, as well as their human costs.

Elizabeth Way and Melissa Marra-Alvarez have made a significant contribution to the production of knowledge by bringing together ideas from two relatively new, specialized fields: Fashion Studies and Food Studies. "Both food and fashion are polyvalent signifiers with important sociological, cultural, and even psychological associations," notes Marra-Alvarez. The economic ramifications of French food and fashion are also highlighted as Way analyzes the historical connections between haute couture and haute cuisine within the context of the Parisian art of living. Citing Bourdieu on consumption as "communication" and the mastery of a "cultural code," she goes on to demonstrate how dressing to dine in a restaurant became a new form of sophisticated display during the Belle Époque.

Probably everyone has powerful memories of food and fashion in relation to their family. One of the most compelling sections of this book focuses on food, fashion, and cultural representation, with essays on Italian, Japanese, and Mexican food, as well as the food and fashion of Chinese immigrants and people of the African Diaspora. Although food and fashion have historically been important markers of cultural

identity, they were not necessarily associated with nation states. Often, food cultures were regional (Neapolitan, say, rather than Italian). Although globalization often homogenized food and fashion cultures, cuisines also developed and were transformed under the impact of immigration, colonialism, and slavery. In recent years, people have not only rediscovered their familial cultures, they have also used food and fashion to disrupt preconceived ideas, while navigating new identities.

It is well known that the term *consumerism* derives from the notion of eating, but I was surprised to learn from Marra-Alvarez that "the mere image or suggestion of food can elicit a visceral response by triggering memories and other associations, making food imagery in fashion a powerful stimulus." Is it any wonder then that designers from Christian Dior to Jeremy Scott have linked fashion with food? Some of these images refer to foods characterized by salty or savory flavors, but the most popular food images seem intended to trigger atavistic tastes for sweetness and pleasure. It is certainly likely that the sight of Jeremy Scott's Moschino Chocolate Bar Evening Dress elicited feelings of desire in many viewers!

Notes

1. Pierre Bourdieu, *Distinction: A Social Critique of the Judgement of Taste*, trans. by Richard Nice (London and New York: Routledge and Kegan Paul, 1984), 1.

2. Stanley Lieberson, *A Matter of Taste: How Names, Fashions, and Culture Change* (New Haven, CT: Yale University Press, 2010).

Foreword by Fabio Parasecoli

Rethinking/Reshaping Systems:
Design in Food and Fashion

It is a pleasure and honor to offer some opening thoughts for this timely and innovative volume that provides in-depth reflections, historical background, and additional information to The Museum at FIT exhibition *Food and Fashion*. Both food and fashion constitute extensive and pervading global systems that have an enormous impact not only on consumers and cultural intermediaries (press, media, public relations, marketing), but also on productive, trade, distribution, and retail networks. For this reason, it is necessary to examine them through complementary lenses that range from economy and politics to cultural studies and sociology. In fact, they have already become the object of a wide and ever-growing corpus of studies and analysis—from marketing to history and politics to anthropology—however, the exploration of the parallels, connections, and overlaps between food and fashion are still largely unexplored. Little systematic and sustained reflection exists on the similarities, differences, and interactions between these two important fields of social life.

The originality of the essays in this volume is in putting together two important aspects of contemporary material life that contribute to the construction of individual and collective identities as well as personal preferences. Any shifts in either of them can have wide local, national, and global repercussions. Food and fashion influence our lives as relevant markers of power, cultural capital, class, gender, ethnicity, and religion, just to mention a few aspects. Market-driven culture has transformed not only our minds but also our bodies into arenas of an unremitting struggle for our heart and soul as consumers. These are arenas where interconnected webs of objects, meanings, practices, and values are constantly formed, transformed, and destroyed.

This volume investigates aspects of the connections between food and fashion in the past and present, while also offering insights into the future. It is precisely in regard to the future that I would like to share these introductory remarks. To do so, I choose the lens of design, which is crucial in terms of innovation and change both in food and fashion, well beyond the trends and cycles that support their markets. While the relevance of design and designers in fashion is fully acknowledged—although theoretical debates and practical concerns inevitably question it—the role

of design in food has only recently become an object of interest. In fact, food design is expanding into a burgeoning field of scholarly research and professional practice.[1] Under its umbrella, we find projects for mass-produced food items and creative chefs' ideas for plating and presenting dishes to their patrons. Food design is mentioned not only when it comes to tableware or restaurant interiors, but also in performances and services. In the definition outlined by Pedro Reissig and the Food Design North America association, the purpose of food design is to "improve our relationship with food, individually or collectively, in the most diverse ways and instances. Its actions can relate to the design of food products, materials, practices, environments, systems, processes and experiences."[2]

Focusing on the improvement of our relationship with food implies reflecting about goals and priorities: it requires judgments about what is good and what is bad. In turn, it raises questions about the authority and power to pass such judgments, and even to identify the aspects that need improvement. These considerations can only develop against the background of broader negotiations about what our society is and what we would like it to be through clashes and mediations among different ideas about the future. In other words, design is inevitably political. Design is not only about creating and producing new things, but also about shaping what is yet to come.

In an interview with *Forbes,* Todd Johnston stated, "Design comes from the Latin word *dēsignāre,* 'to mark out.' To design is to mark out a pattern as a means of making meaning of an experience. A design marks out a vision for what can be; the act of designing is to move with intent to close the gap between existing conditions and that vision."[3] It is the "vision for what can be" that projects us toward the future. After all, as design scholars Susan Yelavich and Barbara Adams observed, "design is always future making."[4] And it can also provide us with tools against the looming risk of "de-futuring," the destruction of viable human futures caused by our unsustainable and unfair modes of inhabiting the world against which design theorist Tony Fry warned us.[5]

Design carries heavy responsibilities, both in food and in fashion. In order to bring to fruition its mission to innovate and usher positive change, design needs to embrace a systemic outlook to both look at the world and operate in it effectively. When a food designer collaborates with a company to create a product, or a fashion designer works with a label on a garment, while they obviously need to concentrate on the task at hand (for which, after all, they are paid), they also need to think about the larger implications of their choices. Where do the materials they use come from? Are they sustainably produced, renewable, and encouraging resilience? How will the new object (or service or experience) be produced? Where? By whom? How will it be distributed and sold? Who will use it? Who will be able to afford it? Will it just turn into additional junk that will haunt our environment, our physical health, and our emotional well-being for years to come? Or will it rather contribute to a better quality of life? However small and limited the project may be, design can open it up to broader

horizons and give it purpose, helping us as individuals and members of society to tackle the urgent challenges that define our present.

Of course, we can do without the latest pastry craze or the most recent season's accessory. Nevertheless, eating is a fundamental human right, and wearing clothes is a necessity for most of humanity. Meeting those basic needs, however, is not enough. Food and clothing should reflect local cultures and preferences, while ensuring people's health and well-being. We are all well aware that this is not always the case. Quite often, the food and fashion industries are mainly motivated by profit, which is a totally legitimate goal until it is pushed to the point where it can damage human beings, including both makers and consumers. It is enough to think about the plight of immigrant workers in the agricultural sector of many countries and the exploitation that takes place in the garment industry around the world. As a matter of fact, both food and fashion have been profoundly influenced by neoliberal globalization in terms of free trade, increasing financialization, expansion of just-in-time distribution, focus on efficiency and quantity rather than on the resilience of the systems, consolidation processes that make it more difficult for emerging companies to assert themselves, and intensification of production with its predictable consequences on the environment.

This is a very tall order. Major transformations of material infrastructures, strategic logistics, and socioeconomic priorities entail interventions that go well beyond the power of the market to adjust itself and achieve the best state of things possible. Personal initiatives, as well intentioned and passionate as they may be, are not enough. What can food and fashion designers do? If design is future making—and, as such, it is inherently political—should designers look outside of their workshops to inform themselves and participate in collective action and political processes well beyond their traditional modes of operation? To what extent are designers ready to shift the habits and traditions of their practice? Will they be able to rethink their role?

Growing numbers of designers are looking for different ways to create and make that do not only contribute to a frenzied consumer culture bent on always-new products. Especially when working autonomously or in collectives, they may propose radically different alternatives, despite the difficulties inherent in launching independent businesses. Evidently, design education is crucial to bring about such transformations, as it contributes to introducing fresh practices, approaches, and even professional ethics. The work of designers can assume artistic qualities and speculative tones that both stimulate and provoke consumers to see themselves as coproducers and civically minded citizens. But these goals cannot be achieved without looking at food and fashion systems in all their puzzling complexity, which may require new practices and perspectives. A volume like this—and the exhibition that inspired it—can support them if they already exist or contribute to make them emerge and thrive.

Notes

1. Fabio Parasecoli, "Food, Design, Innovation: From Professional Specialization to Citizens' Involvement," in *The Bloomsbury Handbook of Food and Popular Culture*, eds. Kathleen Lebesco and Peter Naccarato (London: Bloomsbury, 2018), 27–39.

2. Parasecoli, "Food, Design, and Innovation," 157–8.

3. Victor Hwang, "What Is Design? Unlocking the Genius Within," *Forbes*, February 11, 2014, http://www.forbes.com/sites/victorhwang/2014/02/11/what-is-design-unlocking-the-genius -within-says-expert/#db579ca53939.

4. Susan Yelavich and Barbara Adams, eds., *Design as Future-Making* (London, New York: Bloomsbury Academic, 2014).

5. Tony Fry, *A New Design Philosophy: An Introduction to Defuturing* (Sidney: University of New South Wales Press, 1999), 12.

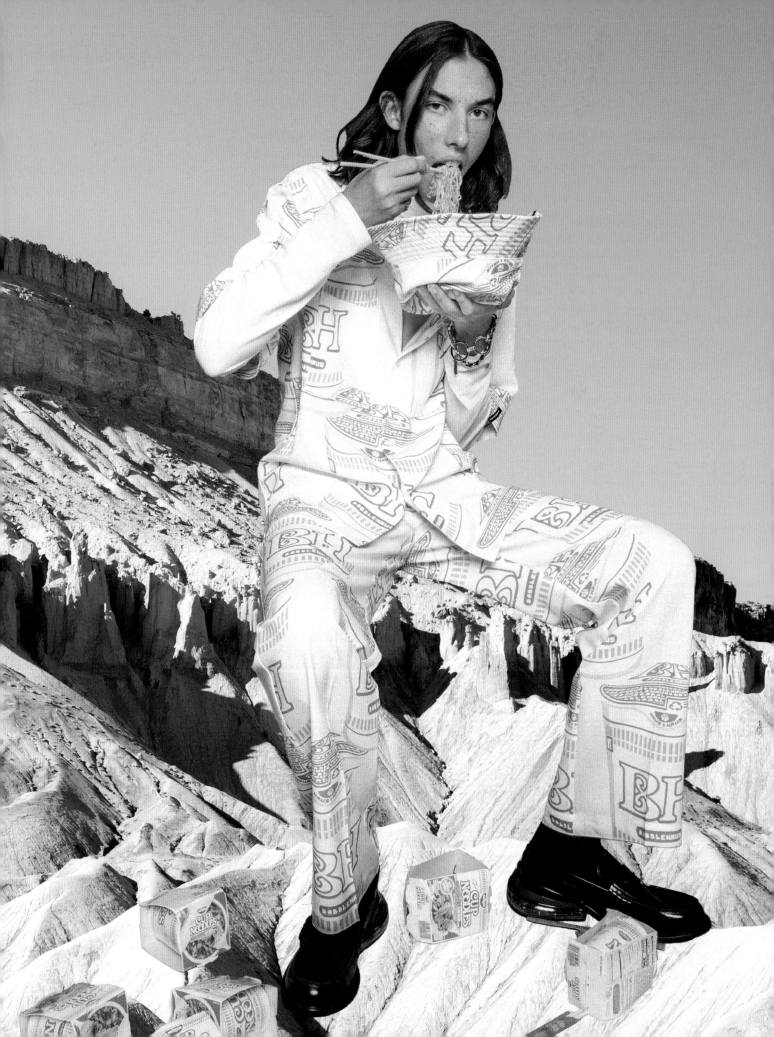

Introduction: Fashioning Food

Melissa Marra-Alvarez and Elizabeth Way

"Fashion shapes our tastes in food almost as surely as it does in dress, and in much the same way. . . ."[1]

<div align="right">Mimi Sheraton, food critic</div>

"The obsession with food that in the past few decades has taken large sections of many Western cultures by storm apparently will not subside any time soon,"[2] wrote food scholar Fabio Parasecoli in 2008. Here he refers not simply to the act of eating, which has always consumed human attention, but to food as culture. Similarly, during the twenty-first century, high fashion has become an integrated part of popular culture, moving from a largely elite and insider-oriented industry that was filtered to the public through print to one that is fully exposed through television, music, the internet, and social media. Public interest in fashion is also apparent in the heightened popularity of fashion exhibitions, as fashion scholars Greer Crawley and Donatella Barbieri note: "Museums are today embracing exhibitions of dress with unprecedented ardor, as it has become evident that their appeal is far more universal than that of other objects."[3] Food may seem harder to display in a museum gallery, yet exhibitions such as the American Museum of Natural History's *Our Global Kitchen: Food, Nature, Culture* (2012) and the Victoria and Albert's *Food: Bigger Than the Plate* (2019) both proved food to be an enticing subject with wide audience appeal. The Museum at FIT exhibition *Food and Fashion* (2023) examines the long-standing impact that food culture has had on fashion culture and highlights some of their intersections. This accompanying volume expands on subjects covered in the exhibition and allows for closer examinations of the historical and contemporary influences of food on the production, perception, and consumption of fashion.

As academic disciplines, fashion and food have been similarly overlooked largely because of their ubiquitous role in everyday life and historic relationship to women's domestic work and production. Prominent fashion historian and curator Valerie Steele noted in her 1991 article, "The F-Word," that fashion had finally begun to be released of its taboo status within academia.[4] Sociologist and food historian William C. Whit notes that, "Although sociologists have often overlooked the importance of food, an increased awareness of the cultural significance of food has developed since the mid-1980s. As a biological product that is culturally appropriated, food can

Figure I.1
BH Signature Ramen Print Set, Bobblehaus, 2020. Photograph by Madeleine Thomas for BOBBLEHAUS

17

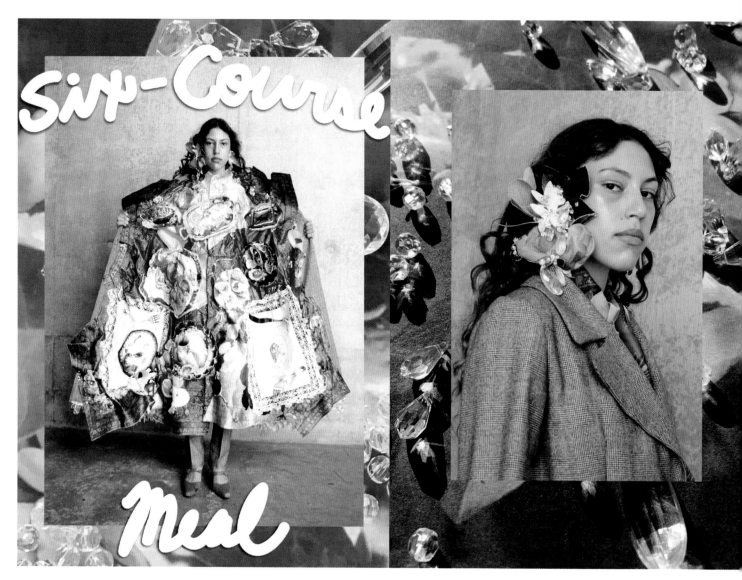

Figure I.2
Leeann Huang's "Six-Course Meal"
coat for spring/summer 2019 was
inspired by the films *La Grand
Bouffe* and *Tampopo*. It opens
to reveal a Surrealist feast with
imagery drawn from the Sunday
market in Bastille and La Grande
Épicerie in Paris. Photograph by
Kristen Jan Wong, photograph
courtesy of Leeann Huang

offer a microcosm of how cultures and subcultures operate."[5] The influential food scholar Jeffrey Pilcher concurred in 2012 that "[t]he history of food, long derided as an amateur's avocation, has finally won professional respectability."[6] Despite its late recognition, food studies is a rich and expanding field populated by scholars bringing interdisciplinary approaches to the contextualization of food culture and practices in historic and contemporary societies. While this volume draws on food studies scholarship, it is a work of fashion studies that takes a broad approach. *Food and Fashion* examines the impact of food at crucial sites of fashion history; within historic and contemporary visual culture; and relating to important contemporary fashion issues, such as sustainability, fair labor, and cultural representation. This work follows in the pioneering research of fashion scholars such as Hazel Clark and Alice Dallabona, who have made critical connections between fashion/design and food. Fabio Parasecoli approaches this intersection from the opposite perspective, drawing significant connections between food and design, as well as popular culture.[7] All of these scholars expand on a relationship between food, fashion, and culture that had been recognized by theorists such as Pierre Bourdieu and Roland Barthes. For example, in his groundbreaking ethnological study of 1960s French bourgeois culture, *Distinction: A Social Critique of the Judgement of Taste*, Bourdieu defined the three elements of consumption used by western society to establish social distinction as food, culture, and presentation (including clothing) as distinctive expressions of class.[8] In his various writings on semiotics, Barthes makes examples of sugar, pasta, and fashion magazines to illustrate how these objects act as symbols that communicate cultural meaning and can be used to make sense of the world around us.[9] Barthes and Bourdieu are continually referenced in both food and fashion studies to highlight how these mediums can function in various societies to express cultural attitudes, beliefs, and conventions. Anthropologist Jane Dusselier makes a compelling case on the connection of material culture—of which fashion is an important part—to food studies, stating, "I came to the study of food via material culture studies. Influenced by Sidney Mintz's scholarship on sugar, I began thinking about the gendering of candy in America." Drawing on Barthes and Claude Lévi-Strauss, who advocated for the study of food, "which many thought of as mundane and not worthy of scholarly attention," she came to recognize the "semiotic frameworks . . . [of food as] a system of communication." Like so many fashion and food scholars, Dusselier acknowledged the necessity of interdisciplinary work. In the same way that a garment cannot be studied as just a protective bodily covering, Dusselier saw the importance of "cross[ing] academic boundaries and reach[ing] beyond understandings of food as solely nutritional and physiological."[10] Considering the similarities between food and fashion as pervasive and expressive vehicles of cultural production, a book on the influence of food is much needed in fashion studies. While this book examines instances of critical cross-pollination,

Figure I.3
"Coffrets Christian Louboutin pour Ladurée," 2009. Ladurée frequently partners with fashion brands such as Christian Louboutin to create limited-edition packaging for their macarons. These partnerships harness the unique synergy between food and fashion and, in this case, amplify French cultural heritage. Illustration by Sarah Boston in collaboration with Christian Louboutin. Courtesy of Christian Louboutin

ranging from the concepts of luxury defined at the court of Versailles to Instagram as a site of identity formation, and addresses topics as varied as class, taste, politics, environmentalism, race and ethnicity, and art, it only begins to scratch the surface of the ways in which food has influenced fashion culture. This is an area ripe for study and we hope *Food and Fashion* will be followed by additional scholarship.

This book is divided into three sections. The first, "Food Meets Fashion: Contemporary and Historical Views," examines cultural moments in which Euro-American high fashion was interlocked with and significantly shaped by the food culture surrounding it, influencing the trajectory of both mediums. In "From Haute Cooking to Fast Food Chic: The Pairing of Food and Fashion," Melissa Marra-Alvarez examines the recent history of food-meets-fashion to explore how food symbolism connotes ideas of connoisseurship and taste, in addition to representing consumption, consumerism, and luxury within contemporary fashion. Marra-Alvarez synthesizes the ideas of philosophers—from Voltaire to Bourdieu—on the elusive nature of taste as it relates to the production and consumption of food and fashion. She applies their concepts to the practices of contemporary fashion designers, such as Karl Lagerfeld's 2014 Chanel-branded "Supermarket" and Telfar Clemens's 2016 bricolage capsule collection inspired by the fast food chain White Castle. This chapter provides critical context for the cultural impulses driving the popularity of food/fashion collaborations today. Stepping back in time, Elizabeth Way traces the history of the French food and fashion luxury sectors to the seventeenth century court of Louis XIV in "Haute Couture, Haute Cuisine." Under the guidance of the autocratic king, food and fashion were elevated to become the most potent symbols of aristocratic extravagance, and this idea was exported as French cultural superiority around Europe. Seventeenth- and eighteenth-century France persists in contemporary culture as an epitome of western luxury and style as exemplified by twenty- and twenty-first century designs by Vivienne Westwood and Jeremy Scott that draw heavily on the food and fashion of the period. In the following chapter, "Dressed to Dine: The Restaurant as Fashionable, Feminine Space," Way continues to contemplate the role of luxury in food and dress into the turn of the twentieth century. At this time, restaurants rose to prominence as public spaces in which women and the nouveau riche could harness food and fashion into soft power through significant displays of conspicuous consumption. Both chefs and couturiers acted as cultural influencers and markers of status, while elites and aspirants vied to be seen eating the latest dishes by Auguste Escoffier or wearing Worth gowns, preferably all at once. These three chapters highlight food and fashion as emblems of class and elite consumption. In eighteenth-century Versailles, food and fashion signified class status as a rigid system—only the elite had access to expensive foods and dress. During the Belle Epoch in cities such as London and New York, there

Figure I.4
Gretchen Röehrs, *Chard On* fashion
illustration from the "Edible
Ensembles" series. © 2018–2020
GRETCHEN RÖEHRS

was more room for class slippage and mobility, and this was often expressed by where one could afford to eat and what clothes one could purchase. By the twenty-first century, however, these ideas are turned on their head by "high-low" food/fashion collaborations that challenge traditional notions of exclusivity and luxury, complicating Bourdieu's idea that fashionable expression is circumscribed by class.

In the next section, "Activism: Nature, Labor, and the Body," the relationship between food and fashion is examined through a political lens, addressing issues of sustainability, labor laws, and body politics. Food and fashion are two of the world's largest industries; what happens in these sectors has massive repercussions on the world's natural resources and its people, both as communities and as individuals. These chapters highlight pressing issues in food and fashion that are currently demanding attention and meaningful solutions. One of the most pressing concerns around the food and fashion industries is their impact on the environment. In "Growing Alternatives: Food, Fashion, and the Natural World," Marra-Alvarez looks at historical back-to-the-land movements from the late nineteenth into the twenty-first century. In highlighting western society's anti-industrial impulses, she draws parallels with twenty-first century slow food and slow fashion movements and looks at how technology is reshaping the relationship between food, fashion, and sustainability. The materials science sector, for example, is finding cutting-edge ways to harness food waste for textile production, offering more responsible alternatives for textile production and reimagining a more sustainable future. Michelle McVicker also looks at food and fashion in relation to industry. In "We Feed You: Protest Fashion and the United Farm Workers Union," she explores how the leaders of the United Farm Workers (UFW) drew on a history of protest fashion and utilized powerful visual symbols to draw attention to the exploitation of agricultural workers and unsafe labor conditions during the 1960s and 1970s. UFW used the same tactics to bring attention to the ongoing safety issues for farm workers during the 2020 COVID-19 pandemic. By expanding on traditional protest clothing to include face masks, they collapsed the space between protest fashion and safety equipment for American food growers. Both the food and fashion industries influence health and body image on a societal and personal level. In "Don't Eat That: Food, Fashion, Dieting, and Disorder," Emma McClendon examines the fashion industry's tension with eating food and fleshy bodies, starting from the nineteenth century. She considers fashion's thin ideal, exploring how the industry has added to mainstream society's fatphobic anxiety, as well as the impact of the emerging body positivity movement. These chapters explore the negative outcomes inherent in global industries, yet also point to movements for activism and positive change.

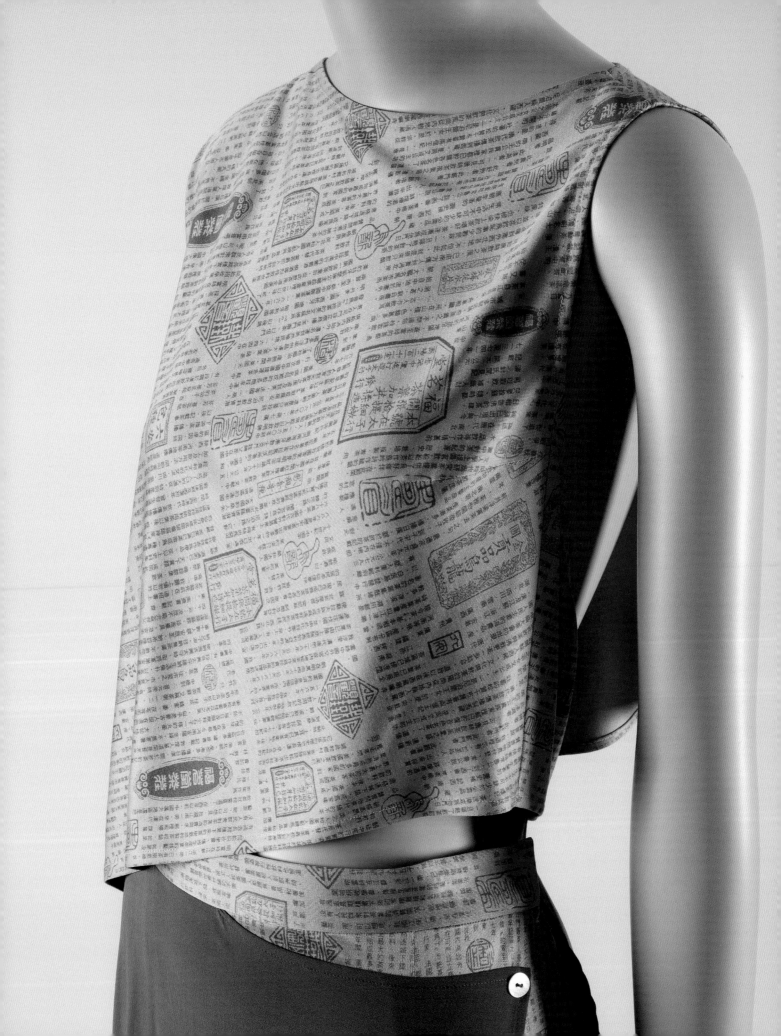

One of the most powerful aspects of both food and fashion is their ability to define and convey cultural identities, both personal and community. In the section "Cultural Representation," five fashion scholars examine the role of food within various cultures as expressed through fashion design. Cultural expression is not straightforward. Philosopher Jean-François Revel points out that centuries of trade and globalization have blurred national boundaries, and, in some ways, homogenized food and fashion cultures.[11] Imperialism and colonialism were driving factors of this homogenization and worked to marginalize and stereotype cultural difference. However, as fashion scholar Malcolm Barnard states, "to some theorists, the consumption of fashion and clothing was one of the ways in which stereotyped social and cultural identities . . . could be investigated and challenged. Among those were race, ethnicity, class and gender: each became an arena in which difference and identity were negotiated through the consumption of fashion and clothing."[12] Through five chapters, this section explores examples of how fashion designers have used food motifs and themes unique to their own ethnic or national backgrounds as a shorthand for cultural identity and pride. Examinations of Italian, Japanese, and Mexican food and fashion illustrate different ways that these media work within their national boundaries and how they project across the globe. Chapters that examine the food and fashion of Chinese immigrants and people of the African Diaspora expand on historian Alison Smith's statement that cuisine "maintained in immigration helps to create a sense of nationality where none existed before . . . food allows individuals to maintain their national identity outside their national space."[13]

In chapter seven, Way explores influential foods of the African Diaspora, including yams and watermelons, as motifs in the work of Haitian-Italian designer Stella Jean and the Paris-based, Mississippi-born Patrick Kelly. These foods help Black people maintain cultural ties to the diaspora, but have also been used to stereotype and oppress them. Jean and Kelly reclaim these foods as celebrations of Black culture. Faith Cooper looks at the role of Chinese food and restaurants in the sartorial expressions of Chinese American designers in chapter eight. Dress and style, and especially food, were means by which mainstream Americans ridiculed Chinese immigrants from the nineteenth century. Generations later, Chinese American fashion designers confront the racist stereotypes faced by earlier immigrants, using Chinese restaurants as spaces for high fashion and celebrating Chinese cuisine. Italy was unified in 1861, and since its inception as a country, food has been crucial to its national image. In chapter nine, Marra-Alvarez examines how representative Italian foods, such as pasta and pizza—which became widely associated with Italian culture through Italian immigrants—along with Italian fashion became vital forms of soft power. They are symbols of prestige united under the "Made in Italy" label. Designers from Franco Moschino to Missoni and Dolce & Gabbana have all drawn on Italy's food culture to challenge and celebrate Italian identity. In chapter ten, Patricia Mears draws upon

Figure I.5
Han Feng uses Chinese tea box labels on this silk ensemble. The Hangzhou-born, New York–based designer drew on her own immigrant roots and the long history of China's international trade in luxury food and fashion, especially tea and silk. Han Feng, silk jersey ensemble printed with Chinese tea box motif, spring 1998, USA. Gift of Han Feng. ©The Museum at FIT

her longstanding expertise on Japanese avant-garde fashion and her many trips to Japan to make connections between food practices and fashion within the culture of Japanese aesthetics. She outlines how these unique expressions, from wabi-sabi to kitsch, freely cross boundaries between food, food packaging, fashion, and retail. These aesthetics have become globalized, yet they retain their distinctively Japanese style. Tanya Melendez-Escalante rounds out the section by focusing on the role of maize in Mexican identity. Corn has been vital to the indigenous cultures of Mexico since prehistory, and it serves as an important marker of the multifaceted national culture. Contemporary designers have found a myriad of ways to draw on its historic symbolism to express modern social ideas, from feminism to the importance of ethical local production of both food and fashion. Food scholar Sandra Johnson has noted that the historical importance of food and its related symbolism lies, in part, in its ability to express a culture's values at any given point in time.[14] This is echoed by fashion scholar Elizabeth Kutesko's definition of dress as "a multifaceted form of cultural expression . . . well equipped as a medium to analyze the widespread economic and cultural exchanges that have transformed contemporary social life."[15] This section brings together food and fashion to amplify their communicative power, better enabling both to reinforce existing cultural identities and disrupt preconceived ideas while navigating new identities.

Food and Fashion's final section, "Art and Visual Culture," examines the convergence of food and fashion in visual mediums, from Renaissance paintings to Instagram selfies. Food and fashion are both inherently sensual objects. They interact with the body and engage the senses. Although food engages with taste and fashion with touch, sight is arguably as important for both in its experiential qualities. Madeleine Luckel addresses the long history of the depiction of food and fashion in art in "The Eye Has to Eat: Food, Fashion, and Art's Enduring Intersects." Food and fashion as manifestations of luxury, desire, and consumerism have long attracted the eye of the artist—from sixteenth-century Venetian painter Lorenzo Lotto to contemporary photographer Lucia Fainzilber, who undeniably invoke fashion and style in their works. Explicit crossovers include Elsa Schiaparelli's lobster dress (1937), created in collaboration with Salvador Dalì, and the Andy Warhol–inspired "Souper" dress produced by the Campbell's Soup Company (1966). Performance art has also served as a rich area of synthesis, from Robert Kushner's 1972 *Robert Kushner and Friends Eat Their Clothes* fashion show, in which models wore garments made of fruits and vegetables, to Lady Gaga's 2010 meat dress. These artworks express how art, food, and fashion interplay to create and express culture. *Food and Fashion* ends with a consideration of the role that social media plays in twenty-first century depictions and experiences of food and fashion. Monica Titton's chapter, "Avocado Toast and Blonde Salad: Critical Perspectives on Fashion and Food on Instagram," looks at Instagram, where fashion, food, and nutrition have become integral to the construction of the influencer's

Figure I.6

This durian-printed 2019 ensemble by the Singapore-based brand Reckless Ericka pays homage to the country's distinctive and renowned food culture. Photograph by Raymond, Capsule Productions, courtesy of RECKLESS ERICKA

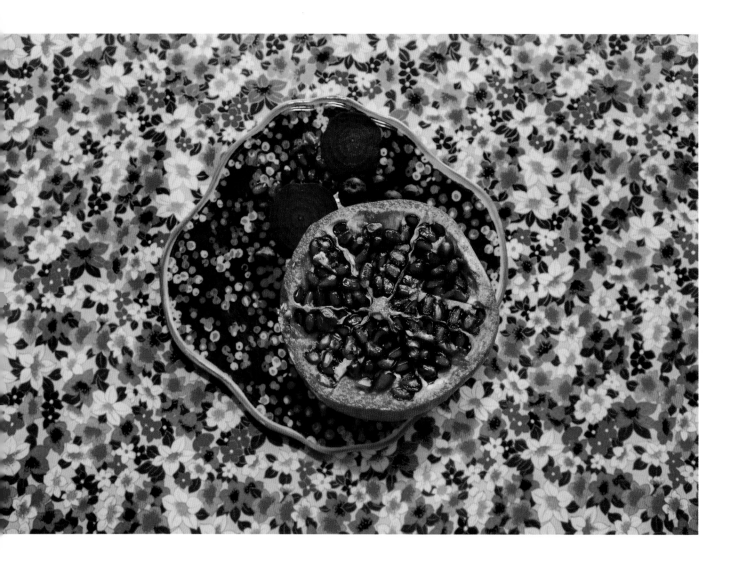

Figure I.7
Lucia Fainzilber, *Pomegranata* photograph, "The Cookbook Series," 2019. Fainzilber's bold aesthetic developed from her earlier career working in fashion photography. "The Cookbook Series" utilizes her eye for color and texture and draws on the importance of food in cultural identity, still life, and social media to create a "harmonic feast for the eye." © Lucia Fainzilber

"fashionable persona." Images of fashion influencers eating or socializing over food, or of foods that they have bought or prepared, have become essential to a carefully constructed fashionable lifestyle. These visual tropes are reminiscent of cooking sections and recipes in traditional fashion and women's magazines but take on a new dimension in online fashion media that engage with ideas of femininity, class, and consumerism.

As early as 1981, food critic Mimi Sheraton noted that trends in food emerge in much the same way as trends in fashion, based on their cultural relevance in society. Over forty years later, the authors of *Food and Fashion* offer this volume, which explores a wide range of topics that illuminate food culture's impact on fashion. As a collective, they illustrate the extensive possibilities of the interdisciplinary exploration of food and fashion and the rich subjects that can be illuminated through their intersection.

Notes

1. Mimi Sheraton, "Fashions in Food, Like Those in Clothes, Follow the Trends," *New York Times*, August 1, 1981, 22.

2. Fabio Parasecoli, *Bite Me: Food in Popular Culture* (London and New York: Berg Publishers, 2008), 1.

3. Greer Crawley and Donatella Barbieri, "Dress, Time, and Space: Expanding the Field through Exhibition Making," in *The Handbook of Fashion Studies*, ed. Sandy Black et al. (London: Bloomsbury Academic, 2013), 44–60.

4. Valerie Steele, "The F-Word," *Lingua Franca*, April 1991, 17–20.

5. William C. Whit, "Soul Food as Cultural Creation," in *African American Foodways* by Anne L. Bower, ed. (Urbana and Chicago: University of Illinois Press, 2009): 45–58, 46.

6. Jeffrey M. Pilcher, "Introduction," in *Oxford Handbook of Food History*, ed. Jeffery Pilcher (London and New York: Oxford University Press, 2012), xvii.

7. Hazel Clark, "SLOW + FASHION—an Oxymoron—or a Promise for the Future …?" *Fashion Theory*, 12:4, (2008), 427–446, DOI: 10.2752/175174108X346922; Alice Dallabona, "At Home with the Missoni Family: Narratives of domesticity within Hotel Missoni Edinburgh," in *Home Cultures: The Journal of Architecture, Design and Domestic Space*, 3:1, (2016): 1–33. DOI: 10.1080/17406315.2016.1122965; Fabio Parasecoli, Bite Me: Food in *Popular Culture* (Oxford: Berg, 2008); Fabio Parasecoli and Mateusz Halawa, *Global Brooklyn: Designing Food Experiences in World Cities* (London: Bloomsbury, 2021).

8. Pierre Bourdieu, *Distinction: A Social Critique of the Judgement of Taste*, trans. Richard Nice (Cambridge: Harvard University Press, 1984).

9. Roland Barthes, "Towards a Psychosociology of Contemporary Food Consumption," in *Food and Culture: A Reader* by Carole Counihan and Penny Van Esterik, eds. (New York: Routledge, 2013): 23–30; Roberta Sassatelli, "Food, Foodways and Italianicity," in *Italians and Food*, edited by R. Sassatelli, (New York: Palgrave Macmillan, 2019), 1; Roland Barthes, The Fashion System, trans. Matthew Ward and Richard Howard (Berkeley: University of California Press, 1983).

10. Jane Dusselier, "Understanding Food as Culture," *Environmental History*, 14: 2 (April 2009): 331–338, 331.

11. Jean-François Revel, *Culture and Cuisine: A Journey Through the History of Food* (New York: Da Capo Press, 1984), 271.

12. Malcolm Barnard, "Fashion: Identity and Difference: Introduction," in *Fashion Theory: A Reader* 2nd Ed., ed. Malcolm Barnard (London: Routledge, 2020), 259.

13. Alison K. Smith, "National Cuisines" in *Oxford Handbook of Food History*, ed. Jeffrey M. Pilcher (Oxford and New York: Oxford University Press, 2012), 444–460.

14. Sandra Johnson, "Edible Activism: Food and the Counterculture of the 1960s and 1970s," honors thesis, Colby College, May 2012, http://digitalcommons.colby.edu/honorstheses.

15. Elizabeth Kutesko, "Introduction: Fashioning Brazil and Brazilian Self-Fashioning," in *Fashioning Brazil: Globalization and the Representation of Brazilian Dress in National Geographic* (London: Bloomsbury Visual Arts, 2018), 1–22.

From Haute Cooking to Fast Food Chic: The Pairing of Food and Fashion

Melissa Marra-Alvarez

In February 2018, culture website *The Cut* proclaimed, "The Biggest Trend at Fashion Week Was Food."[1] Indeed, the fashion runways that season featured a myriad of culinary delights and food references. Calvin Klein used branded silver popcorn bags for invitations and carpeted the runway with popcorn (50,000 gallons of the puffy treat were trucked in for the show).[2] Raf Simons's namesake menswear presentation went a step further by simulating a bacchanalian feast, replete with wine goblets, champagne bottles, and piles of bread, cheese, waffles, fruit, and vegetables that covered the runway to resemble a lengthy banquet table "littered with the detritus of a lavish feast."[3] Pushing the envelope further still, New York–based designer Snow Xue Gao presented her collection in the Chinatown restaurant Jing Fong, where models carried plastic takeout bags and attendees shared tea and dumplings to emphasize the communality of Chinese dining. Underscoring the craftsmanship and visual aesthetics of her collection, designer Rosie Assoulin showed her custom marbled velvets, silks, and cottons alongside artisanal marbled desserts such as meringues and cakes. Molly Goddard presented a *tableau vivant* set in an industrial kitchen where models mingled and snacked on food, highlighting the connections between food, fashion, and socializing.

In recent years, there has been a heightened awareness of the significance of food in Western society. Food references have increasingly made their way into fashion collections, and, in turn, fashion has delved into food culture. Fashion-branded cookbooks, tableware, and kitchen appliances (think Dolce & Gabbana's SMEG toasters and refrigerators) have become *de rigueur*. Luxury brands, such as Burberry, Gucci, Prada, and Ralph Lauren, have opened restaurants, cafés, and bars as extensions of

Figure 1.1
Model carrying a bag of popcorn down a popcorn-covered runway at the Calvin Klein fall 2018 presentation. Photo by Victor VIRGILE/Getty Images

Figure 1.2
Piles of food littered the runway of
Raf Simons's fall 2018 menswear
fashion show. Photo by Victor
VIRGILE/Gamma-Rapho via
Getty Images

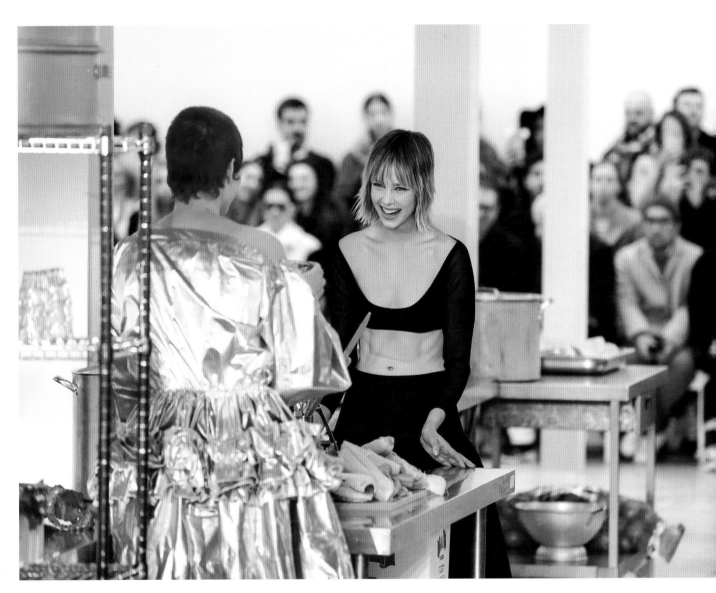

Figure 1.3
Molly Goddard presented a *tableau vivant* set in an industrial kitchen for her fall 2018 collection. NurPhoto/ Contributor/Getty Images

Figure 1.4 (left)
Rick Owens Burger. Rick Owens x
Fred's Downtown at Barneys New
York collaboration, 2018. Barneys
New York

Figure 1.5 (right)
Thom Browne Burger. Thom
Browne x Fred's Downtown at
Barneys New York collaboration,
2018. Barneys New York

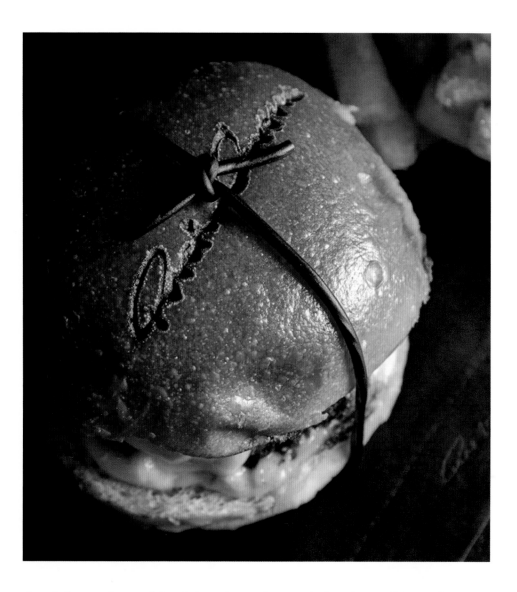

their fashion styles into lifestyle brands. Marketing scholar Alice Dallabona, for example, has highlighted the Missoni brand—encompassing their hotels and restaurants in addition to their fashion—and the culinary, spacial, and design strategies it employs to convey a particularly Italian sense of family and domesticity that aims to create "a sense of closeness and intimacy between the brand and its consumers."[4]

In 2018, Fred's, an upscale eatery at Barney's New York, brought new meaning to the notion of fashion designers as purveyors of "taste" by hosting a designer burger series. American fashion designers Rick Owens, Thom Browne, and Alexander Wang were each commissioned to create their own take on the classic American hamburger. More recently, Laura Kim, of the fashion label Monse; Philip Lim; and Jason Wu are just a handful of the designers who have taken to filling their Instagram feeds with images of their culinary creations.

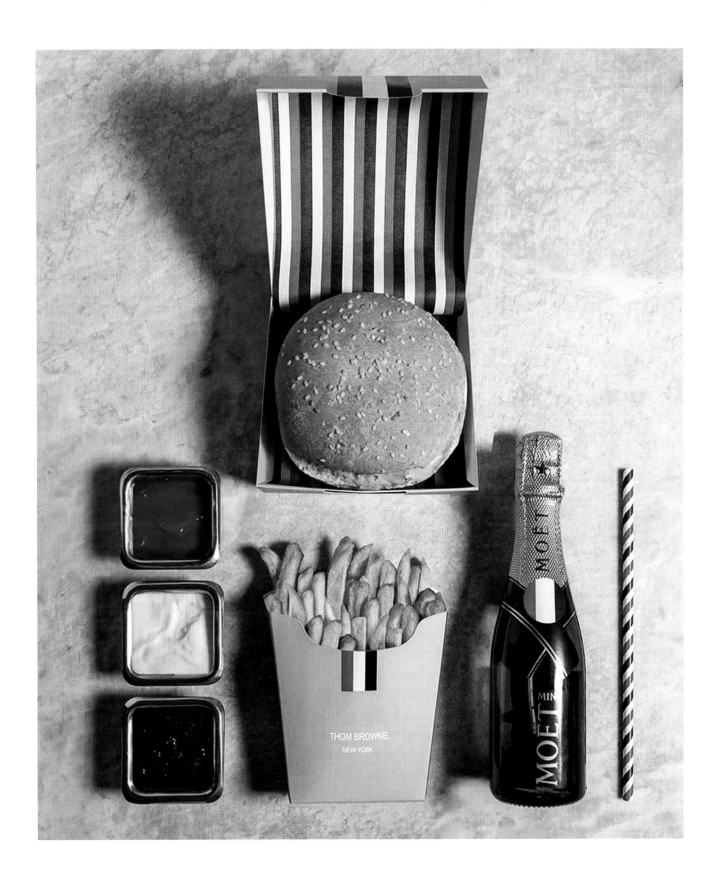

But why have food and fashion become increasingly popular bedfellows? Food and fashion can express cultures and ideas from the macro to the micro. In his 2008 book, *Bite Me: Food in Popular Culture*, food scholar Fabio Parasecoli explains that:

> food is pervasive in contemporary Western pop culture, influencing the way we perceive and represent ourselves as individuals and as members of social groups. However, the ubiquitous nature of these cultural elements makes their ideological and political relevance almost invisible, buried in the supposedly natural and self-evident fabric of everyday life.[5]

Parasecoli has also noted that representations of food in popular culture also connect to larger social and economic issues, "through cultural and social negotiations, food-related meanings and behaviors can be embraced, selectively adopted, or transformed and directed to different goals."[6] Fashion works in similar ways. Through its exhibition and scholarship, The Museum at FIT advocates for the communicative power of fashion on multiple levels and across time. Fashion scholar Malcolm Barnard specifically notes that fashion, among its many broader expressions, is used by the consumer to actively construct and communicate social identity.[7] As mediums that nearly every person engages with daily, food and clothing inevitably facilitate the outward expression of a society's values, as well as the individual's construction of the self. Although food and fashion are elements of culture relating to aesthetics, identity, and social practices, within modern societies, they are also perceived as industrial commodities, given their ties to industries of production and consumption. Furthermore, both food and fashion are polyvalent signifiers with important physiological and psychological associations. In her discussion on the connections between food and culture, Margaret Visser looks to the "unrestricted desire that is central to postmodernism," which has made food symbolism "irresistible within popular culture."[8] Biologists have noted that our senses of taste, sight, and smell work in concert. Olfaction, in particular, has *direct* links to brain centers involved in memory, emotions, and pleasure.[9] These factors feed a literal and figurative hunger that can be translated into a desire for fashionable goods, implying that the mere image or suggestion of food can elicit a visceral response by triggering memories and other associations, making food imagery in fashion a powerful stimulus.

Food and fashion operate in similar ways, and in certain instances can serve as exemplars of luxury and refinement. This chapter explores how, when paired together, food and fashion create powerful metaphors for conveying ideas about taste, class, lifestyle, and consumption, and can become an effective vehicle for co-branding.

Haute Cooking: Lifestyle and Luxury

In her 2016 book *Feast for the Eyes: The Story of Food in Photography*, Susan Bright writes: "Ultimately, food is not only about literal taste, but also about Taste with a capital T—both the lifestyles we aspire to and the building blocks of culture itself."[10] The use of the word "taste" to apply to aesthetics is thought to have emerged between the sixteenth and seventeenth centuries.[11] As Voltaire wrote in 1778, "This sense, this gift of distinguishing our foods has produced in all known languages the metaphor that uses the word taste to express sensitivity to the beauty and defects of all arts."[12] In turn, food becomes a projection of taste in the cultural sense. Food historian Massimo Montanari further explains this idea:

> taste understood as flavor, as the individual sensation of the tongue and palate—an experience that is by definition subjective, fleeting, ineffable . . . taste can also mean knowledge . . . it is the sensorial assessment of what is good or bad, pleasing or displeasing. And this evaluation . . . begins in the brain before it reaches the palate. From this perspective, taste is not in fact subjective and incommunicable, but rather collective and eminently communicable. It is a cultural experience transmitted to us from birth, along with other variables that together define the "values" of a society.[13]

The familiar act of eating (or cooking) becomes a metaphor for the embodiment and actualization of values and attitudes that reflect culturally sanctioned templates.[14] When presented in the context of fashion, as this chapter explores, food as the figural representation of taste becomes even more pronounced, underscoring ideas about lifestyle and reinforcing or challenging notions of refinement and luxury.

The concept of taste plays an integral role in our perceptions of both food and fashion. French sociologist Pierre Bourdieu writes that taste is arbitrarily class-based and determined by dominant classes, "Taste is . . . the source of the systematic expression of a particular class of conditions of existence, i.e., as a distinctive lifestyle."[15] In his book, *The Invention of Taste: A Cultural Account of Desire, Delight and Disgust in Fashion, Food, and Art*, author Luca Vercelloni further examines this idea:

> Refinement in terms of clothing, ornament and look, along with sophistication in what we eat (where the cultural perception of good taste transcends the more material taste for food, or in the taste of the food itself), are not just conventions pertaining to good manners, but stage props essential to the whole theatrical performance. Competing cultural models, together with the symbols of admiration and infatuation, all come under the jurisdiction of taste.[16]

Figure 1.6
Christian Dior, *Bon Bon* dress,
autumn/winter 1947. Christian
Dior Museum-Granville.
© Laziz Hamani

Fashion designers have positioned themselves as arbiters of taste by harnessing the power of food and its associations, especially in regard to luxury, domesticity, and class, as a way to connect their fashion (and personal) brands with greater ideas of good living and the "fashionable lifestyle." A consummate gourmet, French designer Christian Dior laid the groundwork for this connection when he merged his love of *la cuisine* with *la couture*, creating parallels between his fashion designs and French gastronomy. His fall 1947 collection included a dress titled *Bonbon* (a French style of candy), and a fall 1957 white lace evening gown titled *Chantilly* evoked the soft frothy effect of Chantilly cream. These very names and their associations allude to a sense of luxury, pleasure, and indulgence that are at the essence of haute couture. Referring to the artistry behind the creation of both haute couture and haute cuisine, Dior once remarked, "The ingredients in cooking are as noble as those in couture and what I love in my profession is the fulfillment of the work by the partnership of the hands and the mind."[17] The synergy recognized by Dior between food and fashion was fortified by his fashion company after his death. In 1972 the designer's favorite recipes were published in *La Cuisine Cousu-Main* (Tailor-Made Cuisine), a lavish limited edition, aluminum-bound cookbook featuring drawings by fashion illustrator René Gruau. This book capitalized on Dior's reputation as both a designer and gourmand who expected the highest standards of beauty and flawless perfection, a perspective that still has relevance decades later. In 2020, the House of Dior released a free, digital version of the 1972 cookbook during a time when the COVID-19 pandemic had people quarantined in their homes, many longing for a sense of indulgence and comfort. In 2004, highlighting the connections between desire, food, and fashion, the *New York Times* noted that, for the designer Christian Dior, "the all-consuming desire of the creator and the consumer" were one and the same, "whether it was fashion or food that was engaging him."[18]

Other designers have also utilized the power of "good taste" as it relates to food and fashion. In 1967, Italian fashion designer and Paris resident Simonetta published *A Snob in the Kitchen*, billed as a cookbook for the sophisticated hostess. It featured recipes from the Italian aristocracy and their cooks. When the renowned milliner Stephen Jones named it as his favorite cookbook, he proudly mused, "It reeks of that era's jet set glamour."[19] Even arbiters of style such as Betsy Bloomingdale and the Duchess of Windsor, Wallis Simpson, published cookbooks. Fashion designers and fashionable socialites have used cookbooks to highlight food as a class-based emblem of luxury, refinement, and symbol of Taste, further enhancing their own prestige. These earlier works predate contemporary fashion cookbooks, including The Council of Fashion Designers of America's *American Fashion Cookbook* (2009), the *Missoni Family Cookbook* (2018), and artist Viviane Sassen and designer Phillip Lim's *More Than Our Bellies* (2018), which offer a small glimpse into the "tasteful" lifestyles and cultural heritage of the featured designers.

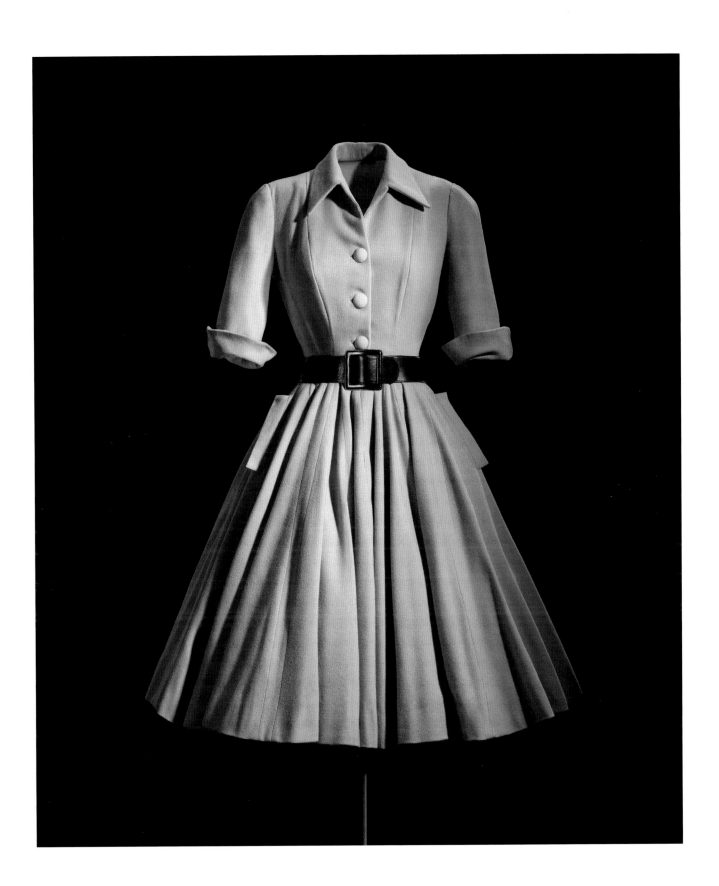

On the other hand, Angie Mar, the former owner and chef of the historic New York restaurant The Beatrice Inn,[20] employs a similar dynamic, drawing on fashion in her cookbook *Butcher + Beast: Mastering the Art of Meat* (2019). Presenting food and fashion as part of a fashionable lifestyle, the book conveys the provocative opulence that characterized her restaurant and its patrons. "Food should be sexy. Food is sensual. It's not about just what we taste. What does it look like when it comes out, who are the people eating it, sitting around the dinner table, the lighting, music, smells in the air," Mar explains.[21] After taking over as chef in 2013, Mar focused on forgotten indulgences to shape her vision, which embodied a mix of masculinity and femininity and evoked a primal sensuality.

Mar's interaction with high fashion informs her creative process in the kitchen. Just as a fashion designer would employ a mood board to plan a new collection, Mar developed dishes for The Beatrice Inn using "word webs." These oftentimes incorporated elements of fashion directly, referencing textures, materials, and other concepts.[22] "I begin with an idea, which might be a word, an emotion, a piece of art or a fashion collection," Mar affirms. An Alexander McQueen collection featuring deconstructed corsets with floral applique and leather combat boots, for instance, inspired the chef to create a dish of squab with roasted apples and an elderflower garnish. This was served under an eighteenth-century crystal cloche filled with smoke.[23] More recent menu items were directly inspired by Christian Dior's fall 2019 haute couture collection. As Mar explains:

> I was so in awe by [the collection] because it was done completely in black and it was so feminine, but it was strong and it was modern and it was architectural. It really forced me to go back and to look at the details in very classic French cuisine, and how to make that modern and how to make that feminine. That's really what our autumn menu is based on is that Dior haute couture show.[24]

With personal essays, recipes, and stylized photographs, Mar's cookbook has the deliberate feel of a fashion magazine, and she employs both food and fashion stylists to create vignettes that evoke an opulent lifestyle. Polaroids by Johnny Miller capture the restaurant's signature dishes, its patrons, and Mar herself—dressed in a series of designer looks, including Oscar de La Renta and Stella McCartney—while eating and drinking. For Mar, designer looks were integral to conveying the spirit of the restaurant, otherwise "it wouldn't have been such a true representation of how we live here, what dinner is like around our tables," she said.[25] Leveraging the connection between the two, Mar's cookbook uses provocative imagery to evoke a heady decadence and present food and fashion as carnal appetites to be sated.

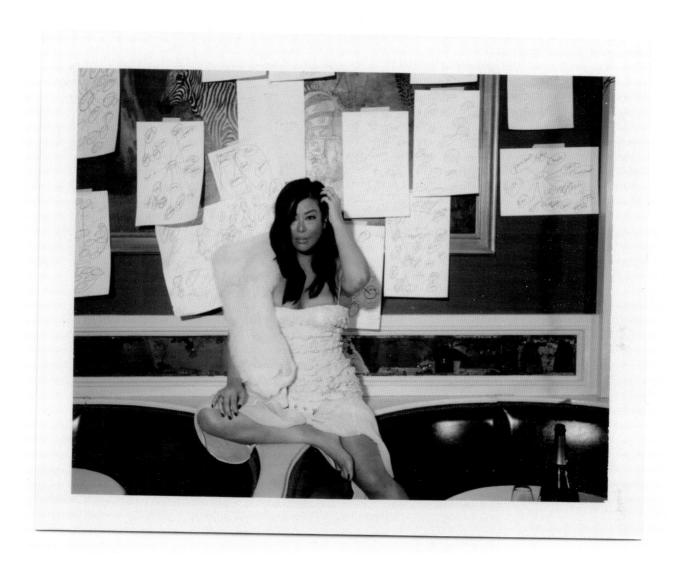

Figure 1.7
Angie Mar, owner and chef of
the Beatrice Inn, posing in front
of her word web concept maps.
Photograph by Johnny Miller/
Edge Reps

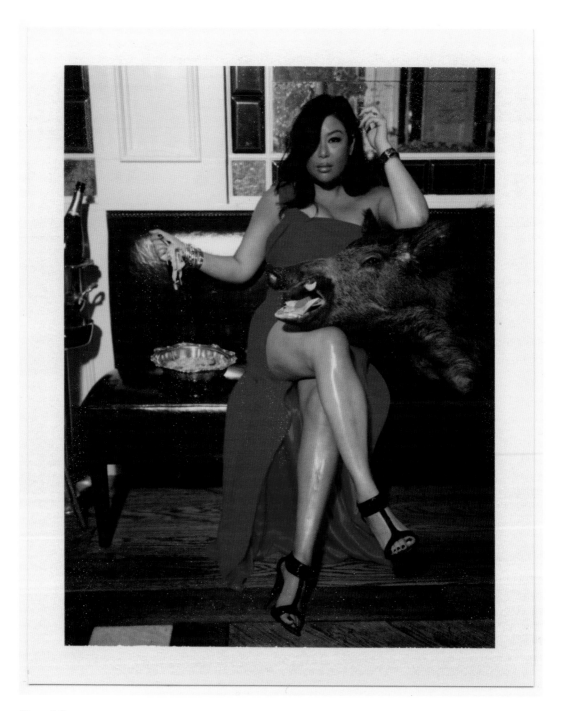

Figure 1.8
Photo from *Butcher + Beast: Mastering the Art of Meat: A Cookbook*
by Angie Mar with Jamie Feldmar. Photography by Johnny Miller.
New York: Clarkson Potter/Publishers (2019). Photograph by
Johnny Miller/Edge Reps

The Double Cs: Consumption and Consumerism

Vercelloni writes, "Impure, changeable and concupiscent, though it may be, taste is the true engine of consumer society."[26] Food and fashion often converge on the concept of taste, speaking to contemporary society's cultures of consumption. Karl Lagerfeld, designer of Chanel, a fashion house historically associated with the highest echelons of good taste, paid homage to consumerism in the fall 2014 ready-to-wear show, set in a "supermarket" built within the Grand Palais in Paris. The show was a dazzling spectacle of luxury and desire. Supermarket aisles were stocked with Chanel-branded products, while models perused them holding shopping baskets accented with the signature Chanel metal chain (a nod to the classic 2.55 handbag). More than one hundred thousand items stocked the shelves, and signs advertised tongue-in-cheek markups of 20 and 50 percent.[27] Among the items were *Lait de Coco* (coconut milk), bottles of *Eau de Chanel* mineral water, *Coco Choco* rice cereals, and *Paris-Londres* gin. The presentation was ultimately a celebration of luxury goods, branding, and consumption. At the show's end, attendees rushed the set in the hopes of bagging a Chanel-branded supermarket souvenir; however, only the produce was up for grabs. *The Guardian* praised Lagerfeld's commentary on commerce and desire, and noted the two were "equally as valid and not something to be ashamed of."[28] Lagerfeld's presentation equates the desire for fashion with the necessity of food, suggesting it is akin to our most basic needs. Once again, fashion is depicted as an appetite to be sated. Margaret Visser notes that, in fact, the term *consumerism* derives from the notion of eating:

> [M]odern economists love the food metaphor for buying stuff, you eat three times a day, and your appetite renews in time for every meal. The obliging never-endingness of the desire for food is then thought of as applying to all things we buy, as though cars, CDs, and handbags disappear down our gullets so that we perpetually need more of them.[29]

The looming irony of the show was that Lagerfeld seemed to promote democracy in fashion, associating his designs with everyday accessible products in a supermarket, despite the fact that Chanel clothing is prohibitively expensive for most consumers. Many who attended his show drew comparisons between Lagerfeld's set and German photographer Andreas Gursky's gigantic work titled *99 Cent 1999*, which was created from multiple images taken at a 99 Cent store in Los Angeles. Depicting endless rows of merchandise with the heads of shoppers floating amidst the aisles, it examines capitalism and consumerism, presenting the viewer with enormous amounts of visual information. Lagerfeld embraced popular culture and often used his fashion

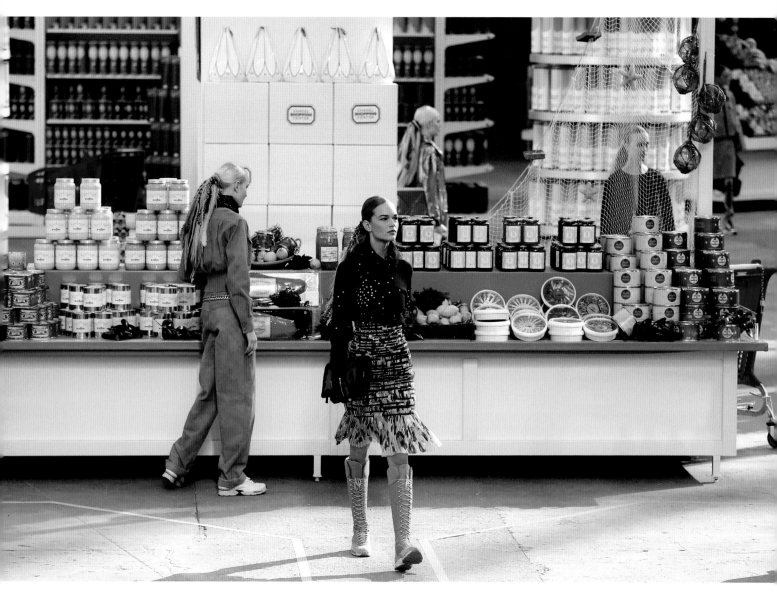

Figure 1.9
"Supermarket" runway show,
Chanel, fall 2014. PATRICK
KOVARIK/AFP via Getty Images

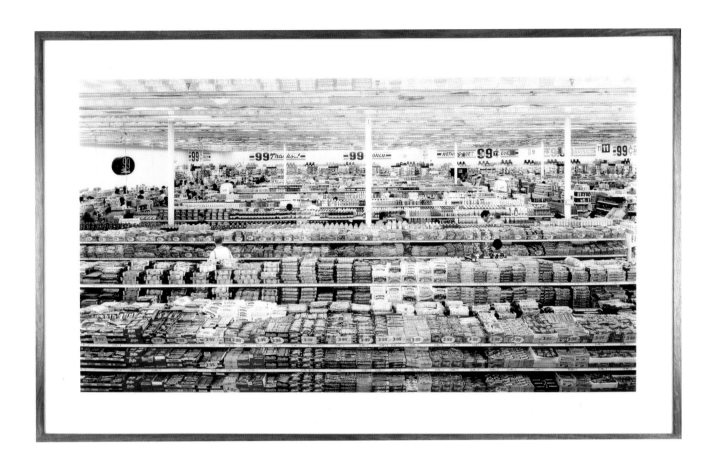

presentations to provoke and create satire. In this instance, the Chanel "fashion super-market" was used to make the luxury shopping experience appear quotidian. Parasec-oli underlines this concept when he writes:

> Food's neutrality and ordinariness can normalize various cultural and social dynamics, making them invisible and allowing ideologies to operate more effi-ciently, extending their reach to the most intimate aspects of individual lives. Eating and cooking, seemingly trivial and familiar acts, offer an apt environ-ment of the embodiment and the actualization of values, attitudes, and behav-iors that reflect widely accepted and culturally sanctioned templates.[30]

For Lagerfeld, a veteran of the fashion industry, the message of his Fall 2014 celebra-tion of luxury consumerism was "Fashion is a supermarket, so shop!"[31]

Figure 1.10
Andreas Gursky, *99 Cent 1999*. Chromogenic print mounted on Plexiglas in artist's frame. AM 2000-96. Repro-photo: Philippe Migeat. Musee National d'Art Moderne, Centre Georges Pompidou, Paris, France. Andreas Gursky, Artists Rights Society (ARS), New York/VG Blind-Kunst, Bonn. © Andreas Gursky/Courtesy Sprüth Magers/Artists Rights Society (ARS), New York © CNAC/MNAM, Dist. RMN-Grand Palais/Art Resource, NY

Food references obviously afford designers a provocative means to comment on the rampant consumerism of capitalist societies. In the same season Lagerfeld presented his supermarket collection, designer Jeremy Scott made his debut at Moschino with a collection that presented luxury fashion in the context of fast food, juxtaposing ideas of class distinction that equally celebrate high and low culture. Fashion journalist Tim Blanks described the collection as a "mutant hybrid of Ronald McDonald and Coco Chanel."[32] Scott's collection also experimented with the power of branding in both fast food and fashion. For example, in an amalgam of brand imagery, the golden arches of McDonald's (one of the most recognizable symbols around the world) were reconfigured as the Moschino label's heart-shaped "M" design. The collection also drew correlations between the concepts of fast food and fast fashion, a phenomenon popularized by stores such as H&M, Zara, and Forever 21, which churn out vast quantities of inexpensive accessible clothing, often runway knock-offs, for eager consumers. "It's also a bit like a commentary about the waste too. I mean throwing away the packaging. So, in a way it's like taking the packaging and making something beautiful in it," Scott said of the collection.[33] In retrospect, Scott's collections typically mix elements of high and low culture, juxtaposing glamour—seen in the collection's Chanel-inspired suits and sculptural evening gown silhouettes—with the more mundane, such as junk foods.

The notion of food as a signifier of consumerism, consumption, and, by extension, capitalism prompted designer Demna Gvasalia of Vetements to present his spring 2020 collection inside the largest McDonald's in Paris. "Menus" for the show were stamped on McDonald's napkins, with "Kapitalism" and "Global Mind Fuck" as two of the "courses." Vetements has a history of subverting fashion industry norms and of co-opting corporate logos. Gvasalia drew on the corporate might of McDonald's to symbolize greed and gluttony, two conditions often viewed as intrinsic to the fashion industry. The website *Highsnobiety* wrote that the collection "provoked questions surrounding capitalism and its associated hierarchies, transforming pop-culture signifiers that are often disregarded in high fashion. This time, the focus was fast food, and the result was a feast for the eyes."[34] For Gvasalia, presenting in a McDonald's also offered a sense of nostalgia. In Gvasalia's home country of Georgia, McDonald's was the first corporation from the West to establish itself in the former Soviet Republic. "It was like the maker [sic] of capitalism, and all the rich people from all around would bring their kids for birthday parties," he recalled. "We'd never seen a Big Mac or drank a Coke. I always wanted to be able to have my own celebration in McDonald's. And now—I can!"[35]

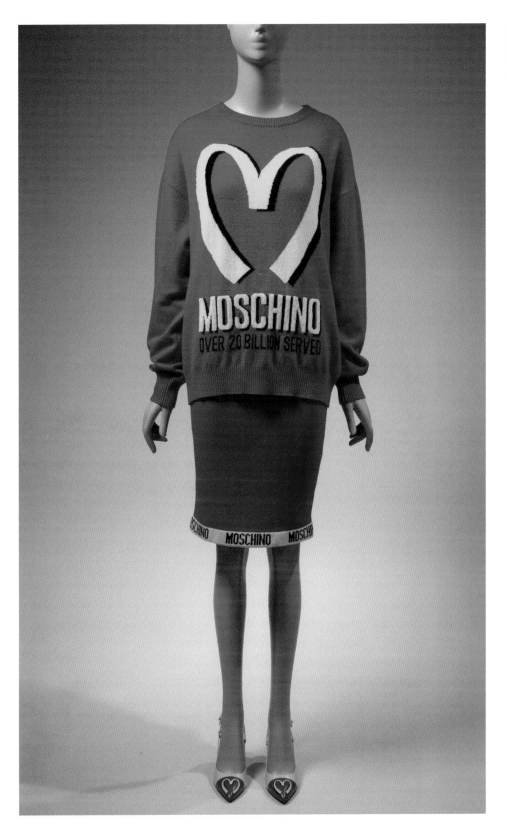

Figure 1.11
Jeremy Scott for Moschino, ensemble, fall 2014, Italy. Gift of Moschino. ©The Museum at FIT

Fast-Food Chic and Co-Branding

A number of streetwear brands have found success in limited edition collaborations with fast-food chains. Mutually beneficial, these offer unique opportunities for co-branding, which allow for the reimagining of each brand into a unique, albeit temporary, composite brand, which expands its identity and customer base. Similar to streetwear labels, fast-food chains have a loyal clientele and offer consistent products. However, both also promote a culture of "product drops," or special goods available in limited quantity for a limited time. Arguably, the excitement surrounding McDonald's McRib sandwich, introduced in 1982 and periodically rereleased for limited times, is similar to the hype that surrounds the latest Supreme drop or sneaker collaboration.

Commemorating the launch of its new delivery system in 2017, Pizza Hut teamed with the Shoe Surgeon, a sneaker customizer with a substantial social media following, to create sixty-four Bluetooth-enabled "Pie Top" sneakers. Later that same year, a separate collaboration resulted in a limited edition "Pizza Parka" made from the same insulation material used in pizza delivery bags.[36] According to the *Wall Street Journal*, the coat was one of the top five news stories trending on Twitter the week of its debut.[37] "It's easy to understand how these small-batch partnerships can be so mutually beneficial: fashion and food companies alike have noticed that their fans have an insatiable appetite to own a limited-edition whatever—be it Nike Jordans or the one-day-only Szechuan sauce at McDonald's," wrote journalist Jacob Gallagher.[38] However, not everyone is a fan. Brand consultant Chris Black expressed, "A [restaurant] collaboration with streetwear, to me, takes the whole fun out of it. Then it becomes a commodity for teenagers, like everything else."[39]

For fast-food companies, fashion collaborations can serve as a means of elevating identity to "become a lifestyle brand, rather than just another take-out spot."[40] Successful fashion/food collaborations can make the common elite, giving fast food a luxury status, albeit for a limited time. On the flip side, these partnerships can also create accessibility for a consumer base that could not typically afford these luxury brands. Following the launch of McDonald's e-commerce site, Golden Arches Unlimited, which featured apparel and accessories, New York designer Alexander Wang partnered with McDonald's China in 2020 on the limited edition "Black x Golden" collection. In addition to specialty menu items, the collaboration featured the Tyvek® *AW Golden Lunch Bag*, modeled after McDonald's take-out bags, and the luxury *AW Golden Picnic Basket* emblazoned with the classic Alexander Wang "A" in silver, along with a McDonald's co-brand leather tag on the handle. Danielle Bailey, managing vice president of the global research and intelligence company Gartner L2, explained, "Because young Chinese shoppers, who are the drivers of luxury consumption in the

Figure 1.12
Demna Gvasalia for Vetements,
spring 2020 fashion show. Photo by
Victor VIRGILE/Gamma-Rapho
via Getty Images

country, specifically cite collaborations as a key factor in their decisions to purchase luxury goods, burgers with a side of handbags makes sense to feed the hunger of millennials constantly on the hunt for the next new thing."[41] These collaborations take on multiple forms and are received with varying levels of enthusiasm. In 2020, Supreme—arguably the most coveted streetwear label today —partnered with Oreo on limited edition Supreme x Oreo cookies. On February 20, after a month of online promotion, Supreme released its red branded Oreo cookies, then available online and at Supreme's New York store for $3 a pack. The cookies sold out almost immediately and, according to one media outlet, packs of Supreme's Oreos were re-selling on eBay for $23,300. More than one hundred bids were reported.[42]

Figure 1.13
Stan Herman, McDonald's uniform,
1975, USA. Gift of Stan Herman.
© The Museum at FIT

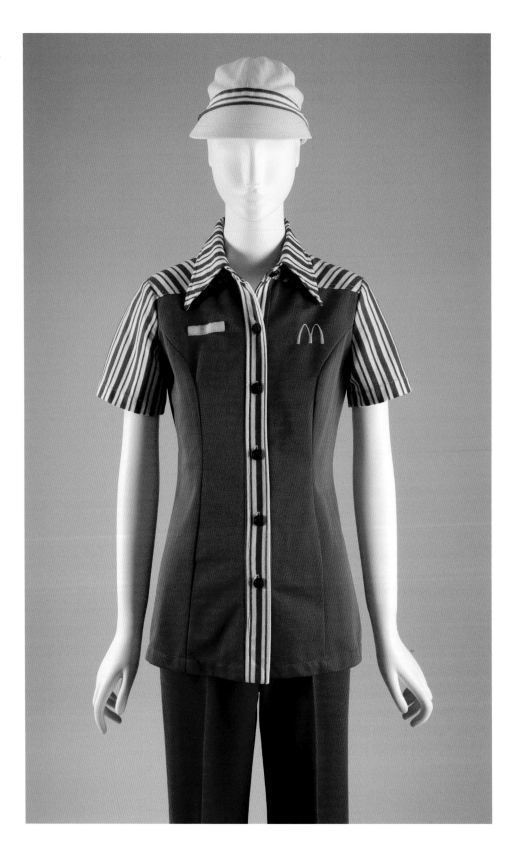

To commemorate White Castle's ninety-fifth anniversary, the Liberian-born designer Telfar Clemens was approached by the burger chain to design a co-branded uniform for its franchise locations across the United States. The request came following a 2015 New York Fashion Week afterparty hosted by Clemens for his label Telfar, which was held at a White Castle in Times Square. Photos of White Castle employees dancing in front of the kitchen while handing out free burgers and fashionistas mixing cocktails from a soda fountain circulated on social media. "We thought, 'Why not see what we can learn from high fashion and be part of it?'" said Jamie Richardson, White Castle vice president.[43] This, however, was not the first time a fashion designer was recruited to create fast-food uniforms. In 1975, veteran Seventh Avenue designer Stan Herman was commissioned by McDonald's to create a standard uniform for franchise workers in an effort to establish a cohesive brand identity. Clemens's unisex uniform design for White Castle was based on his split-neck polo, a runway look from the fall 2016 collection.[44] The collaboration also resulted in a co-branded, limited edition capsule collection of deconstructed garments, complete with a mash-up of the Telfar and White Castle logos. Proceeds from the capsule collection went to the Robert F. Kennedy Human Rights Liberty and Justice Fund, which provides bail to imprisoned minors.

Figure 1.14
Telfar Clemens with White Castle employees wearing two versions of his uniform shirt. Photograph courtesy of White Castle Management Co.

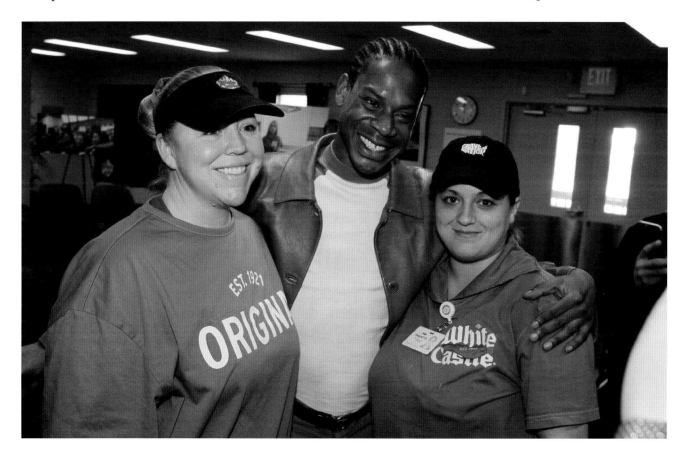

Figure 1.15
Telfar x White Castle
capsule collection, spring/
summer 2017. Photograph
by Jason Nocito

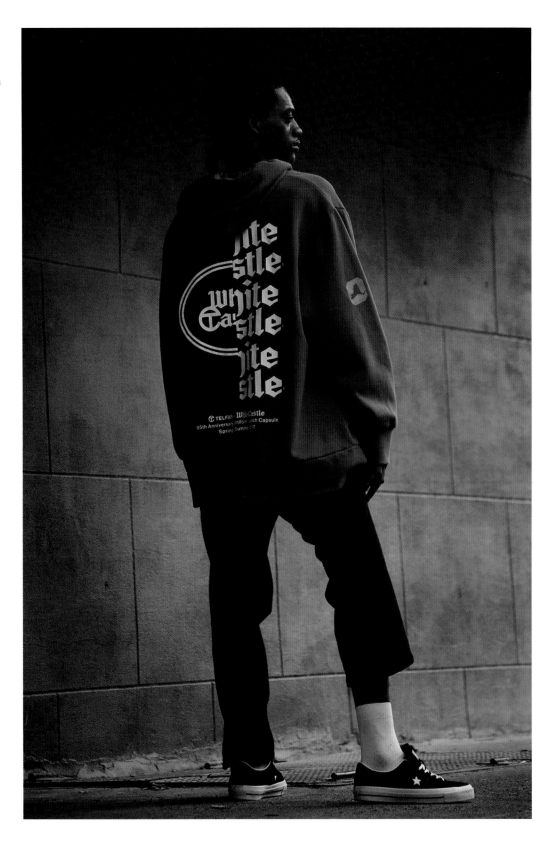

Within his own fashion label, Clemens's designs aim to blur the distinction between high and low culture, as well as demarcations of sex and class.[45] This concept is reinforced by the company's tag line, "It's not for you — it's for everyone."[46] For him, creating a unisex co-branded fast-food uniform aligned with the ethos of his brand. "The idea was to make people aspire to wear what someone working at White Castle is wearing and break down that barrier," Clemens told *CR Fashion Book*.[47] Commenting on the proliferation of fast food/fashion collaborations that followed his partnership with White Castle, Clemens remarked, "After we did White Castle there was this whole trend about 'downmarket' collaborations, but I think that really misses the point. It's corny to talk about 'elevating' things—we want to make fashion horizontal."[48] Telfar teamed up with White Castle again in 2020 to revamp their uniform for the company's 100th anniversary. This time, uniform offerings expanded to include T-shirts, polos, aprons, visors and a royal blue du-rag—the first time this hair accessory was offered as part of the official uniform. These were designed with the same laid-back ease of his fashion line, opening the conversation of accessibility in an industry that values exclusivity. "Telfar has taken our uniform to a new place," Richardson said in a statement, "creating something that's distinctive, attractive and comfortable, and something our team members will feel great in whether they're at work or hanging out with friends and family."[49]

At times, food and fashion can cross paths unintentionally. In 2020, singer Beyoncé's Ivy Park clothing line launched its Ivy Park x Adidas collaboration, which featured a maroon and orange color scheme. For many, this recalled the employee uniforms at Popeyes Louisiana Kitchen, almost immediately prompting social media posts with images comparing the two. When the Ivy Park line sold out in a week, Popeyes used the opportunity to promote and sell its own uniform merchandise on its website, with all proceeds directed to its charitable foundation. The chain used actual employees to model the clothes, integrating visual elements of the Ivy Park ad campaign into its own, and using the tagline, "That Look from Popeyes." The resulting campaign not only capitalized on the cachet of Ivy Park as a coveted streetwear brand, but also accentuated the connections between southern food, streetwear, and Black culture.

In his essay "Toward a Psychosociology of Contemporary Food Consumption," Roland Barthes, a theorist who engaged with both food and fashion, argues that food is more than products to be examined via statistical or nutritional studies; food is also "a system of communication, a body of images, a protocol of usages, situations, and behavior."[50] Food, with all its symbolism and associations, has become a valued means of appealing to consumers' instinctual desires. By engaging with food culture, fashion is able to convey a host of sociocultural messages (and critiques) while "feeding" consumer appetites. As the spheres of food and fashion collide, parallels relating to class, intimacy, pleasure, luxury, connoisseurship, and desire emerge. One might say the fashion world has realized that the way to consumers' hearts is through their stomachs.

Figure 1.16
Jeremy Scott for
Moschino, junk
food dress, fall
2014. Courtesy
of Moschino

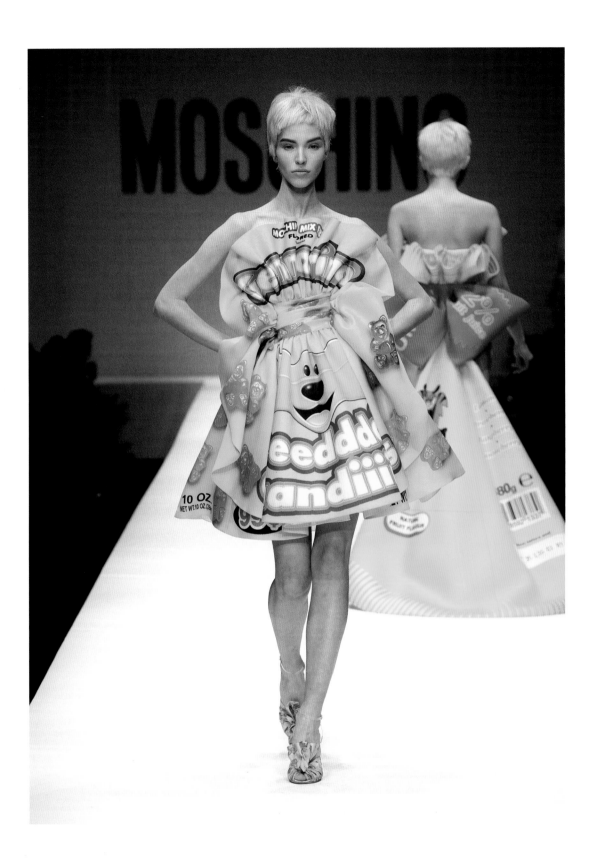

Notes

1. Emilia Petrarca, "The Biggest Trend at Fashion Week Was Food," *The Cut*, February 15, 2018, https://www.thecut.com/2018/02/food-at-new-york-fashion-week-fall-2018.html.

2. Dena Silver, "The Most Surprising Trend of NYFW? Snacks on the Runway," *Observer*, February 14, 2018, https://observer.com/2018/02/trend-report-fashion-snacks-on-the-runway-fall-2018/.

3. H.W. Vail, "At New York Fashion Week, Raf Simons Presents His Own Movable Feast," *Vanity Fair*, February 8, 2018, https://www.vanityfair.com/style/2018/02/raf-simons-new-york-fashion-week.

4. Alice Dallabona, "At home with the Missoni family: narratives of domesticity within Hotel Missoni Edinburgh," *Home Cultures*, 2016, 13 (1): 1–21. DOI: 10.1080/17406315.2016.1122965

5. Fabio Parasecoli, *Bite Me: Food and Popular Culture* (London and New York: Berg, 2008), 4.

6. Fabio Parasecoli, "Food and Popular Culture," in *Food in Time and Place*, eds. Paul Freedman, Joyce E. Chaplin, and Ken Albala (Oakland: The University California Press, 2014), 325.

7. Malcolm Barnard, "Production and Consumption," in *Fashion Theory: A Reader*, ed. Malcolm Barnard (London and New York: Routledge, 2007), 334.

8. Margaret Visser, "Food and Culture: Interconnections," *Food: Nature and Culture* 66 (1) (Spring 1999): 117–130.

9. Michael J. Ryan, *A Taste for the Beautiful: The Evolution of Attraction* (Princeton: Princeton University Press, 2018), 110.

10. Susan Bright, *A Feast for the Eyes: The Story of Food in Photography* (New York: Aperture, 2017), 1.

11. Luca Vercelloni, *The Invention of Taste: A Cultural Account of Desire, Delight and Disgust in Fashion, Food, and Art*, trans. Kate Singleton (London: Bloomsbury, 2016), 5.

12. Vercelloni, *The Invention of Taste*, 10.

13. Massimo Montanari, *Food Is Culture*, trans. Albert Sonnenfeld (New York: Columbia University Press, 2004), 55–56.

14. Parasecoli, "Food and Popular Culture," 331.

15. Pierre Bourdieu, *Distinction: A Social Critique of the Judgement of Taste*, trans. Richard Nice (Cambridge: Harvard University Press, 1984), 175.

16. Vercelloni, *The Invention of Taste*, 16.

17. Patricia McColl, "Dior's Haute Cuisine," *Women's Wear Daily*, December 28, 1972: 4–5.

18. Tim Blanks, "The Last Temptation of Christian," *New York Times*, August 18, 2002, F153–153.

19. Hugh Montgomery, "Stephen Jones: 'Champagne Is Far More Fun with Cheap Crisps Than Canapes,'" *The Independent*, June 12, 2011, https://www.independent.co.uk/life-style/food-and-drink/features/stephen-jones-champagne-is-far-more-fun-with-cheap-crisps-than-canap233s-2294671.html.

20. The Beatrice Inn closed its doors on January 1, 2021. Mar reopened in spring 2021, in a new location (right next door) with the "Inn" dropped from the restaurant's name. The new iteration of the restaurant draws on the Beatrice Inn's history and reinvents the longstanding institution. See Tejal Rao, "The 'Inn' Is Out at the Beatrice, but History Still Holds Sway," *New York Times*, November 23, 2020, https://www.nytimes.com/2020/11/13/dining/beatrice-inn-angie-mar.html.

21. Alex Baggs, "Angie Mar's Cookbook Is a Giant Middle Finger to All Other Cookbooks," *Bon Appétit*, October 21, 2019, https://www.bonappetit.com/story/angie-mar-butcher-and-beast.

22. Angie Mar with Jaime Feldmar, *Butcher + Beast: Mastering the Art of Meat* (New York: Clarkson Potter, 2019), 211.

23. Zach Weiss, "Beauty and the Bea," *L'Officiel USA* (Winter 2019/2020): p. 32–35.

24. "Chef Angie Marr Is a Star" (transcript of interview by Kerri Diamond with Angie Marr), *Cherry Bombe*, https://cherrybombe.com/angie-mar-transcript.

25. Kristen Tauer, "Beatrice Inn Chef Angie Mar Lays It All Out in Her First Cookbook, 'Butcher + Beast'" *Women's Wear Daily*, September 26, 2019, https://wwd.com/eye/people/angie-mar-cook book-butcher-beast-beatrice-inn-1203307814/.

26. David Howes, "Preface: Accounting for Taste," in Vercelloni, *The Invention of Taste*, p. xii.

27. Tim Blanks, "Chanel Fall 2014 Ready-to-Wear," *Vogue*, March 4, 2014, https://www.vogue.com /fashion-shows/fall-2014-ready-to-wear/chanel.

28. Imogen Fox, "Supermarket Sweep as 'Riot' Breaks Out for Karl Lagerfeld's Chanel Collection," *The Guardian*, March 4, 2014, https://www.theguardian.com/fashion/fashion-blog/2014/mar/04 /supermarket-karl-lagerfeld-chanel-collection-paris.

29. Visser, "Food and Culture: Interconnections," 122.

30. Parasecoli, "Food and Popular Culture," 331.

31. Blanks, "Chanel Fall 2014 Ready-to-Wear."

32. Tim Blanks, "Moschino Fall 2014 Ready-to-Wear," *Vogue*, February 20, 2014, https://www.vogue .com/fashion-shows/fall-2014-ready-to-wear/moschino.

33. Vlad Yudin, *Jeremy Scott: The People's Designer*, filmed in 2015 (New York: The Vladar Company/ Netflix, 2017): 38:11–38:55.

34. Heather Snowden, "Vetements Took Over a McDonald's at Paris Fashion Week," *Highsnobiety*, June 21, 2019, https://www.highsnobiety.com/p/vetements-ss20-mcdonalds/.

35. Sarah Mower, "Vetements Spring 2020 Ready-to-Wear," *Vogue*, June 21, 2019, https://www.vogue .com/fashion-shows/spring-2020-ready-to-wear/vetements.

36. Jacob Gallagher, "You Want Fries with That Shirt? Fast Food Chains Make Fashion News," *Wall Street Journal*, October 30, 2017, https://www.wsj.com/articles/you-want-fries-with-that-shirt -fast-food-chains-make-news-in-the-fashion-world-1509380058 .

37. Gallagher, "You Want Fries with That Shirt?"

38. Gallagher, "You Want Fries with That Shirt?"

39. Steve Dool, "Why Food Merch Is Having a Fashion Moment," *Fashionista*, April 24, 2018, https:// fashionista.com/2018/04/food-merch-clothes-fashion-trend?li_source=LI&li_medium=m2m -rcw-fashionista.

40. Joe Niehaus, "Fast Food Fashion: Why Restaurant Chains Are Going from Tacos to T-shirts," *Medium*, February 19, 2020, https://medium.com/better-marketing/fast-food-fashion-6cce 3a23f5e1.

41. Christine Chou, "McDonald's and Alexander Wang Merge Food and Fashion," *Alizila*, January 13, 2020, https://www.alizila.com/mcdonalds-alexander-wang-bag-collection.

42. Kristin Salaky, "Supreme's 3-Pack of Bright Red Oreos Sold Out Almost Instantly But Are Still Being Sold for Thousands of Dollars on Ebay," *Delish*, March 26, 2020, https://www.delish.com /food-news/a30982084/supreme-oreo-cookies/.

43. Gallagher, "You Want Fries with That Shirt?"

44. Dominic Cadogen, "Telfar and Fast Food Chain White Castle Release Collab," *Dazed*, October 18, 2017, https://www.dazeddigital.com/fashion/article/37448/1/telfar-and-fast-food-chain -white-castle-release-collab-capsule-collection.

45. Antwaun Sargent, "Exclusive: Telfar Clemens Discusses His New Uniforms for White Castle," *Vice*, September 5, 2017, https://i-d.vice.com/en_us/article/paa5kv/exclusive-telfar-designs -white-castles-new-uniforms.

46. See Telfar company website, https://telfar.net/about.

47. Brittany Adams, "What Is It about Fashion's Unhealthy Obsession with Fast Food?" *CR Fashion Book*, October 24, 2017, https://www.crfashionbook.com/fashion/a13026990/fashion-trend-fast -food-designers-moschino-mcdonalds-telfar-white-castle/.

48. Cadogen, "Telfar and Fast Food Chain White Castle Release Collab."

49. Shannon Carlin, "Get Ready To 'Crave' The New White Castle x Telfar Uniform Collab," *Refinery 29*, April 14, 2021, https://www.refinery29.com/en-us/2021/04/10420062/telfar-white-castle -uniform-collaboration-100th-birthday.

50. Roland Barthes, "Toward a Psychosociology of Contemporary Food Consumption," in *Food and Culture: A Reader*, eds. Carole Counihan and Penny Van Esterik (New York: Routledge, 2013), 23–30, 24.

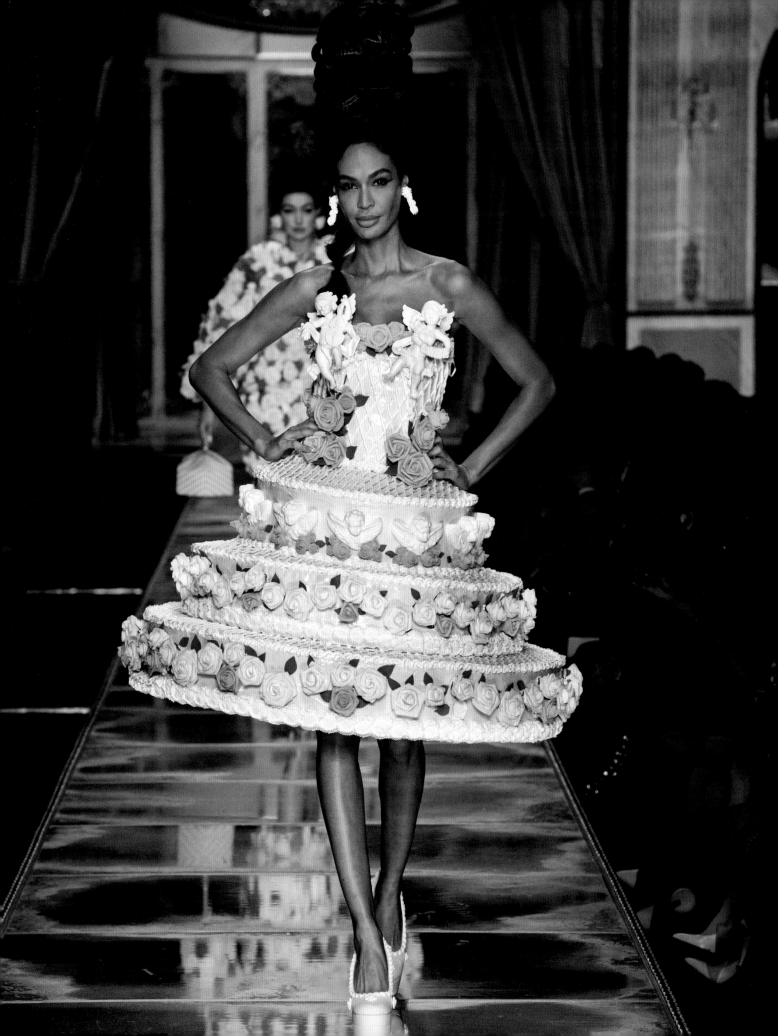

Haute Couture, Haute Cuisine

Elizabeth Way

"The Parisian version of the art of living has never ceased to exert a sort of fascination in the 'Anglo-Saxon' world, even beyond the circle of snobs and socialites, thereby attaining a kind of universality."

Pierre Bourdieu

Ideas of national identity live in the cultural imagination more than they reflect absolute realities or histories; however, they can be pervasive and powerful. The French had an outsized impact on Eurocentric culture beginning in the mid-seventeenth century. The visual codes established during this time and continuing into the eighteenth century left an indelible mark on the west. Consider a soft pink damask gown, circa 1765. The details—the pannier silhouette, square neckline edged in fluted lace, stomacher with satin bows, and elbow-length sleeves with lace *engageantes*—are distinctive in the international cultural imagination as unmistakably eighteenth-century French style. Never mind that this *robe à l'anglaise* (a French invention, despite its name) is made from silk woven in Spitalfields, London, the gown's probable origin. French pastry, recognizable in similar rococo colors, has the same effect. Macarons are also generally and immediately accepted as French confections, though they may have originated in Italy, only coming to France with Catherine de' Medici. The indisputable Frenchness of these objects is helped along by the words used to describe them: *petit fours* and *mille-feuille* are sweet, tantalizing, creamy desserts in subtle pastels that illustrate the same elegant swirls, varied textures, and distinctive silhouettes found in the *robe à l'anglaise*. Taste historian Luca Vercelloni notes that the growing influence of women in the French court during this period transformed the display of luxury from outsized public events to more private expressions, increasing "what was spent on durable goods such as clothing, jewelry and furnishings, which in turn ushered in forms of sensuality and refinement that are closer to female tastes. This explains the . . . supremacy of rococo over baroque, and the growing impact of intricate pastries and desserts in the overall universe of refined cuisine."[1]

Figure 2.1
Jeremy Scott for Moschino, fall 2020. Courtesy of Moschino

Figure 2.2
Silk damask *robe à l'anglaise*, circa 1765, England. © The Museum at FIT

During the mid-seventeenth century, some western elites began consciously taking their cues on luxurious living from the French, not just by mimicry, but by buying French fashions and hiring French chefs when they could. Fashion and food may be the most potent symbols of this aristocratic extravagance, and these ideas persist in contemporary culture. British fashion designer Vivienne Westwood, for example, drew on the iconic images associated with French luxury and feminine excess in her fall 1995/1996 collection. A white cotton t-shirt shows an eighteenth-century woman in a candy pink gown, seated at a small table, laid with bread and pastries, drinking tea or coffee. The ultra-fashionability of the woman—her skirt tucked into an artful pouf and drape, the pink feathers and blue ribbons on her hat echoing the blue of her tiny shoes—implies that she is French, but the caption, naming the collection "Vive La Cocotte," confirms it. Westwood was inspired by Ninon de l'Enclos (1620–1705), a French author and courtesan, who "reflected the designer's fascination with seventeenth- and eighteenth-century French salon culture, the arts, literature, politics, and their relation to high-society women."[2] Cocotte translates to prostitute (though it came into popular use during the nineteenth century), and Westwood's collection

Figure 2.3

Illustration from *Le cannameliste français, ou, Nouvelle instruction pour ceux qui desirent d'apprendre l'office* by Joseph Gilliers, 1751. A cannameliste is defined as one who "takes care of candied fruit, sugar works, refreshing liquors, pastilles, etc." Houghton Library

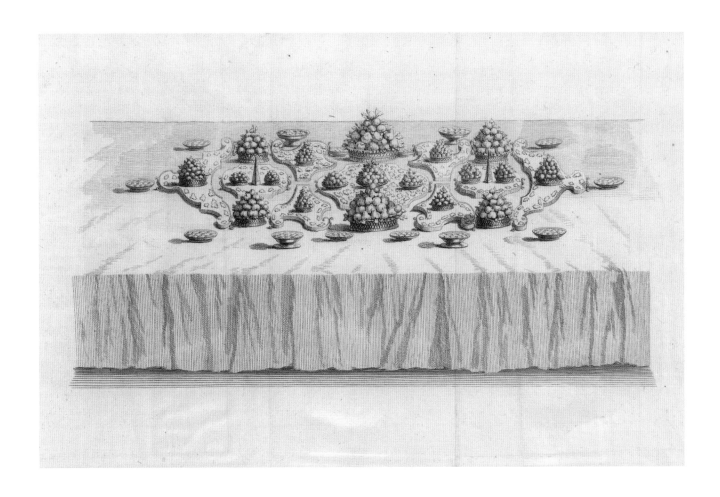

Figure 2.4
Vivienne Westwood, "La Cocotte"
collection cotton t-shirt, fall/winter
1995/1996, England. Gift of
Timothy Reukauf, Stylist.
© The Museum at FIT

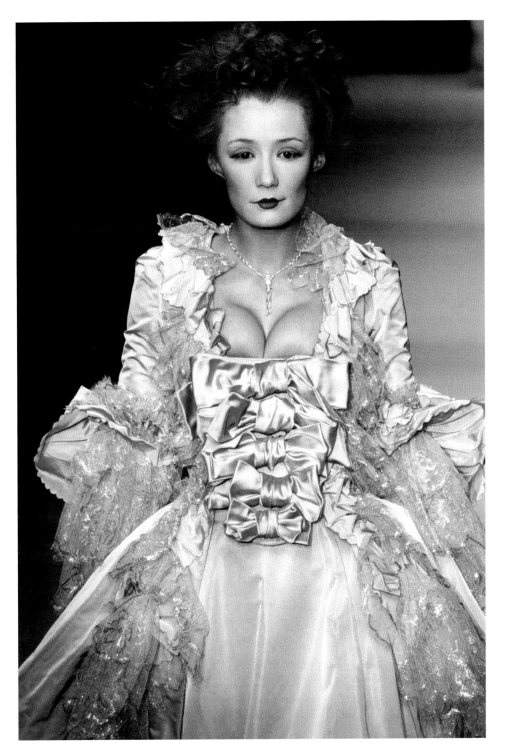

Figure 2.5
Vivienne Westwood, "La Cocotte"
collection, fall/winter 1995/1996.
©FirstVIEW/IMAXtree.com

explored the power and independence exercised by courtesans of the period. Despite de l'Enclos serving as inspiration, many of Westwood's designs reflected the influence of later eighteenth-century fashion. The image on the t-shirt dates to 1784, and a pink dress in Westwood's collection is very similar to the authentic circa-1765 *robe à l'anglaise*. Her designs conflate a century of French fashion and distill it into an archetype of the *Ancien Régime*: an elite woman who is alternately celebrated and reviled for her consumption. She eats and drinks expensive, imported foods, but also voraciously consumes fashion.

In the 2006 film *Marie Antoinette*, director Sofia Coppola creates a scene of immense luxury, desire, and consumption that brings Westwood's ideas to life because the ravenous, fashionable, eighteenth-century feminine archetype is most popularly personified by Marie Antoinette (1755–1793). Although Coppola's interest in the human side of the queen—manifested in "the idea that she was a real girl . . . that there were all these teenagers running around in Versailles being in charge"—was critiqued, the film was most noted for its aesthetics, inspired by food and fashion.[3] Critics commented extensively on the film's beauty and the "seductive pastel palette inspired by the 'sherberty colors' of the celebrated macaroons [*sic*] of Paris confectioner Ladurée."[4] Coppola illustrates Marie Antoinette's deep unhappiness, ameliorated through consumption, in a scene that plays on popularly imagined practices of French aristocrats. Merchants visit the queen and her friends in her private rooms, showing off sumptuous silk fabrics in bright colors ("I like the pink. It's like candy!" the queen squeals), painted fans, and embellished shoes, designed by Manolo Blahnik for the film. The dizzying array of fashion goods are challenged on screen by cakes and pastries decorated with petals, sugar work, and pastel and golden accents that rival them in color, texture, and luxury. The women fit on gloves in front of heaping plates of petit fours and continually sip champagne. Their grasping and caressing of the silk fabrics, accompanied by "ooohs" and "aahhs," is matched by the grabbing of bonbons and sugared orange peels by the handful. The Duchesse de Polignac struggles to take a bite of an enormous tart, leaving whipped cream on her face. Flashes of pure luxury—rows of jewel-like shoes and fanciful desserts—alternate on screen to Bow Wow Wow's version of the bubblegum pop song, "I Want Candy." This combination of food and fashion perfectly embodies the attitude of youthful privilege and excess. *The New York Times* noted that "Many critics and observers saw the film as a comment on modern celebrity youth culture, with Marie Antoinette as an eighteenth-century Paris Hilton," and that it perhaps reflected Sofia Coppola's own privileged Hollywood upbringing.[5]

Figure 2.6
Still from *Marie Antoinette*,
directed by Sophia Coppola, 2006.
Courtesy of Photofest

American fashion designer Jeremy Scott utilized the food and fashion of late eighteenth-century France to illustrate yet another sentiment. His fall 2020 ready-to-wear collection for Moschino commented on unstable political situations around the world, perhaps indicating that many societies were on the verge of momentous and violent shifts similar to the French Revolution. Scott stated, "Well on the geopolitical spectrum, thinking about the 1780s and what's going on today globally: Are the Hong Kong protests against an oppressive government? In Chile they're protesting against a rise in subway fares; obviously my home country's gotta lotta shit goin' on, and y'all Brex-exiting . . . there's a lot happening."[6] Like Westwood, Scott made deliberate reference to eighteenth-century fashion through pannier skirts, lace-trimmed sleeves, and towering wigs, but with a less literal approach, shortening hems to miniskirt length and mixing in twentieth-century garments. Scott directly conflated pastry with fashion, designing tiered dresses resembling layered cakes in rococo colors and embellishments that recalled piped icing rosettes and swags.

In three instances expressing three different ideas—subversive women's empowerment, the triumphs and tribulations of privileged youth, and the tumultuous state of twenty-first century geopolitics—the combination of eighteenth-century French food and fashion proved a powerful metaphor, one that could immediately resonate with contemporary audiences. Westwood, Coppola, and Scott accessed an idea that lives in popular culture: this period in French history represents an epitome of luxurious consumption, best illustrated by fashion and food. French philosopher Pierre Bourdieu wrote of consumption as "a stage in the process of communication, that is, an act of deciphering, decoding, which presupposes practical or explicit mastery of a cipher or code."[7] For the eighteenth-century aristocrats at the court of Versailles or in Paris, the code was understood. The details of an ensemble—the trim on a bodice, a skirt's drapery, the newest hairstyle—were easily read by the informed eyes of the cultured elite class. In the same way, the food that they ate was comprehended as elegant, innovative, and elevated above the necessity of hunger by its design, ingredients, and accouterments, even more than its taste. These subtle details were learned over a privileged lifetime and were based on the extreme exclusion of their class. Within the work of Westwood, Coppola, and Scott, the "decoding operation, which implies the implementation of a cognitive acquirement, a culture code" works on the exact opposite principle of *inclusion*. Nearly two and a half centuries later, the visual codes embedded in aristocratic French consumption are common enough knowledge to stand as metaphors for other ideas. Popular culture has associated both the look of pannier gowns with towering hairstyles and the misattributed quote "Let them eat cake" to Marie Antoinette enough times that Scott's reference to the hedonistic luxury preceding the French Revolution lands. How did this rarified historic world come to exact so much influence over contemporary British and especially American culture?

Figure 2.7
Jeremy Scott for Moschino, fall 2020. Courtesy of Moschino

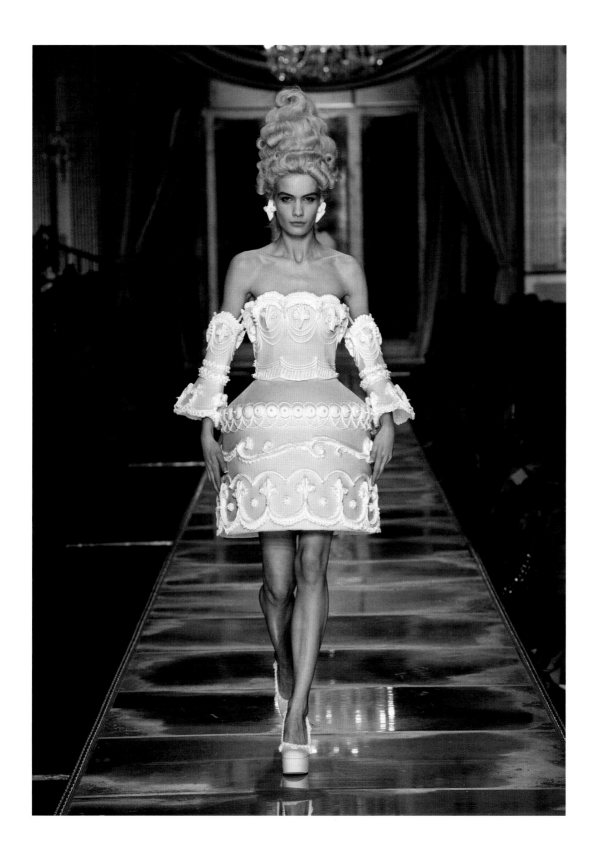

Westwood, Coppola, and Scott created "art which imitates art, deriving from its own history the exclusive source of its experiments and even of its breaks with tradition. An art which ever increasingly contains reference to its own history demands to be perceived historically."[8]

Luxury in the Court of Versailles

The beginning of France's long domination over Eurocentric culture finds a reasonable starting point in the reign of King Louis XIV (1638–1715). French cultural scholar Joan DeJean contends,

> When [Louis XIV's] reign began, his nation in no way exercised domination over the realm of fashion. By its end, his subjects had become accepted all over the Western world as the absolute arbiters in matters of style and taste, and his nation had found an economic mission: it ruled over the sections of the luxury trade that have dominated commerce ever since.[9]

When Louis XIV began his personal rule in 1661, he established France's luxury economy as one "driven by fashion and taste,"[10] as well as his finance minister Jean-Baptiste Colbert's (1619–1683) protectionist economic plans. Historian Ragnhild Hatton writes,

> The court-life of conspicuous consumption as far as clothes were concerned . . . created demands for lacemakers, tailors and embroiderers, for jewellers, bootmakers and hatters. Export was aimed at, both in Europe and overseas, and these new manufactures, especially clocks, fine textiles, lace and *objets d'art*, were added to the traditionally peasant-produced exports of salt, wine, brandy and course textiles.[11]

DeJean dramatically states, "By the end of the seventeenth century, the two concepts that have ever since been most essential to both the country's fame and its trade balance had been invented and had immediately become inextricable from France's national image: haute cuisine and haute couture" (though these terms would not be used until the nineteenth century).[12] This period also saw a large increase in European tourist travel to Paris, further spreading the idea of the city and country as the origin of elite luxury.[13] Although cities and countries had acted as cultural arbiters in the past (Italian city-states during the Renaissance, for example), this period of French cultural domination was more widespread than ever before and its influence longer lasting, arguably continuing into the present day.

Figure 2.8
Louis le Grand l'Amour et les Délices de son Peuple . . . les Actions de grâce, les festes et les Réjouissances pour le parfait rétablissement de la santé du Roy en 1687, engraving of a dinner for Louis XIV at the Hotel de Ville de Paris, January 30, 1687. Unknown author, Public domain, via Wikimedia Commons

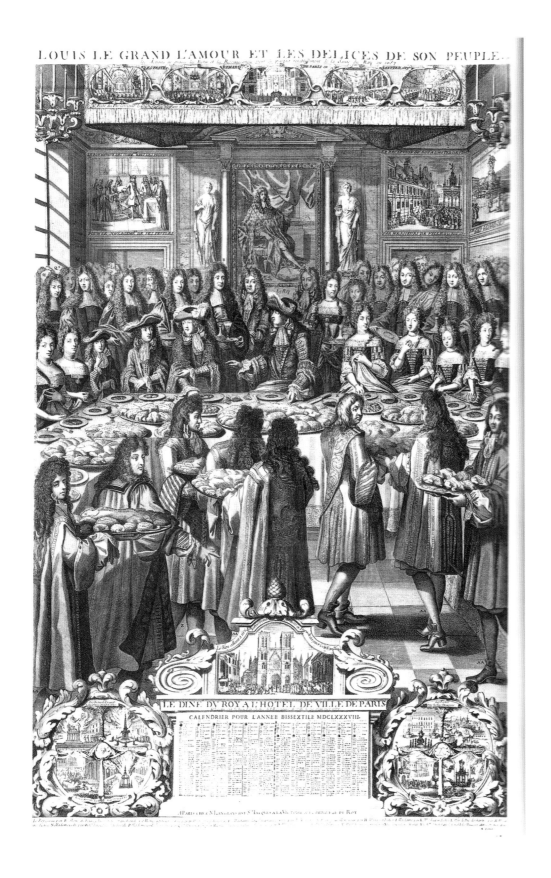

The King's Cuisine

Louis XIV's interest in food stemmed from his mother, the former Spanish princess, Queen Anne. She was exceptionally close to her children and "loved her food: not only the proverbial Spanish chocolate but bouillon, sausages, cutlets . . . [the result] was a positive image of food and eating for the young Louis: in time his appetite would astonish Europe and burden his court."[14] The food that he ate was dramatically different from medieval and Renaissance cuisine. In 1651, François Pierre, chef to the Marquis d'Uxelles, published a cookbook titled *Le Cuisinier françois* (*The French Chef*), under the name La Varenne. DeJean credits it as "the harbinger of a culinary revolution as a result of which food became cuisine and cuisine became French."[15] *The French Chef* and the French cookbooks that followed it broke with established styles of cooking that emphasized imported Asian spices such as cinnamon and nutmeg as dominant flavors, and focused on more "natural," local ingredients, such as French herbs like parsley, thyme, and chives. Lighter sauces and fresh produce were also accentuated—green peas, for example, were famously en vogue at Versailles after they were presented to the king in 1660.[16] Ingredients still associated with French food today—butter, truffles, shallots—became desirable over the intensely pungent food of the past that often mixed sweet and savory flavors.[17] *The French Chef* was printed as *The French Cook* in England in 1653, disseminating these new ideas of fine food and branding them as distinctly French.[18] *Le Patissier françois* (*The French Pastry Maker*) was published in 1653, and besides giving exact instructions on how to make now-standard types of dough, it included recognizable recipes: chaussons aux pommes (French apple turnovers), choux (used to make éclairs and cream puffs), and beignets.[19]

Louis XIV's dining habits embraced and encouraged these changes; he favored herbs, game, and fresh vegetables and fruit, grown in his gardens and orchards at Versailles.[20] The standard of luxury that he set also encouraged the French aristocracy to patronize chefs, creating an environment of discernment that gave rise to gastronomy. Journalist and philosopher Jean-François Revel notes that the word *gastronome* was not used until the nineteenth century; however, "the corresponding figure is born in the seventeenth century."[21] And although the sauces and dishes named for the famed political and social leaders of the period—Richelieu, Conti, Maintenon, and Colbert—were not invented by their namesakes, "the fact that they were created for them, perhaps at their instigation, that they were placed under their aegis is proof of the gradual formation of a gastronomical patronage capable of subsidizing the spirit of discovery."[22] Before high-end restaurants, professional chefs served the aristocratic class within their households, and just as the relationship between fashion creators and ladies of the court gave rise to creative partnerships that bestowed power and prestige on both sides and across class lines, the relationships between chefs and their noble employers were "the beginnings of that dialogue

Par vn excez de friandise,
 Jcy lon donne du ragoust;
 Et lon y vend, pour plaire au goust,
 Toute sorte de marchandise.

Chascun y trauaille à son tour,
 Chacun met la main à la paste;
 L'vn fait des pastez à la haste,
 Et l'autre les met dans le four.

Pour de l'argent on donne à tous
 Des maccarons, des darioles,
 Des gasteaux diuers des rissoles
 Du biscuit, et de petits chous.

Cette boutique à des delices,
 Qui charment en mille façons
 Les filles les petits garçons,
 Les seruantes et les Nourrices.

A Paris, Chez Mel.r Tauernier, Graueur et Imprimeur du Roy pour les Tailles-deuces, demeurant en l'Isle du Palais, sur le Quay qui regarde la Mogisserie, à l'Asphere, auec Priuilege du Roy.

between the food-lover and the creator that allows the former to find an interpreter capable of realizing his ambitions and the latter to give free rein to his imagination, knowing that its labors will be understood."[23] These artisans were elevated to a highly respected status in a period when social mobility was rare. Aristocratic epistolary writer Madame de Sévigné wrote in 1671 of a banquet for Louis XIV hosted by the Prince of Condé in Chantilly and of,

> the great Vatel, late maitre-d'hotel to M. Fouquet, and in that capacity with the prince, a man so eminently distinguished for taste, and whose abilities were equal to the government of a state—this man, whom I knew so well, finding, at eight o'clock this morning, that the fish he had sent for did not come at the time he expected it, and unable to bear the disgrace that he thought would inevitably attach to him, ran himself through with his own sword.[24]

Figure 2.9
Abraham Bosse, *Le Patisserie* (*The Pastry Cook's Shop*), engraving, 17th century. Yale University Art Gallery

De Sévigné conveys not only the high stakes of feeding the nobility, but also that Vatel, a man employed to oversee the table of Nicolas Fouquet, France's Superintendent of Finances, and then the powerful, aristocratic Condé family, was highly respected and admired. The king himself said of Vatel's death, "He had his own kind of honor."[25] Vatel was expert in creating a fantastical atmosphere for the French aristocracy through the preparation and presentation of food. Before his suicide, for example, he orchestrated an outdoor meal set in a grove of citrus trees and flowers, enhanced by chandeliers and candelabra, a marble and gold fountain, Chinese porcelain vases, and live musicians.[26]

Sociologist and French food scholar Priscilla Parkhurst Ferguson references sociologist Georg Simmel in noting that although eating is the most routine of activities, it simultaneously "gives rise to the most extensive and elaborate systems of social distinction."[27] She adds, "spectacle . . . provides a key to understanding French cuisine and its impact."[28] Grand dinners, whether served at Versailles or other noble palaces, were focused on aesthetics. *Service à la française* was a system by which the dishes for each course were laid on the table all at once. "Display dominated, and never more so than when the centerpiece was one of the outsized sugar sculptures or architectural pastry constructions. . . . All elements of the culinary presentation favors a collective aesthetic experience."[29] These ideas remained central during the eighteenth century. Elite chefs introduced the fancy desserts still associated with French luxury food—meringues, crème brûlée, and sorbets.[30] By the time Vincent La Chapelle, chef at various times to the Prince of Orange, John V of Portugal, and Madame de Pompadour, published *Le Cuisinier moderne* (*The Modern Cook*), first in English in 1733 and then in French two years later, French cuisine was well recognized as a point of pride in the national culture and the international standard of fine food in the Eurocentric world. Furthermore, a lively discourse had developed on the changing fashions in cuisine. Revel writes that

> [t]he feeling of something new at hand was so constantly present in the eighteenth century, in this domain as in others, that people of the period could not help but be amazed by the continuous renewal of their cuisine. Just as there was talk in the realm of ethics and science and philosophy of the progress of the enlightenment, so people constantly congratulated themselves on belonging to the century of modern cuisine.[31]

With its expectations of novelty and one-upmanship, Revel continues, "There is reason to consider the cuisine of the end of the eighteenth century as the ideal toward which the evolution of gastronomy was tending."[32]

La Mode

The culture of cuisine functioned in conjunction with fashion, which also thrived on spectacle and was even more visible and readily exported to the rest of Europe. Fashion historian Valerie Steele notes that important changes occurred in the French fashion system during the late seventeenth century. Colbert, recognizing the importance of fashion, created protectionist laws that forbade foreign imports, while boosting French textile weaving in Lyon and lace making. Fashion workers were invited to France, and although the revocation of the Edict of Nantes drove Protestants out of the country in 1685 (some took their silk weaving talents to London, among other places, establishing the Spitalfields industry), government policies and the lavish court dress of Versailles, both regimented and required, made fashion a leading French industry. These protocols ensured that the nobility was occupied away from decentralizing monarchical power while they simultaneously consumed French fashion goods and promoted them to the courts of Europe.[33]

While court dress ossified at Versailles, fashion change occurred in Paris. Unlike cuisine, which came to be professionally dominated by men, women were breaking into the fashion business. Steele writes, "Until 1675, clothing production for both men and women was legally restricted to the guild of tailors, who were all men. However, that year the *maîtresses couturières* [seamstresses or dressmakers] of Paris were permitted to form their own guild, making clothes for women and children."[34] Just as chefs attained status by serving the elite, couturiers such as Madame Villeneuve, Madame Rémond, Madame Prévot, and Madame Charpentier were renowned and successful dressmakers. The construction of the court dress, the *grand habit*, was still legally assigned to tailors, so couturiers introduced a novel style: the less formal mantua, which was a loose, long overdress that became fashionable throughout Europe.[35] Even more important to fashion innovation, the female mercers' guild of *marchande de modes* was formed to sell trimmings and accessories—vital components of fashion during this period when the overall silhouette was slow to change. Although aristocratic dining at this time was fairly private, fashion was becoming more public as permanent shops on fashionable streets replaced seasonal fairs and home visits from tailors.[36] Newspapers, fashion dolls, and engraved plates also played an important part in disseminating fashion information to women in the provinces and other countries, just as cookbooks by elite chefs spread information on the changes in cuisine.[37] The combination of creative female fashion producers, public consumption of fashion attracting more customers, and constant reportage by the press created an environment in which personality, style, and novelty became as important as communicating status and wealth. Trends in accessories and fabrics quickly cycled in and out

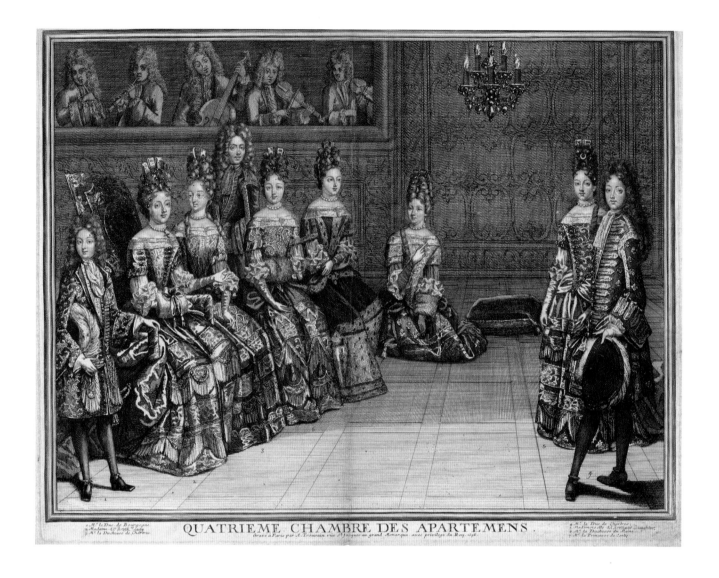

QUATRIEME CHAMBRE DES APARTEMENS.

Figure 2.10

Antoine Trouvain, *Quatrième chambre des apartemens*, etching of the Duke of Chartres and Mademoiselle with noble women at the palace of Versailles, circa 1696. © The Trustees of the British Museum

of fashion, along with colors and details such as the shapes of sleeves or the widths of ribbons.[38] Ladies of the royal court patronized the couturiers and *marchande de modes,* but others in Paris also consumed fashion news and dressed as stylishly as they could afford. During the late seventeenth century, fashion became *la mode* throughout Europe. France, and especially Paris, gained a reputation as the source of the most fashionable garments and accessories, which were very much in demand. DeJean notes that "from the 1670s on . . . England imported more than twenty times more luxury goods than it exported to France," and Parisian fashion dolls were desperately awaited throughout Europe and its colonies.[39]

Toward the end of Louis XIV's reign, young women of the court began to rebel against the outdated formal wear enforced at Versailles. When the king died in 1715, Louis XV's regent Philippe d'Orléans briefly moved the court back to Paris,

consolidating what Steele called the "double-headed fashion capital."[40] Fashion historian Aileen Ribeiro writes, "There was a new feeling of freedom after the dead hand of tradition was lifted from a society dominated by a rigidly formal court."[41] From the heavier baroque colors and fabrics of the late seventeenth century, lighter colors and fabrics of the rococo style became popular. Royal patronage still played a role, though indirectly, under Louis XV:

> The supremacy of French style in the fashion world was undoubted, and although he was too lazy to regulate on dress like his predecessor, the king liked fashionable women around him. Of all his mistresses, Madame de Pompadour was the most influential in the dissemination of French taste and fashions; she was almost the personification of the playful, three-dimensional elegance of rococo style in dress.[42]

French women led European fashion by adopting looser fitting gowns. These garments were seen as overtly sensuous and shocking for their resemblance to boudoir dress, but over time became more fitted and accepted by other European elites. Mantuas, informal wear in 1670, were adopted as court dress across Europe during the first half of the eighteenth century. The sack dress, or *robe volante*, its voluminous shape requiring yards of French silk textiles, was "so typically French . . . that it was known all over Europe as the *robe à la française*; conversely, the waisted gown deriving from the mantua became known in the second half of the century as the *robe à l'anglaise*" because "fashionable English ladies [were] happier with the security given by the more tailored cut."[43] These gowns were worn with hoops during the 1720s and 1730s, and although the extremely wide panniers fell out of fashion by the 1770s, they were retained for court dress, cementing their silhouette onto the image of a wildly extravagant Marie Antoinette. While as queen, she outrageously overspent her clothing allowance; her style as a young dauphine drew ire at court for being too informal and daring rather than vice versa. She was criticized for eschewing the stiffly boned *grand corps* (corset) and riding horses in breeches, and later, at the end of her reign, her popularization of cotton muslin gowns sparked outrage for blurring class lines as well as utilizing non-French textiles.[44]

Steele points out that Marie Antoinette's visibility made her style influential, but she was an early adopter and not a fashion originator. By the late eighteenth century, actresses set styles and "fashion professionals were also exerting greater influence."[45] The trimmings of gowns were vastly important to keeping in style, and *marchande de modes*, like *maîtres d'hôtel* such as Vatel, became trusted and respected partners in creating the luxurious lifestyle of the French nobility. Rose Bertin (1747–1813) was the most widely acclaimed, opening her lavish shop Le Grand Mogol in 1773 on Rue Saint-Honoré, and making it a destination for fashionable Parisians and foreign

Figure 2.11
French women led European
fashion throughout the eighteenth
century. Jean François de Troy, *The
Declaration of Love*, oil on canvas,
circa 1724. The Metropolitan
Museum of Art, Bequest of Mrs.
Charles Wrightsman, 2019

tourists. She sold "bonnets, shawls, fans, spangles, furbelows, silk flowers, gemstones, laces, and other accessories," displayed in large windows to attract passersby.[46] She outfitted Marie Antoinette for Louis XVI's coronation in 1775 in a dress covered in embroidery, sapphires, and other gems, and, to some, its *au current* style "suggested more devotion to of-the-moment sartorial caprices than to the ancient dignity of the French throne."[47] Bertin, working with the famous hair stylist Monsieur Léonard, developed the *pouf* in 1774. Along with the pannier silhouette of the court gown, this powdered hairstyle/headdress with internal scaffolding and a tiny still life placed within curled and frizzed hair, has inextricably come to represent eighteenth-century French fashion, and was readily adopted by the queen early in her reign. *Poufs* depicted up-to-the-moment events and were an obvious barometer of the constant whirlwind of change in Parisian fashions, which were widely reported, imitated, and increasingly criticized across France, Europe, and the growing colonial world.[48] Bertin served elites across Europe and kept a shop in London. French fashion and literature scholar Caroline Weber notes that the last decades of the eighteenth century saw increased textile production and evolving attitudes toward consumption. Women spent exponentially more on fashion than men. Marie Antoinette and Rose Bertin represented the pinnacle of a fashion system that also increasingly catered to middle- and working-class Parisiennes.[49]

In many ways, food and fashion not only coexisted to create the luxurious fantasy of eighteenth-century aristocratic luxury but also collided. Besides its luxury economy, which was based mostly in Paris, France relied heavily on its rural agriculture and peasant workers—a situation made painfully apparent by famine and subsequent riots in the late 1780s. The aristocracy readily acknowledged France's agricultural products, if not its working classes; gowns, such as the gauzy silver one made by Bertin for Madame du Barry in 1782, featured "bunches of golden wheat-ears." The dress's motif also included "gold corn-ears," a nod to a New World import and European colonialism abroad.[50] Prevailing preferences in design and culture also affected both mediums. The modern cuisine that La Chapelle pioneered during the 1730s embraced light delicate flavors at the same time that the rococo aesthetic emerged from the baroque style. During the later eighteenth century, the writing of Jean-Jacques Rousseau (1712–1778) created fervor for romantic naturalism among elites, as historian Rebecca Spang explains:

> Marie Antoinette's shepherdess costume—though certainly austere in comparison with the robes of court ceremony—was also far finer, and infinitely cleaner, than the wool garments of real sheep farmers . . . Jacques Rousseau extended his stirring critique of "civilization" to the table, but . . . he celebrated neither the dark bread of peasant fare, nor the acorns eaten by the "primitive man" . . . Instead Rousseau's sensitive characters inhabited a milk-and-honey world of (comparatively expensive) fruits and dairy products.[51]

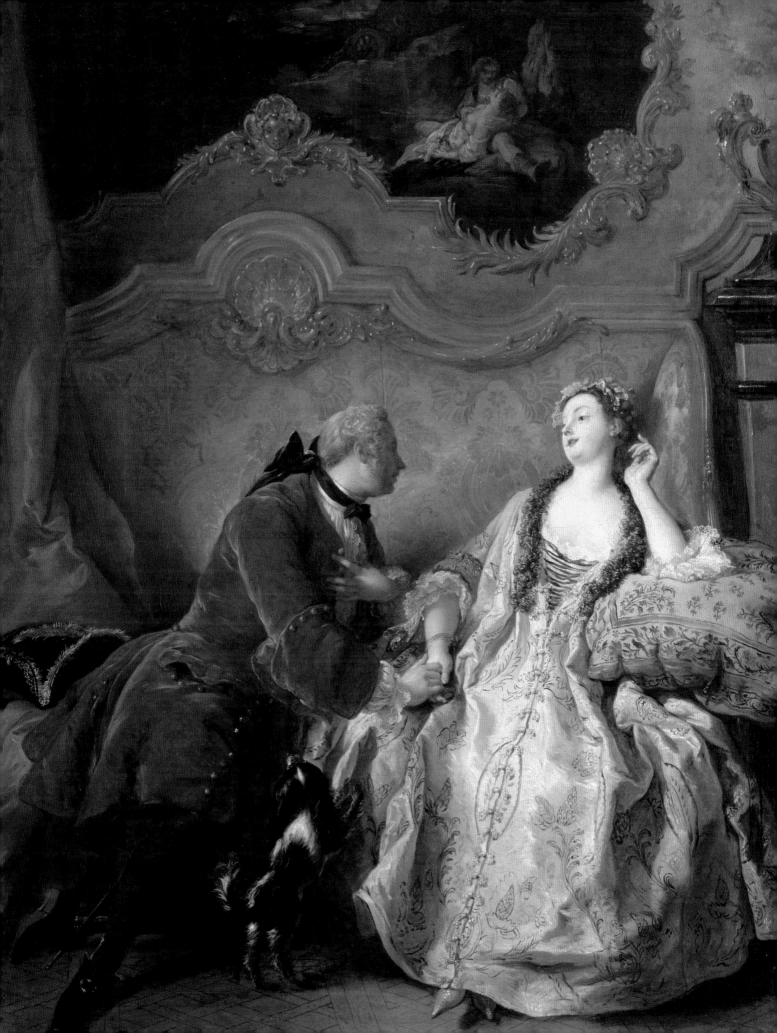

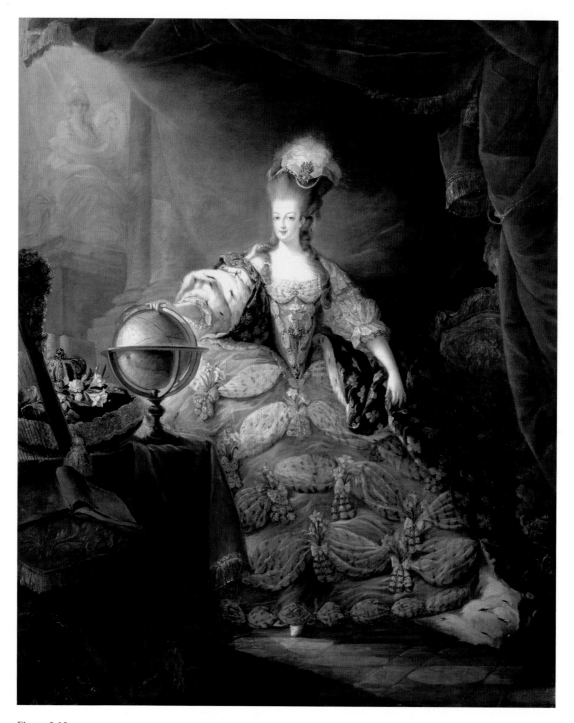

Figure 2.12
Jean-Baptiste Gautier Dagoty,
*Portrait of Marie-Antoinette of
Austria*, oil on canvas, 1775.
Palace of Versailles

This aristocratic disconnect had dire consequences for the French nobility during the Revolution, but Paris did not lose its influence over food and fashion. France was not without its foreign influences during this period, driven by rapidly expanding European imperialism and colonialism. This included a large variety of New World foods, such as sugar, produced by slave labor; as well as Chinese tea, textiles, and porcelain; African coffee; and Indian (and later American) cotton fabrics, first made fashionable by women of the French Caribbean. However, the period between the mid-seventeenth and late eighteenth centuries became a crystalized and idealized image of French culture, as referenced by Westwood, Coppola, Scott, and many others—including Japanese "girl culture," as noted by Patricia Mears in chapter ten. This period enabled the birth of haute couture and haute cuisine, and both would continue to advocate internationally for the supremacy of French culture. Parkhurst Ferguson's statement on food is just as easily applied to French fashion: "French cuisine no longer governs the food world as it once did. Even so, whether praised or disparaged, imitated or rejected, it has made modern cuisine in its own image."[52]

Notes

1. Luca Vercelloni, *The Invention of Taste: A Cultural Account of Desire, Delight and Disgust in Fashion, Food, and Art* (London: Bloomsbury, 2016), 26.

2. Lorelei Marfil, "Vivienne Westwood Celebrates 20th Anniversary of Vive La Cocotte," *Women's Wear Daily*, November 20, 2015, https://wwd.com/fashion-news/fashion-scoops/vivienne-westwood-20th-anniversary-vive-la-cocotte-brigitte-stepputtis-10283661/.

3. Kenneth Turan, "From the Archives: A Royally Divisive Queen: The Politics Behind Cannes' Boos for Sofia Coppola's 'Marie Antoinette,'" *Los Angeles Times*, May 27, 2017, https://www.latimes.com/entertainment/movies/la-et-mn-archives-sofia-coppola-marie-antoinette-boos-20170527-story.html.

4. Turan, "From the Archives."

5. Kristin Hohenadel, "French Royalty as Seen by Hollywood Royalty," *The New York Times*, September 10, 2006, https://www.nytimes.com/2006/09/10/movies/moviesspecial/10hohe.html.

6. Luke Leitch, "Fall 2020 Ready-To-Wear: Moschino," *VogueRunway.com*, February 20, 2020, https://www.vogue.com/fashion-shows/fall-2020-ready-to-wear/moschino.

7. Pierre Bourdieu, *Distinction: A Social Critique of the Judgment of Taste*, translated by Richard Nice (Cambridge: Harvard University Press, 1984), 2.

8. Bourdieu, *Distinction*, 3.

9. Joan DeJean, *The Essence of Style: How the French Invented High Fashion, Fine Food, Chic Cafés, Style, Sophistication, and Glamour* (New York: Free Press, 2007), 2.

10. DeJean, *The Essence of Style*, 7.

11. Ragnhild Hatton, *Louis XIV and His World* (New York: Putnam's Sons, 1972), 64.

12. DeJean, *The Essence of Style*, 7–8.

13. DeJean, *The Essence of Style*, 4, 16.

14. Antonia Fraser, *Love and Louis XIV: The Women in the Life of the Sun King* (New York: Nan A. Talese, 2006), 15.

15. Fraser, *Love and Louis XIV*, 107.

16. Fraser, *Love and Louis XIV*, 116.

17. DeJean, *The Essence of Style*, 109, 113; Priscilla Parkhurst Ferguson, The French Invention of Modern Cuisine," in *Food and Time and Place*, eds. Paul Freedman, Joyce E. Chaplin, and Ken Albala (Oakland: University of California Press, 2014), 235.

18. DeJean, *The Essence of Style*, 109.

19. DeJean, *The Essence of Style*, 112.

20. Hatton, *Louis XIV and His World*, 116.

21. Jean-François Revel, *Culture and Cuisine: A Journey Through the History of Food* (New York: Da Capo Press, 1984), 149.

22. Revel, *Culture and Cuisine*, 150.

23. Revel, *Culture and Cuisine*, 155.

24. *The Letters of Madame de Sévigné*, ed. Mrs. Hale (Boston: Roberts and Brothers, 1869), 44.

25. DeJean, *The Essence of Style*, 130.

26. DeJean, *The Essence of Style*, 128.

27. Priscilla Parkhurst Ferguson, "The French Invention of Modern Cuisine," in *Food and Time and Place*, edited by Paul Freedman, Joyce E. Chaplin, and Ken Albala (Oakland: University of California Press, 2014), 237.

28. Ferguson, "The French Invention of Modern Cuisine."

29. Ferguson, "The French Invention of Modern Cuisine."

30. Revel, *Culture and Cuisine*, 153–155; DeJean, The Essence of Style, 118–119.

31. Revel, *Culture and Cuisine*, 177.

32. Revel, *Culture and Cuisine*, 158.

33. Valerie Steele, *Paris Fashion: A Cultural History* (New York: Bloomsbury, 2017), 26–27.

34. Steele, *Paris Fashion*, 27.

35. DeJean, *The Essence of Style*, 55–57.

36. Steele, *Paris Fashion*, 27–28; DeJean, *The Essence of Style*, 40–44.

37. Steele, *Paris Fashion*, 28; DeJean, *The Essence of Style*, 46–47.

38. DeJean, *The Essence of Style*, 45–49, 52.

39. DeJean, *The Essence of Style*, 36, 67, 81; Steele, Paris Fashion, 2, 28.

40. Valerie Steele, *Paris, Capital of Fashion* (London: Bloomsbury Visual Arts, 2019), 14; Steele, *Paris Fashion*, 29. The court moved back to Versailles in 1722.

41. Aileen Ribeiro, *Dress in Eighteenth Century Europe 1715–1789* (New Haven: Yale University Press, 2002), 11.

42. Ribeiro, *Dress in Eighteenth Century Europe*, 11.

43. Ribeiro, *Dress in Eighteenth Century Europe*, 34–38; Steele, Paris Fashion, 31.

44. Ribeiro, *Dress in Eighteenth Century Europe*, 44, 222, 226–227; Caroline Weber, *Queen of Fashion: What Marie Antoinette Wore to the Revolution* (New York: Henry Holt and Company, 2006), 67–68, 81–82, 160–161; Steele, Paris Fashion, 39–40.

45. Steele, *Paris Fashion*, 39.

46. Steele, *Paris Fashion*, 103.

47. Weber, *Queen of Fashion*, 95.

48. Weber, *Queen of Fashion*, 104–105.

49. Weber, *Queen of Fashion*, 102–103; Ribeiro, *Dress in Eighteenth Century Europe*, 68–69.

50. Ribeiro, *Dress in Eighteenth Century Europe*, 219.

51. Rebecca L. Spang, *The Invention of the Restaurant: Paris and Modern Gastronomic Culture* (Cambridge: Harvard University Press, 200), 41–42.

52. Ferguson, "The French Invention of Modern Cuisine," 237.

Inside the image: SAVOY HOTEL · LONDON GRAND FOYER of RESTAURANT

Figure 3.1
Grand foyer and restaurant of the
Savoy Hotel, London, postcard,
1906. Amoret Tanner/Alamy
Stock Photo

Dressed to Dine: The Restaurant as Fashionable, Feminine Space

Elizabeth Way

In the preface to *A Guide to Modern Cookery*, first published as *Le guide culinaire* in 1903, chef Auguste Escoffier outlines the late nineteenth century changes in elite English dining, particularly the rise of restaurants. Escoffier's book, credited with defining the art of French cooking, explains the appeal: "Since restaurants allow of observing and of being observed, since they are eminently adapted to the exhibiting of magnificent dresses, it was not long before they entered into the life of Fortune's favourites."[1,2] Although restaurants existed during the Roman Empire and thrived in China from the eleventh century, modern European iterations emerged in Paris during the 1760s. Historian Rebecca Spang notes that, "Until well after the middle of the nineteenth century, restaurants were to remain an almost exclusively Parisian phenomenon, one rarely encountered outside the French capital."[3,4] Escoffier, working closely with Swiss hotelier César Ritz, first at the Savoy Hotel and then at the Carlton, helped usher in the popularity of elite restaurants in London, thereby creating a new type of social space in the city, perfectly designed to show off the latest tastes and styles. Escoffier introduced new kinds of foods to the English palate—lighter fare in smaller portions that dazzled with delicate new tastes and stunning presentations, while Ritz created an atmosphere to bring in an untapped segment of high society. Author Luke Barr notes that in London, unlike Provence and Baden-Baden, where Ritz had previously managed hotels with grand dining rooms, "Women did not traditionally eat in restaurants. They entertained at home, and their husbands ate at their private clubs."[5] Yet, while managing the Savoy from its opening in 1889, Ritz designed the decor to "abolish the gentlemen's-club quality of the place and introduce a sense of lightness and femininity. . . . He wanted men to bring their wives to dinner at the Savoy, for he knew it was women who would make the restaurant fashionable . . . the

success of the restaurant depended on the element of theater and people-watching that only a mixed crowd could produce."[6] Ritz understood that women's fashion was the main act of this theater of dining. When he went on to design his own eponymous hotel in Paris, he took pains experimenting with the restaurant lighting to best flatter female diners and built an expensive set of stairs "so that ladies entering the dining room or leaving it may do so dramatically."[7]

Escoffier's description of the restaurant as a place to show off magnificent dress is depicted in a 1906 illustration of the Savoy's large restaurant. There is very little food or drink on the tables, and the men are attired in white tie evening dress, virtually indistinguishable from the waiters. The lavish room with vaulted ceiling, pink Corinthian columns, chandeliers, and large-scale portraits is only rivaled by the women dressed in an array of off-the-shoulder gowns in soft pastels or saturated tones. Hair swept up in graceful volumes and swirling skirts set off the tightly corseted waists. The female diners pose with their accessories: gloves, shawls, fans, and male escorts. A short flight of stairs in the background frame a woman in a white gown—her frothy train trailing behind her as Ritz imagined. The diners seem relaxed, almost languid, in sharp contrast to an *Illustrated London News* image from the next year. The New Year's Eve dinner party is depicted in the same columned dining room, but the guests actively celebrate as the full skirts of satin and tulle ball gowns flow between tables of champagne glasses.

These illustrations show the emergence of the restaurant as a new space in turn-of-the-century London for fashionable display. And unlike public parks and promenades, the racetrack, opera, and theatre, which had their own accessories to fashionability, restaurants incorporated food as a highly visible symbol of wealth, sophistication, and social-insider status. In his essay "Toward a Psychosociology of Contemporary Food Consumption," theorist Roland Barthes writes, "Food serves as a sign not only for themes but also for situations; and . . . means for a way of life that is emphasized, much more than expressed, by it. To eat is a behavior that develops beyond its own ends, replacing, summing up, and signalizing other behaviors, and it is precisely for these reasons that it is a sign."[8] Although not prominent in the previous images, the dishes that Escoffier served—including *cuisses de nymphes à l'Aurore* (Thighs of Nymphs at Dawn: cold, poached frog legs with chaudfroid sauce) or *pêches Melba* (peaches with vanilla ice cream and sugared raspberry puree, served in a block of ice carved into a swan in celebration of opera singer Nellie Melba's role in *Lohengrin*)—were signs of an overt expression of modern wealth, newly situated in London restaurants at this time. The public consumption of this food was inextricable from the display of fashionable clothing in this expression. Both were vital to the elite restaurant. In noting the success of the Savoy as a fashionable space, Barr writes, "Escoffier's cooking was the key to the equation: the visceral, sensual pleasure of the food; the bottles of champagne that went with it; and the theatrical drama of the dining room, a place to see and be

Figure 3.2
"New Year's Eve at the Savoy Hotel," January 5, 1907,
The Illustrated London News. The newspaper noted,
"A thousand guests sat down to supper at the Savoy on
New Year's Eve and saw the New Year in amid a scene
of boisterous enthusiasm . . . Everything is now being
transferred to the restaurant, and even the New Year's Eve
ceremonies, once domestic of the domestic, are celebrated
in public." © Illustrated London News Ltd/Mary Evans

seen."[9] At this time, London was the most economically powerful and technologically advanced city in the western world, with New York on its heels, yet Paris held sway as the cultural capital whose food and fashion were assiduously copied. These markers of sophistication were defined by their conspicuousness. Fashion historian Valerie Steele writes of Paris, "Both modern fashion and the modern city emphasized the libido of looking," emphasizing that "fashion only acquires meaning . . . within the context of particular sites, where fashion performers and spectators interact and fashion is displayed to greatest effect."[10] The novel French and internationally-inspired food that Escoffier served at the Savoy restaurant was crucial, working together with the fashion on display in the dining room to convey an elegantly leisured lifestyle and social currency to wealthy peers.

Western society was undergoing significant class-based shifts as industry created vast wealth for new groups of people. Restaurants became proving grounds for these newly rich to flaunt their success and attempt to enter the traditionally elite classes. Unlike private homes or gentleman's clubs, restaurants in London at the turn of the twentieth century were open to those who could look the part of an aristocrat. Barr notes, "Anyone—anyone with money, that is—could eat like a king at the Savoy, and that had never been true before. The nouveau riche had arrived, but until now, there had never been anywhere for them to go to announce their arrival."[11] This created inevitable friction with old-moneyed Londoners who were also drawn to the fashionability of the restaurant. In his discussions on class distinction, philosopher Pierre Bourdieu defined cultural capital as a "culturally-specific 'competence,' albeit one which is efficacious—as a 'resource' or a 'power'—in a particular social setting."[12] These competencies were "inculcated" through institutions such as the family and schools, and were learned over a lifetime by Europe's aristocracy, who would have had little chance to mix with wealthy people outside of their class before the mid-to-late nineteenth century. Fashion, food and eating habits, manners, and modes of conveying wealth were all distinct competencies that separated elite classes from the nouveau riche. Yet, in the new space of the restaurant, these groups co-existed. Tensions eventually gave way to redistributions of social power and evolving ideas of cultural capital in the new century.

Looking like an elite was essential. Clothing was prominently regulated at the Savoy restaurant—from the "waiters in ties and aprons, the headwaiters in black ties, [and] the senior staff . . . [in] morning coats with tails. Escoffier would sometimes wear the traditional chef's whites and toque blanche, usually on Sunday, but generally he wore a long frock coat, cut just above the knee, and a tie."[13] Women followed fashion and etiquette dictates on dinner dressing, though these standards were loosening to allow more options toward the end of the nineteenth century. *The Woman's World* magazine announced, "Now, women dress for dinner in as many different ways as the meal is served. . . . Low gowns, half high gowns, or tea gowns which are akin to [opulent]

dressing gowns, or tea gowns that closely resemble the revised court bodice, inspired by the modes of mediaeval times—all these are popular!"[14] Despite the style of gown, respectable dress was *de rigueur*. Ritz implemented a policy requiring formal dress for dinner to guard the reputation of the hotel. Women had to be accompanied in the evening and could not wear hats; in his experience, large evening hats, together with visible makeup, indicated the types of lower-class prostitutes who would shock and repel respectable ladies.[15] Just as French chefs such as Escoffier, and Marie-Antoine Carême before him, set international standards in haute cuisine and its ostentatious presentation, France was also the source of the haute couture worn and copied by international elites. The dissemination of French sophistication, in both fashion and food, relied on a dialogue between cities. While Escoffier flourished in London, decades earlier, the Englishman Charles Frederick Worth had revolutionized French fashion in Paris. Americans were important consumers in both cities and helped circulate fashionable styles and practices. Historian Andrew Haley notes that after the American Civil War, new economic opportunities gave rise to "a wealthy class of capitalists who . . . turned to Europe to find markers of their social standing. Along with imported marble, Old Master paintings, and haute couture, they imported French culinary culture (and the chefs and waiters required to prepare and serve it)."[16]

The Restaurant: Paris to New York to London

There had been many suppliers of prepared food and drink during the *Ancien Régime*, including taverns, inns, caterers, butchers, pastry cooks, and *cafetiers* (coffee roasters). In France, these suppliers were "strictly regulated, according to guild rules . . . thus a *rôtisseur* [roaster] did not have the right to prepare stews or baked goods."[17] The upper classes did not typically dine in public; however, fashionable inns and bistros did exist to cater to the aristocracy. For example, Gédéon Tallemant des Réaux wrote in his *Historiettes*, completed around 1659, of an establishment in Saint-Cloud where Louis XIII's brother Gaston d'Orléans ate and drank with his friends.[18] Restaurants were popularly believed to have developed during the French Revolution when chefs to aristocratic families, newly out of work, could take advantage of the collapse of the guild system to open their own businesses and recreate the type of fine dining that they had produced in elite homes. However, just as the white, muslin gowns that supposedly represented republicanism first became fashionable as aristocratic dress *before* the revolution, restaurants first appeared in Paris during the *Ancien Régime*. At this time, "restaurants" referred to consommés and restorative broths marketed to frail, ill people who could not consume solid foods. Restauranteurs' rooms were marked by their differences from other places to buy ready-made food. At inns, for example, mealtimes were fixed, and the proprietor chose the food, served family-style at the table d'hôte. Restauranteurs served diners at individual tables who ordered

from menus at unfixed mealtimes. Early restauranteurs worked within the established guild system and served a social mix of "dukes and actresses, clergymen and philosophers."[19] Personal service made restaurants truly innovative: "The restaurant owner invited his guest to sit at his or her *own* table, to consult his or her *own* needs and desires, to concentrate on that most fleeting and difficult to universalize sense: taste."[20] The practice of à la carte dining soon caught on with other food businesses, and restaurants quickly began serving more substantial meals.[21] Gastronomic writing of the early nineteenth century helped popularize restaurants, and "by the 1820s . . . the restaurants of the French capital—with their four-column menus, confused eaters, and waiters of variable politeness . . . had become a true cultural institution, among the most familiar and distinctive of Parisian landmarks."[22]

From the beginning, restaurants were sites of social performance—places to perform "the elite pursuit of individual health,"[23] a fashionable pastime of the era. They were stylishly decorated with candles, lamps, and mirrors, and unlike cafés, catered to fashionable and respectable women as well as to men. Spang notes, "Central as they were to the definitions of eighteenth-century sensibility and nineteenth-century opulence, women had never been absent from restaurant dining rooms in Paris."[24] Women, seen as delicate with weak constitutions, were *more* likely to visit restauranteurs for soothing bouillons; some establishments offered private rooms to respect ladies' sense of propriety. Inevitably, restaurant rooms, as semi-private, public spaces, became convenient locations for trysts.[25] By the 1830s, travelers from England and the United States saw restaurants, such as the famous Véry or the Café de Paris, as essential places to observe French life. Many travelers were surprised by the presence of women—from the hostess, the "lavishly dressed 'belle dame au comptoir,'" to the diners, "well dressed women [who] added to a restaurant's many civilized delights."[26] Some tourists who were shocked by fashionably adorned women publicly eating, sipping champagne, and glancing in the many mirrors "with as much nonchalance as if they were in their own dressing rooms" condemned them as immodest and the French as lacking domesticity.[27]

Despite the criticism, New York high society was relatively quick to embrace restaurants as fashionable settings. The city's most prominent restaurant, Delmonico's, opened as a pastry shop and café during the 1820s and achieved its reputation as an elite restaurant by 1848. In 1862, Delmonico's relocated to the stylish intersection of Fifth Avenue and Fourteenth Street, and brought on French chef Charles Ranhofer, who was credited with elevating American dining through French cuisine and service.[28] At this time, Delmonico's became "a social institution, influencing the manners, tastes, and customs not only of the city but of the nation for decades to come."[29] By the 1880s, elite French restaurants had spread across the country. They printed their menus exclusively in French (as a gatekeeping method to discourage middle class diners) and served dishes such as *ris de veau piqué aux épinard* (sweetbread

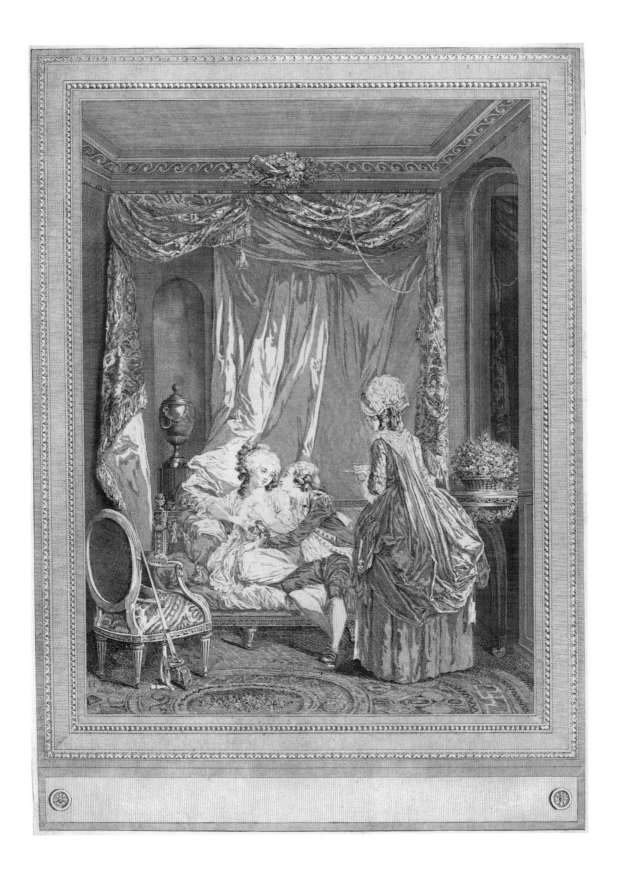

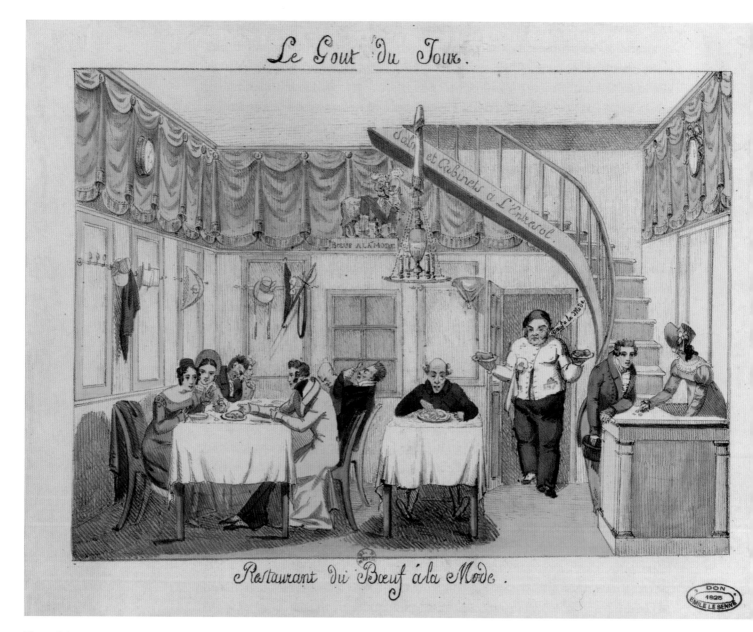

Figure 3.4
This illustration shows the
fashionable interiors and female
consumers of early nineteenth-
century Parisian restaurants.
Restaurant du Boeuf à la Mode
(*The Trendy Beef Restaurant*), 1825.
Bibliothèque nationale de France

with spinach), as well as Gallicized versions of distinctly American dishes, such as *terrapin à la Maryland*.[30] During the 1860s, Delmonico's began to welcome escorted female diners, and it became a central space for the women who dominated New York's elite social scene.

An 1877 newspaper article covering a flower party held at Delmonico's for the "aid of the Northeastern dispensary" shows an evening affair in which women outnumber the men. The illustration details the gowns with tight cuirass silhouettes topped with low scoop-backed necklines and tiny cap sleeves, or more modest collars paired with lace cuffs. The skirts, swept back and draped into soft bustles and accented with scalloped trims, pleats, lace, ribbons, and bows, are presented much more clearly than the flowers covering a central table with no food in view. New York's modern restaurants were noted by "An American Lady in London," who declared in *Harper's Bazar* in 1878, "There is not in London a single hotel or restaurant which can equal the best hotels of New York and Philadelphia, and in the matter of *cafés* there is nothing that approaches Delmonico's."[31] By 1895, *Harper's Bazar* nostalgically praised the restaurant and its prominence in New York society: "The mothers of to-day who sit there surrounded by their daughters sat here twenty years ago . . . and had these same merry breakfasts and dainty luncheons."[32] Upper-class New York women had begun taking the breakfasts, luncheons, and teas that they previously hosted in their homes at respectable restaurants. This behavior marked New York women's modernity and independence. Charles Dana Gibson captured versions of this archetypical "New Woman" in *Scribner's Magazine* at the turn of the century. "A New York Day Noon" shows three young women in chicly tailored daytime ensembles with high necks, long sleeves, and elaborate hats dining together without male companions. Class and reputation, however, were important factors in this practice as *maîtres d'hôtel* and waiters frequently barred unrecognized women or those who were deemed middle class, based mainly on their dress. Haley notes, "Restaurants, among other urban and cultural and consumer institutions, treated society women as incorruptible 'ladies' but did not automatically extend the same respect to their middle-class counterparts."[33] Additionally, in most cases, dinner services still required escorts. *Harper's Bazar's* article on Delmonico's underscored that by the 1890s, "Women may always go alone to Delmonico's during the day, but no women, well known as they may be, are ever admitted after dark unless accompanied by some gentleman."[34] In 1907, Harriot Stanton Blatch, daughter of suffragette Elizabeth Cady Stanton, sued the Hoffman House hotel in New York for denying her and her friend access to its rooftop restaurant for dinner. The Hoffman House won the case and the right to bar unescorted women in that particular dining room. The hotel offered other rooms for unescorted women to eat dinner; the rooftop was open to unescorted women before six o'clock.[35]

Vogue credited American influence, not French, for the spread of elites frequenting restaurants, writing, "There is a howl from London over the importation of wretched

Figure 3.5
New York City, the "flower
party," in aid of the Northeastern
dispensary, given at Delmonico's,
Tuesday evening, April 3, 1877. The
Miriam and Ira D. Wallach Division
of Art, Prints and Photographs, The
New York Public Library Digital
Collections

Figure 3.6
Emile Pingat's 1878 silk brocade, lace, and silk satin dinner dress closely resembles the styles illustrated at the flower party. Photo by Chicago History Museum/ Getty Images

Figure 3.7
Charles Dana Gibson, "A New York Noon Day," *Scribner's* magazine, September 1898. Cabinet of American illustration, Library of Congress

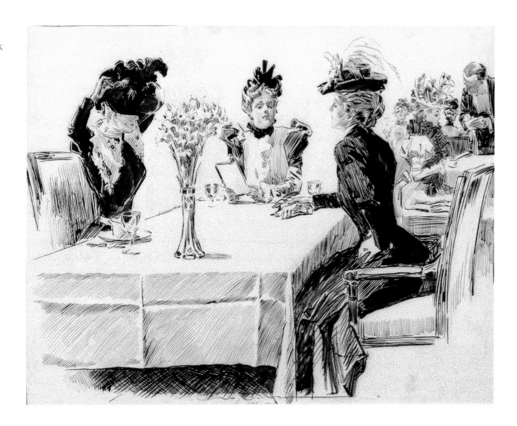

American fashions and customs. . . . The chief complaint is that London has adopted the American fashion for giving dinners and dining at hotels and restaurants . . . now he [the Englishman of the higher classes] gives dinners at the Savoy, at the Metropole, at the Grand, even at the Criterion . . . moreover he invites his womenkind to join him."[36] There was some truth in this claim. Although women had been eating in Parisian restaurants for more than a century, the highest levels of the French aristocracy during the Belle Époque were as unconvinced as their English peers that public restaurants were appropriately respectable and fashionable for women of their caliber. When César Ritz opened his hotel in Paris in 1898, he was sure to locate it at the Place Vendôme, near the House of Worth, the jewelers Chaumet and Boucheron, and the perfumer Guerlain. Still, the restaurant was only deemed fashionable after social stars such as the Duke and Duchess d'Uzès and the Count and Countess de Janzé attended dinner parties there. Ritz also catered to these elite women by introducing the novelty of British afternoon tea, "Le Five O'Clock." In good weather, the gardens at the Ritz filled with fashionable women drinking tea and eating tea cakes.[37] By the turn of the twentieth century, it was accepted throughout the elite western world that women brought the full weight of social life to public dining and were essential to creating fashionable and, therefore, in-demand and lucrative spaces. Chef Escoffier

even preferred female eaters, claiming "the secret to his success . . . 'is that most of my dishes were created for the ladies!' They had a finer palate, he was convinced; a woman was his ideal customer."[38]

Dressing to Dine

Upper-class women had divided their days by changes of clothing throughout the nineteenth century, and different levels of formality were required by different meals. However, public dining changed the way women dressed to eat. In 1864, Eliza Leslie stated in her *Guide to True Politeness* that it is "ungenteel to go to the breakfast-table in any costume approaching to full dress" with the assumption that this breakfast would be taken in a private home.[39] However, a decade later, Emmeline Raymond's report for *Harper's Bazar* on Paris fashion included a long description of a pale blue faille and muslin delaine breakfast dress with a demi-train, and flounces of cashmere and English embroidery that could have been intended for a restaurant meal.[40] An even more lavish dress would have been worn by Mrs. Charles Putnam and her guests in 1891 at her "elaborate wedding breakfast at the Savoy Hotel."[41]

Leslie advised for "dressing for a hotel dinner," still generally held at the table d'hôte in 1864:

> It is not well to adopt a full evening costume, and to appear as if attired for a ball; for instance, with a coloured velvet gown; or one of a splendid brocade; or a transparent gauze material over a satin; or with short sleeves and bare neck in cold weather; or with flowers or jewels in the hair. Such costumes should be reserved for evening parties.[42]

From its inception, the restaurant at the Savoy was a different type of space. It catered to ladies and gentlemen coming from the nearby opera house, as well as the opera's stars, who enjoyed late-night suppers in their full evening dress. Ritz's wife Marie observed, "Society in London was still ostentatious. It showed itself, dressed to the nines, at the theater, the opera, the park, and even, thanks to the drawing power of Ritz's name, the public restaurant at the Savoy." At one dinner, "[Nellie] Melba wore a black-and-dark-green lace dress with black roses sewn onto the skirt, and a necklace that showed off an enormous diamond. She was stunning."[43] The changes in formality and ostentation in mealtime dressing indicated larger changes at the end of the nineteenth century: "The social life [was] . . . changing; everyone could feel it. This was the fin de siècle, and the old order was shifting—with a little encouragement."[44] Class, if not racial, distinctions were challenged as the nouveau riche of industrialists and merchants displayed their vast wealth, what sociologist Thorstein Veblen would name "conspicuous consumption" in 1899. Restaurants were undeniably modern

Figure 3.8
Isabel A. Mallon, "Dressing for Dinner," *Ladies' Home Journal*, October 1893.

DRESSING FOR DINNER
By Isabel A. Mallon

THE custom of having a late dinner is very general, and to my way of thinking it is one to be commended. Therefore it is wise for a woman to have a dinner gown—it may be as simple or as elaborate as possible, but in its short train, in its permitting the throat to show, and in its frills and frivols it accentuates the difference between the street and the home gown.

I honestly believe that the making one's self look pretty for dinner will do more toward keeping a man at home than all the opinions of ologies that were ever delivered by women dressed in dowdy gowns. The best knowledge for a woman to possess is how to be attractive and how to make her home the most delightful place in the world.

The materials for the dinner dress are many in number. That used for the ordinary a. home dinner may be of soft woolen stuff, of silk, or if one's surroundings permit it and one's purse makes it possible, of the velvets and brocades that are dedicated oftenest to more formal occasions.

A DAINTY DINNER DRESS

A DINNER dress intended to be worn by a woman to whom dead white is possible is shown in Illustration No. 1. The skirt, while it seems plain across the front, is quite full at the back, and as it is on the ground an inch or two, this fullness is so

THE GRAY DINNER TOILETTE

THE woman who has too much color to wear white, and who, from the multitude of materials, selects a silver gray crêpe, arranges for herself a dinner dress that is not only becoming but that has a certain air of distinction about it. One that is especially becoming is pictured in Illustration No. 2, and is worn by a dark-haired, dark-eyed, rosy-cheeked young matron. The soft crêpe is made up over a lining of very pale green silk, so pale that it simply blends in with the gray and does not offer a contrast. About the edge is the usual gathered flounce, which is of very thin gray chiffon folded over green chiffon, while above it sways a more elaborate flounce of gray net, heavily embroidered with steel spangles. The bodice is a round one fastening in the back, and high in the neck. The collar is a soft fold of the crêpe with a steel buckle at one side, and the bodice decorations are sections of gray net, steel-spangled, fitted like armor over the body itself and reaching far up on the corsage. The sleeves are of the crêpe, and are drawn up in a sort of full way to just below the elbow, where a frill of the two-shaded chiffon, drawn to the outer side and held down under a steel buckle, forms the finish. The girdle, which seems a continuation of the bodice decoration, is of the steel-spangled net, and hooks in the back, where long ends of it fall down on the short train. The hair is worn high, and a comb of steel in the shape of a crescent is arranged coquettishly at one side.

THE EMPIRE DESIGNS

THE modified Empire design, that is, the one not in one piece, which has a skirt and belt over the round bodice, is best liked for the dinner dress. I am speaking now of the dinner dress that is to be made of silk, and which is quite fine enough to be worn to any function. The veritable Empire dress all in one piece, and with a Watteau fold at the back, is fancied by the woman who has it developed in an inexpensive material, and retains it exclusively for home wear. The cutting out of the dress at the neck has changed somewhat, the broad, square effect being given the preference over the round one, but this, it must be remembered, is not cut a particle lower than the English round neck; it only goes a little further across on the shoulders. It is essentially modest, and I wish I could make the general woman understand that the real artist in dressmaking never cuts a bodice immodestly, for when a woman loses that charm she ceases to be artistic. The sleeves are long, and very elaborate effects by puffs, with lace or chiffon frills, and with flat bead garnitures are upon them. The colors in vogue for dinner dresses are white, pale gray, blues and greens. Pale pink is also liked.

DINNER GOWN OF BLACK CRÊPE

ONE of the most artistic of the simpler dinner gowns is made of black crêpe-cloth and is shown in Illustration No. 3. While not following the outline exactly of the Empire dress it is, nevertheless, in one piece, the upper part being shaped into the figure and the fullness flowing from below the waist in the back into the short train. It has a high-necked *guimpe* of coarse coffee-colored lace which fits back and front perfectly, and is finished by a collar, a very high one of the same lace. Tiny lace buttons with loops of lace cord close the *guimpe* in front. Just where this joins the material across the bust is a broad sash of coffee-colored satin ribbon at least four

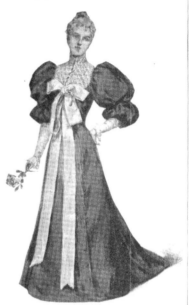

DINNER GOWN OF BLACK CRÊPE (Illus. No. 3)

inches wide, which is tied just in the centre in long loops and ends, and reaches almost to the edge of the skirt. The sleeves are two full puffs of the crêpe, and below that have close-fitting cuffs formed of folds of the satin ribbon.

If one wearied of the contrasting color black or jet could be substituted for the coffee lace, but as the contrast is considered to be a good one I should advise the retaining of it for, at least, one season.

SILVER GRAY DINNER TOILETTE (Illus. No. 2)

arranged that it stands out in regular folds. The material used is dead white silk. About the edge are two five-inch frills of white chiffon, and above them, appliquéd on the fabric is an insertion of deep coffee-colored lace, a deep *point de Venice*. The bodice, which is a round one, is of the silk, and has the neck cut out square, that is, the broad square, not the long one, while falling over it is a deep frill of chiffon, and above this, resting against the neck itself is an insertion of the lace that is drawn in to fit by a narrow love ribbon. The sleeves have a deep puff of white silk, and from the elbow to the wrist a close-fitting cuff of lace that is carefully buttoned over on the outside so that it shapes to the arm. The belt is a folded one of satin ribbon the color of the lace, with two rosettes, one just each side of the front, concealing where the ends overlap. Accompanying this dress is a *guimpe* of the lace with a collar of satin ribbon like the belt, which may be assumed when one does not wish to wear a low neck. With this gown all jewelry is out of place unless it should be a few favorite rings.

DINNER GOWN OF WHITE SILK (Illus. No. 1)

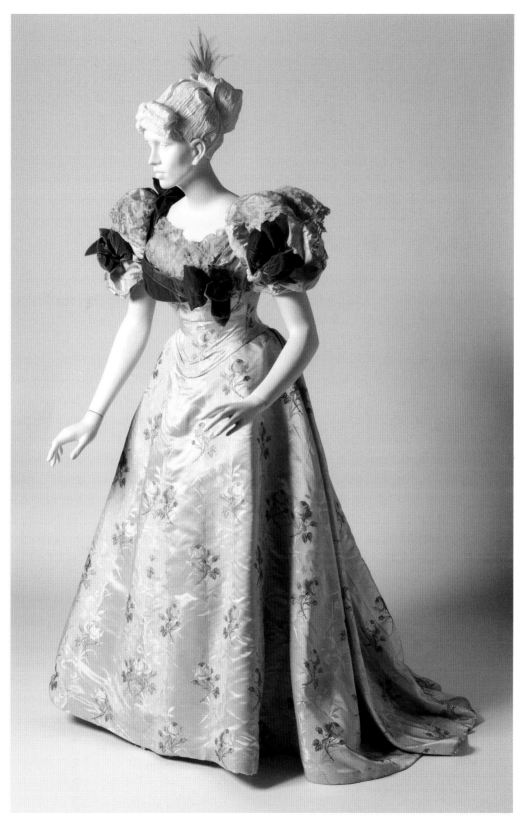

Figure 3.9
This Worth evening gown was one style among many deemed appropriate for a lavish public dinner and resembles a dinner dress illustrated by *Ladies' Home Journal* in 1893. Silk evening gown, House of Worth, circa 1895, accession number: 20480-1, Bruce Museum, Greenwich, CT

spaces and sites of these changes. In 1896, *Vogue*'s London correspondent reported on the new fashion for Sunday dinners in restaurants, a practice that had been previously outlawed.[45] The article cites the Duchess of Devonshire and the Prince of Wales hosting receptions on Sundays, as well as others attending "dinners given at the various restaurants and hotels by those who have the most perfect tables at home." Restaurant dinners allowed previously segregated members of society to mix:

> Thus you may now see Lady Wolverton, her mother, Lady Dudley, the young Duchess of Leeds or Lady Warwick dining with their party at one table at the Savoy, while at the adjoining one members of the jeunesse dorée, in no wise abashed by the proximity, will be entertaining stars of the Alhambra and Empire corps de ballet.[46]

The shifting social codes of high society are evident in the wide variety of dinner dress deemed acceptable and fashionable at elite restaurants. While fashions for daytime dining throughout the nineteenth century consistently featured long-sleeved, high-necked ensembles, accessorized with hats and gloves, at dinner a lady could wear an open neckline and jewelry. Turn-of-the-century fashion plates show a large variety of styles from high necks with long or three-quarter sleeves, to low V-neck, square, or rounded necklines, or styles in between that covered the décolletage with transparent fabric. Details such as embellished necklines, puffed sleeves, and contrasting trims on bodices created visual interest above the table line, and trains were included on skirts to sweep into dining rooms and drape prettily from chairs. Isabel Mallon, writing for *Ladies' Home Journal* in 1893, explained, "a dinner gown . . . may be as simple or as elaborate as possible, but in its short train, in its permitting the throat to show, and in its frills and frivols it accentuates the difference between the street and the home gown."[47] A *Harper's Bazar* article published in 1899 admitted that dinner dresses could be hard to distinguish from ball gowns.[48]

Whatever the privileged women of New York or London chose to wear, they still looked to Paris for guidance and shopped there if they could. A 1895 *Good Housekeeping* article complained, "it is unfortunate for the average American woman in Paris that the Parisian dressmaker has a fixed, unwavering idea that all Americans are rich, and that a higher price can be asked and obtained," while readily admitting, "the highest grade of dressmakers in Paris consider themselves artists, and quite justly, too, for the work turned out from their hands is often a dream, a poem in tone, color and form. . . . All this is of course expensive, but if one has the money it is an excellent investment, for such a costume is perfectly satisfactory till worn out."[49] The author mentioned few couturiers by name, except for Charles Frederick Worth, the most famous and influential couturier of the day, whose success

and popularity again reflected a shifting international social world. The couturier opened his atelier in 1858, and was important, as Steele states, "because he transformed the couture from a craft (*couture*) into a creative industry (*grand couture*), which was the predecessor to what we now know as *haute couture*. From being a person who sews dresses, the term 'couturier' became redefined by the 1860s as 'a person who directs a fashion house, who created designs.'"[50] Worth presented himself as an artist and creative authority, a view that elevated tradesmen and craftspeople and one that Escoffier shared. Instead of collaborating with his clients as other female couturieres did, Worth designed series of gowns from which clients chose. Steele notes that Worth encroached upon a female-dominated industry that employed tens of thousands of women in a myriad of positions during the nineteenth century. Although he was initially mocked, Worth was able to position himself similarly to other men within an increasingly professionalized, industrialized, capitalist economy in which skilled workers were male, and women were overwhelmingly relegated to unskilled, poorly paid work.[51] This shift mirrored the earlier professionalization of cooking. Philosopher and journalist Jean-François Revel quotes Charles Pinot Duclos who wrote that during the early eighteenth century, "there were chefs only in first-class households. More than half the magistrates employed only female cooks" to point out the distinctions made between a female "tradition of manual skills and instruction within the family, and the cuisine of the [male] chef, based on invention and reflection."[52] Revel emphasizes the devaluation of female labor but adds, "This antifeminist distinction should not, of course, prevent us from noting that often chefs [and couturiers] are women and vice versa."[53] Within the nineteenth-century context of decreasing status for working women, elite women also played their role as accessories to their husbands' success and were paradoxically vital executors of the kind of soft power that made restaurants fashionable and successful.[54] Barr contends that "of all the social, cultural, political, and technological changes under way, none was more important than the emergence of women on the public stage."[55] This applied to the traditional elites but also the nouveau riche. Worth made his reputation during the 1860s from the patronage of Empress Eugénie de Montijo and her circle, but also dressed *demimondaines* and wealthy American women who could pay the exorbitant prices for his gowns.[56] In the same way, "The restaurant may have served the most refined, daring, and sometimes shockingly expensive food in the world, but it was not exclusive. All were welcome, including Jewish fur tradesmen. The Savoy offered a new and democratic kind of luxury, and cooking was very much at the center of it."[57] Barr's optimistic assessment pointed to the evolving society of the early twentieth century; however, social barriers were far from removed, not only for Jewish elites but also for any nonwhite people with money and social aspirations.

Conclusion

In 1923, the American actress and designer Josephine Earle opened a dressmaking shop on Saville Row, intruding on the male tailoring district. She also "outraged convention in the dress world by opening her establishment with a 'cocktail dress parade' instead of the more customary tea."[58] Earle showed the latest fashions in the "sheath and tubular silhouette . . . extremely short and suitable only for young figures."[59] Fashion historian Elyssa Schram Da Cruz notes, "During the 1920s, newfound concepts of individuality and a repudiation of the Edwardian matronly ideal of respectable womanhood gave rise to the new phenomenon of the 'Drinking Woman,' who dared to enjoy cocktails in mixed company."[60] This woman of the "the progressive fashionable elite" was in need of a more flexible wardrobe, embodied by the cocktail dress. Cocktail hour between six and eight o'clock required the daytime modesty of long sleeves and high necklines, but women might go directly to dinner or an evening event. Early iterations were ensembles. A fashion buyer in 1928 noted the popularity of "the 'cocktail dress,' the sleeveless one with jacket appropriate for afternoon, for dinner, or evening wear."[61] They were distinguished from daywear by more formal fabrics and elaborately embellished cocktail hats.[62] One of the earliest illustrations identified as a "cocktail dress" in *Women's Wear Daily* in 1926 shows an opulently jet-beaded, black couture ensemble by Martial et Armand "with a detachable jacket of

Figure 3.10
Black and off-white silk crepe cocktail ensemble, circa 1930, USA. Gift of L. Graham Patmore. © The Museum at FIT

Figure 3.11 (opposite)
"The Cocktail Hour Is Observed in Retail Imports," *Women's Wear Daily*, September 8, 1926. Courtesy of Fairchild Archive

The Cocktail Hour Is Observed in Retail Imports

The "Cocktail Dress," of Martial et Armand, Is of Black Chiffon, With a Detachable Jacket of Chiffon, Forming a Bloused Effect in the Back and a Bolero Effect in Front. Wide Bands of Jet Embroidery Trim the Jacket and Form a Border on the Skirt.

When the Jacket Is Removed the "Cocktail Dress" Becomes an Evening Gown Trimmed With Rhinestone Embroideries at the Neck, the Armholes and on the Hip.

A Suzanne Talbot Dress Is of Bright Red Fabric With a Suede Finish. The Bodice Has an Exaggerated Bloused Effect and the Skirt Is Finely Pleated. The Tight Sleeves Are Finished With Wide Cuffs. Flowers to Match at Each Side of the Waist and on the Shoulder Form the Trimming.

A Two-Piece Evening Gown of Gold Cloth by Carette Has a Pleated Skirt, and a Jumper Trimmed With Inserts of the Pleated Fabric. A Belt of Gold Leather Fastens in the Front With a Square Buckle.

Models Imported by
B. Altman & Company.

Sketched by a WOMEN'S WEAR Artist.

chiffon, forming a bloused effect in the back and a bolero effect in the front . . . when the jacket is removed the 'cocktail dress' becomes an evening gown trimmed with rhinestone embroideries."[63] Just as *cuisses de nymphes à l'Aurore* and opulent dinner dresses designated the turn-of-the-century urban elite, the abbreviated cocktail dress, simultaneously practical and luxurious, paired with libation in hand, indicated new forms of sophisticated display and consumption for women into the next century.

Notes

1. Auguste Escoffier, *A Guide to Modern Cookery* (London: William Heinemann, 1907), v.

2. Luke Barr, *Ritz and Escoffier: The Hotelier, The Chef, and the Rise of the Leisure Class* (New York: Potter/Ten Speed/Harmony/Rodale, 2018), Kindle edition, 271.

3. Rebecca L. Spang, *The Invention of the Restaurant: Paris and Modern Gastronomic Culture* (Cambridge: Harvard University Press, 200), 2.

4. Paul Freedman, "Restaurants," in *Food in Time and Place*, eds. Paul Freedman, Joyce E. Chaplin, and Ken Albala (Oakland: University of California Press, 2014), 253–275.

5. Barr, *Ritz and Escoffier*, 87, 7, 43.

6. Barr, *Ritz and Escoffier*, 87.

7. Barr, *Ritz and Escoffier*, 238, 214.

8. Barthes, Roland, "Toward a Psychosociology of Contemporary Food Consumption," in *Food and Culture: A Reader*, ed. Carole Counihan and Penny Van Esterik (London: Routledge, 1997), 20–27.

9. Barr, *Ritz and Escoffier*, 108, 173, 272.

10. Valerie Steele, *Paris Fashion: A Cultural History* (New York: Bloomsbury, 2017), 139.

11. Barr, *Ritz and Escoffier*, 84.

12. Elliot B. Weininger, "Foundations of Class Analysis in the Work of Bourdieu," in *Erik Olin Wright*, ed., Alternative Foundations of Class Analysis (2002): 119–179, 123. https://www.ssc.wisc.edu/~wright/Found-all.pdf (accessed May 13, 2021).

13. Barr, *Ritz and Escoffier*, 62.

14. Barr, *Ritz and Escoffier*, 25.

15. Barr, *Ritz and Escoffier*, 102–103.

16. Andrew P. Haley, *Turning the Tables: Restaurants and the Rise of the American Middle Class, 1880–1920* (Chapel Hill: University of North Carolina Press, 2011), 21.

17. Jean-François Revel, *Culture and Cuisine: A Journey Through the History of Food*, translated by Helen R. Lane (New York: Da Capo Press, 1984), 204; Spang, The Invention of the Restaurant, 92.

18. "Gédéon Tallemant des Réaux," *Encyclopædia Britannica*, November 6, 2019, https://www.britannica.com/biography/Gedeon-Tallemant-des-Reaux; Revel, Culture and Cuisine, 204.

19. Spang, *The Invention of the Restaurant*, 25, 24, 2.

20. Spang, *The Invention of the Restaurant*, 75.

21. Spang, *The Invention of the Restaurant*, 65, 77, 91.

22. Spang, *The Invention of the Restaurant*, 2, 150–151.

23. Spang, *The Invention of the Restaurant*, 28.

24. Spang, *The Invention of the Restaurant*, 199, 32–33, 55–57.

25. Spang, *The Invention of the Restaurant*, 41, 54, 80.

26. Spang, *The Invention of the Restaurant*, 199.

27. Spang, *The Invention of the Restaurant*, 200, 199.

28. Lewis A. Erenberg, *Steppin' Out: New York Nightlife and the Transformation of American Culture* (Chicago: University of Chicago Press, 1984), 9–11.

29. Haley, *Turning the Tables*, 25.

30. Haley, *Turning the Tables*, 26–28.

31. "An American Lady in London," *Harper's Bazar*, June 1, 1878, 356.

32. "At Delmonico's," *Harper's Bazar*, December 7, 1895, 1011–12.

33. Haley, Turning the Tables, 151.

34. "At Delmonico's," *Harper's Bazar*, December 7, 1895, 1011–12.

35. Haley, *Turning the Tables*, 144–148.

36. "Features: This Spring, When Grossmith - He of the Expansive Smile…," *Vogue*, May 31, 1894, 222.

37. Barr, *Ritz and Escoffier*, 230, 229, 168.

38. Barr, *Ritz and Escoffier*, 210.

39. Eliza Leslie, *The Ladies' Guide to True Politeness and Perfect Manners or, Miss Leslie's Behaviour Book* (Philadelphia: T.B. Peterson & Brothers, 1864), 105.

40. Emmeline Rayond, "Paris Fashions," *Harper's Bazar*, November 7, 1874, 726–727.

41. "Americans Wedded in London," *New York Times*, January 8, 1891, 4.

42. Leslie, *The Ladies' Guide to True Politeness*, 120.

43. Barr, *Ritz and Escoffier*, 86, 68.

44. Barr, *Ritz and Escoffier*, 86.

45. Barr, *Ritz and Escoffier*, 69.

46. Ermyntrude, "Society: London Sunday Entertaining," *Vogue*, March 26, 1896, 230.

47. Isabel A. Mallon, "Dressing for Dinner," *Ladies' Home Journal*, October 1893, 19.

48. "Formal and Informal Dinner Gowns," *Harper's Bazar*, December 9, 1899, 1068.

49. Mary Elton McClellan, "Paris Dressmaking and Dressmakers: Artists Who Guarantee Their Work," *Good Housekeeping*, January 1895, 17–19, 17.

50. Steele, *Paris Fashion*, 117–118.

51. Steele, *Paris Fashion*, 119–121; Barr, Ritz and Escoffier, 66.

52. Revel, *Culture and Cuisine*, 180.

53. Revel, *Culture and Cuisine*, 180.

54. Joanne Entwistle, "Fashion—Attacks On" in *The Berg Companion to Fashion*, ed. Valerie Steele (Oxford: Bloomsbury Academic, 2010).

55. Barr, *Ritz and Escoffier*, 88.

56. Steele, *Paris Fashion*, 118, 124.

57. Barr, *Ritz and Escoffier*, 84.

58. "New London House Features Short Youthful Types: American Actress Shows Comprehensive Collection of Models— From Tweed Country Suits to Exotic Fur Wraps," *Women's Wear Daily*, November 6, 1923, 2, 31.

59. "New London House Features Short Youthful Types," 2, 31.

60. Elyssa Schram Da Cruz, "Cocktail Dress," in *The Berg Companion to Fashion*, ed. Valerie Steele (Oxford, England: Bloomsbury Academic, 2010).

61. "Dresses-Cocktail Dress Said to Sell Well in Helena Shop," *Women's Wear Daily*, January 24, 1928, SIII37.

62. Schram Da Cruz, "Cocktail Dress."

63. "The Cocktail Hour Is Observed in Retail Imports," *Women's Wear Daily*, September 8, 1926, 3.

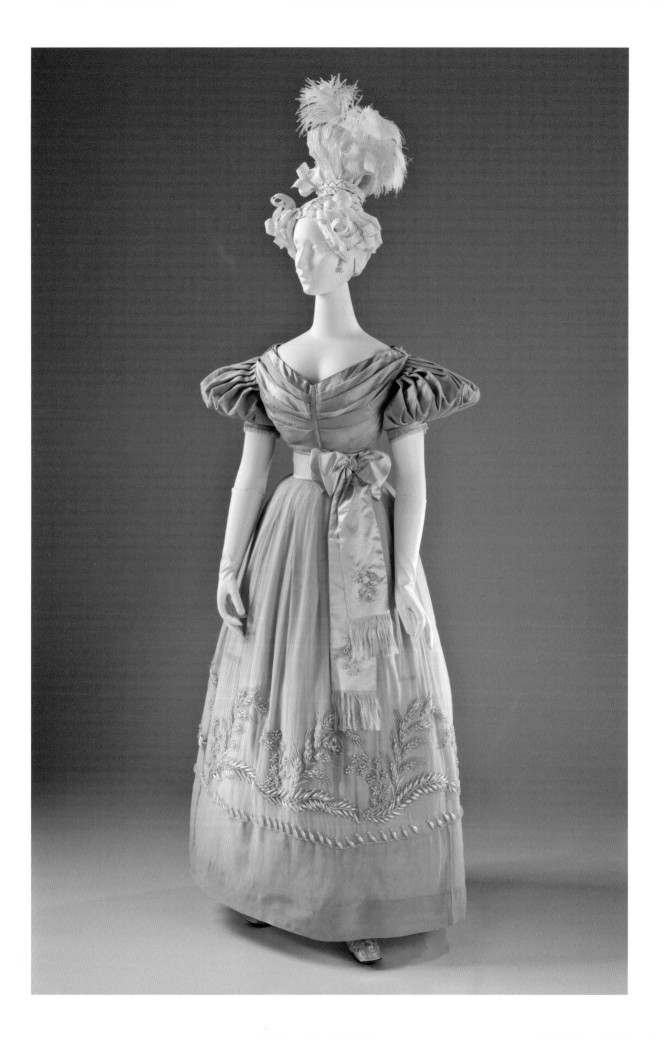

CHAPTER FOUR

Growing Alternatives: Food, Fashion, and the Natural World

Melissa Marra-Alvarez

Throughout much of human history, cooking and the production of garments have been reliant on materials harvested from the land. Clothing fibers were derived from locally grown stock, at times using byproducts of food cultivation. Today, both industries continue to have a notable impact on the environment. "Food and farming have a clear connection," says farmer and plant dye advocate Helen Krayenhoff. "You can see fields of food, but you can also see fields of clothing in the cotton, linen, hemp, and indigo being grown."[1]

In the foreword to the exhibition catalog *Food: Bigger Than the Plate*, Tristram Hunt, director of the Victoria and Albert Museum, writes, "Our current food system—much of which took shape during the Industrial Revolution—needs redesigning for our modern society."[2] The same may be said of the fashion industry, which was also born out of industrialization during the nineteenth century. Throughout history, tensions between urbanized societies and the natural world have often prompted "back-to-the-land" movements. In these conflicts, food and fashion have been central to identity politics, serving as conspicuous signifiers of respective allegiances. Today, designers and scientists are working together to push the boundaries of creative research, rethinking the relationship between industry and nature. The field of synthetic biology, for example, brings together multiple disciplines, from the biological sciences to engineering to design, in an attempt to "biologize" industries and overcome global challenges to benefit people and the planet.[3] As noted by the Center for Genomic Gastronomy, "The twenty-first century is indisputably the biological century, and the farm is where the action is."[4]

Figure 4.1
Woman's Dress, England, (c. 1830). Silk plain weave (organza) and silk satin with imitation-pearl glass. Collection of the Los Angeles County Museum of Art (LACMA).

Food historian Massimo Montanari writes that transitioning from a hunting economy to one of production dramatically changed humankind's relationship with the land.[5] However, he cautions that contemporary perspectives where "man in an industrial or postindustrial culture is tempted to recognize a fundamental 'naturalness' in agricultural activities" can be misleading.[6] He suggests that dominant values of the food system are not defined in terms of "naturalness," but instead represent cultural processes akin to the taming, transformation, and reinterpretation of nature.[7] He writes:

> The fact is, the domestication of plants and the taming of animals in some way gives man the power to make himself the ruler of the natural world, to proclaim himself exempt from the relationship of total dependency in which he had always lived . . .[8]

Across many societies, cultivated grains such as wheat, corn, rice, and sorghum were the fulcrum upon which economic relationships, political power, cultural iconography, and religious rituals were formed.[9] According to Montanari, although they originated in the natural world, once these staples were selected as food products (or clothing material), they became a cultural choice. In other words, while these foodstuffs are products of the land from which they are grown, their prominence in societies, including how they are cultivated and consumed, are emblematic of a society's cultural values. In his preface to *Food Is Culture*, series editor Albert Sonnenfeld writes, "What humans grow involves selectivity, of course, but even the wildest 'natural' or spontaneous growth and 'wild' livestock, those elements of biological or horticultural environment and genetics that constitute 'natural selection' are 'cultural.'"[10] Cooking transforms a raw material into a product with cultural significance, just as textile production does with materials such as silk, cotton, hemp, or wool.

Because of their inherent connection to nature, food and fashion have been intimately tied to "back-to-the-land" movements in western society. Late eighteenth-century Romanticism influenced western society's views about nature and the place of humans within it. The naturalist philosophy of Jean-Jacques Rousseau was often concerned with food and diet as well as aspects of fashion, as noted by Elizabeth Way in chapter two. Likewise, the "back-to-the-landers" of the 1960s and 1970s favored organically grown produce and natural textiles over industrial farming methods and chemically produced synthetic fabrics. Once again, a new wave of reform has these industries restructuring areas of production to focus on seasonal, locally sourced produce and materials, as well as regenerative farming methods. Additionally, farmers, scientists, and designers are reshaping agricultural production and revolutionizing the role of food and food waste in the field of fashion and design for the twenty-first century.

Living the Simple Life

During the Industrial Revolution, the advent of new technologies in the West produced higher agricultural yields, facilitating the increased production of food and textiles, ultimately shifting economies from ones based in agriculture to those rooted in industry. Although it was common for textiles to depict stylized imagery of important agricultural products such as wheat, fruit, and vegetables; a fundamental shift had, nonetheless, occurred, altering western society's relationship with the natural world. With increased urbanization, farming and rural life became abstract concepts to many, far removed from their daily experiences and consciousness.

By the close of the eighteenth century, industrialization began precipitating counter-movements seeking a reconnection with nature. Rousseau, for example, encouraged emancipation from the tethers of conventional luxury, favoring a relationship with nature uncorrupted by the elements of modern life.[11] Rousseau's novel *Julie* (1761) celebrates country life, eschewing elitist French food (haute cuisine) in favor of the rustic foods it was replacing.[12] His back-to-nature ideals also urged a simplicity of dress as an antidote to "the overwrought, overpriced costumes of the French capital."[13] Rousseau's works were embraced by those among the French elite who held romanticized views of country life, which included dressing in shepherdess style gowns, "milkmaid's bonnets," and headdresses of fruits and vegetables.[14] A man's waistcoat, circa 1785, embroidered with sheaves of wheat and an elaborate pastoral scene that showcases a shepherd and shepherdess transporting wheat and herding cattle, artfully flaunts these romanticized views. As a result, these early pastoral impulses are often dismissed as sentimental reactions to industrialization. In the collection of the Museum at FIT, an early nineteenth-century roller-printed cotton textile features an abundance of fruits and vegetables, suggesting the bountiful rewards of a fertile garden. Ironically, roller printing—a mechanical improvement on the copperplate printing technique—was an industrial innovation that allowed manufacturers to print larger quantities of fabrics at greater speeds for lower prices.[15]

The nineteenth century heralded an explosion in the production of luxury goods. For some, the demands of a modern society were perceived as imposing false "needs" and promoting the labor oppression behind the increased provision of luxury goods.[16] In her 1982 book *Back to the Land: The Pastoral Impulse in England from 1880 to 1914*, historian Jan Marsh notes that during England's late Victorian era, the urge to "return to nature" attracted not only those who were opposed to modern urban life but also those for whom Victorian conventions and proprieties seemed restrictive.[17] The solution lay in a return to a simpler life, based on natural relations and a free expression of emotion.[18] Among the supporters of "simple life" ideologies were British art critic John Ruskin (1819–1900) and decorative arts and textile designer William Morris (1834–1896). Believing that green landscapes were essential for spiritual well-being,

Figure 4.2
Man's Vest, with pastoral theme
embroidery including wheat motifs
and a shepherd and shepherdess
herding cattle. France, circa 1785,
altered circa 1795. Silk satin with
silk embroidery and silk grosgrain
ribbon. Collection of the Los
Angeles County Museum of Art
(LACMA).

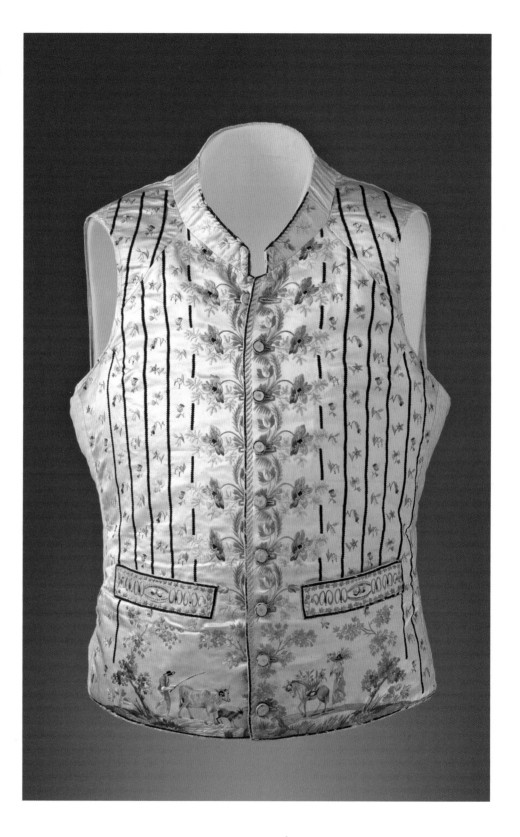

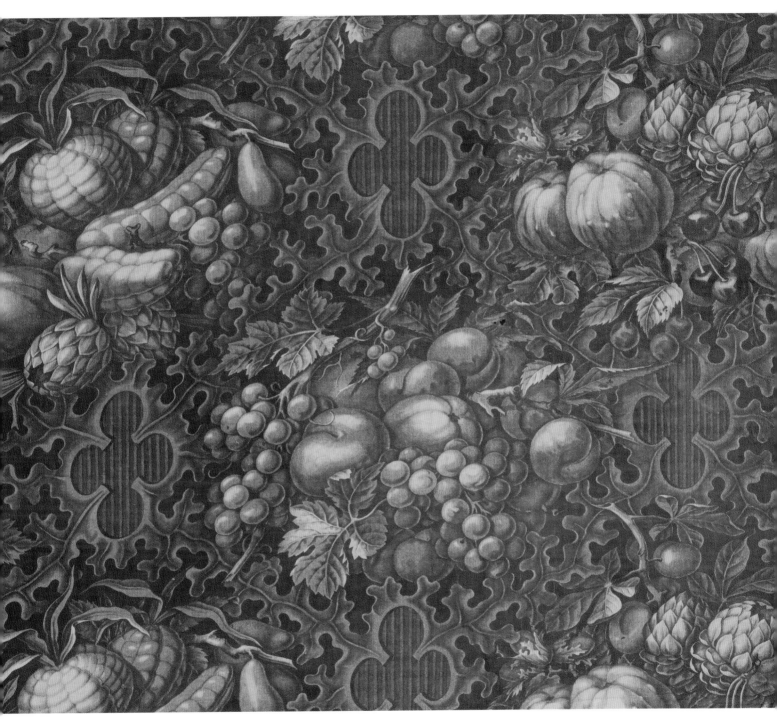

Figure 4.3
Roller-printed cotton textile, 1825–
1835, France. Gift of Cyrus Clark
Co., Inc. © The Museum at FIT

they promoted agricultural cooperatives, encouraging city dwellers to return to the land as cottage farmers to grow their own food and live out this simple life.

William Morris was associated with the British Arts and Crafts movement, which embraced romantic values of folk culture in opposition to the artificiality of modern life and promoted aesthetics representing the beauty of nature. Morris championed a principle of handmade (nonindustrialized) production, manually block-printing textiles and utilizing natural dyes derived from plant and vegetable matter rather than chemical aniline dyes. While he was intimately engaged in the decorative arts, his involvement with the Society for the Protection of Ancient Buildings brought him into the public eye, where he began to lecture and write about the environment and the problems of city life.[19] He argued that wealth is "what Nature gives us and what a reasonable man can make out of the gifts of Nature for his reasonable use. The sunlight, the fresh air, the unspoiled face of the earth, food, raiment and housing necessary and decent."[20] Marsh notes that Morris's influence and association with the decorative arts is well known; however, less is documented about his views on the urban versus rural environments.[21]

Vegetarianism was considered incidental to a natural way of life; it was "virtually obligatory" for those inclined to progressive views.[22] The practice took hold in England in the late 1840s, and spread throughout Europe and to the United States before its resurgence in Britain during the 1880s.[23] Aside from its health benefits, the vegetarian diet was regarded, among progressives, as a means of reconnecting humankind with the source of its nourishment. In 1895, a columnist for the *Vegetarian Review* wrote:

> The ordinary man or woman thinks only of food as an article to be purchased at the nearest cheesemongers or butchers, whilst the vegetarian recognizes the fact—simple enough in all conscience—that man depends for his food upon his mother Earth, and that the greater the gulf between him and the direct production of his food the more dangerous his position becomes.[24]

Many vegetarians also condemned the slaughter of animals for food or fashion on moral grounds. In his book *Animal Rights* (1892), Henry Salt, a simple life pioneer, denounced the killing of animals as "reckless barbarism."[25] These beliefs arose in the context of a natural world increasingly under assault by urban expansion and commercial and industrial developments.[26] The fashion industry, in particular, came under criticism by early conservation groups and dress reformers alike for its wanton harvesting of wild animal parts. The millinery trade, for example, threatened the extinction of numerous bird species whose feathers were coveted adornments for women's hats. With an emerging appreciation of this dilemma came the development of wildlife protection societies both in England and the United States.

Figure 4.4
Liberty & Co. Ltd., smocked dress, England, c.1893–1894. British, pongee silk with smocking and machine-made lace. © Victoria and Albert Museum, London

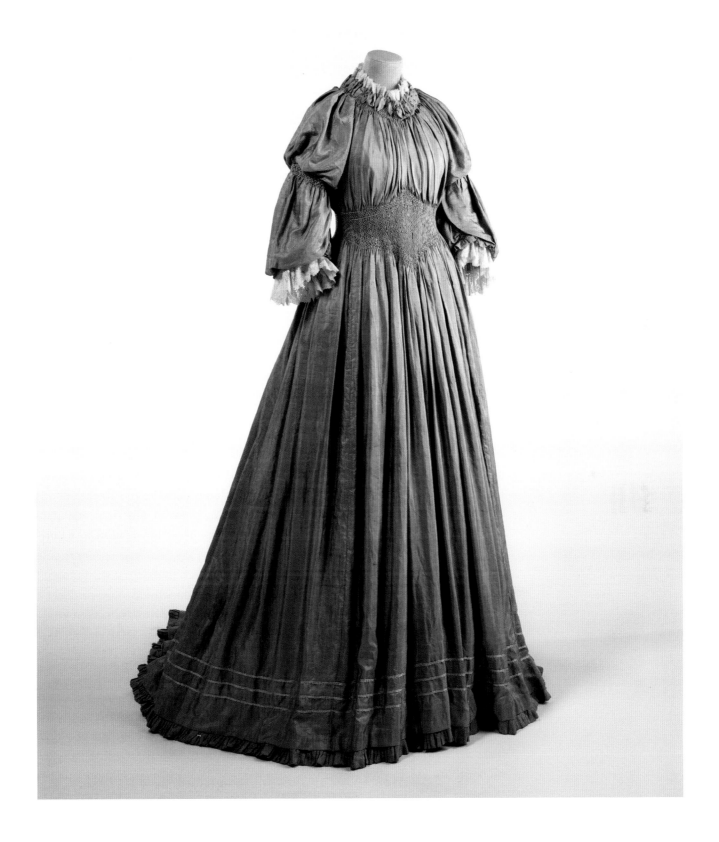

Victorian fashions were incompatible with the simple life, and the progressive thinking associated with dietary reforms also led to changes in the realm of dress. These included "aesthetic" reform styles derived from the dress of the pre-Raphaelite artists, who were colleagues of Morris and Ruskin. For women, loosely fitting garments and tea gowns that accommodated the natural figure and promoted ease of movement were favored. Additionally, organic plant dyes that produced natural hues fell into favor and were considered a healthier option to "garish" synthetic aniline dyes, which were derived from coal tar. From 1875 onwards, the retailer Liberty of London offered textiles, tea gowns, and other aesthetic dress styles, and included Morris and Ruskin among its patrons. By the 1880s, the Rational Dress Society was explicitly advocating for dress reform based on health and hygiene. In addition to opposing tight-laced corsetry, society members urged the use of wool garments, which they believed to be the healthiest option because wool allowed skin to breathe and release toxins.

In many ways, the belief system of the simple life practitioners set the tone for and echoed attitudes toward capitalism, food production, and dress that were held by the counterculture movement of the 1960s and 1970s in the United States. As Marsh notes, both movements were anti-industrial impulses that prioritized a return to the land, a revival of handicrafts, and a simplification of daily life.[27]

Hippie Counterculture and Back-to-the-Landers

Jonathan Kauffman, author of *Hippie Food, How Back-to-the-Landers, Longhairs, and Revolutionaries Changed the Way We Eat* (2018), asserts that although the nineteenth and early twentieth centuries saw the invention of canning and other methods of processing foods, World War II marked a turning point in American manufacturers' ability to produce processed foods into forms never before seen in nature. Kauffman writes:

> Out of the war came the technological processes to produce dried soup powders and pudding mixes, salad oils, canned fruit juices, and ready-to-eat meals. Out of the war, too, came sixty-five approved pesticides, including DDT, invented by scientists researching nerve gases. . . . Those advances merely set the stage for a postwar boom in agriculture, food manufacturing, and retail.[28]

Additionally, between the 1950s and late 1960s, the "Green Revolution," precipitated by the work of American scientists, cultivated resilient, high-yield strains of staples like corn and rice. The resulting demand for these cultivars encouraged large-scale monoculture and, by 1959, American farms were producing 60 percent more product than they had been at the start of the war.[29]

During the late 1960s and early 1970s, food production realized both the fears and idealism of young Americans.[30] In opposition to rampant industrialization, the natural food movement sought to restore cuisine to its preindustrial forms, in part via agricultural reform against the unregulated use of chemical fertilizers and pesticides such as dichlorodiphenyltrichloroethane (DDT). In 1962, a groundbreaking book by ecologist Rachel Carson, titled *Silent Spring*, galvanized a burgeoning environmental movement by shedding light on the harmful effects of DDT on ecosystems and human populations. Disillusioned youth established a counterculture intent on rediscovering "the true basis of culture in nature through the creation of their own food systems."[31] Kauffman writes, "The counterculture embroidered the ubiquitous, populist subject of food with all other ideas of how life should be: how people should be treating the earth, what their bodies need, how they should engage in work."[32] A new way of thinking about food emerged, one which championed environmental sustainability and health. Stressing the interconnectedness of humans and the land, it placed individuals in closer contact with the source of their food, affording an option outside the food industry.

During this period food choices again became politicized with the realization that what one buys and consumes carry large-scale implications relating to global hunger, the environment, and capitalism.[33] Numerous "food revolutions" emerged, based on anti-commercial views, and calling for social reform aimed at equal access to food. In their search for natural foods, some young Americans moved to rural areas because eating organically was difficult to do in cities.[34] Many turned to communes, where subsistence farming formed the basis of communities prioritizing ideals of clean living and food equity. *Diet for a Small Planet* (1971), a cookbook by Frances Moore Lappé promoting a vegetarian diet, became the first major publication to examine the environmental impacts of meat production and how it promotes global food scarcity. Others found inspiration in the philosophy and diet of Zen macrobiotics, a holistic approach to living originated by Japanese philosopher George Ohsawa. With its focus on natural organic materials—locally sourced and seasonally produced— Zen macrobiotics helped to promote foods such as brown rice and tofu among the counterculture.

The promotion of organic agriculture and the successful marketing of "natural" foods are the greatest successes of this new wave of back-to-the-landers. During the late 1960s, hundreds of thousands of Americans heeded the back-to-the-land rallying cry.[35] Farmers markets established across the US facilitated more direct connections between farmer and consumer, which, in turn, brought greater recognition to organic farming practices.[36] The movement also embraced seminal writings in the science of organic farming and soil management, including the work of mycologist Sir Albert Howard, and Edward Hyam's 1952 book, *Soil and Civilization*. Aspects of

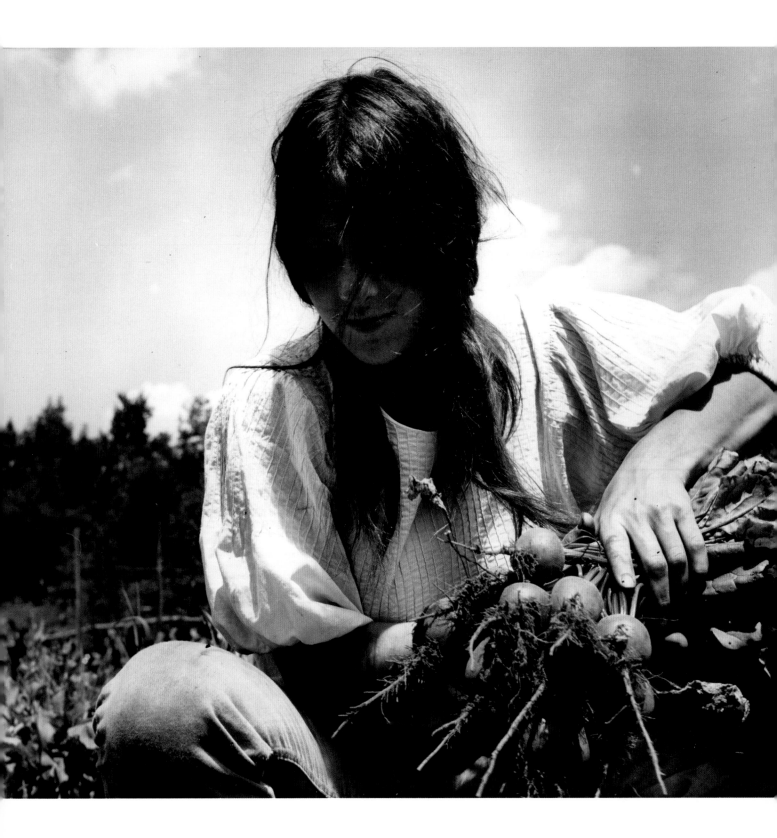

this research, which derived from ancient farming methods, lent a romanticized mysticism to these pursuits that appealed to the counterculture. Their emphasis on clean eating also stimulated interest in home gardening that appealed to the wider public. "I refuse to make my Caesar salad with that stuff they sell at the store," James Drotleff, vice president of an Ohio rolling oil firm, told *The New York Times* in 1971.[37]

The enthusiasm for organic produce even took hold in popular culture. In 1973, the San Francisco denim company, Levi's, released a fashion line aptly named "Fresh Produce." Although there was no direct connection to the organic farming prevalent at the time, the branding was influenced by industry labels of California produce. Apparel was packaged in wooden produce crates,[38] and a tiny orange carrot on the pocket tab indicated an item was part of the Fresh Produce line. In the Spring of 1973, Levi's newsletter, *Saddleman's Review,* reported, "The vegetables illustrate the idea behind Fresh Produce, that fickle fashion, like perishable produce, ought to be moved into the marketplace while it is ripe and popular, and moved out before it loses its appeal."[39] The analogy to ripe, "fresh" produce was carried further still: "No item will be carried in the Fresh Produce collection for more than 180 days," another Levi's newsletter announced. "By that point it will either be moved into mass production or dropped."[40]

One limitation of the back-to-the-land movement was its largely white demographic. Kauffman writes, "A generation of activists, inspired by the civil rights movement to change the world, was rarely able to change it—or at least their food—in ways that invited Latinos, African Americans, Native Americans, and a tiny but swelling group of Asian Americans to join them."[41] However, certain agricultural methods, such as rotating crops to optimize nutrients in the soil, had already been in practice in the South, promoted by George Washington Carver, who encouraged Black sharecroppers to grow multiple crops with differing seasonalities within the same fields. Among them were peanuts, which were more nutritious than the "meat, meal, and molasses (3M)" diet consumed by many sharecroppers and which restored nutrients to depleted soil.[42]

Community Supported Agriculture (CSA) was another agricultural model practiced among Black communities in the United States years before it became a widespread movement. It was introduced by Booker T. Whatley, a Black horticulturist and agricultural professor during the 1960s and 70s. In an effort to empower Black farm owners who were often denied loans and Federal grants, Whatley advocated for what he called "clientele membership clubs," which required customers to pay up front for a season of food as a way of guaranteeing business and supporting the community.[43] In turn, this allowed farmers a more secure means of business because they could "plan production, anticipate demand, and, of course, have a guaranteed market."[44]

Figure 4.5
Hippie woman picking beets on a farm in Vermont, c. 1970. Photo by Rebecca Lepkoff, courtesy of Vermont Historical Society

115

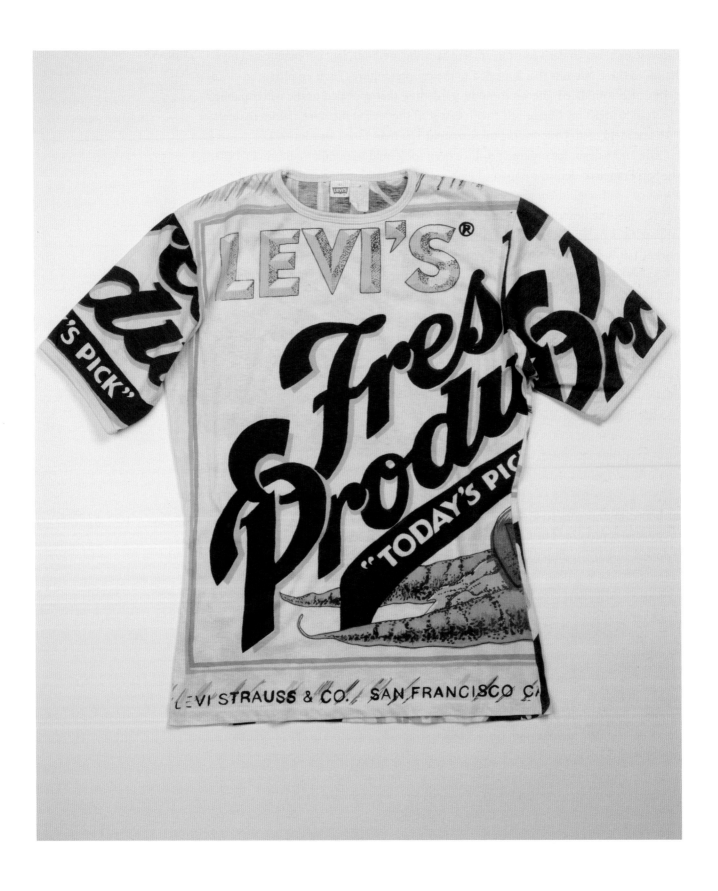

Commenting on fashion as a political phenomenon, sociologist Tim Edwards writes that the social movements of the 1960s and 1970s sought to politicize appearance as part of an overall politics of identity, which included self-definition and self-presentation in everyday life.[45] If the movement was characterized by "opting out" of mainstream commercial pursuits, handcrafted "ethnic" fabrics and clothing were worn to communicate the same ethics and belief systems as one's food choices. The politics of food and fashion being closely aligned, eating brown rice or whole wheat bread became as much of a political statement as wearing hand-woven Indian textiles, for example. Natural plant fibers, such as linen and hemp, were favored over industrial synthetics like polyester, which was a symbol of industrial modernity at that time. By the late 1960s and early 1970s, a handcrafted quality had become particularly valued in sartorial expression. Just as the counterculture embraced the foods and flavors of previously eschewed cuisines from Asia and Latin America, fashions were adopted that borrowed from traditional Indian, Mexican, and Native American dress and related traditional crafts. Ultimately, the stage was set for the "eco-fashion" of the 1990s, a movement inspired by the principles of deep ecology that embraced recycled materials, organic fabrics, and natural dyes.

Figure 4.6
A t-shirt from Levi's "Fresh Produce" line, 1970s. Courtesy Levi Strauss & Co. Archives

From Farm to Fashion

Contemporary globalization and mass consumerism have greatly impacted the ways food and clothing are produced and sold, making the effects of our choices far-reaching and complex. Food scholar Fabio Parasecoli notes that environmental changes and political and cultural shifts—which include the "mediatization of food"—have made our choices of foodstuffs increasingly relevant to the public discourse.[46] Clothing production, which also functions on a global scale, has enormous implications for modern society, as well.[47] Our reliance on farmers to grow crops, raise livestock, or produce fibers (for clothing and textiles) has placed agricultural industries at the center of the examination of sustainable practices.

As the sourcing of local and organic foods becomes more prevalent, farmers and designers alike are acknowledging the growing connections between "slow food" and "slow fashion." Encompassing more than 150 countries worldwide, the slow food movement promotes "clean, fair, and good" foods by preserving endemic food cultures and traditions,[48] counteracting the rise of fast food, and educating the public about how food choices affect the world around us. The movement has inspired renewed interest in local farming practices, prioritizing locally available (seasonal) produce and farm-to-table cuisine. In highlighting a slow fashion model that runs parallel to slow food, fashion scholar Hazel Clark credited the slow food initiative with "represent[ing] the effective possibilities of different ways of thinking and doing outside of the mass-market, and beyond food."[49]

Motivated by the principles of slow food, slow fashion also prioritizes local resources, direct links between producer and consumer, and sustainability. Clark writes, "[Slow fashion] presents a prospect of fashion minus many of the worst aspects of the current global system, especially its extreme wastefulness and lack of concern for environmental issues."[50] Both movements are focused on slowing down production in order to promote the work of local craftsmen, greater ecological awareness, and, ultimately, product quality over quantity. Another important aspect of slow fashion that parallels slow food is the support for heritage diversity through education.[51]

In recent years, the slow food movement has precipitated an increase in small local farming initiatives, including urban farming and community gardens. According to Slow Food Europe's website:

> Slow Food promotes a model for agriculture based on a rediscovery of the value of local agriculture, the short distribution chain, and locally closed cycles of production and consumption. It is a model that prioritizes soil fertility, the presence of people in the countryside and biodiversity protection.[52]

As consumers come to accept the value systems and processes inherent to farm-to-table food, efforts are underway to help them understand the relationship between farm and fashion. Just as people can visit farms to better understand where their food comes from, they can do the same to discover the origins of their clothing. Doing so allows them to grasp the interconnectedness between what we eat and what we wear, as well as associated economic and environmental concerns. "Ideally, our clothing would be created with the same consideration as the produce that we eat: made with food-grade fibers, which can be been dyed and softened with vegetable oils (enzymes) created by the food industry," writes Ashley Denisov, founder of the sustainable clothing brand 1x1.[53]

Elements of slow food and slow fashion converge in a gown by the label Isoude. Made from organic silk and using natural dyes, it evokes a wine-stained tablecloth and the communal spirit of food shared at a dinner party. A similar farm-to-fashion ethos permeated designer Mimi Prober's spring 2021 collection. Prober's "Edwardian-meets-bohemian"[54] looks were colored with natural dyes derived from avocado and pomegranate, and the celebrated chef Nina Clemente was featured as a model. Prober works directly with local, family-owned, sustainable farms and mills to source natural pigments, including Japanese indigo grown in upstate New York. Her collection highlighted connections between "garden and plate," and "reflect[ed] on our roots, from the atelier to the farm and natural dye house, working locally and intimately."[55]

Figure 4.7
Looks from Mimi Prober's spring 2021 collection naturally dyed with avocado and pomegranate to produce dusty rose and soft yellow hues. Photo: Patrik Andersson

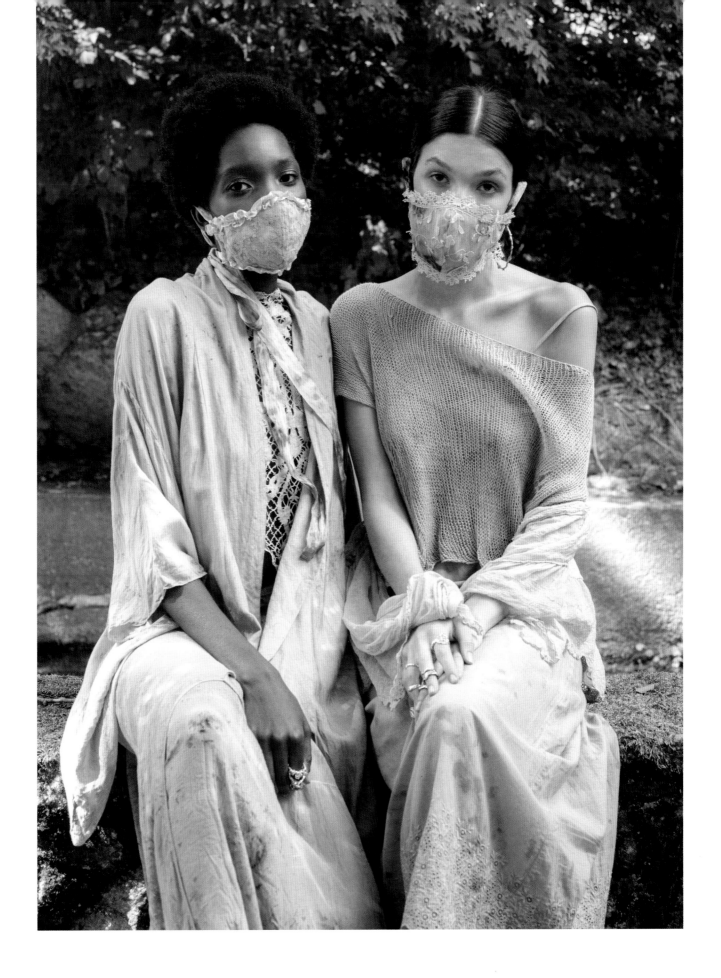

Organic farming continues to evolve, with regenerative agricultural methods being the topic du jour in food and fashion. Industrial agriculture produces many of the most environmentally damaging effects, including chemical pollution, nutrient depletion of soils, and consequent decreases in biodiversity. Regenerative agriculture offers a paradigm shift prioritizing heterogeneous crop plantings that preserve ecosystem functions and stability to forestall climate change. Following the Industrial Revolution, the rate of carbon emission into the atmosphere has increased exponentially.[56] Regenerative farming practices facilitate the transference of carbon from the atmosphere to the earth, where it fortifies soils and becomes food for microorganisms and mycelia that help nourish plant life. [57]

In 2019, the Ellen MacArthur Foundation launched a food initiative campaign that was aimed at mitigating the lack of public awareness about the connections between food, climate, and biodiversity.[58] *Regenerative fashion,* a term now circulating in fashion circles, relates to trends that encourage a restructuring of farm-to-fashion production methods to go beyond mere sustainability. "We don't need to be sustainable, we need to be regenerative," Aras Baskauskas, CEO of Los Angeles fashion label Christy Dawn, told *Vogue.*[59] In December 2019, Kering, the French luxury conglomerate behind brands like Alexander McQueen and Bottega Veneta, partnered with the Savory Institute, a nongovernmental organization that is dedicated to the support of holistic land management and regenerative practices.[60] "I do believe fashion is where we can mainstream regenerative agriculture," explains Rebecca Burgess, founder of Fibershed, a nonprofit organization that develops regenerative textile systems. "I think in some ways, it's more poised than the food industry to lead [the conversation], because fashion is more permanent. You don't know what I ate for breakfast, but you know what I'm wearing."[61]

Although regenerative agriculture is new to the public discourse, its techniques have been practiced since antiquity in traditional societies of the world. "Many of the farmers in India said this was like going back to their traditional practices, which is very exciting," said Helena Barbour, head of sportswear at Patagonia. In 2020, the company released its first collection of t-shirts crafted from regenerative cotton farmed in India. "They said their great-grandfathers used to farm like this, but then they just got approached by all the chemical companies [selling] synthetic fertilizers," continued Barbour.[62] As alternatives to mainstream systems, regenerative methods have begun to elucidate the interconnections between food, fashion, and the natural world, showing consumers that they are not just buying an item of food or clothing, but "a whole system and chain of meanings."[63]

Figure 4.8
Isoude, hand-painted organic silk and cotton dress, spring/summer 2009, USA. Gift of Katie Brierley.
© The Museum at FIT

What if your food could improve the field it came from?

Figure 4.9
What if your food improve the field it came from? From the Ellen MacArthur Foundation food initiative campaign, 2019. © Ellen MacArthur Foundation, 2020

Food, Food Waste, and Fashion

According to a 2013 report by the Food and Agriculture Organization of the United Nations, approximately one-third of all food produced for human consumption is wasted each year.[64] Statistics such as these have led the biotech materials industry to explore ways to transform food waste into novel materials that can be used in textile and product designs. These include leather alternatives derived from coffee grinds, grape skins, mushrooms, and even the shells of crustaceans. Discarded crop material, such as banana byproducts, corn husk, flax and hemp stalks, as well as the waste from processed sugar cane, can be spun into natural fibers for woven garments.[65] The Agraloop process, which was developed by the startup company Circular Systems, utilizes byproducts of wheat, rice, corn, milk protein, sugarcane, and banana to engineer natural "bio-fibers" that can be incorporated into yarns and textiles for the fashion industry.[66] This "bio process" represents a closed-loop system implemented at the farm level by using modular mini-mills, which produce plant-based energy from the same food waste.[67] Innovative methods such as these, which are integral to the establishment of a circular economy, are contributing to a paradigm shift in which nothing goes to waste, and everything is renewable.[68]

With advances in biofabrication technologies, the potential for radical change in the fashion industry is made possible. "One of the big challenges is transforming prototype biological processes into industrial-scale production, which will enable products to be widely available and affordable," explained Natsai Audrey Chieza, founder and director of Faber Futures. "Fashion will need to become more comfortable with longer R&D [sic] cycles and perhaps somewhat slower consumption."[69] But is this possible? In recent years, a growing number of start-up companies have partnered with major fashion brands to bring greater attention to agricultural byproduct materials. The Italian start-up Orange Fiber has produced a silk-like cellulose yarn from scraps of citrus peel. In 2017, Orange Fiber partnered with Salvatore Ferragamo on floral printed scarves and dresses. For Carmen Hijosa, founder of Piñatex, establishing a circular economy was the impetus for the development of her natural leather alternative made from cellulose fibers extracted from pineapple leaves. Piñatex has recently worked with Hugo Boss and Veja to produce limited-edition sneakers. Even potato offcuts have found a new fashionable life. The London-based eyewear brand Cubitts produced Redux, a line of eyeglasses with frames made from waste materials including corn husks, wood, coffee grounds, and potato starch. The latter is sourced from Chips Board, a company that produces material using waste supplied by frozen food manufacturer McCain.[70]

In 2020, the California-based biotech company Bolt Threads™ announced its new bio-material Mylo™. Mylo is an animal-free leather alternative made from renewable mycelium (the branching underground structure of mushrooms) which is grown by scientists and expert mushroom farmers in a European warehouse once used to produce specialty mushrooms for the gourmet food market. Sheets are then processed, dyed, and embossed into a finished leather-like material.[71] In October, *The New York Times* reported that rival brands adidas, lululemon, Kering, and Stella McCartney all signed on to partner with Bolt Threads to create products from Mylo and are collectively investing in its ongoing development and production operations.[72] "We had to convince these industry competitors that this was about tackling a bigger challenge together than any of them could solve alone," said Dan Widmaier, the CEO and founder of Bolt Threads.[73]

Figure 4.10 (opposite)
A scarf from the Ferragamo Orange Fiber collection, spring/summer 2017. Photo courtesy of Ferragamo and Orange Fiber

Figure 4.11
Bolt Threads™ mycelium mats, grown by scientists and expert mushroom farmers in a European warehouse formerly used to produce specialty mushrooms for the gourmet food market. Image courtesy of Bolt Threads

Figure 4.12
Marina Hoermanseder, strap skirt made from Piñatex, a vegan leather made from cellulose fibers extracted from pineapple leaves, fall 2020. Photo © Stefan Kraul. Image courtesy of Marina Hoermanseder

Partnerships such as these are motivating additional designers to experiment with food waste materials, even if they do not label themselves a sustainable fashion brand. For fall 2020, Austrian designer Marina Hoermanseder reimagined her signature leather "strap skirt" in Piñatex pineapple leather. Show attendees that season were gifted goodie bags made from 100 percent agricultural waste. "I am not a fully sustainable person—we are NOT an eco label—but it's not about a couple of people doing it perfectly, but ALL of us doing it imperfectly!" Hoermanseder posted to her Instagram account.[74] Although food waste textiles do not fix the problems generated by the food and fashion industries, adopting these technologies and materials allows designers to "introduce change in customers practices in order to guide them toward more sustainable practices."[75]

Conclusion

In his book *Food* (2019), Parasecoli writes that "food waste is just one aspect that needs to be dealt with to address sustainability, we experience it tangibly on the one hand, especially in terms of the money we lose and the guilt we may (or may not) experience."[76] While fashion and food industries have had an uncomfortable relationship with the environment, fashion items made from agricultural waste materials alleviates producers and consumers of some of the guilt associated with the consumption process that drives these industries. Because fashion is worn on the body, it can function as a conspicuous symbol of social and environmental responsibility and serve as an entry point for larger societal conversations. However, as Parasecoli points out, to effectively contend with issues of food production and consumption, it is important to elucidate the complex relationships between society, production, and the environment.[77] This will require interdisciplinary collaborations to bridge different forms of knowledge and allow creativity to flourish. This is a call for new dialogues in light of Montanari's claim that "[culture] takes place where tradition and innovation intersect."[78]

Notes

1. Ashley Denisov, "How Food, Farming And Fashion Are More Connected Than You Think," *The Good Trade*, n.d., https://www.thegoodtrade.com/features/conscious-food-farming-fashion.

2. Tristram Hunt, "Foreword," in *Food: Bigger Than the Plate*, ed. Catherine Flood (London: V&A Publishing, 2019), 7.

3. Claudia Vickers, Meagan Palmer, et. al., "Realizing the potential of synthetic biology to help people and the planet," *World Economic Forum*, April 05, 2021. https://www.weforum.org/agenda/2021/04/synthetic-biology-potential-people-and-the-planet-gtgs21/

4. Catherine Flood and May Rosenthal Sloan, "Farming," in *Flood, Food: Bigger Than the Plate*, 49.

5. Massimo Montanari, *Food Is Culture* (New York: Columbia University Press, 2004), 3.

6. Montanari, *Food Is Culture*, 3.

7. Montanari, *Food Is Culture*, xi.

8. Montanari, *Food Is Culture*, 6.

9. Montanari, *Food Is Culture*, 7.

10. Albert Sonnenfeld, "Series Editor Preface," in Montanari, *Food Is Culture*, ix.

11. Caroline Weber, *Queen of Fashion* (New York: Henry Holt, 2006), 132.

12. S.K. Wertz, "Taste and Food in Rousseau's Julie, or the New Heloise," *The Journal of Aesthetic Education* 47, no. 3 (2013): 24–35.

13. Weber, *Queen of Fashion*, 132.

14. Weber, *Queen of Fashion*, 145–146.

15. Melinda Watt, "Textile Production in Europe: Printed, 1600–1800," in *Heilbrunn Timeline of Art History*, October 2003, https://www.metmuseum.org/toah/hd/txt_p/hd_txt_p.htm.

16. Julia Twig, "The Vegetarian Movement in England, 1847–1981: A Study in the Structure of Ideology," doctoral thesis, London School of Economics, University of London, Autumn 1981, https://ivu.org/history/thesis/simple.html#3.

17. Jan Marsh, *Back to Land: The Pastoral Impulse in England, from 1880–1914* (London: Quartet Books, 1982), 5.

18. Marsh, *Back to Land*, 5.

19. Marsh, *Back to Land*, 15.

20. William Morris, "Useful Work v. Useless Toil," in *Collected Works of William Morris XXIII*, quoted in Marsh, *Back to Land*, 16.

21. Marsh, *Back to Land*, 12.

22. Marsh, *Back to Land*, 15.

23. Marsh, *Back to Land*, 196.

24. *Vegetarian Review*, March 1895, p. 72, quoted in Marsh, *Back to Land*, 201.

25. Marsh, *Back to Land*, 196–197.

26. Twig, "The Vegetarian Movement in England."

27. Marsh, *Back to Land*, 7.

28. Jonathan Kauffman, *Hippie Food: How Back-To-The-Landers, Longhairs, and Revolutionaries Changed the Way We Eat* (New York: William Morrow, 2018), 5.

29. Kauffman, *Hippie Food*, 5.

30. Kauffman, *Hippie Food*, 5.

31. Sandra Johnson, "Edible Activism: Food and the Counterculture of the 1960s and 1970s," honors thesis, Colby College, May 2012, http://digitalcommons.colby.edu/honorstheses.

32. Kauffman, *Hippie Food*, 13.

33. Interview with Kauffman by Brie Mazurek in "Why Hippie Food Still Matters," *CUESA*, January 26, 2018, https://cuesa.org/article/why-hippie-food-still-matters.

34. Raymond A. Sokolov, "The Food at the Heart of Commune Life," *The New York Times*, December 2, 1971, 60.

35. Kauffman, *Hippie Food*, 183.

36. Interview with Jonathan Kauffman, https://cuesa.org/article/why-hippie-food-still-matters.

37. Todd Hunt, "Homegrown Vegetables Will Set a Pace for the Seventies," *The New York Times*, January 9, 1972, https://www.nytimes.com/1972/01/09/archives/homegrown-vegetables-will -set-a-pace-for-the-seventies.html.

38. "Vogue Boutique: Pretty Ways to Move/April Travel," *Vogue*, April 1, 1973, 131.

39. "Introducing: Fresh Produce," *Saddleman's Review*, Spring 1973.

40. "A New Line," *Levi's Letter*, November 15, 1972.

41. Kauffman, *Hippie Food*, 15–16.

42. Rachel Kaufman, "In Search of George Washington Carver's True Legacy," *Smithsonian Magazine*, February 21, 2020, https://www.smithsonianmag.com/history/search-george -washington-carvers-true-legacy-180971538/.

43. Shelby Vittek, "You Can Thank Black Horticulturist Booker T. Whatley for Your CSA," *Smithsonian Magazine*, May 20, 2021. https://www.smithsonianmag.com/innovation/you-can -thank-black-horticulturist-booker-t-whatley-your-csa-180977771/

44. Booker T. Wheatley quoted in Vittek, "You Can Thank Black Horticulturist."

45. Tim Edwards, "Express Yourself: The Politics of Dressing Up," in *Fashion Theory: A Reader*, ed. Malcolm Barnard (London: Routledge, 2007), 191.

46. Fabio Parasecoli, *Food* (Cambridge: The MIT Press, 2019): 165.

47. Hazel Clark, "Slow + Fashion—an Oxymoron—or a Promise for the Future…?" *Fashion Theory* (2008) 12:4, 427–446.

48. Slow Food USA's Guiding Principles, https://slowfoodusa.org/wp-content/uploads/Slow-Food -USA-Guiding-Principles.pdf [no longer available online].

49. Clark, "Slow + Fashion – Women's Wisdom," *Fashion Practice* (2019) 11:3, 309–327.

50. Clark, "Slow + Fashion – An Oxymoron," 428.

51. Melody LeHew and Jana Hawley, "Slow Fashion: Utilizing the Slow Food Movement as a Model," conference proceedings, International Textile and Apparel Association, Inc., Montreal, Quebec Canada, 2010, https://www.researchgate.net/publication/304014164_Slow_Fashion_Utilizing _the_Slow_Food_Movement_as_a_Model.

52. The Agriculture We Want to See, https://www.slowfood.com/sloweurope/en/topics/agriculture/.

53. Denisov, "How Food, Farming and Fashion Are More Connected Than You Think."

54. Laird Borrelli-Persson, "Mimi Prober: Spring 2021 Ready-to-Wear," *Vogue*, September 16, 2020, https://www.vogue.com/fashion-shows/spring-2021-ready-to-wear/mimi-prober.

55. Mimi Prober, press release, spring 2021 collection.

56. Emily Farra, "Regenerative Agriculture Can Change the Fashion Industry—And the World. But What Is It?" Vogue, May 12, 2020, https://www.vogue.com/article/regenerative-agriculture -sustainable-fashion-christy-dawn-fibershed.

57. Farra, "Regenerative Agriculture."

58. The Food Initiative Launches a Food-climate-biodiversity Messaging Campaign, October 16, 2019, https://www.ellenmacarthurfoundation.org/news/the-food-initiative-launches-a-food -climate-biodiversity-messaging-campaign [no longer available online].

59. Farra, "Regenerative Agriculture."

60. Farra, "Regenerative Agriculture."

61. Farra, "Regenerative Agriculture."

62. Farra, "Regenerative Agriculture."

63. Nevana Stajcic, "Understanding Culture: Food as a Means of Communication," *Hemispheres* no. 28, 2013: 7–8.

64. "Food Wastage Footprint: Impacts on Natural Resources, Summary Report," Food and Agriculture Organization of the United Nations, 2013, https://www.fao.org/sustainable-food -value-chains/library/details/en/c/266219/.

65. "Food Waste Is Going to Take Over the Fashion Industry," *Fast Company*, June 15, 2018, https:// www.fastcompany.com/40584274/food-waste-is-going-to-take-over-the-fashion-industry.

66. Agraloop BioFibre, https://circularsystems.com/agraloop.

67. "Wear Your Food! How Food Waste Becomes Fashion," *Eluxe Magazine*, June 16, 2018, https:// eluxemagazine.com/fashion/food-waste-becomes-fashion/.

68. Fabio Parasecoli and M. Halawa, "Rethinking the Global Table," in *Food: Bigger Than the Plate*, 84–85.

69. Clara Rodríguez Fernández, "How Biotechnology Is Changing the Way We Make Clothes," *Labiotech*, https://www.labiotech.eu/industrial/biofabrication-fashion-industry/.

70. Amy Frearson, "Cubitts Makes Redux Glasses from Potatoes," *Dezeen*, August 29, 2019, https:// www.dezeen.com/2019/08/29/cubitts-redux-glasses-waste-materials-recycled-plastic-bioplastic/.

71. Elizabeth Paton, "Fungus May Be Fall's Hottest Fashion Trend," *The New York Times*, October 2, 2020, https://www.nytimes.com/2020/10/02/fashion/mylo-mushroom-leather-adidas-stella -mccartney.html.

72. Paton, "Fungus May Be Fall's Hottest Fashion Trend."

73. Paton, "Fungus May Be Fall's Hottest Fashion Trend."

74. Marina Hoermanseder, Instagram account (@marinahoermanseder), January 17, 2020.

75. Parasesoli and Hawala, "Rethinking the Global Table," 83.

76. Parasecoli, *Food*, 86.

77. Parasecoli, *Food*, 91.

78. Montanari, *Food Is Culture*, 7.

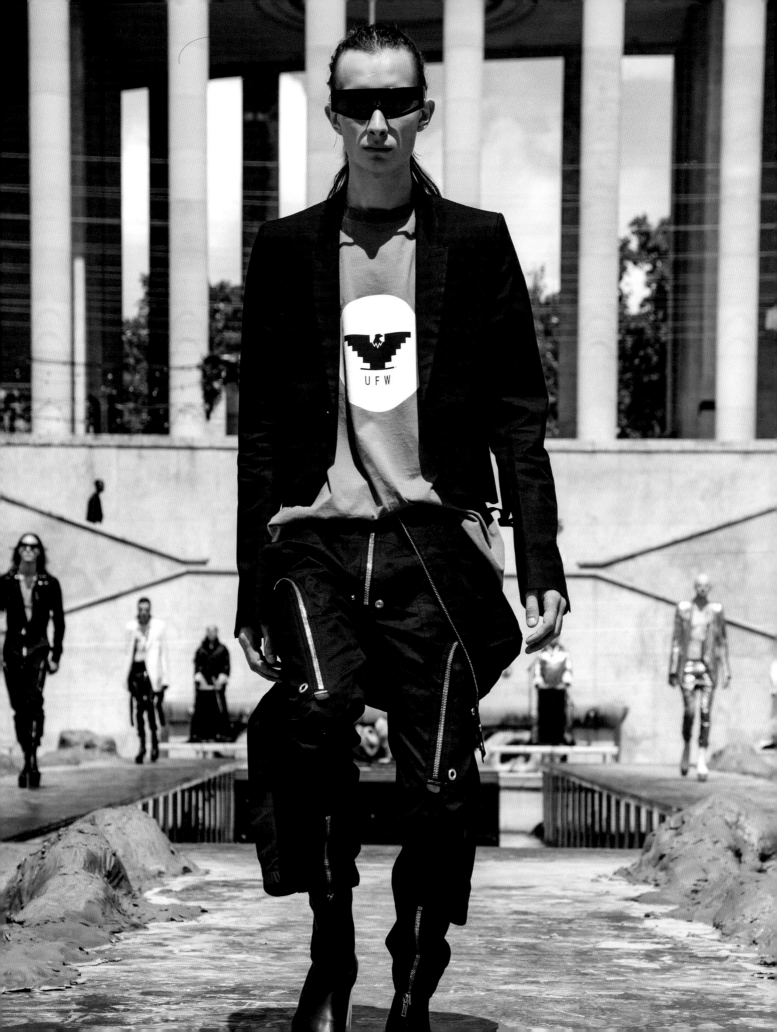

We Feed You: Protest Fashion and the United Farm Workers Union

Michelle McVicker

American fashion designer Rick Owens tapped into his Mexican roots for his spring 2020 menswear collection, titled *Tecuatl,* after his maternal grandmother's maiden name. His mother Concepción (nicknamed Connie) is of Mixtec heritage, which means she is Native Mexican. Born in Puebla, she worked as a seamstress and learned to cut patterns.[1] Owens's American father, John Owens, was a social worker who met Connie in 1958 while teaching English in Mexico.[2] Owens prefaced the show by stating, "My Mexican-ness is very abstract,"[3] and further explained his bilingual upbringing:

> My mother and I learned English together when she started taking me to nursery school, and my father worked in the Porterville Public Court System as a translator for the Mexican migrant farmworkers that were a major part of the San Joaquin [Valley] agricultural industry.[4]

Porterville, California is associated with the production of citrus fruits.[5] There, Owens's father often served as a court interpreter for Mexican migrant agricultural workers.[6]

Although Owens has previously stated that his designs are very autobiographical, his Mexican heritage was relatively unknown publicly and, until this collection, had yet to be expressed through his designs. *Tecuatl* was prompted by the increasing tension regarding immigration reform in the United States.[7] The sartorial manner in which Owens expressed his abstract manifestations of "Mexicanidad" demonstrates how a sense of belonging to a nation offers "a way to study articulations that are both political and aesthetic and that bring intersectionalities to light."[8] In his representation of cultural identity, he consciously avoided the folkloric side of Mexican

Figure 5.1
The Rick Owens spring/summer 2020 collection *Tecuatl* prominently featured the United Farmer Workers (UFW) Union Eagle Mark logo. Courtesy of OWENSCORP

133

culture, but he incorporated discernible Mexican inspiration.[9] For multiple pieces, he collaborated with the United Farm Workers of America (UFW) by prominently featuring their trademarked Eagle Mark, a clear signifier of the labor union, on black and gray t-shirts, jackets, silver necklaces, and keychains. Owens's website explicitly stated that proceeds from the collaboration would go to "benefiting their [UFW's] continuing efforts."[10]

United Farm Workers Union: Fashion as Protest

As Smithsonian curator and food historian L. Stephen Velazquez states, "Food's importance is not just what's on our plates, but the labor and distribution systems behind it."[11] The United Farm Workers of America was founded in 1962 by César Chávez, Dolores Huerta, Gilbert Padilla, and other early organizers. It was the first effective labor union of farmworkers in the United States.[12] Motivated to protect workers from violence and discrimination, they led successful strikes and a worldwide boycott of table and wine grapes grown in Delano, California, which resulted in the California Agricultural Labor Relations Act of 1975—the first law of its kind in the United States—granting state farmworkers the right to collectively organize and bargain for better wages and working conditions. Owens's use of the UFW symbol drew on the organization's history as well as a history of American protest t-shirts dating to the 1950s. Used as a blank canvas for political rhetoric, they allow individuals to wear their ideologies on their chests.[13] From the Vietnam War protests of the 1960s onward, t-shirts have served as a rapid and inexpensive way to respond to and express political statements.[14] At the height of UFW's activism during the late 1960s and early 1970s, most protest fashions were hand-painted and customized, seen in the clothing choices of the UFW's founders and followers.

Dolores Huerta (b. 1930) was born in New Mexico but grew up in Stockton, California. Her father, Juan, was a farmworker and union organizer, and her mother's community activism inspired her own. As a teacher, Huerta was made aware of her students' poor living conditions and became frustrated by the lack of support within the education system. A fierce proponent of economic justice, Huerta believed that she could best aid her students by helping farmworker parents win more equitable working conditions. According to Taína Caragol, curator of Latino art and history, Huerta renounced the middle class status that her family had achieved because she thought it hypocritical to fight for farmworkers while leading a more affluent life.[15] Like all other union officials and employees, she made a salary of $5 a week, plus gas money, food, and housing. In 1965, Huerta directed the UFW's Delano grape strike boycott and advocated for consumer rights, bringing national attention to the plight of farmworkers. The boycott resulted in the entire California table grape industry signing a three-year collective bargaining agreement with the UFW in 1970.

Figure 5.2
Dolores Huerta wears an example of protest fashion: a screen-printed image of the slogan, "There's blood on those grapes. Don't Buy Gallo Wine" on a white t-shirt. Chris Sánchez, gelatin silver print, 1973. Walter P. Reuther Library, Archives of Labor and Urban Affairs, Wayne State University. Courtesy of Clara Productions, LLC

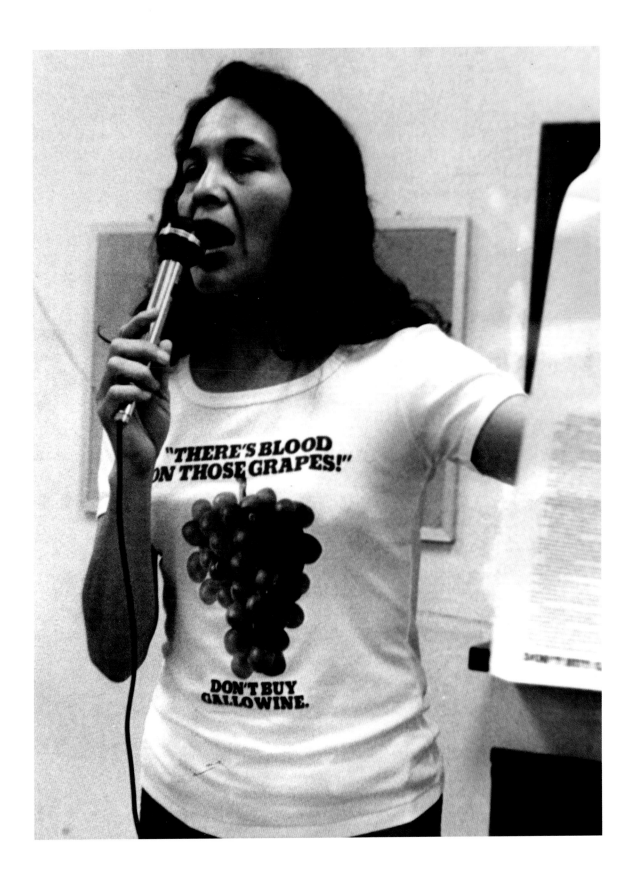

César Chávez (1927–1993), a first generation Mexican American, was born near Yuma, Arizona. At age eleven, he began employment as a farmworker after his family lost their own farm during the Great Depression. Both Huerta and Chávez understood the rebellious power of fashion and how it could be used to reclaim marginalized identities from a young age. As a teenaged Pachuco (zoot suit wearer), Chávez lived in California during the Zoot Suit Riots of the 1940s. Huerta's brother was brutally beaten by white men in 1945 for wearing a zoot suit.[16] Chávez and Huerta brought their experiences during the height of the Chicano movement to their UFW leadership.

In 1962, Chávez asked his brother Richard to design a symbol to represent the organization and give the farmworkers a sense of ownership, dignity, and pride. Journalist and labor scholar Miriam Pawel describes how Chávez's symbol choice demonstrates his skill as a tactician: "He researched emblems, including cigarette boxes and Nazi flags, and concluded that the most potent color combination was red, black and white."[17] The color choices were later described by the union: red for sacrifice, black for struggle, and white for hope.[18] Lastly, the Aztec eagle was incorporated—its wings in the shape of an inverted Aztec pyramid—representing the indigenous heritage with which many Mexican Americans identify. When retelling the creation story, Chávez confirmed that the intention was always to create a symbol that could be easily replicated: "[Richard] then squared off the wing edges so that the eagle would be easier for union members to draw on the handmade red flags."[19] Once the distinctive flag was unveiled at the first convention of the National Farm Workers Association (NFWA) on September 30, 1962,[20] the black eagle became widely used, worn on hats that protected marchers from the sun, shown on picket signs, or stenciled on homemade serapes.[21] At the height of the labor strikes during the 1970s, women turned their living quarters, which were provided by agricultural companies, into factories to manufacture banners and flags for upcoming protests.[22] Since then, the UFW Eagle Mark has symbolized victory in its successful contract negotiations and "the extensive goodwill and recognition built up by the UFW in the broader Latino and Hispanic communities."[23] Its significance has gone beyond the realm of labor unions as it continues to represent a sign of hope for the Chicano movement at large.

Dolores Huerta prioritized functionality (she led many physical acts of protest, including marches, pickets, boycotts, and sit-ins) and the visibility of protest symbols and messages over mainstream fashionability. She considered new clothing a frivolity and primarily sourced her wardrobe from donations.[24] A supporter, for example, hand knit her a red vest with the UFW Eagle Mark prominently featured on the front. She favored it for speeches and photographs because the emblem showed up so well.[25] This red vest is representative of what fashion scholar Emma McClendon calls "resistance clothing." It differs from "fashion" as it is seen as a vital tool of individual agency and collective protest—a way to make a group's (or individual's) identity clearly visible

Figure 5.3
The UFW Eagle Mark symbol was widely adapted onto clothing, as seen on this homemade jacket patch during a 1966 Sacramento strike. Jon Lewis photograph, courtesy of LeRoy Chatfield, © Yale University. All rights reserved.

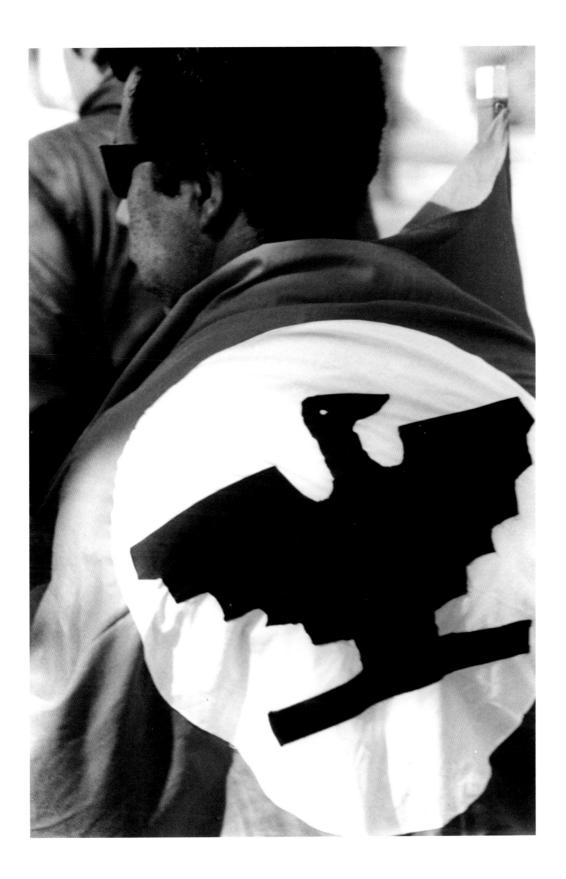

by means of a single symbol.[26] The vest was so synonymous with her figure as an activist that it was displayed as part of the Smithsonian National Portrait Gallery's One Life exhibition. Huerta continues to honor her Mexican American cultural background through her clothing choices as she is often photographed wearing ponchos, Mexican embroidered blouses, and huipiles.[27]

Figure 5.4
Huerta was the first Latina to be included in the *One Life* series at the Smithsonian National Portrait Gallery. During the exhibition's inauguration in 2016, which coincided with the fiftieth anniversary of the 1965 Delano grape strike and boycott, a poem was recited specifically citing the symbolism of Huerta's Eagle Mark vest: "The difference is your red knit vest, small enough to be a child's, with the black eagle soaring across the room toward us." Dolores Huerta, portrait, c. 1970s, Photographer unknown. Walter P. Reuther Library, Archives of Labor and Urban Affairs, Wayne State University. Courtesy of Clara Productions, LLC

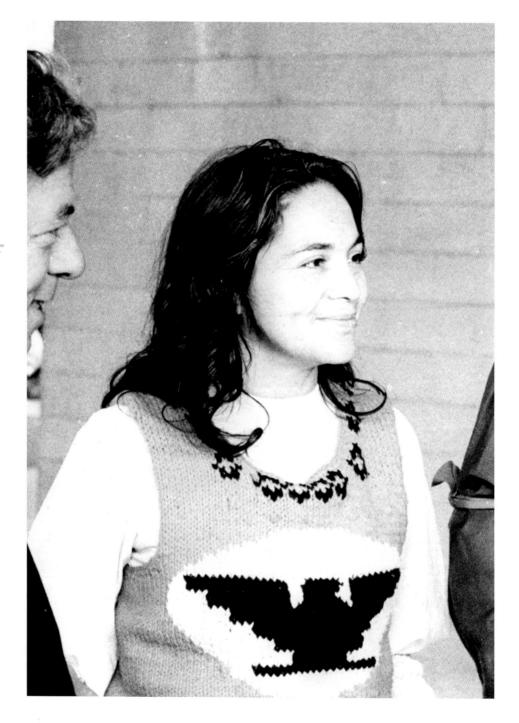

As opposed to Huerta's handmade vest, Chávez wore a black satin polyester bomber jacket later in life that bore the UFW logo and the name "Cesar Chavez" embroidered in white letters on the front.[28] The bomber jacket is a classic military style that was developed during World War I for fighter pilots. Chávez served as a seaman in the US Navy from 1946 to 1948 and may have favored military styling in homage to his service for his country. As fashion historian Jennifer Craik describes, "Military uniforms still hold a central place in contemporary sartorial, ritualistic and communicative arrangements as a means of conveying power relations, status, authority and role."[29] Chávez's jacket was one of several made for UFW officers and high-ranking

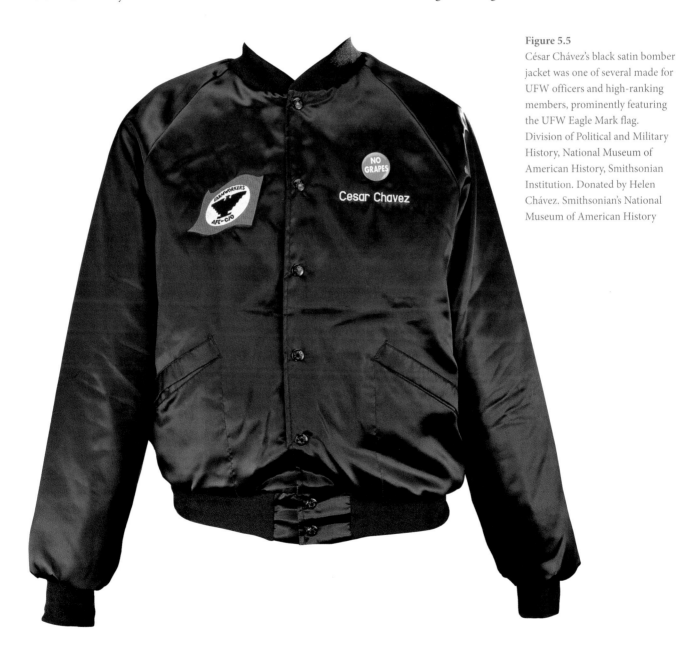

Figure 5.5
César Chávez's black satin bomber jacket was one of several made for UFW officers and high-ranking members, prominently featuring the UFW Eagle Mark flag. Division of Political and Military History, National Museum of American History, Smithsonian Institution. Donated by Helen Chávez. Smithsonian's National Museum of American History

members,[30] representing what cultural anthropologist Richard Kurin states as "the measure of success of its owner."[31] Shortly after Chávez's death in 1993, American labor curator Harry Rubenstein approached Chávez's wife Helen to donate the piece to the Smithsonian National Museum of American History.[32] The preservation of this object in a nationally represented institution solidifies Chávez's cultural significance, not just for Mexican Americans, but for all Americans, expanding his legacy as an agricultural labor union leader to a social rights activist.

From Illegal to Essential: Face Masks as Personal Protective Equipment

Immigration reform has been an ongoing issue in American agricultural labor policy. From the creation of the UFW, Chávez opposed illegal immigration and reported undocumented workers to authorities.[33] He thought employers would use undocumented workers as strike breakers, and that temporary workers would undermine the wages of Mexican American residents and citizens.[34] As a US-born Mexican American, he conformed to a clear hierarchy of who he believed deserved labor rights and union representation. These hierarchies are still relevant to the American agricultural workforce. According to the US Department of Agriculture, about half of all crop hands in the United States—more than one million people—are undocumented immigrants.[35] The 2020 COVID-19 pandemic brought new focus to these issues and the long-awaited recognition of the vital importance of many labor sectors—specifically, agricultural field workers, who were deemed "essential" by the federal government, although many still faced potential deportation.[36]

Agriculture is one of the most dangerous labor industries in the United States as farmworkers are exposed to numerous environmental and chemical hazards.[37] Personal protective equipment (PPE) is recommended by the Environmental Protection Agency (EPA) as the primary way to protect farmworkers. According to the US Department of Labor Occupational Health and Safety Administration (OSHA), PPE can include items such as "gloves, safety glasses and shoes, earplugs or muffs, hard hats, respirators, or coveralls, vests and full body suits."[38] The first union contracts achieved by the UFW required protective clothing and testing of farmworkers on a regular basis to monitor pesticide exposure.[39] Since then, the lack of uniform protection—especially in regard to PPE—has become common.[40] Throughout the COVID-19 pandemic, the Centers for Disease Control and Prevention (CDC) and OSHA issued only voluntary guidelines to protect workers. As "nonbinding recommendations," the national response by farm owners and employers was uneven, and no national policy to protect all farm laborers was enacted. Although the CDC encourages employers to provide clean cloth or disposable face coverings, the UFW discovered these recommendations were not enforced.[41]

#WeFeedYou Slogan

Another phenomenon of the pandemic era is the widespread use of face masks as protective gear for the general public and, subsequently, their adoption as fashion items for personal expression by both designers and wearers.[42] Simultaneously, in reaction to mounting social justice crises, face masks became a new iteration of the protest t-shirt. The intersectional issues of agricultural workers' rights, protest fashion, and the global health crisis came together in UFW face masks designed in 2020, bearing the hashtag slogan #WeFeedYou. Jocelyn Sherman, UFW's social media director developed the slogan around 2016; however, during the COVID-19 pandemic, the slogan took on new meaning. In an effort to provide the PPE that farmworkers were not receiving from their employers, including masks, the UFW initiated donation drives in which supporters purchased masks for workers. The masks were designed by Justin Watkins, project manager of the UFW's marketing department, who was motivated to create supplies that both protected and elevated their spirits by recognizing them as essential workers in the community.[43] According to Molly Hart, UFW Operations Manager:

> I Am Essential/Soy Esencial on protective face masks and the hashtag #WeFeedYou have become inextricably tied in the public's minds to the farmworker community, some of our nation's most valuable essential workers, continuing to work and keep food on our tables during the pandemic, and to the UFW's efforts to protect them when many growers will not.[44]

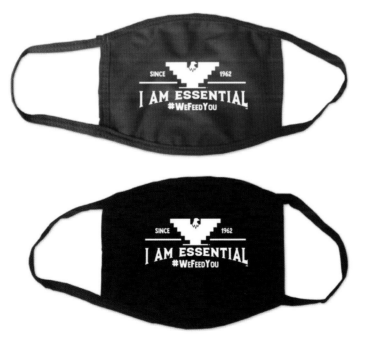

Figure 5.6
#WeFeedYou masks, designed by Justin Watkins, Project Manager of the UFW's Marketing Department. I Am Essential is the intellectual property of the UFW and is used with permission of the United Farm Workers of America, www.ufw.org

Conclusion

Food scholar Young Chen states, "Food provides special insights into the complexities of race and ethnicity in American history."[45] The UFW continues to actively champion legislative and regulatory reforms that protect farmworkers, such as immigration reform and the use of pesticides.[46] Although these issues may seem removed from the average person's dinner plate, they intimately affect the food Americans consume. PPE has always been vital to the safety of farmworkers, and the COVID-19 pandemic exacerbated that need. Like food, fashion creates a powerful and complex platform to address and explore social justice for marginalized groups. Rick Owens collaborated with UFW for his *Tecuatl* collection because he wanted to help create a broader understanding of farmworkers and felt the Eagle Mark symbol was integral to his Mexican identity.[47] As a self-reportedly biographical designer, his 2020 collection, which was inspired by his mother's Mexican heritage and designed twenty-five years after establishing his brand, speaks to the complexities of Latinx identity and how fashion can serve as a marker for Latinidad for first-generation Americans. Both César Chávez and Dolores Huerta used their physical bodies to protest in labor organization, but they also utilized them as canvases for resistance clothing and protest fashion, whether dressed in a zoot suit or wearing the symbols of the UFW. This symbol has most recently been adapted to pandemic-driven face masks that make allegiance to essential agricultural workers—many of whom are illegal immigrants—clear with new forms of protest fashion. These potent examples combine the labor of food and fashion into resistance.

Notes

1. John Jeremiah Sullivan, "Rick Owens Is Still Out There," *GQ*, September 25, 2018, https://www.gq.com/story/rick-owens-is-still-out-there-john-jeremiah-sullivan-profile.

2. John Colapinto, "Elegant Monsters," *The New Yorker*, March 3, 2008, https://www.newyorker.com/magazine/2008/03/10/elegant-monsters.

3. Luke Leitch, "Spring 2020 Menswear: Rick Owens," *VogueRunway.com*, June 20, 2019, https://www.vogue.com/fashion-shows/spring-2020-menswear/rick-owens.

4. Emma Elizabeth Davidson, "Rick Owens Responds to Trump's Wall by Exploring His Mexicanness for SS20," *Dazed*, June 20, 2019, https://www.dazeddigital.com/fashion/article/44948/1/rick-owens-trump-wall-mexico-paris-fashion-week-tecuatl-ss20-paris-fashion-week.

5. James Anderson, "33 Things You Need to Know about Rick Owens," *i-D*, December 19, 2018, https://i-d.vice.com/en_us/article/mby45x/rick-owens-guide.

6. Leitch, "Spring 2020 Menswear: Rick Owens."

7. In his show notes, Owens stated, "I've been motivated to explore my personal Mexicanness as a reaction to the US President's fixation on a border wall."

8. Susan B. Kaiser, *Fashion and Cultural Studies* (London: Bloomsbury Academic, 2013), 54.

9. Leitch, "Spring 2020 Menswear: Rick Owens."

10. Rick Owens website, https://www.rickowens.eu.

11. L. Stephen Velazquez, "Feeding America: The people and politics that bring food to our table," *Smithsonian blog*, February 21, 2013, https://americanhistory.si.edu/blog/2013/02/feeding-america-the-people-and-the-politics-that-bring-food-to-our-table.html.

12. The National Labor Relations Act (NLRA) of 1935 established people's right to collective bargaining to creating and forming unions, but specifically excluded agricultural workers.

13. Emma McClendon, *Power Mode*, exhibition label text.

14. Dennita Sewell, "T-Shirt," *The Berg Companion to Fashion* (Oxford: Bloomsbury Academic, 2010), 691.

15. Taína Caragol, email correspondence, September 1, 2020.

16. Debra Michals, "Dolores Huerta," National Women's History Museum, 2015, www.womenshistory.org/education-resources/biographies/dolores-huerta.

17. Miriam Pawel, "How Cesar Chavez Changed the World," *Smithsonian Magazine*, November 2013, https://www.smithsonianmag.com/history/how-cesar-chavez-changed-the-world-3735853/.

18. Richard Kurin, *The Smithsonian's History of America in 101 Objects* (United States: Penguin Publishing Group, 2016), 575.

19. UFW, "United Farm Workers of America Trademark Licensing Frequently Asked Questions (FAQ)," May 18, 2016, https://ufw.org/wp-content/uploads/2017/01/UFWTrademarkfaq-5-18-16.pdf.

20. UFW, "UFW Chronology," https://ufw.org/research/history/ufw-chronology/.

21. Ed Fuentes, "How One Flag Went from Representing Farmworkers to Flying for the Entire Latino Community," *Takepart*, April 2, 2014, http://www.takepart.com/article/2014/04/02/cultural-history-ufw-flag.

22. Fuentes, "How One Flag Went from Representing Farmworkers to Flying for the Entire Latino Community."

23. Today, the UFW reserves exclusive rights to use the Eagle Mark under Federal Trademark Registration No.090466; UFW, "FAQ."

24. Google Arts and Culture, "One Life: Dolores Huerta," https://artsandculture.google.com/culturalinstitute/beta/exhibit/one-life-dolores-huerta-national-portrait-gallery/ygLC-xrhjA9CIA?hl=en.

25. Mario T. Garcia, *A Dolores Huerta Reader* (Albuquerque: University of New Mexico Press, 2008), 95.

26. Emma McClendon, *Power Mode: The Force of Fashion* (Italy: Rizzoli International Publications, Incorporated, 2019), 77.

27. Taína Caragol, email correspondence, September 1, 2020.

28. Kurin, The Smithsonian's History of America in 101 Objects, 573.

29. Jennifer Craik, Uniforms Exposed: From Conformity to Transgression (Oxford: Berg, 2005), 44.

30. Owens Edwards, "When Union Leader Cesar Chavez Organized the Nation's Farmworkers, He Changed History," *Smithsonian Magazine*, October 2005, https://www.smithsonianmag.com /history/when-union-leader-cesar-chavez-organized-nations-farmworkers-changed-history -70776286/.

31. Kurin, *The Smithsonian's History of America in 101 Objects*, 573.

32. Edwards, "When Union Leader Cesar Chavez Organized the Nation's Farmworkers, He Changed History."

33. Ted Hesson, "Cesar Chavez's Complex History on Immigration," May 1, 2013, https://abcnews .go.com/ABC_Univision/Politics/cesar-chavezs-complex-history-immigration/story?id= 19083496.

34. David G. Gutiérrez, *Walls and Mirrors: Mexican Americans, Mexican Immigrants, and the Politics of Ethnicity* (Berkley: University of California Press), 135.

35. Economic Research Center, "Farm Labor," https://www.ers.usda.gov/topics/farm-economy/farm -labor/.

36. Miriam Jordan, "Farmworkers, Mostly Undocumented, Become 'Essential' During Pandemic," *The New York Times*, April 2, 2020, https://www.nytimes.com/2020/04/02/us/coronavirus -undocumented-immigrant-farmworkers-agriculture.html.

37. Thomas Arcury, "Latinx Child Farmworkers in North Carolina: Study Design and Participant Baseline Characteristics," *American Journal of Industrial Medicine* 62,2 (2019): 156–167.

38. United States Department of Labor, "Personal Protective Equipment," https://www.osha.gov /personal-protective-equipment.

39. UFW, "UFW Successes Through the Years," https://ufw.org/ufw-successes-years/.

40. Bob Ortega, "He's Considered an 'Essential' Worker. What He Feels, Though, Is Underpaid and at Risk," *CNN Investigates*, June 26, 2020, https://www.cnn.com/2020/06/26/us/farmworker -coronavirus-invs/index.html.

41. Centers for Disease Control and Prevention website, https://www.cdc.gov/coronavirus/2019 -ncov/community/guidance-agricultural-workers.html.

42. Jessica Bumpus, "How Face Masks Have Become the Symbol of 2020," Harper's Bazaar, August 24, 2020, https://www.harpersbazaar.com/uk/fashion/a33742806/how-face-masks-became-the -symbol-of-2020/,

43. Justin Watkins, email correspondence, September 1, 2020.

44. Molly Hart, email correspondence, August 20, 2020.

45. Young Chen, "Food, Race, and Ethnicity," in *The Oxford Handbook of Food History* (New York: Oxford University Press, 2012), 429.

46. UFW, "Our Vision," https://ufw.org/about-us/our-vision/.

47. Molly Hart, phone conversation, August 31, 2020.

Don't Eat That: Food, Fashion, Dieting, and Disorder

Emma McClendon

In 2016, Model Alliance founder and activist Sara Ziff teamed up with researchers from Harvard and Northeastern University to conduct a study on the prevalence of eating disorders among models working at New York Fashion Week. The resulting report was the largest study to date on eating disorders in professional modeling and the first to link unhealthy weight control behaviors (UWCB) to agency pressure.[1] It revealed 81 percent of participants had a body mass index (BMI) that would classify as underweight. Despite the low weight of the participants, 62 percent of the participants reported that they were asked to lose weight or change their shape by their agencies, 54 percent were told that they would not be able to book jobs unless they lost weight, and 21 percent were told that they would lose agency representation unless they lost weight.[2] Participants also reported:

> . . . sometimes, often, or always engaging in the following behaviors for weight loss in the past year: skipping meals (56%), dieting (71%), fasts/cleanses/detoxes (52%), using weight-loss supplements or diet pills (23%), self-induced vomiting (8%), and using stimulants such as Ritalin (16%) or cocaine (7%), or using intravenous drips [as food substitutes] (2%).[3]

When discussing the report, Ziff often notes people's lack of surprise at the results. She explains that the average person largely assumes eating disorders run rampant in the modeling industry, and so a report proving it seems "a bit like saying water is wet."[4] But this study represents an important step in using data-driven research to prove not only the widespread adoption of UWCB among models, but also to reveal the role that industry gatekeepers such as agents, stylists, casting directors, and designers play in promoting them. This constitutes an unhealthy and dangerous work environment. For Ziff, it is a labor issue. It is also proof of the deeply entrenched tension the fashion industry has with food.

Figure 6.1
Crystal Renn shot by Terry Richardson for *Vogue Paris*, October 2010. Terry Richardson/ Art Partner

Food is cultural, social, and connected to fashion in myriad ways, as this volume clearly demonstrates. But at its most basic level, food is nutrients. It is sustenance. It keeps our bodies alive. Yet this act of eating, of feeding the body, of taking in calories, fats, sugars, proteins, etc., has become increasingly tinged with fear, judgment, and stigma—not just in fashion, but throughout society more broadly, particularly in the United States. From fashion magazines to newspaper articles and documentaries, we are bombarded with information on what we should and *should not* eat. Why is the act of eating so anxiety ridden?

One major factor is the discourse around the "obesity epidemic." Dr. Lindo Bacon (formerly Dr. Linda Bacon) and Dr. Lucy Aphramor recount a striking example of the fear mongering tone of this discourse in their book *Body Respect*. Bacon and Aphramor are leading nutritional scientists pioneering the inclusive healthcare approach dubbed "Health at Every Size." As they describe, in 2002, the US Surgeon General Richard Carmona "described obesity as 'the terror within, a threat every bit as real to America as the weapons of mass destruction.'"[5] Food is a thing to be feared. The surgeon general, a proxy for the US government, openly likens obesity, and by extension burgers and fast food, to terrorism a year after the September 11, 2001 attacks on the Word Trade Center and when the country was on the brink of the war with Iraq. Food and fat are a clear and present danger.

For Bacon and Aphramor, instances like this laid the foundations for "the collective irrationality that underlies [the] 'obesity epidemic.'"[6] They go on to break down countless reports from the Center for Disease Control, the World Health Organization, and other institutions to show how weight is not synonymous with health. You cannot look at a person and know their health based on their size. As they explain, even within the medical community, a bias that places too much importance on weight as a metric of health rages, which obscures other risk factors for patients, including genetic, environmental, and socioeconomic factors. This stigma leads to a disparity in the quality of healthcare provided to those who are deemed "overweight" and "obese." Although Bacon and Aphramor's findings are too many and too varied to recount fully here, one vital study to which they point is the work of physiologist and nutritionist Jon Robinson. In a survey of published data, Robinson compared the incidence of type 2 diabetes in children in the United States due to weight gain to a host of other diseases, including cancer, autism, and cerebral palsy. For every 100,000 children between the ages of 10 and 19, he found 12 cases of type 2 diabetes, 15 cases of cancer, 340 cases of autism, and 240 cases of cerebral palsy. However, even more striking, per 100,000 children, he found *2,900* cases of eating disorders.[7] As Bacon and Aphramor conclude, "It is not a coincidence that eating disorders are so high in a climate of fat fear mongering. . . . We don't have an epidemic of obesity; our epidemic is one of judgment, bias, and hyperbole."[8] The true health risk to individuals is our cultural attitudes around food and bodies—a culture of judgment.

It has been proven that eating disorders are the most fatal type of mental illness.[9] Risk to life stems from complications due to malnutrition, but also substance abuse and suicide. And although there are many causes of eating disorders, both individual and cultural, it has been shown that media images promoting the "slender ideal" (of which fashion industry publications and advertisements play a major role) are a leading cause of the internalization of this ideal, feelings of body dissatisfaction, and pressure to conform through the adoption of UWCB among adolescent girls.[10] There have been attempts to mitigate the risk of fashion imagery through legislation both in the United States and abroad. For example, in 2016 the Advertising Standards Authority (ASA) in the United Kingdom banned a Gucci ad because "the model leaning against the wall appeared to be unhealthily thin in the image, and [they] therefore concluded that the ad was irresponsible."[11] In its response to the ASA, Gucci issued a statement, calling the judgment of a model as unhealthily thin a "subjective issue" and defending the ads placement in the *Times* as a periodical geared toward an "older, sophisticated" and "adult and mature" audience instead of the at-risk demographic of adolescents.[12] This episode highlights the murkiness of the issue, and, as a result, it is not surprising that such moves to ban advertisements are rare occurrences.

Although eating disorders are, of course, an extreme psychological condition, disordered eating (including the innocuous-sounding habit of dieting) has become an internalized component of everyday life, which is no more nefarious than going to a weekly yoga class or on a jog around the park. In fact, restrictive attitudes toward food are often applauded as examples of good discipline and self-control. Actress and wellness influencer Gwyneth Paltrow openly fasts and discusses the health benefits of highly restrictive diets on her lifestyle website Goop. Even *The New York Times* published an article titled "The Benefits of Intermittent Fasting" in February 2020.[13] The article's tagline boasted, "I was skeptical, but it turns out there is something to be said for a daily fast, preferably one lasting at least 16 hours."[14] Food scholar Richard A. O'Connor grapples with this issue in his work on "de-medicalizing" anorexia. As he explains, he was struck by the realization that "anorexia was anything but exotic. Its extraordinary asceticism had ordinary roots: schooling, sports, work and healthy eating all taught self-denial. . . . Anorexics simply exaggerated—and eventually incarnated—the deferred gratification that's so widely preached for the young."[15]

People often assume that dieting and fitness culture are a relatively new phenomenon, which is not surprising, given the language used to promote these regimens. Each diet or exercise style is touted as the "latest" or "new" or "breakthrough" secret that proves why everything that you tried before did not work. But looking back at American *Vogue* issues from the turn of the twentieth century, one quickly sees how entrenched this type of rhetoric already was over a century ago. Dieting has been part of *Vogue* since it first began publication in the 1890s. An article from September 1894 titled "How to Be Beautiful" offers clear guidelines on what (and what not) to

eat, dictating, "Plenty of vegetables, chicken, eggs, milk and fruit, ought to be the almost invariable diet of a pretty woman; a diet from which fish, game, heavy butcher's meat, condiments, pastry, liquors, pepper and vinegar, ought to be nearly entirely excluded."[16]

The prevalence of dietary guides and the extreme nature of the advice increased exponentially in the twentieth century. In an issue from 1913, an article titled "*The Diet's the* Thing" has an entire section dedicated to "Starvation Methods."[17] It outlines methods of skipping meals, and even recommends a woman fast for two days "during which absolutely no food is eaten" and then eating for a period of time "omitting nothing that she desires from her menu" before repeating the two-day fast, which is a textbook binge/restrict cycle of anorexia.[18] The goal of this regimen was to lose "five to ten pounds each month, though some lose considerably more weight."[19] In February 1956, *Vogue* announced the formation of its own "Diet Authority," a panel of (all male) physicians, who could advise on the "do's" and "don't's" of dieting to maintain a fashionable physique.[20] The panel's crowning achievement was a new plan unveiled in the same issue called "How to Stay 10 Lbs. Thinner," which included (among other prescriptions) eating "as little as 800 to 1,000 calories a day . . . for a month."[21] You can trace the legacy of these articles to today, when a quick glance on Vogue.com reveals titles like "What's the Best Way to Cleanse? A Guide to Detoxing in 2019" and "The Healthy Diet of the Future Focuses on When—Not Just What—You Eat."[22,23] The exact wording of these articles may be different, but the message is the same. Since its inception, *Vogue*—the most influential publication in global fashion—has positioned the female body and its relationship to food as something to be carefully regulated and controlled. A woman cannot simply eat; she must have a planned diet.

When *Vogue* first went into publication in the late nineteenth century, anxieties over the "modern woman" were at a fever pitch. As women were gaining increased freedoms in education and public life, narratives reinforcing traditional gender roles dominated popular literature—narratives that promoted a view of women as physically and psychologically weaker than men. In part, these views were a result of Darwinian evolutionary theories, and their adaptation to human gender roles, particularly Darwin's views on sexual differentiation and the division of labor between the sexes as key to natural selection. In *The Descent of Man*, first published in 1871, Darwin himself contended, "Woman seems to differ from man in mental disposition, in her greater tenderness and less selfishness," and that the law of the deviation of averages proves "the average standard of mental power in man must be above that of a woman."[24] But the perceived "weakness" of woman also made her potentially dangerous. It aligned her with the "lower" life forms of animals and plants, and gave her an unstable character. She could tip over at any moment into the realm of wild beasts, driven by hedonistic impulses toward physical and material pleasures. This concept connected to Judeo-Christian mythology of woman as Eve, the archetype of the corrupting

Planche XXIII.

ATTITUDES PASSIONNELLES

EXTASE (1878).

Figure 6.2
Charcot, *Attitudes passionnelles – extase*, 1878, from *Iconographie photographique de la Salpêtrière*, vol. 2. The J. Paul Getty Museum, Los Angeles

weaker sex. Eve eats an apple, she gives in to her appetite and hunger, and this dooms humanity for eternity. Eve is the original harbinger that a hungry woman (an eating woman) is an evil woman. Against this cultural backdrop, it is no wonder that *Vogue* recommends that its society readers do everything they can to present themselves as self-disciplined and in control of their appetites.

The fin-de-siècle fear of (and fascination with) the wild woman is perhaps best represented by neurologist Jean-Martin Charcot's 1878 photographic series of his patient Augustine posed in the gestures of "hysteria" (his newly codified neurological condition). With arms raised, seemingly in the grips of some invisible force, her hair undone, cascading past her shoulders, her body uncorseted, draped only in a cotton sheath, Augustine becomes the paragon of the wild, sexual woman. More than 130 years later, photographer Terry Richardson shot plus-size model Crystal Renn for *Vogue Paris* (see frontispiece). Arms raised, hair down, Renn too is posed in the grips of ecstasy. It is the ecstasy of the forbidden: Pasta! Carbs! A single noodle hangs from her open mouth as she lifts fistfuls of saucy spaghetti with her manicured and bejeweled hands. She is a twenty-first-century Augustine, both enticing and a warning. Her beauty, makeup, coiffure, and sparkling jewels draw us in, heightened by the pleasure in her expression, but the massive pile of pasta that fills the bottom quarter of the frame (no plate in sight), and the way the tomato sauce drips down her fingers, arms, and jewelry reminds us that this is a woman out of control. She is not clean and composed. She has given into something deeper, and while it excites us, it also makes us nervous, underscored by Renn's designation as a "plus-size" model (the fashion industry's euphemism for fat).

Fashion scholar Jess Barry contrasts the images of Renn with a phenomenon that she describes as the "gluttonous gamine," in which thin models are posed with "gratuitously" decadent bounties of food.[25] In her discussion of Miles Aldridge's 2008 photo series for *Vogue Italia*, Barry highlights the contrast between the "elaborately prepared food" and "the flawless body of the model that does not consume it"—a contrast that stresses "the underlying understanding . . . that fashion is incompatible with undisciplined bodies."[26] For Barry, this connects to the dichotomy between the paradigms of the grotesque and the classical body—a dichotomy philosopher Mikhail Bakhtin defined as the "open, protruding, irregular" body of the grotesque versus the closed, contained, and symmetrical beauty of the classical body.[27] As Barry describes, the grotesque body is dominated by the primary needs of eating, drinking, defecating, and sex, whereas the classical body is idealized, closed, and distanced from its viewer. It is

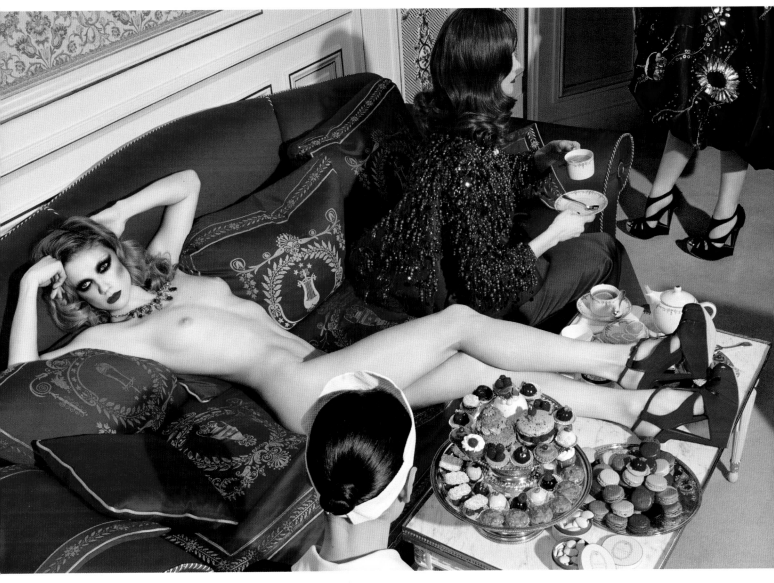

Figure 6.3
Miles Aldridge, *A Dazzling Beauty #4*, shot for *Vogue Italia*, March 2008, p. 226–227. Miles Aldridge/ Trunk Archive

an image and object to be admired.[28] What makes Renn "grotesque" is not her size, so much as her unbridled display of bodily function: eating.

Indeed, on the rare occasions when larger-sized bodies have been featured in fashion magazines and advertisements, they have typically been posed in a way to distance the body from food and instead align the model's curvaceous form with ideals of fine art. Shown without clothing, skin, flesh, and rolls on display is a means of assimilating the fat body into an acceptable cultural framework, namely the "Rubenesque" nude. Take, for example, the image of plus-size model Lizzie Miller that appeared in the September 2009 issue of *Glamour* magazine. She is shown seated and smiling, gazing away from the camera, tastefully posed to obstruct a full view of her breasts but allowing the camera to capture her fleshy stomach. At the time of its publication, *Glamour* was applauded for showing a "real" woman. But because she is naked, this "real" woman is suspended outside the temporal space of fashion trends. She becomes a timeless archetype, a voluptuous Venus.

Since 2009, other publications and companies have produced similarly composed images as the body positivity movement has moved into the mainstream—most recently in advertisements for trendy e-commerce fashion and beauty brands Everlane and Glossier. But the problem with these images is that there can be a schism between the body-positive images that these companies project on billboards and Instagram, and the products that they actually sell. As plus-size fashion scholar Lauren Downing Peters explains:

> Looking at Everlane specifically, what was ironic about its much ballyhooed panty rollout was the fact that, although it used a curve model as the face and body of the campaign, the range only goes up to a size XL, which corresponds to a 32.75-inch waist, or approximately a size 10 (a.k.a. *not* plus size).[29]

Peters dubs this phenomenon "size appropriation" and views it as part of a "woker-than-thou" marketing strategy that is increasingly defining millennial-liberal brands. It is the use of the body as decoration or object—not as a person or consumer. The nudity (or semi-nudity) of Everlane's model makes her a symbol. By disrobing her, the image defangs the threat of the fat woman. Naked, she is statuesque, archetypal, and an unthreatening visual stand-in for progressive, body-positive values, like the anonymous blindfolded figure of justice. She is a "woke" logo that does not require the company or consumer to acknowledge her as a person.

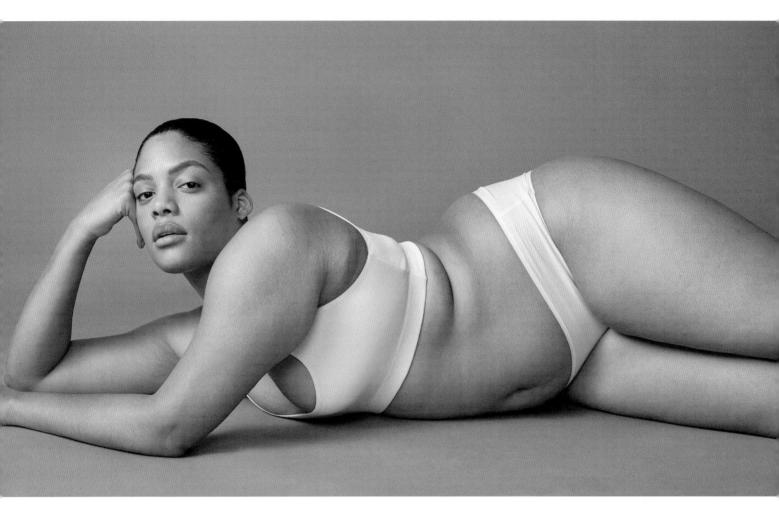

Figure 6.4
Everlane underwear ad, 2018.
Courtesy of Everlane

In 2017, *British Vogue* selected plus-size model Ashley Graham for its cover star, shooting her fully clothed in the latest fashions and strutting about the city as any straight-sized model would be shown. Neither eating nor nude, she transcends the grotesque/Venus dichotomy of the fat female body. The editorial was rightfully praised as an important step forward for the industry. But in the issue's "Letter from the Editor," then-Editor-in-Chief Alexandra Shulman exposed (without naming names) that several top fashion houses had refused to send clothes to dress Graham for her shoot. They did not want to be associated with the plus-size market.[30] Such is the continued tension in fashion. For all the movements toward body positivity and inclusivity that have happened in recent years—be they editorials or advertising campaigns—beneath the surface of these moments of "progress" lurks size-bias, fat phobia, and discrimination.

Three years after Ashley Graham's editorial in *British Vogue*, celebrity trainer and fitness personality Jillian Michaels sat for a live-streamed video interview on health and body positivity with the website Buzzfeed. In the middle of the conversation, the interviewer Alex Berg brought up Graham and also musical artist Lizzo, praising them for "putting out images we don't normally get to see, of bodies that we don't get to see being celebrated."[31] At this, Michaels cut in to criticize Lizzo for "glorifying" obesity, saying, "Why are we celebrating her body? Why does it matter? Why aren't we celebrating her music? . . . 'Cause it isn't going to be awesome if she gets diabetes."[32] Michaels's comments were immediately condemned as fatphobic and discriminatory across Twitter and media outlets from *The Washington Post* to CNN. Indeed, as already noted, it has been scientifically proven that you cannot determine a person's past, present, or future health just by looking at them, fat or thin. Weight does not equal health. However, Michaels's comments reveal the extent to which size, diet, food, and health are still conflated and the rampant stigma that persists against larger bodies. And size does not exist in a vacuum, but intersects with race, class, age, ability, and gender identity in the judgment of bodies, adding further dimension to these issues.

In February 2020, one month after Michaels's comments, Lizzo appeared on the red carpet for the annual BRIT Awards wearing a dress by Jeremy Scott for Moschino that resembled the wrapper of a Hershey chocolate bar dramatically twisted around her body into a glamorous fishtail silhouette. The look was the recreation of a design from his first collection for the Italian brand for fall 2014. Body-hugging around the hips and waist, with a plunging back, the word *chocolate* sweeping around the front, and the "nutritional facts" (including caloric content) cascading down the skirt, the dress is the ultimate manifestation of the tensions inherent in fashion's relationship with food and the female body. The dress puts the wearer's body on full view, celebrating her curves with its tight fit, even as it simultaneously binds her inside food and

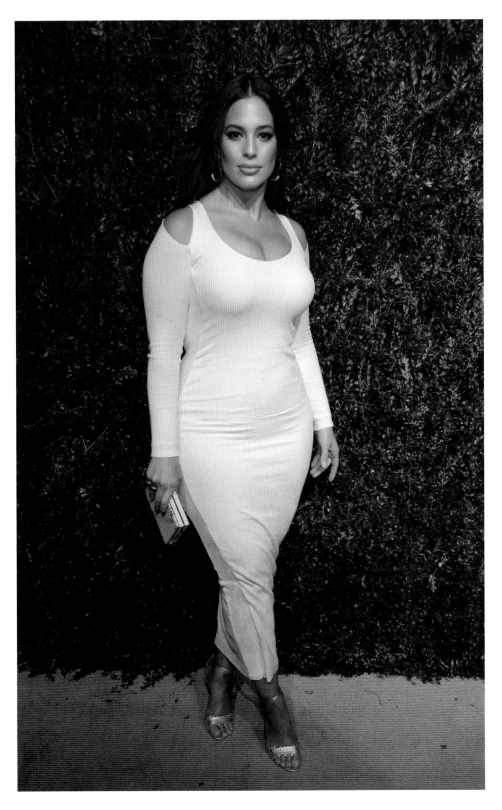

Figure 6.5
Ashley Graham at the 14th Annual
CFDA Vogue Fashion Fund Gala,
2017 John Palmer/Media Punch/
Alamy Live News

Figure 6.6
Lizzo at the 2020 BRIT Awards
wearing Moschino's chocolate bar
dress by Jeremy Scott. Karwai Tang/
WireImage/Getty

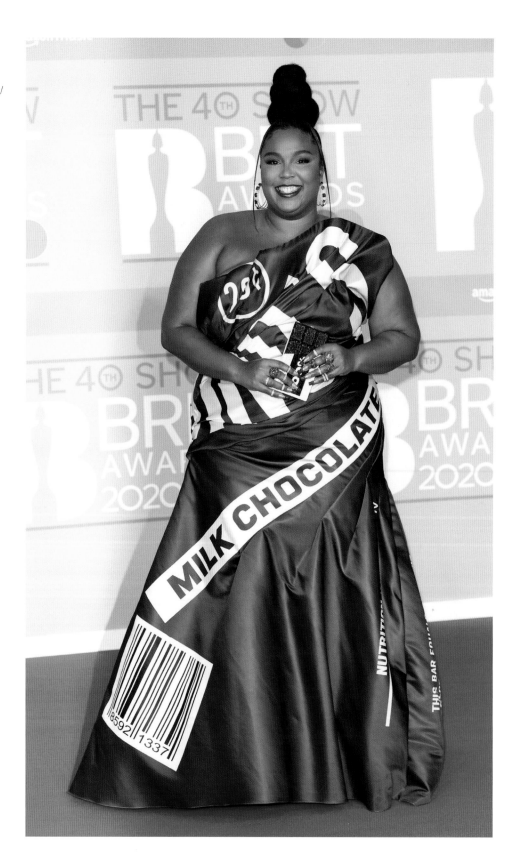

nutritional information. At her most glamorous, the woman cannot separate her body from the food that feeds it. And Scott has chosen chocolate—the most tantalizing of foods, the pleasure of its taste equated to sex, while its fat and sugar content make it forbidden.[33] On Lizzo, the power of the dress compounds. She becomes a walking fashion rebuke of Michaels's ignorance. She owns her size, style, and the connection between her body and food. Hers is a body that eats, and it is also a body that wears high fashion.

Representation is important. The way different-sized bodies are shown and positioned matters. We live in a world where a person's size is immediately associated with food, health, discipline, and disease. Thinness is the ideal, and restriction is praised. Equally, fatness is feared and publicly shamed. Over the course of the twentieth century, the sexist and moralizing overtones of the thin ideal became internalized to the point of being forgotten entirely, even as the subliminal messaging remained. Discussions of size became about "obesity" and "health." Fatness was "the terror within." But whether *Vogue* uses the terms *starvation methods* or *detoxifying cleanses,* the message is the same: food must be controlled. In fashion, eating is always dangerous.

Notes

1. Rachel F. Rodgers, Sara Ziff, Alice S. Lowy, Kimberly Yu, S. Byrn Austin, "Results of a Strategic Science Study to Inform Policies Extreme Thinness Standards in the Fashion Industry," in *International Journal of Eating Disorders* (2017, 50), 284–292.

2. Rodgers et al., "Results of a Strategic Science Study," 284–292.

3. Rodgers et al., "Results of a Strategic Science Study," 287.

4. Sara Ziff, quote taken from video of Ziff moderating a panel on modeling and body positivity during the Fashion & Physique symposium at The Museum at FIT, February 18, 2018, https://www.youtube.com/watch?v=KDP0augHnuQ.

5. Linda Bacon and Lucy Aphramor, *Body Respect: What Conventional Health Books Get Wrong, Leave Out, and Just Plain Fail to Understand about Weight* (Dallas: BenBella Books, Inc, 2014), 11.

6. Bacon and Aphramor, *Body Respect*, 11.

7. Bacon and Aphramor, *Body Respect*, 30–31.

8. Bacon and Aphramor, *Body Respect*, 31 and 11.

9. Frederique R. E. Smink, Daphne van Hoeken, and Hans W. Hoek, "Epidemiology of Eating Disorders: Incidence, Prevalence and Mortality Rates," in *Current Psychiatry Reports* (August 2012: 4(4)), 406–414.

10. Michael P. Levine and Sarah K. Murnen, "'Everybody Knows That Mass Media Are/Are Not [pick one] a Cause of Eating Disorders': A Critical Review of Evidence for A Causal Link Between Media, Negative Body Image, and Disordered Eating in Females," in *Journal of Social and Clinical Psychology* (Vol. 28, No. 1, 2009), 9–42.

11. Quote from Advertising Standards Authority in Mark Sweney, "Gucci Ad Banned Over 'Unhealthily Thin' Model" in *The Guardian* (April 6, 2016), https://www.theguardian.com/media/2016/apr/06/gucci-ad-banned-unhealthily-thin-model-asa.

12. Quote from Gucci in Sweney.

13. Jane E. Brody, "The Benefits of Intermittent Fasting," in *The New York Times*, February 18, 2020, https://www.nytimes.com/2020/02/17/well/eat/the-benefits-of-intermittent-fasting.html.

14. Brody, "The Benefits of Intermittent Fasting."

15. Richard A. O'Connor, "De-medicalizing Anorexia: Opening a New Dialog," in *Food and Culture: A Reader*, eds. Carole Counihan and Penny Van Esterik (New York: Routledge, 2013), 278.

16. Marquise de Panhael, "How to Be Beautiful," in *Vogue*, September 6, 1894, Vol. 4, Issue 10: 158.

17. "The Diet's the Thing," in *Vogue*, September 15, 1913, Vol. 42, Issue 6: 108.

18. "The Diet's the Thing."

19. "The Diet's the Thing."

20. "Health: Announcing Vogue's Diet Authority," in *Vogue*, February 15, 1956, Vol. 127, Issue 3: 64–67, 128–134.

21. "Health: How to Stay 10 Lbs. Thinner" in *Vogue*, February 15, 1956, Vol. 127, Issue 3: 68.

22. Mackenzie Wagoner, "What's the Best Way to Cleanse? A Guide to Detoxing in 2019," Vogue.com, January 1, 2019, https://www.vogue.com/article/best-cleanse-infrared-sauna-colonic-microbiome-diet.

23. Kate Branch, "The Healthy Diet of the Future Focuses of When—Not Just What—You Eat," Vogue.com, January 16, 2019, https://www.vogue.com/article/best-diet-to-lose-weight-intermittent-fasting-circadian-rhythms-gut-health-skin.

24. Charles Darwin, *The Descent of Man, and Selection in Relation to Sex* [1871], reproduced in *Charles Darwin: Evolutionary Writings*, ed. James A. Secord (New York: Oxford University Press, 2008), 304.

25. Jess Barry, "Gluttony and the Gamine: Seduction and Revulsion Through Consumption in Fashion Photography" in *Fashion, Tyranny & Revelation*, ed. Damayanthie Eluwawalage (Oxford, United Kingdom: Inter-Disciplinary Press, 2016), 85.

26. Barry, "Gluttony and the Gamine," 88, 86.

27. Mikhail Bakhtin quoted in Barry, "Gluttony and the Gamine," 86.

28. Barry, "Gluttony and the Gamine," 86.

29. Lauren Downing Peters, "When Brands Use Plus-Size Models and Don't Make Plus-Size Clothes," *Vox*, June 5, 2018, https://www.vox.com/2018/6/5/17236466/size-appropriation-brands-clothes-plus-size.

30. Jamie Feldman, "This News About Ashley Graham's British Vogue Cover Is Infuriating," *Huffington Post*, December 7, 2016, https://www.huffpost.com/entry/ashley-graham-vogue_n_58481f88e4b08c82e888f325.

31. Alex Berg quoted in Katelyn Esmonde, "What Celeb Trainer Jillian Michaels Got Wrong About Lizzo and Body Positivity," *Vox*, January 15, 2020, https://www.vox.com/culture/2020/1/15/21060692/lizzo-jillian-michaels-body-positivity-backlash.

32. Esmonde, "What Celeb Trainer Jillian Michaels Got Wrong."

33. See Barry, "Gluttony and the Gamine," 86.

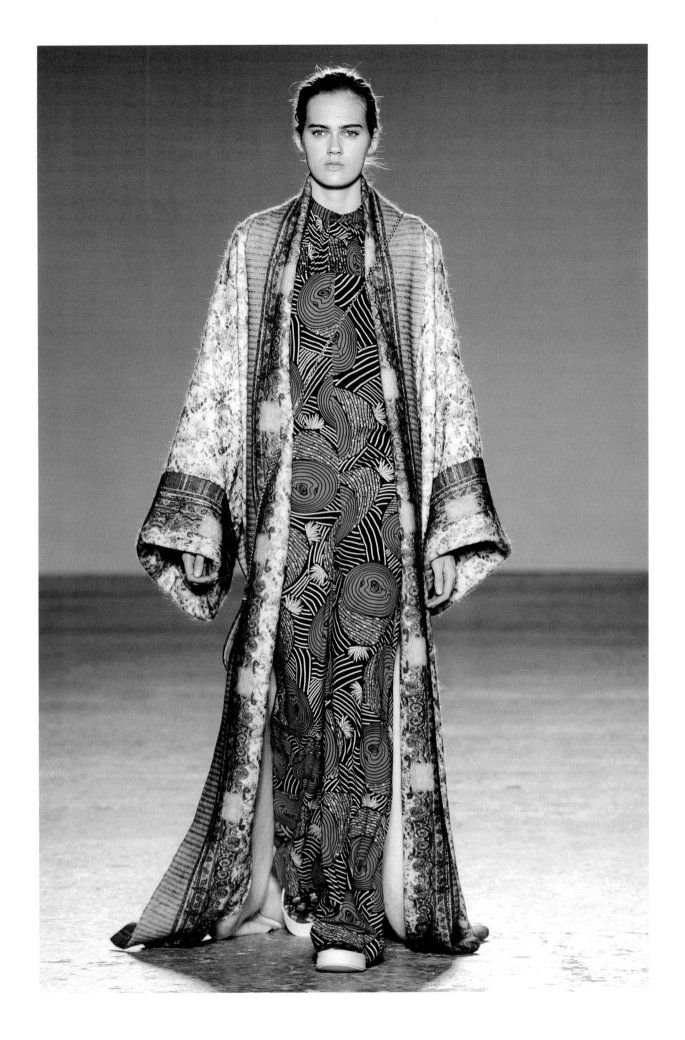

Wax Print Yams and Watermelon Hats: The African Diaspora in Food and Fashion

Elizabeth Way

Stella Jean: Wax, Stripes, and Yams

Stella Jean's fall 2015 collection was inspired by the culture of the Himalayas; however, it reflected Jean's diverse aesthetic aims, "I am genuinely interested in multicultural crossovers. . . . It's not about one culture prevailing on the other. Rather, I am an advocate for the seamless blending of the apparently disparate."[1] The artful combination of disparate elements and wide ranges of cultural inspiration are signatures of the Rome-based Stella Jean brand, though African and diasporic textiles and motifs often play a central role. A fashion journalist succinctly oversimplified the aesthetic as "African prints on European forms."[2] One of Jean's fall 2015 "African print" fabrics was a graphic black cotton with undulating white lines surrounding vibrant forms of what seem to be orange and brown root vegetables: yams, a staple food in West Africa. This fabric was produced in Burkina Faso under the aegis of the Ethical Fashion Initiative, part of the International Trade Centre under the World Trade Organization and the United Nations, "which aims to reduce global poverty by involving micro-entrepreneurs in the developing world through international and regional trade."[3] Stella Jean is well known for its commitment to fair labor practices. Since 2013, the designer consistently embarks on "missions" in which she "goes in the field . . . and after a first period of meeting and research of the various indigenous skills, many of which are dying out, she studies together with local artisans, how to develop a product fashion-textile-accessory combining the host country's traditional craftsmanship with the well-known Italian design and savoir-faire."[4] Jean's coproduced fabrics have included bogolan (mud cloth) from Mali, kente cloth from

Figure 7.1
Stella Jean, fall 2015. Daniele Oberrauch/IMAXtree.com

Ghana, and faso dan fani and pagne from Burkina Faso. The boldly patterned yam pagne, a type of fabric used for wrappers throughout West Africa, overtly references what is commonly thought of as "African" or wax print fabric.[5] In combination with yams, it is a particularly telling symbol of the deeply enmeshed relationship between food and textiles in African and diasporic cultures.

Yams, which are indigenous to Africa and Asia (unrelated to sweet potatoes, indigenous to the Americas), and "African prints," which are European, industrially produced fabrics inspired by Southeast Asian textiles and marketed to African buyers, are two markers of the international history of African and diasporic dress and culinary practices, representing a cosmopolitan and wide-spread cultural group that nonetheless shares ideas, motivations, and practices in food and fashion as vital outlets for cultural expression. Although wild yams grow in the Himalayas and are foraged to supplement local diets,[6] they represent a much larger part of the cuisine and culture of West Africa. Historian Robert Hall notes the historical importance of West African yams, which supported population growth from their domestication around 5000 to 4000 BCE and have been integrated into celebratory festivals and religious practices. Culinary historian Jessica Harris writes, "In Ghana and Nigeria and other countries within the belt where yams are the major starch, traditional yam festivals like Homowo remain common. New yams are propagated from old ones, and so the tuber has come to symbolize the continuity of life."[7] Together with an imported Asian variety, African yams are "a staple crop for more than 40 percent of the population of West Africa and eaten by many more as a secondary food. Furthermore, more than two-thirds of the world's yams are grown in the area between the Ivory Coast and the Cameroon."[8] Burkina Faso is not a major yam exporter; cotton is the major export, supporting its rich weaving tradition and attracting Stella Jean to its artisans. However, yams are grown for local consumption, and the country is surrounded by the world's leading producers.[9,10]

Dutch traders introduced wax prints to West Africa during the late nineteenth century. Dutch textile manufacturers attempted to industrialize the production of Javanese batik and take over the Indonesian market; however, as anthropologist Nina Sylvanus explains, their production process was flawed: "[The] duplex roller-printer imprinted hot resin on both faces of the cloth . . . revers[ing] the designs much like the original, hand-made, batik. But the replication process had one major shortcoming: as the resin dried up, it cracked and inadvertently 'imprinted' small veins and spots on the cloth."[11] The cracks were unacceptable to Javanese consumers, but they created unique variations within the lengths of the colorful and lightweight cotton cloth that appealed to West African consumers. Wax prints were among a number of European and Asian textiles already traded and consumed in West Africa. They were distinctively incorporated into dress over the twentieth century, transformed by local wholesalers and tailors

into fashion that adopted some European structures but were conspicuously African. For example, M. Amah Edoh notes, "In Togo, as in much of West Africa . . . Dutch wax cloth has been appropriated by Togolese users into cloth-centered meaning-making practices that predated the cloth's arrival . . . these practices . . . have leveraged cloth not only as dress and adornment, but also in the marking of kinship ties, and in the celebration of important life events, such as births, marriages and funerals, and as a form of currency and wealth—female wealth specifically."[12] That West African fashion makers adopted imported textiles as their own is not unique; the English similarly embraced Indian chintzes, though crucially different is that wax prints became "African prints" under oppressive European colonization. Yet, this transformation exemplifies how African people adaptively and creatively participated in the international market, and how it transformed their cultures. For example, Asian foods, including varieties of rice and black-eyed peas, were staples in areas of Africa before the Columbian Exchange.[13] Anthropologist Sidney Mintz documents the diets of enslaved Africans as "rich in cassava, maize, and peanuts, foods that originated in the Americas, travelled to Africa, became incorporated into aspects of African cuisine, and then returned to the New World via Africanized make-overs."[14]

The yam pagne fabric in Stella Jean's shirtwaist dress directly reflects her "Wax and Stripes" philosophy: wax prints represent her Haitian heritage on her mother's side and stripes recall her Italian father's business shirts. Jean reflects on the convoluted history of "African" wax prints and her own identity, stating, "We think wax comes from West Africa. The slaves sent to the Caribbean islands came from West Africa. Yet wax is European, like me. No one ever believes I am Italian, but I am."[15] Jean challenged these perceptions by creating a truly African print. Her partnership with weavers in Burkina Faso relocates the creative and skilled labor from European textile producers to African artisans and represents a distinctly West African food. But like wax prints, which have been fully incorporated into West African and diasporic fashion culture, the yam's journey through the diaspora is complicated and transnational. Slavers seeking to discourage hunger strikes during the horrendous Middle Passage supplied enslaved captives with familiar foods such as yams, subsequently bringing these foods to the Caribbean. Yams were grown in Haiti to feed enslaved workers and spread throughout the tropical New World as "a standard food of black peasants."[16,17] However, this transplanted yam species was the one Asian variety grown in West Africa (*Dioscorea alata*).[18] Enslaved communities also substituted native sweet potatoes for their familiar staple.[19] Yam dishes—from West African and Caribbean fufu to the candied yams of the southern United States—represent a cuisine that connects Black people to their African and diasporic culture; however, like wax prints, they have been transformed by the interconnected influences of Africa, Asia, Native America, and by European colonialism and enslavement.[20]

Figure 7.2
Stella Jean, cotton dress and socks,
fall 2015, Italy. Gift of Stella Jean.
© The Museum at FIT

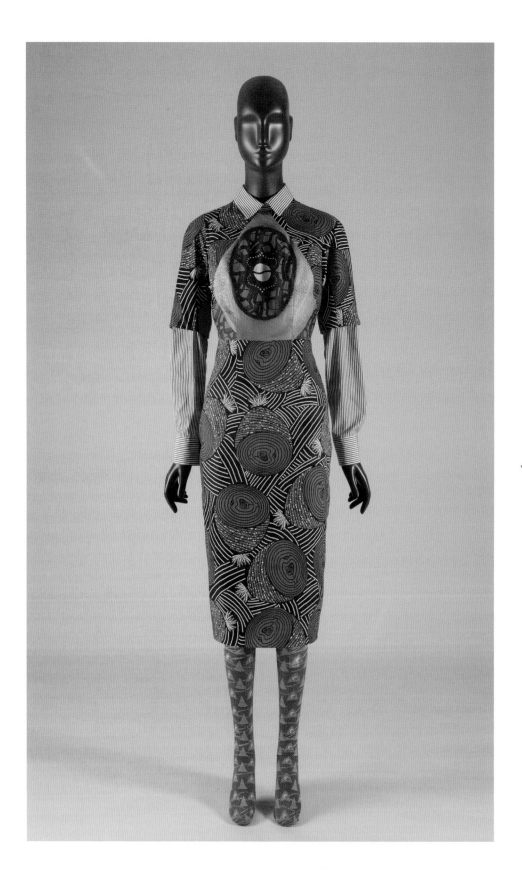

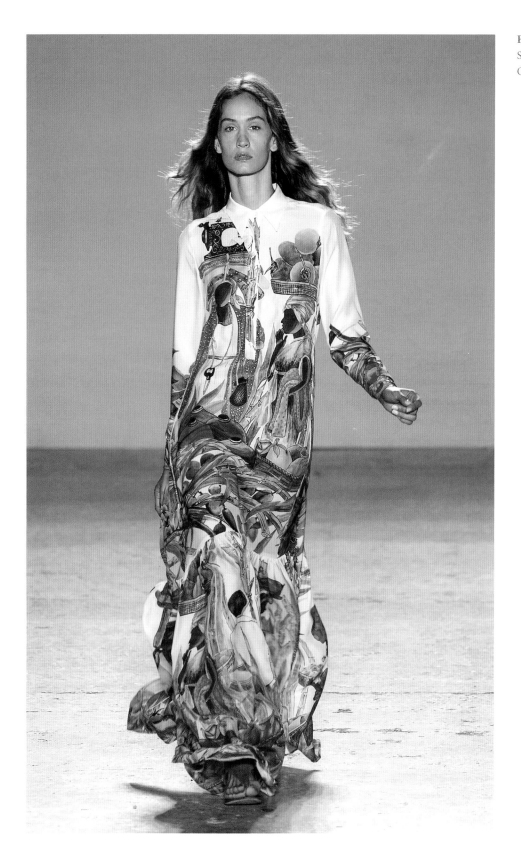

Figure 7.3
Stella Jean, spring 2015. Daniele
Oberrauch/IMAXtree.com

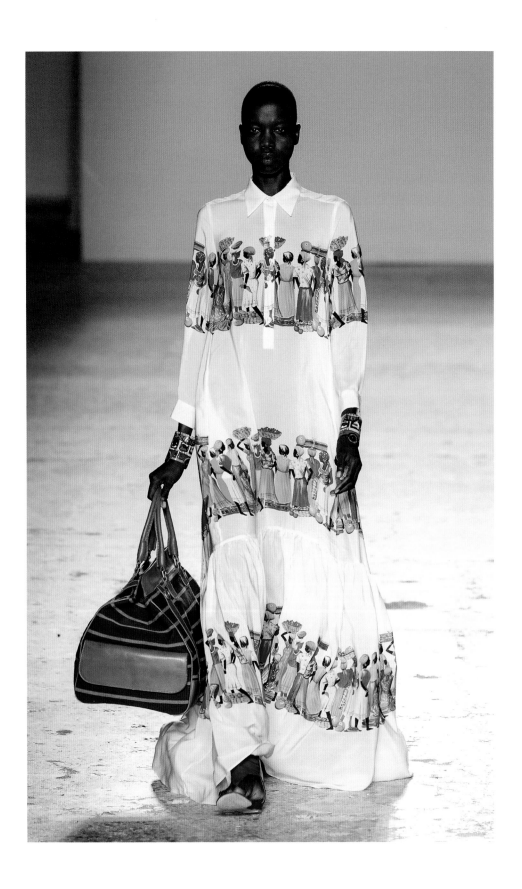

Figure 7.4
Stella Jean, spring 2015. Daniele
Oberrauch/IMAXtree.com

Harris notes that "most of the Africans who arrived early on mainland America were culturally fluid and used to existence on their multicultural and multilingual home continent."[21] West Africans relied on these skills to survive as enslaved people in the Americas. Food and fashionable expression were lifelines, connecting them to their African past and helping them create new American cultural identities. Stella Jean's bricolage of fabrics, techniques, and patterns, injected into contemporary European high fashion, as well as her own cultural background, reflects Africa's history as an important nexus of the intricately connected Old World and its peoples' vital role in the establishment of post-Columbian New World societies. Flowing shirtdresses from her spring 2015 collection, for example, feature painterly scenes of Haitian market women, not only the fruit sellers with baskets of lush produce on their heads but also the dressmakers and tailors balancing bolts of fabric and sewing machines. Here, Jean directly connects her fashion practice with the food and entrepreneurial women of her mother's country, illustrating the central role food and fashion play in expressing her complex diasporic identity.

Patrick Kelly: Watermelons and Overalls in the Southern United States

Patrick Kelly often used his fashion practice to explore and recontextualize controversial images of Blackness. His spring 1988 collection, for example, featured denim overalls, red bandana prints, and watermelon motifs. Although he was based in Paris, Kelly created a collection that spoke directly to his Mississippi childhood, as well as the history of southern Black Americans and their relationship to food and fashion. Slavery and plantation agriculture are the most overt ways that food and fashion have influenced diasporic culture. The Columbian Exchange, and the colonization and capitalist production of agriculture in the Americas—most prominently sugar and cotton—relied on slave labor and created a cycle of brutality and oppression for both enslaved Africans and Native Americans. The Old World's foods, textiles, tastes, and knowledge were transplanted not only by colonizers but also by enslaved Africans, who, for example, introduced new foods such as okra and watermelons, as well as knowledge of rice cultivation, cattle husbandry, cooking techniques, and dying and weaving skills.[22,23] The exchange was bilateral, as historian Alfred Crosby writes: "The increased food production [maize, manioc, and other American plants] enabled the slave trade to go on as long as it did. . . . The Atlantic slave traders drew many, perhaps most, of their cargoes from the rain forest areas, precisely those areas where American crops enabled heavier settlements than before."[24] Once transported, slave owners broke up ethnic groups and used uniform clothing and meager food rations to control enslaved communities, suppress individuality, and create hierarchies. Yet, fashion and food were two vital ways that enslaved people resisted and asserted their humanity.

Figure 7.5
Patrick Kelly, spring 1988
runway show, Paris. Photo
by PL Gould/IMAGES/
Getty Images

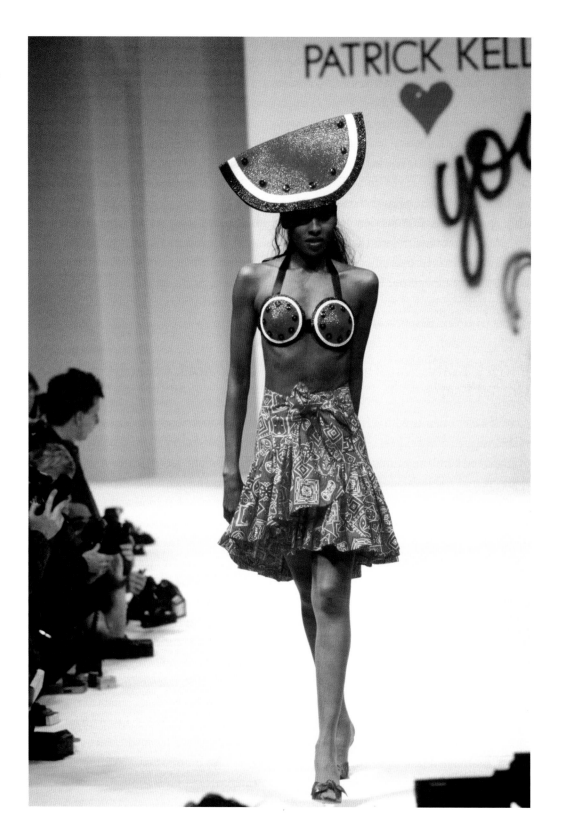

Fashion historian Katie Knowles states that nineteenth-century enslaved Americans on large plantations typically received annual or semiannual rations of cloth or ready-made garments, cheap and bought in bulk, or produced their own clothing, processing cotton and wool from fiber to finished garment. Enslaved men and women supplemented these with secondhand and new fashionable goods: "Enslaved people who dressed in cast-off clothing or made their own hoop skirts challenged the social system by participating in the current fashion system. By dressing up, slaves were able to assert themselves as members of the fashionable world, as well as express their individuality."[25] In the same way, historian Charles Joyner states that food "had immense cultural and ideological significance: the choice of particular foods and particular means of preparation involved issues of crucial importance to the slaves' sense of identity. Slave cooks not only maintained cultural continuity with West African cuisine but also adapted the African tradition creatively to the necessities and opportunities of a new culinary environment."[26] These means of expression were tied together, supporting and enabling each other. West Africa has a strong tradition of textile production (exemplified contemporarily by Stella Jean's artisanal partners) and the majority of enslaved Africans were taken from agricultural communities. They utilized both sets of knowledge and passed them down, planting their own gardens, raising animals, and making, dying, modifying, and maintaining their clothing in their limited free time. African Americans also learned of local agriculture and quarry from Native Americans, who were a major influence on diasporic cuisine.[27,28] Extra food grown or caught could be sold or bartered, especially for clothing. Through production, purchase, gifts, and theft, enslaved people supplemented the low quality and insufficient food and clothing provided by slaveholders.[29,30]

The end of slavery did little to change the dynamics between African American agricultural workers and white landowners in the United States South. Mainstream media promoted images that reinforced racist stereotypes. Material culturalist Psyche Williams-Forson documents early twentieth-century illustrations that "relied heavily upon a series of signifiers, signified, and linguistic messages to convey slanderous ideologies as natural," specifically as related to Black Americans and chickens. She writes, "All in all, the imagery, whether of African American men, women, or children in compromising positions with [stealing, being scared of, or bullied by] chickens is perversely overwhelming."[31] A potent example is imagery that compared the figure of the fashionable Black dandy, personified by the minstrelsy character of Zip Coon, to chickens, which were seen as "low on the evolutionary food chain and also one of the cockiest of animals."[32] The slur "coon" was derived from racoon—an animal that stole chickens, thus essentializing the theft practiced by some underfed enslaved people, and the fashionable "image of Zip Coon made a mockery out of those who had any kind of aspirations, whether economic, political, social, or cultural."[33]

Engaging with fashion in the Jim Crow South posed dangers beyond mockery. During the early twentieth century, sociologist Hylan Lewis interviewed a young Black man living in South Carolina who warned, "'Don't go down town all dressed up. They liable to beat you cause they say they don't know you and they been knowing me all my life but if I go down town dressed up they won't know me.' White people 'don't like nobody who don't wear overalls and don't work like digging ditches.'"[34] Denim overalls, marketed as sturdy and practical workwear during the late nineteenth century, came to represent disenfranchised sharecroppers and their uneven relationship with landowners and the American capitalist economy, even as southern Black Americans fought to challenge the status quo.[35,36] Clothing associated with rural Black southerners found equivalents in food. Visual culture historian Brenna Wynn Greer notes that a 1937 *Life* magazine featured a Black man on its cover, posed back-to-camera, wearing only denim work pants with suspenders and sitting atop a wagonful of watermelons.

> In the span of a year, the photo-magazine had already achieved a readership numbering several million: one would be hard pressed to find a more influential media space than its publication's cover. For precisely this reason, however, African Americans likely did not celebrate the cover as a "breakthrough" representational event. For one, as a portrait on anonymity—which none too subtly tapped prevailing stereotypes linking blacks and watermelons—the photograph stymies recognition of black subjectivity. The image also did little to define America away from its enslaved past.[37]

Wynn Greer also notes that inside the *Life* issue, a stacked tier of photographs illustrated that "All southerners like watermelon." White "Georgia girls" are shown on top of an image of a "colored mammy," which sits above a picture of pigs. All are eating watermelon, and the caption reads, "What melons the Negroes do not consume will find favor with the pigs."[38]

Despite the negativity of these stereotypes, Black Americans were the most influential contributors to southern foodways. The cuisine that political and culturally conscious Black Americans reclaimed as "soul food" during the 1960s not only includes distinctly West African traditions, such as yam dishes, cooked greens, and fried and barbequed meats, but also adaptive dishes that enslaved cooks created from the less desired foods given to them, such as chitlins, pork ribs, and pig feet. Moreover, as the cooks in wealthy households, Black men and women mastered European haute cuisine and created new dishes.[39] Food historian Frederick Douglass Opie writes, "By the nineteenth century the majority of Southerners ate like enslaved Africans and free African Americans, enjoying all parts of the hog, corn bread, greens, sweet potato pie, candied yams, and black-eyed peas and rice."[40] Historical archaeologist Kelley Fanto

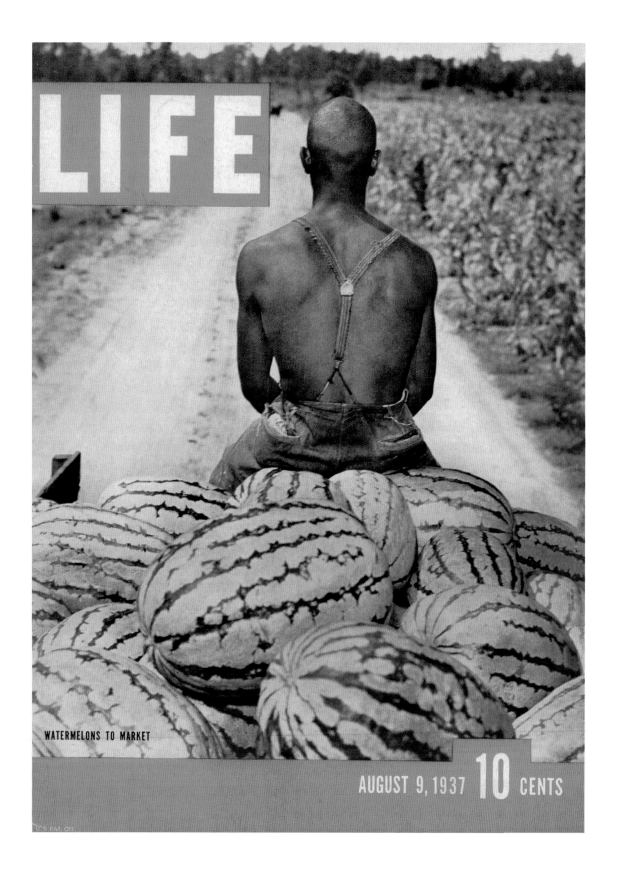

Deetz notes that the formally trained Hercules and James Hemmings (chefs to George Washington and Thomas Jefferson, respectively) "were the nation's first celebrity chefs, famous for their talents and skills," and other enslaved chefs, now unknown:

> create[ed] and normaliz[ed] the mixture of European, African, and Native American cuisines that became the staples of Southern food. . . . They created favorites like gumbo, an adaptation of a traditional West African stew; and jambalaya, a cousin of Jolof rice, a spicy, heavily seasoned rice dish with vegetables and meat. These dishes traveled with captured West Africans on slave ships, and into the kitchens of Virginia's elite.[41]

Patrick Kelly provocatively played on the food and fashion stereotypes associated with Black southerners in his spring 1988 collection. Black male models danced down the runway wearing denim overalls, followed by an elegant model in a tiered and ruffled bandana-print skirt, paired with a crisp white blazer and wide-brimmed hat. The bandana fabric appeared in several other ensembles, some of which were accessorized with watermelon bra tops and large, watermelon slice–shaped hats. Contemporary reviews especially noted the watermelon motifs among the dozens of ensembles that were shown. *New York Times* fashion critic Bernadine Morris, for example, wrote that they "add flavor to his white piqué ruffled dresses," but did not comment on the reference to Black culture, stating, "The clothes are good, but what matters most is the joyful spirit the designer projects."[42]

Kelly was indeed known for his joy and sense of fun, seemingly embodied in his signature ensemble: oversized denim overalls with colorful accessories. Yet Kelly was well-educated on both art and African American history, and his look, as well as his reference to Black stereotypes, was intentional. Fashion historian Eric Darnell Pritchard writes, "His personal style, and especially his overalls, were both a reflection of some central tenets of his aesthetic enterprise, while simultaneously linking him and his work ever more overtly to the history, politics, cultural traditions, and aesthetics of the Black southern poor and working classes."[43] Referring to the watermelons and bandanas ("like those featured in representations of Mammy's and Aunt Jemima pancake ads"), Pritchard continues, "As a designer, Kelly's original and controversial visual vocabulary blended the real, painful, and also traumatic histories of race in the United States, including racial terror and racist iconography."[44] This was very much part of Kelly's own personal history. He was famously inspired by his grandmother, who worked as a domestic, celebrating her style and creativity. He also followed in the footsteps of generations of Black entrepreneurs, working adaptively and utilizing fashion and culinary skills. Historical archeologist Ann Yentsch and Harris both emphasize cooking skills and catering and restaurant businesses as important

Figure 7.7
Patrick Kelly, ensemble, spring/ summer 1988. Philadelphia Museum of Art: Gift of Bjorn Guil Amelan and Bill T. Jones in honor of Monica Brown, 2014, 2014-207-1a-e

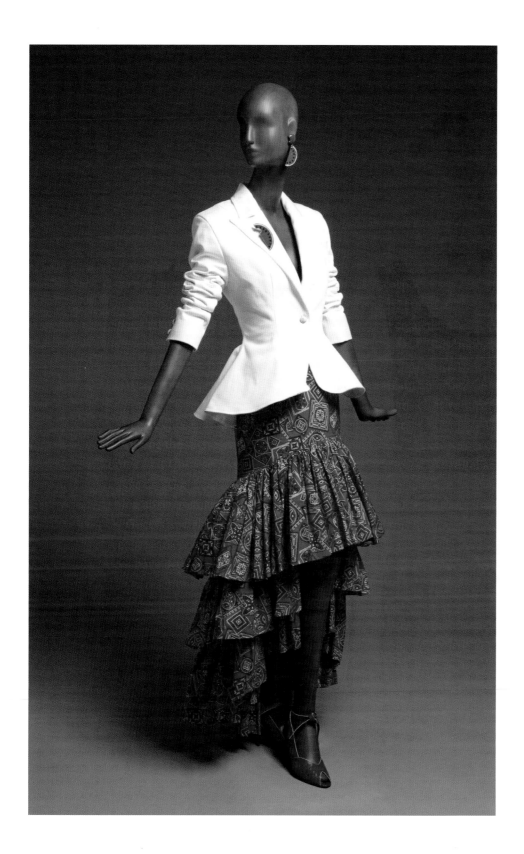

Figure 7.8
Patrick Kelly, cotton denim overalls
dress, fall 1987, France. Gift of
Bjorn G. Amelan and Bill T. Jones.
© The Museum at FIT

avenues to financial gain for Black Americans from the eighteenth century. Many started impromptu businesses from carts on street corners or sold in markets like the Haitian women Stella Jean depicted.[45,46] Kelly not only began his fashion career selling his designs on Parisian sidewalks, but also supplemented his income by catering fried chicken.[47,48] He continuously expressed his Blackness through food and fashion, making it part of his persona. "Kelly loved to host gatherings . . . and invite friends to share some of his favorite soul food dishes—fried chicken, macaroni and cheese, collard greens, candied yams, and cornbread. These are just some of the oft-repeated details contributing to the narrative bricolage wedding Kelly's fashion label to the racial, class, gender, and sexual politics implicit to Black representation."[49]

Although some of Kelly's work was provocative—*Vogue* reported in 1989 that "buyers weren't thrilled with a spring collection featuring bandannas and watermelon hats"[50]—the Patrick Kelly brand was extremely successful, and Kelly was an insightful creator, remembered after his untimely 1990 death for his groundbreaking career. Fashion journalist Eric Wilson wrote, "Kelly's work opened the discourse of fashion to areas that had usually been taboos—as a black man appropriating stereotypical or racist imagery into his work, as an American in succeeding in Paris, as a designer employing a sense of happiness and humor in a traditionally sober pursuit."[51]

Conclusion

The idea that food and fashion are vital cultural markers is as true for the vastly multi-faceted and far-flung African diasporic culture as it is for any other. Harris underscores how they work together to create Black identities, exemplifying the 1970s in the United States as a period when "Members of the Nation of Islam were identified by their bow ties and their well-pressed suits" and hijabs, as well as their bean pies and rejection of pork and alcohol. "Dashiki-clad cultural nationalists ate a diet that was multicultural and infused with international flavor," including jollof rice and callaloo seafood stew. "The upwardly mobile bourgeois continued to dine on Eurocentric foods," while no doubt following Eurocentric fashions, and "the classic foods of the African American South—stewed okra and butter beans, pork chops and fried chicken—maintained their place at the table as well."[52] Stella Jean's and Patrick Kelly's designs add to this tiny sample representing the multitudes of Black culture. These are highly individualized expressions, yet they all illustrate the bricolage of the African Diaspora that has continually and creatively adapted and incorporated transcultural influences.

Notes

1. Angelo Flaccavento, "Stella Jean Fall 2015 Ready-to-Wear," *Vogue.com*, February 25, 2015, https://www.vogue.com/fashion-shows/fall-2015-ready-to-wear/stella-jean.

2. Kerry Olsen, "Stella Jean Spring 2016 Ready-to-Wear," *Vogue.com*, September 23, 2015, https://www.vogue.com/fashion-shows/spring-2016-ready-to-wear/stella-jean.

3. "Ethical Fashion Initiative," International Trade Centre website, n.d., http://www.intracen.org/itc/projects/ethical-fashion/

4. "Laboratorio delle Nazioni® Business Model and Sustainable Development Platform," Stella Jean website, n.d., https://www.stellajean.it/project/ [no longer available online].

5. Christopher Richards, "The African Wrapper" in *Berg Encyclopedia of World Dress and Fashion: Africa*, eds. Joanne B. Eicher and Doran H. Ross (Oxford: Berg Publishers, 2010).

6. Robert Hoffpauir, "Subsistence Strategy and Its Ecological Consequences in the Nepal Himalaya," *Anthropos* 73, no. 1/2 (1978): 215–252.

7. Jessica B. Harris, *High on the Hog: A Culinary Journey from Africa to America* (New York: Bloomsbury, 2012), 14.

8. Robert L. Hall, "Food Crops, Medicinal Plants, and the Atlantic Slave Trade" in *African American Foodways*, ed. Anne L. Bower (Urbana and Chicago: University of Illinois Press, 2009), 19.

9. Pierre H. Guiguemde, Jean Dresch, Hubert Jules Deschamps, and Myron Echenberg, "Burkina Faso," *Encyclopædia Britannica*, August 30, 2019, https://www.britannica.com/place/Burkina-Faso/Independence#accordion-article-contributors.

10. Joyce Chepkemoi, "World Leaders in Yam Production," *World Atlas*, accessed May 19, 2020, https://www.worldatlas.com/articles/world-leaders-in-yam-production.html.

11. Nina Sylvanus, "Fashionability in Colonial and Postcolonial Togo," in *African Dress: Fashion, Agency, Performance*, eds. Karen Tranberg Hansen and D. Soyini Hansen (London: Bloomsbury Academic, 2013), 30–44.

12. Edoh, M. Amah "From African Print to Global Luxury: Dutch Wax Cloth Rebranding and the Politics of High Value" in *African Luxury Aesthetics and Politics*, eds. Mehita Iqani and Simidele Dosekun (Bristol: Intellect, 2019), 82.

13. Hall, "Food Crops, Medicinal Plants, and the Atlantic Slave Trade," 25–26.

14. Quoted in Frederick Douglass Opie, "Influences, Sources and African Diaspora Foodways" in *Food in Time and Place*, eds. Paul Freedman, Joyce E. Chaplin, and Ken Albala (Oakland: University of California Press, 2014), 193.

15. Marion Hume, "Fashion's New Stella," *The Business of Fashion*, September 17, 2013, https://www.businessoffashion.com/articles/intelligence/fashions-new-stella.

16. Hall, "Food Crops, Medicinal Plants, and the Atlantic Slave Trade," 20–21.

17. Harris, *High on the Hog*, 30.

18. Hall, "Food Crops, Medicinal Plants, and the Atlantic Slave Trade," 20.

19. Harris, *High on the Hog*, 20.

20. Harris, *High on the Hog*, 55–56.

21. Harris, *High on the Hog*, 24, 56.

22. Hall, "Food Crops, Medicinal Plants, and the Atlantic Slave Trade," 23, 28, 30, 32.

23. Harris *High on the Hog*, 145.

24. Quoted from Hall, "Food Crops, Medicinal Plants, and the Atlantic Slave Trade," 28.

25. Katie Knowles, "Fashioning Slavery: Slaves and Clothing in the United States South, 1830–1865," *Dress*, 38:1 (2012): 24–36, 33.

26. Quoted from Hall, "Food Crops, Medicinal Plants, and the Atlantic Slave Trade," 31.

27. William C. Whit, "Soul Food as Cultural Creation" in *African American Foodways*, ed. Anne L. Bower (Urbana and Chicago: University of Illinois Press, 2009), 47–49.

28. Opie, "Influences, Sources and African Diaspora Foodways," 193.

29. Knowles, "Fashioning Slavery," 30, 34.

30. Anne Yentsch, "Excavating the South's African American Food History" in *African American Foodways*, ed. Anne L. Bower (Urbana and Chicago: University of Illinois Press, 2009), 65–67.

31. Psyche Williams-Forson, "Chicken and Chains: Using African American Foodways to Understand Black Identities" in *African American Foodways*, ed. Anne L. Bower (Urbana and Chicago: University of Illinois Press, 2009), 128.

32. Williams-Forson, "Chicken and Chain," 131.

33. Williams-Forson, "Chicken and Chain," 128, 130.

34. Shane White and Graham White, *Stylin': Africa n American Expressive Culture from its Beginnings to the Zoot Suit* (Ithaca and London: Cornell University Press, 1998), 154.

35. Emma McClendon, *Denim: Fashion's Frontier* (New Haven: Yale University Press, 2016), 90.

36. Eric Darnell Pritchard, "Overalls: On Identity and Aspiration from Patrick Kelly's Fashion to Hip Hop," *The Funambulist* 15 (Clothing and Politics #2): 35.

37. Brenna Wynn Greer, *Represented: The Black Imagemakers Who Reimagined African American Citizenship* (Philadelphia: University of Pennsylvania Press, 2019), 2.

38. Greer, *Represented: The Black Imagemakers*, 3.

39. Whit, "Soul Food as Cultural Creation," 46–48, 51–52.

40. Opie, "Influences, Sources and African Diaspora Foodways," 202–203.

41. Kelley Fanto Deetz, "The Enslaved Chefs Who Invented Southern Hospitality," *Zacalo Public Square*, July 19, 2018, https://www.zocalopublicsquare.org/2018/07/19/enslaved-chefs-invented-southern-hospitality/ideas/essay/?xid=PS_smithsonian.

42. Bernadine Morris, "American in Paris Adds a Happy Note," *New York Times*, October 22, 1987, C10.

43. Pritchard, "Overalls," 33, 36.

44. Pritchard, "Overalls," 32.

45. Yentsch, "Excavating the South's African American Food History," 170–174.

46. Harris, *High on the Hog*, 116–138.

47. Eric Wilson, "Putting Patrick Kelly in Perspective," *Women's Wear Daily*, April 7, 2004, 14.

48. Rebecca Voight, "Remembering Patrick Kelly: American Whimsy in Paris," *Women's Wear Daily*, January 3, 1990, 28.

49. Pritchard, "Overalls," 33.

50. Julia Reed, "Talking Fashion: Patrick Kelly," *Vogue*, September 1989, 786.

51. Wilson, "Putting Patrick Kelly in Perspective," 14.

52. Harris, *High on the Hog*, 210, 217–220.

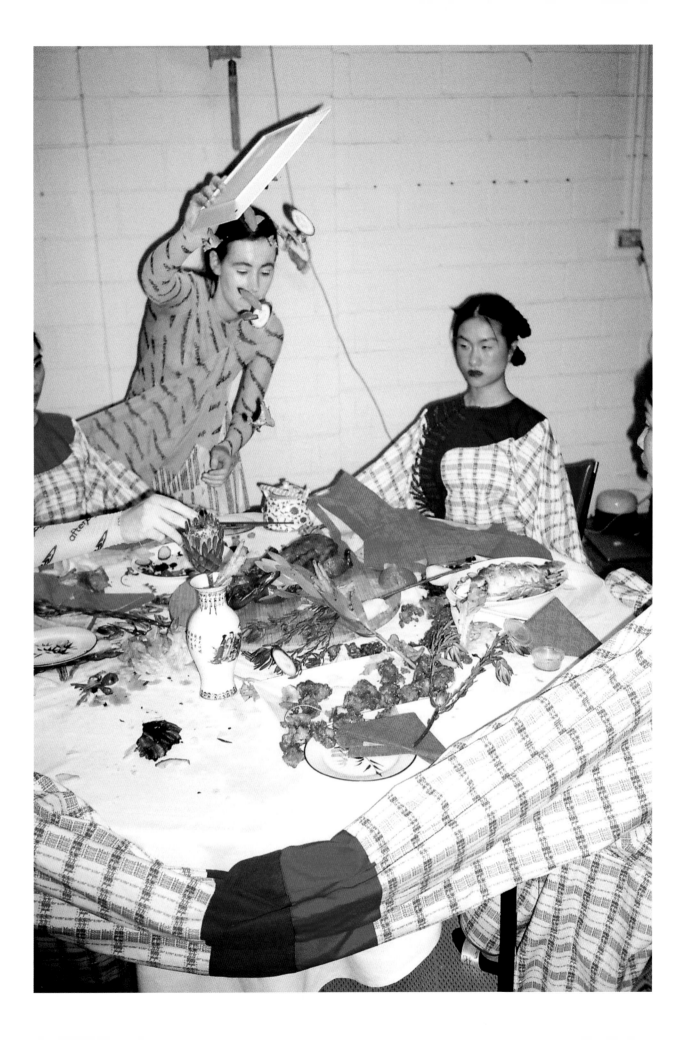

The Cross-Cultural Transformations of Chinese Food and Fashion

Faith Cooper

With their performance piece, "Eating the Other," artists and designers Betty Liu and Claire Myers used food and fashion to illustrate negative stereotypes of Chinese culture.[1] The piece aimed to "highlight how the Western gaze creates a uniform idea of China that appears across different mediums in the media."[2] As a part of the performance, models sat around a table with a variety of Chinese dishes; however, they were unable to eat the food because they were sewn together by their oversized qipaos (also known as cheongsams), which represented the narrow perceptions of Chinese fashion through the eyes of the West. While the Chinese models watched, two Caucasian models threw and picked at the Chinese dishes, symbolizing the Western attitude of picking and choosing ethnic food to their liking. For this piece, Liu found inspiration in the internalized racism that she experienced as a child. She believes, "There are definitely more and more artists and creatives questioning and subverting traditional Western portrayals of Chinese food. We need to welcome these voices to bring more complex and nuanced depictions of Chinese cuisine."[3]

Throughout China's history, both food and dress have played dominant roles in Chinese cultural expressions and have together been emphasized through ancient concepts. In Confucius' *Analects*, which is believed to have been written during the Warring States Period (475–221 BCE), it is stated, "One who has set his intentions upon the Way but is still ashamed of his clothing and food is 'not worth engaging in discussion.'"[4] Another ancient philosopher, Han Feizi, proclaimed, "If you ask which is more vital to the success of human beings, food or clothing, it is clear that people cannot do without either one of them; both are tools necessary for sustaining life."[5]

Figure 8.1
Eating the Other is a performance piece created by Betty Liu and Claire Myers, 2018. Photograph by Ruby Jurecka

During the nineteenth century, Chinese people—most of whom originated from China's southeast coastal regions—began to immigrate to the United States. Upon arrival, their foreign food and dress habits were among the first indicators that they were of a "stranger" status.[6] Many Americans viewed Chinese people as a danger to Western communities and attacked their customs, such as their Qing Dynasty queue hairstyles and preference for eating rice. Scholar Wendy Rouse Jorae explained, "Clothing and material culture proved significant in the debate over the future of the Chinese American community."[7] To avoid further persecution, many Chinese people homogenized to Western society and adopted garment and restaurant trades, creating a "transnational identity."[8] By 2015, the population of the United States included five million Chinese Americans, many of whom were creating new cultural shifts and constructing their own identities.[9] Included in this group were young designers who were using different mediums, such as food and fashion, to identify with their culture and overturn Western narratives.

From China to Chop-suey

During the nineteenth century, Americans labeled the Chinese as "celestials" and characterized them as being "despicable and barbaric people but also dangerous propagators of epidemics."[10] Although many Chinese immigrants wished to hold on to their traditions as a nostalgic reminder of their homeland and an expression of their cultural identity, anti-Chinese forces made it troublesome. Some Americans believed that, due to their foreign dress and food customs, the Chinese were unable to homogenize into Western society. Racist stereotypes, such as eating rats, were created and spread across the country, intensifying anti-Chinese xenophobia. In an 1874 issue of *Harper's Bazaar*, a journalist wrote of her experience eating a Chinese dinner. She explained, "Having heard much of the obnoxious stuff I should have to eat, and been duly cautioned that I should be ill for at least a week afterward, I intimated to a medical friend that I was about to 'dine à la Chinoise,' and should probably require his services that evening."[11] The writer revealed that she survived the meal, which, her friend explained, was only because she had the digestion of a horse. Americans also characterized common Chinese dishes as being inferior to Western standards. For example, the American Federation of Labor published the pamphlet, "Some Reasons for Chinese Exclusion: Meat vs. Rice, American Manhood vs. Asiatic Coolieism—Which Shall Survive?" which expressed "A decrease in our Chinese population will reduce the imports of foodstuffs and clothing used by the Chinese (which would be a benefit), but will have no effect whatever on the imports of silk and teas (which is not an unmixed blessing)."[12] Toward the end of the nineteenth century, anti-Chinese sentiment reached an all-time high. In 1882, President Chester A. Arthur signed the Chinese Exclusion Act, prohibiting the Chinese from entering the country.

Figure 8.2
Advertisement for Rough on Rats pesticide and insecticide, 1880s. It was printed by the Boston-based firm Forbes. Transcendental Graphics/Getty Images

One of the major arguments anti-Chinese groups spread as "Yellow Peril" ideology was that Chinese people were a threat to the American workforce. Consequently, the only jobs available to them were "feminized" labor, such as cooking and cleaning clothes in private homes.[13] By 1920, nearly half of the Chinese population in the United States were working in household service occupations.[14] Although they still faced public discrimination, the Chinese were praised for their work ethic and loyalty in servitude positions—some even calling them "Yellow Angels."[15] In 1934, *Vogue* suggested to its readers,

> To those who have lived in China, to those who live on our Pacific Coast, the Chinaman is accepted as a family servant. But on the Atlantic seaboard, he is an exotic, and usually the chic prerogative of the bachelor. Indeed, Chinamen are rare. Most of those you encounter are Koreans. But having your Chinaman, there is no one who can equal him, especially for a modest menage a deux.[16]

Many Americans believed that, as a result of their successful "domestic aptitude," Chinese people excelled only as servants, and could not possibly succeed in other areas, which blocked them from achieving independent or alternative careers.[17] However, as the Chinese community in the United States grew, they utilized their experience and skills working in households to establish clothing and food businesses, such as laundries and restaurants.

Upon immigrating to the United States, many Chinese people were subjected to harmful stereotypes and became victims of violent racist acts. In turn, Chinese communities sought to conform to Western standards and American society; however, this response was less of a desire to assimilate and more of a survival and business technique. For example, second-generation Chinese writer Pardee Lowe expressed why his father abandoned his queue when immigrating to the United States: "A queue, he very early learned, conferred neither dignity, respect nor power. It was a dirty, outlandish Manchu habit, derided by Americans."[18] Food and diet stereotypes associated with barbarism also prevented many Chinese from successfully opening restaurants where the American public would feel comfortable. In an 1872 issue of *Appletons' Journal*, Alexander Young predicted, "It is not likely that Chinese delicacies of the table will ever become popular in this country."[19] When Chinese immigrants began to open restaurants in the West, they were challenged to overcome racist food associations, and forced to think of creative ways to change this narrative.

Many Chinese people were angered by the racist food stereotypes that Westerners heavily promoted. Chinese civil rights activist Wong Chin Foo lectured in New York in 1877: "I never knew that rats and puppies were good to eat until I was told by American people."[20] In order to establish lucrative restaurant businesses, the Chinese amended

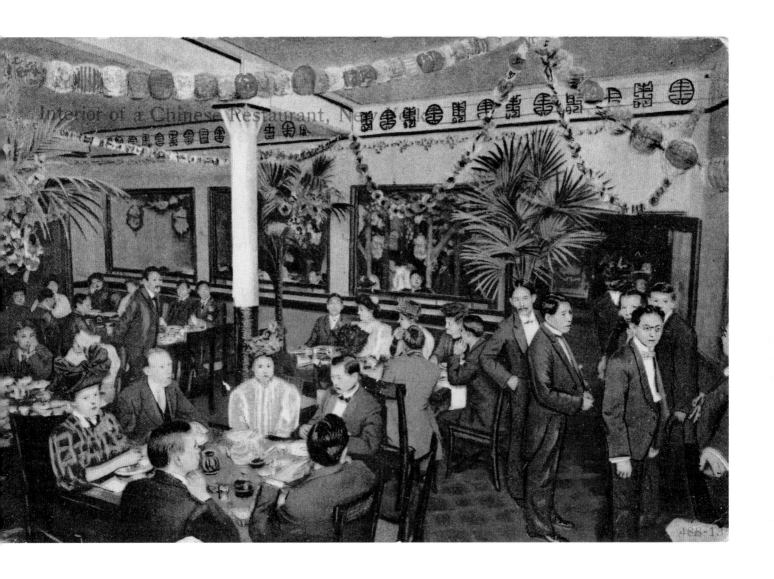

their traditional recipes to American tastes. Because many of the early Chinese immigrants originated from Guangdong Province, many popular Chinese-American dishes, such as chop suey, derived from Cantonese cuisine.[21] To further attract customers, Chinese restaurants offered large quantities of food for low prices and convenient services, such as meal delivery. Between 1900 and 1920, the number of Chinese restaurants doubled in many American cities.[22] During a visit to the United States in 1911, Chinese nationalist leader Sun Yat-sen observed, "There is no American town without a Chinese restaurant."[23] Once China became an American ally during World War II, the popularity of Chinese cuisine grew immensely. The Chinese Exclusion Act was also repealed in December 1943, permitting a quota of 105 Chinese people to immigrate to the United States annually.

Figure 8.3
Postcard of the interior of a New York Chinese Restaurant, 1907–1918. The Miriam and Ira D. Wallach Division of Art, Prints and Photographs, The New York Public Library Digital Collections

By the 1970s, Chinese food was an international success. According to a survey by the National Restaurant Association, "Oriental takeout" restaurants grew 131 percent between 1982 and 1987.[24] By 2001, more than 90 percent of Americans claimed to have tried Chinese food and 63 percent ate it at least once a month.[25] Although restaurants have proven to be successful businesses for many Chinese Americans, the number of Chinese-owned restaurants in the United States is now decreasing. Journalist and author of *The Fortune Cookie Chronicles* Jennifer Lee explained, "It's a success that these restaurants are closing. These people came to cook so their children wouldn't have to, and now their children don't have to."[26] Moving away from occupations previously associated with Chinese immigrants, Chinese Americans are entering a period of cultural shift marked by new ideas and passions, such as the business of fashion.

From Laundromats to Fashion Design

In 2010, *The New York Times* published the article, "Asian Americans Climb Fashion Industry Ladder" and claimed, "Their ascent to the top tier of New York fashion represents an important demographic shift on Seventh Avenue."[27] In 2018, twenty out of the 141 labels on the Council of Fashion Designers of America fashion week calendar included designers of Chinese descent.[28] This influx is a 200 percent increase from previous years. Helen Koh, former director of the Museum of Chinese in America, explained, "Now you don't think of Chinese-Americans in fashion in terms of laundromats. You think of fashion designers."[29] Although many Asian American designers take pride in their cultural identity, as a group they are individual designers and do not have "one particular Asian mode of expression."[30] Many have, however, used food to demonstrate and embrace their cultural backgrounds, which is a common community-building activity among Asian Americans. Food historian Jeffrey Pilcher addresses the dual role of food in strengthening cultural ties within immigrant communities and maintaining connections to homelands. He writes, "Such practices of cooking and eating together were particularly important among marginalized groups, whose foods were often derided as unhealthful or immoral by dominant social groups."[31] Therefore it is not surprising that a number of contemporary Chinese American designers have found inspiration in Chinese food culture. They have used their platform to honor their cultural backgrounds, while challenging Western stereotypes of Chinese people.

Although Chinese restaurants have become mainstream worldwide, many non-Chinese people still perceive them as exotic. The Vetements spring 2016 collection, created by Georgian designer Demna Gvasalia, was presented at the Chinese restaurant Le President, located in Paris' second Chinatown, Belleville. Many fashion critics commented on the unorthodox venue and described the still-operating

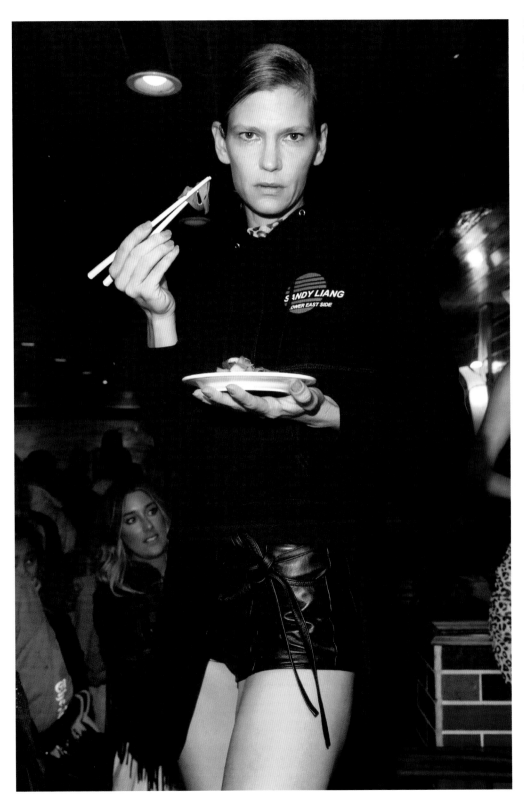

Figure 8.4
Sandy Liang spring/summer
2019 presentation at Congee
Village. Amy Sussman/WWD,
Courtesy of Fairchild Archive

restaurant as "tacky," "dingy," and "gaudy." [32,33,34] Although some have admired Chinatown for its "ultra kitschy" ambiance, Chinese American designer Sandy Liang explained, "It does look cool. And I get that people get fascinated with things, especially things that they aren't a part of, but I just feel like everybody can be respectful." [35] Liang presented her spring 2019 collection at her father's Chinese restaurant, Congee Village, which is located on the edge of New York's Chinatown. Guests were presented with look books resembling a Chinese restaurant menu and watched as models posed around dinner tables and a variety of her father's dishes. Liang has included Chinatown references in her past collections, including taking inspiration from the apron skirts worn by the Congee Village restaurant chefs, the styles worn by Chinese produce suppliers, and the cropped wide-legged pants worn by the older Chinese women who frequent the area. [36] She expressed, "It makes me sad when [stuff like that] becomes trendy because that means they matter less in a way, or that their coolness is ephemeral. But for me, it's just who I am. Like, it can't go out of trend for me." [37]

When designer Snow Xue Gao moved from Beijing to New York to study fashion, she included observing people in Chinatown in her design process. [38] Gao's work is a combination of Eastern and Western aesthetics and "a form of art that reflects society, philosophy, and business." [39] For both her fall 2018 and spring 2019 shows, she presented her collections at Jing Fong, one of New York's largest Chinese restaurants. Her guests were invited to enjoy tea and dumplings while listening to the restaurant's lunchtime rush of their regular dim sum customers. [40] The restaurant owners had originally disapproved of the idea of a fashion show until Gao promised to "leave it as it is, a Chinese restaurant." [41] Gao also designed the Jing Fong uniforms for more than one hundred of its employees. She explained, "Nobody has really thought to design a uniform for a Chinese restaurant." [42]

In 2020, three fashion designers of Chinese descent launched non-fashion culinary projects reaching beyond their fashion audiences. These projects are arguably more relatable than their design practices. As Anne Anlin Cheng, a Princeton professor and scholar of race and critical food studies, states, "the most digestible thing about Asian Americanness today for mainstream America is arguably the way of connections to foods." [43] Jason Wu started a food diary Instagram account, @mrwueats; Phillip Lim published a digital and more affordable version of his cookbook, *More Than Our Bellies*; and Humberto Leon of Opening Ceremony opened his restaurant, Chifa. Although these projects are not solely focused on Chinese food, all three designers have expressed that part of their food inspiration has come from their upbringings and a desire to embrace it. When Wu introduced his Taiwanese mother's fried rice recipe to *The New York Times*, he recalled the internalized racism that he experienced as a child: "There weren't a lot of Asian kids in my class, so we would get teased. Like 'Oh, hey, enjoy your *cabbage*.' . . . Growing up in the West, I was always wanting

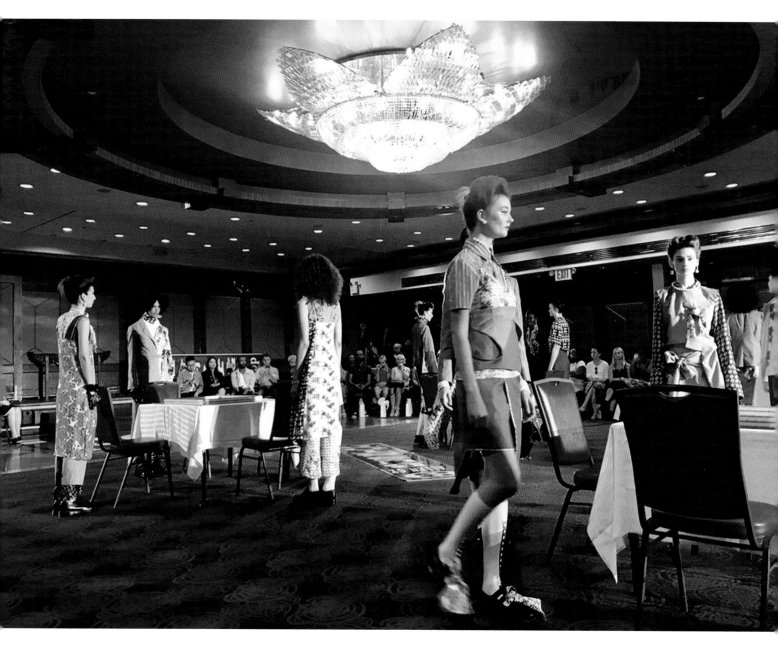

Figure 8.5
Snow Xue Gao spring/summer
2019 presentation at Jing Fong.
Photograph by Akiko Ichikawa

Figure 8.6
Image from *More Than Our Bellies* by Phillip Lim and Viviane Sassen. Photo by Viviane Sassen

to be very Westernized to fit in. And in my twenties, I really started re-embracing my roots."[44] Lim explained his upbringing: "My parents wanted me to assimilate into Western culture, but the rules, food and language at home were all Chinese . . . Then, one day, I was missing my mother so much. She used to make me this basil ginger chicken which always put me in a good mood. I bought the ingredients I thought were in it and went home and recreated it."[45] Leon of Opening Ceremony currently acts as the creative marketing director of his Chinese and Peruvian restaurant, Chifa, with his mother helming the kitchen. He explained, "It's a reflection of what we grew up with at home." As the Asian American community uses food and fashion to embrace its cultural heritage, Western brands are simultaneously adopting Chinese food references to attract China's emerging luxury consumer.

From West to East

Since first arriving in the United States, Chinese immigrants were encouraged to assimilate to Western beauty and fashion standards. However, in recent years, Chinese consumers have dominated the luxury market, spending several hundreds of billions of RMB annually on luxury goods.[46] By 2025, Chinese consumers are expected to make up 40 percent of the world's luxury market, spending about 1.2 trillion RMB on luxury items. Chinese American designer Alexander Wang, whose immigrant family worked at a laundromat and owned a restaurant, observed, "There's definitely a sense of pride. China used to be known as a copy-cat country but now, whether it's digital companies or shopping malls, every brand [wants to test out] that market because it's the most advanced."[47] To attract this growing demographic, Western luxury brands are targeting Chinese consumers directly, incorporating Chinese design aesthetics and food references into their business models. For example, for Chanel's Paris-Shanghai pre-fall 2010 presentation, Karl Lagerfeld created the Chanel "take away" purse, which resembled a Chinese restaurant takeout box.[48] (It is important to note, however, that these types of containers were created by Americans, who added generic Asian-inspired designs, such as pagodas, and words in an ersatz Chinese font.)[49] For Gucci's "Roman Rhapsody" cruise 2018 campaign, creative director Alessandro Michele chose representatives of Rome's multicultural community to serve as models. Among those chosen was Chinese immigrant Sonia Fenxia, owner of Hang Zhou, Rome's first Chinese restaurant to be included in the prestigious Italian food and wine magazine *Gambero Rosso*. It is rare to see an ordinary Chinese woman featured in a fashion advertisement; however, Fenxia's appearance gathered more than 500,000 likes on Gucci's social media accounts, and the campaign became viral in China.[50] Over recent years, non-Asian fashion designers who have embraced Chinese cultural references have been both praised or accused of appropriation, while others have garnered larger reactions.

In November 2018, Dolce & Gabbana was organizing the largest fashion show in the brand's history, known as "The Great Show." To promote the presentation, which was to be held in Shanghai, Dolce & Gabbana launched a video campaign titled "Eating with Chopsticks by Dolce & Gabbana," which featured Chinese model Zuo Ye. One of the videos depicted Ye struggling to eat a large cannoli, while a male voice mockingly narrated, "Let's use these small stick-like things to eat our great pizza margherita."[51] The videos evoked anger among many Chinese Weibo social media users. One explained, "If we don't kick D&G out of China now, there will be many other foreign brands trampling on our Chinese dignity!" Another commented, "That's explicit racism. D&G's stereotyping China. [The videos] only show the brand's outdated view about China."[52] Within twenty-four hours of the videos' launch, Dolce & Gabbana

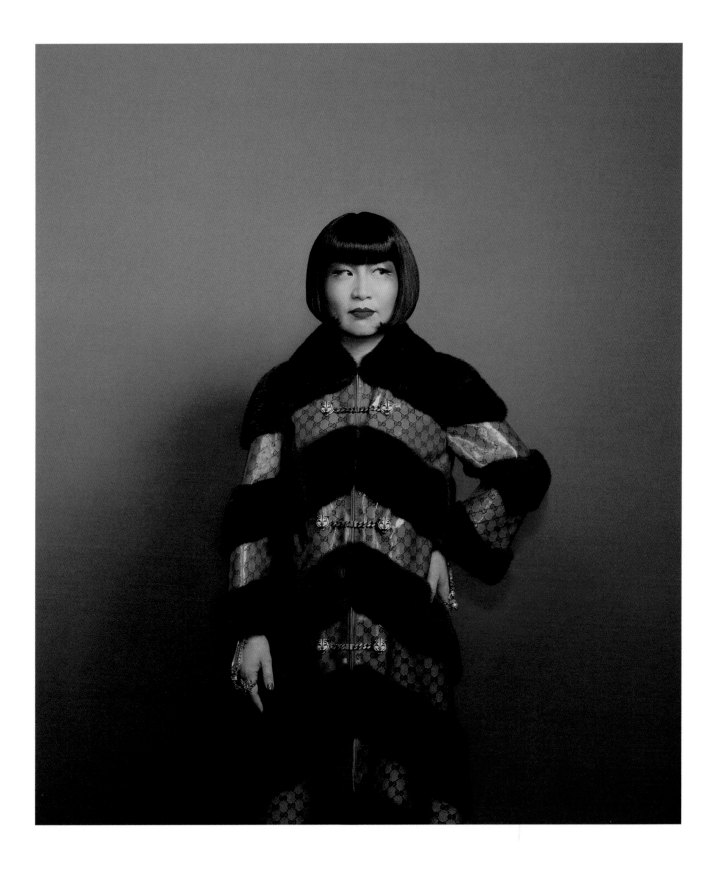

removed them from its Weibo account; however, hours before "The Great Show" was to premiere, messages from Stefano Gabbana's Instagram were leaked online. His messages described the Chinese as "ignorant dirty smelling mafia" among other racist statements.[53] The leaked messages went viral, leading hundreds of Chinese people involved in the show to withdraw. Protests emerged at Dolce & Gabbana stores worldwide, and Chinese e-commerce companies removed its products from their online stores. "The Great Show" was canceled, and Domenico Dolce and Stefano Gabbana issued a statement explaining, "Our dream was to bring to Shanghai a tribute event dedicated to China which tells our history and vision." In response to the controversy, China's state-run media outlet Xinhua News Agency requested foreign brands to respect Chinese consumers.[54]

Throughout Chinese cultural history, food and fashion has developed and transformed around the globe. Modern Chinese writer and intellectual Lin Yutang wrote, "It is almost amusing to see the often self-conscious determination to be really Chinese, to eat Chinese food, to live in Chinese ways, to dress in Chinese clothes."[55] Although Chinese immigrants tried to hold on to their cultural traditions in the United States, they were faced with discrimination. To escape racial persecution, the Chinese embraced Western standards and established lucrative garment and restaurant businesses. Although China was once associated with barbarism, today it is the world's biggest exporter; has the fastest-growing, trillion-dollar economy; and has the second-largest economy, following the United States.[56,57] Asian Americans are the fastest-growing racial group in the United States, with Chinese Americans making up the largest population (23%) of that demographic.[58] Over recent years, many empowered Chinese people around the globe are succeeding in areas beyond their associated stereotypes. As fashion historian Valerie Steele predicts, "The full impact of Chinese-heritage designers on the international world of fashion is still to be realized."[59] Chinese culture is evolving around the world, and positive perceptions of it will continue to grow in both the food and fashion industries.

Figure 8.7

Sonia Fenxia in Gucci's "Roman Rhapsody" Cruise 2018 campaign. Photo by Mick Rock for Gucci. Creative Director: Alessandro Michele, Art Director: Christopher Simmonds, Hair Stylist: Paul Hanlon, Makeup Artist: Yadim Carranza

Notes

1. Merlyn Miller, "In 'Eating the Other,' Fashion and Food for Confronting the Objectification of Chinese Culture," *MOLD*, February 28, 2019, https://thisismold.com/visual/art/in-eating-the-other-fashion-and-food-for-confronting-the-objectification-of-chinese-culture#.XQj08hZKiUk.

2. Miller, "In 'Eating the Other.'"

3. Betty Liu, email interview, July 16, 2020.

4. Erin Cline, *Confucius, Rawls, and the Sense of Justice* (New York City: Fordham University Press, 2013), 125.

5. Philip J. Ivanhoe and Bryan W. Norden, eds., *Readings in Classical Chinese Philosophy* (Indianapolis: Hackett Publishing, 2001), 335.

6. Sue F. Chung, *Chinese in the Woods: Logging and Lumbering in the American West* (University of Illinois Press, 2015), 37.

7. Wendy Rouse Jorae, "The Limits of Dress: Chinese American Childhood, Fashion, and Race in the Exclusion Era," *The Western Historical Quarterly* 41, no. 4 (Winter 2010): 463.

8. Rouse Jorae, 454.

9. Pew Research, "Key Facts About Asian Americans," Pew Research Center, September 8, 2017, https://www.pewresearch.org/fact-tank/2017/09/08/key-facts-about-asian-americans/.

10. Yong Chen, *Chop Suey, USA: The Story of Chinese Food in America* (New York: Columbia University Press, 2014), 19.

11. "A Chinese Dinner," *Harper's Bazaar*, May 9, 1874, 305.

12. American Federation of Labor, "Some Reasons for Chinese Exclusion: Meat Vs. Rice, American Manhood Against Asiatic Coolieism. Which Shall Survive?" (US Government Printing Office, 1902), 23.

13. Joan Wang, "Race, Gender, and Laundry Work: The Roles of Chinese Laundrymen and American Women in the United States, 1850–1950," *Journal of American Ethnic History* 24, no. 1 (Fall 2004): 60.

14. Wang, "Race, Gender, and Laundry Work," 61.

15. Chen, *Chop Suey, USA*, 48.

16. Grace Hegger, "Features: My Cook Is a Chinaman," *Vogue*, October 15, 1934, 76.

17. Chen, *Chop Suey, USA*, 47.

18. Rouse Jorae, "The Limits of Dress," 461.

19. Alexander Young, "Chinese Food and Cookery," *Appletons' Journal: A Magazine of General Literature* 8, no. 171 (July 1872): 293.

20. Haiming Liu, *From Canton Restaurant to Panda Express: A History of Chinese Food in the United States* (Chicago: Rutgers University Press, 2015), 39.

21. Chen, *Chop Suey, USA*, 144.

22. Jennifer Lee, *The Fortune Cookie Chronicles: Adventures in the World of Chinese Food* (Cornwall: Twelve, 2008), 56.

23. Chen, *Chop Suey, USA*, 8.

24. Lee, *The Fortune Cookie Chronicles*, 174.

25. Pei Liu and Junehee Kwon, "The Exploration of Effects of Chinese Cultural Values on the Attitudes and Behaviors of Chinese Restaurateurs Toward Food Safety Training," *Journal of Environmental Health* 75, no. 10 (June 2013): 38.

26. Amelia Bierenberg and Quoctrung Bei, "Chinese Restaurants Are Closing. That's a Good Thing, the Owners Say," *The New York Times*, December 24, 2019, https://www.nytimes.com/2019/12/24/upshot/chinese-restaurants-closing-upward-mobility-second-generation.html.

27. Eric Wilson, "Asian-Americans Climb Fashion Ladder," *The New York Times*, September 5, 2010, 1.

28. Cathaleen Chen, "Fashion Designers Boldly Embrace Their Chinese Heritage," *The Business of Fashion*, October 8, 2018, https://www.businessoffashion.com/articles/intelligence/chinese-heritage-fashion-designers.

29. Eric Wilson, "Documenting a Growing Force in Fashion," *The New York Times*, April 25, 2013, E2.

30. Thessaly La Force, "The Asian-American Fashion Designers Who Shaped the Industry," *The New York Times*, April 13, 2020, https://www.nytimes.com/interactive/2020/04/13/t-magazine/asian-american-fashion-designers.html.

31. Jeffrey M. Pilcher, *The Oxford Handbook of Food History* (New York: Oxford University Press, 2012), xxi.

32. Susie Lau, "The Label That Brought Kanye to a Tacky Chinese Restaurant," *Dazed*, October 2, 2015, https://www.dazeddigital.com/fashion/article/26810/1/deconstructing-vetements-ss16-chinese-restaurant-kanye.

33. Matthew Schneier, "Vetements Brings Its Brand of Disruption to Couture," *The New York Times*, July 1, 2016, https://www.nytimes.com/2016/07/03/fashion/vetements-couture.html.

34. Jake Hall, "Getting Up Close and Personal with VETEMENTS SS16," *Dazed*, December 18, 2015, https://www.dazeddigital.com/fashion/article/28880/1/getting-up-close-and-personal-with-vetements-ss16.

35. Rachel Hodin, "Sandy Liang, Congee Village Heiress," *The Face*, July 8, 2019, https://theface.com/style/sandy-liang-new-york-congee-village-heiress.

36. Chen, "Fashion Designers Boldly Embrace Their Chinese Heritage."

37. Hodin, "Sandy Liang, Congee Village Heiress."

38. Kristopher Fraser, "Snow Xue Gao Finds Inspiration from Chinatown for Fall/winter 2018," *Fashion United*, February 10, 2018, https://fashionunited.uk/news/fashion/snow-xue-gao-finds-inspiration-from-chinatown-for-fall-winter-2018/2018021028098.

39. Nicky Campbell, "Snow Xue Gao Brings Eastern Culture West to NYFW," CFDA, January 31, 2019, https://cfda.com/news/snow-xue-gao-brings-eastern-culture-west-at-nyfw.

40. Monica Kim, "Spring Summer 2019," SNOW XUE GAO, September 8, 2018, https://www.snowxuegao.com/collections/spring-summer-2019.

41. Hikmat Mohammed, "Meet Snow Xue Gao, The Buzzy Designer Dressing Restaurant Staff — And Rihanna," *ELLE*, June 12, 2018, https://www.elle.com/uk/fashion/a20715710/label-to-know-snow-xue-gao/.

42. Mohammed, "Meet Snow Xue Gao."

43. J. M. Coghlan, ed., *The Cambridge Companion to Literature and Food* (Cambridge: Cambridge University Press, 2020), 215.

44. Nick Marino, "Jason Wu's Untraditional (and Easy) Fried Rice," *The New York Times*, September 7, 2018, https://www.nytimes.com/2018/09/07/t-magazine/food/jason-wu-fried-rice-ham-recipe.html.

45. Florence Derrick, "Fashion Guru Phillip Lim Turns His Creativity to the Kitchen," July 1, 2019, https://www.florencederrick.com/2019-7-3-designer-dining-interview-with-phillip-lim/.

46. "China Luxury Report 2019," McKinsey & Company, April 2019, X.

47. Chen, "Fashion Designers Boldly Embrace Their Chinese Heritage."

48. Lisa Movius, "Karl Lagerfeld Talks Shanghai and Fashion." *Women's Wear Daily*, December 4, 2009.

49. Lee, *The Fortune Cookie Chronicles*, 139.

50. Liu Chen, "Female Chinese Restaurant Operator in Italy Becomes a Sensation After Acting in Gucci 2018 Campaign Video," CGTN, December 10, 2017, https://news.cgtn.com/news/304d544d31637a6333566d54/index.html.

51. Yuhan Xu, "Dolce & Gabbana Ad (With Chopsticks) Provokes Public Outrage in China," NPR.org, December 1, 2018, https://www.npr.org/sections/goatsandsoda/2018/12/01/671891818/dolce-gabbana-ad-with-chopsticks-provokes-public-outrage-in-china.

52. Xu, "Dolce & Gabbana Ad."

53. Xu, "Dolce & Gabbana Ad."

54. Xu, "Dolce & Gabbana Ad."

55. Lin Yutang, *My Country and My People* (Portsmouth, NH: William Heinemann LTD., 1936), ix.

56. "China Index of Economic Freedom," The Heritage Foundation, n.d., https://www.heritage.org/index/country/china.

57. Prableen Bajpai, "The 5 Largest Economies In The World And Their Growth In 2020," NASDAQ, January 22, 2020, https://www.nasdaq.com/articles/the-5-largest-economies-in-the-world-and-their-growth-in-2020-2020-01-22.

58. Pew Research Center, "Asian Americans," Pew Research Center's Social & Demographic Trends Project, n.d., https://www.pewsocialtrends.org/rise-of-asian-americans-2012-analysis/overview/.

59. Valerie Steele, *Fashion at MOCA: Shanghai to New York* (New York: Museum of Chinese in America, 2013), 3.

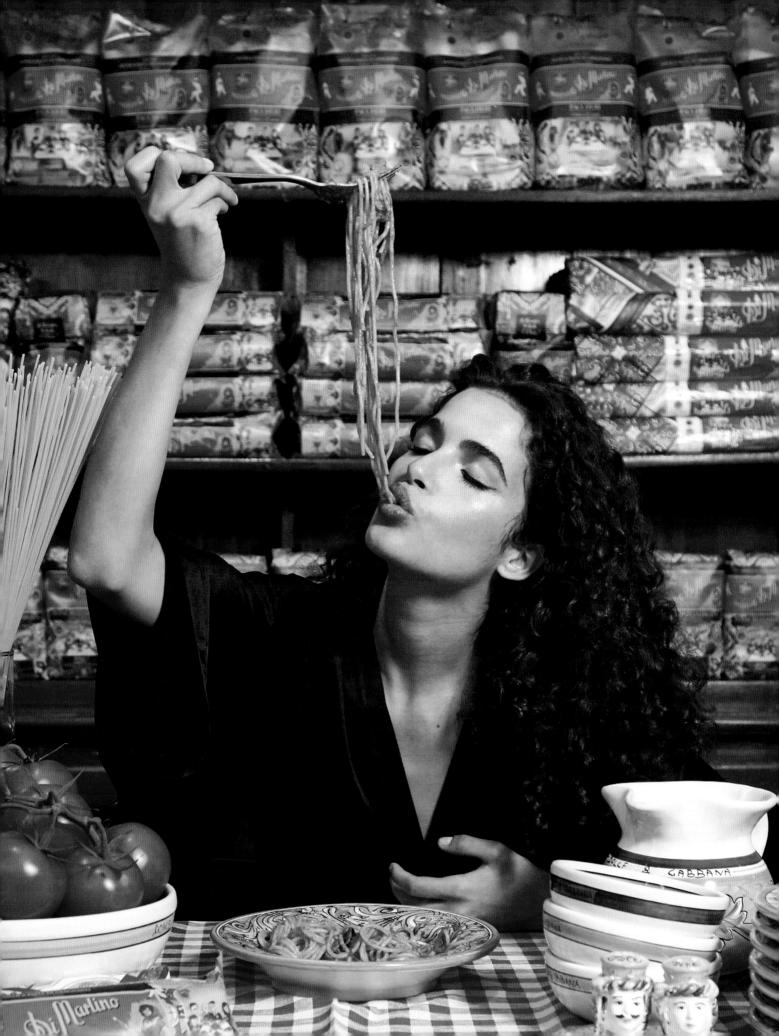

I piaceri della tavola: Food, Fashion, and Italian Identity

Melissa Marra-Alvarez

Food is arguably one of the most conspicuous elements of Italian identity. Dishes such as spaghetti and pizza have merged with the Italian character in public consciousness and have become foundational to the image of Italy as a nation. The foods of Italy, however, are actually quite diverse, varying among regions as the result of a culinary history dating back to antiquity. Although such perceptions oversimplify the complexities of a rich history of food and culture, they nonetheless form a construct of what Roland Barthes termed *Italianicity*, recognized by Italians and non-Italians alike. In *The Rhetoric of the Image*, Barthes explains, "*Italianicity* is not Italy; it is the condensed essence of everything that could be Italian, from spaghetti to painting."[1]

In the introduction to the book *Italians and Food*, sociologist Roberta Sassatelli asserts that food culture is central to the way that Italians mark their national identity and to the consolidation of *Italianicity* in a global context.[2] She also notes that gastronomic identity, like other aspects of identity, is "a continuous construction that consolidates through practice, across history and geography."[3] During the turn of the twentieth century, food served as a powerful symbol of collective identity for the Italian diaspora in the United States, as eating became an act of self-identification and pride. In his book *The Italian American Table: Food, Family and Community in New York City* (2013), Simone Cinotto writes, "When the first great wave of Italians arrived in New York in the 1890s, they brought with them neither a sense of nation nor any single concept of 'Italian' cooking."[4] He argues that foods such as pasta, marinara sauce, and pizza emerged as identity-building symbols for immigrant Italians, embodying the distinctive characteristics of domesticity and intimacy.

When Italy as a nation was finally unified in 1861, there was no one national cuisine, "but rather a patchwork of local food habits that reflected divides between the diets of the well-off and the working poor, and those of the cities and the countryside."[5]

Figure 9.1

Advertising image from Dolce & Gabbana's collaboration with the Italian pasta company Pastificio Di Martino, 2017. Courtesy of Dolce & Gabbana with photography by Davide Gallizio and model Chiara Scelsi

Figure 9.2
Neapolitan peasants eating macaroni, 1869. Photographer Conrad Georgio, Library of Congress Prints and Photographs Division Washington, D.C. 20540 USA

Reflecting the notion that creating a nation requires more than political unification, writer and statesman Massimo d'Azeglio reportedly proclaimed, "Italy is made, now let us make Italians."[6] With this goal in mind, Italy's food culture and foodways assumed a significant role in forging solidarity and projecting a consolidated Italian culture. Food historian Massimo Montanari maintains that an evolving "Italian" gastronomic identity, was integral to shaping an equally evolving "Italian" cultural identity that, in turn, both reflected and inflected the national and political character of "Italy."[7]

In 1891, Italian businessman Pellegrino Artusi set out to unify his country's gastronomic practices and to establish a shared culinary language. His cookbook, *Science in the Kitchen and the Art of Eating Well*, was integral to the founding of a national model of Italian cuisine, and to the creation of a symbolic unity of the Italian people. Artusi traveled throughout Italy and focused on those cities with markets and relationships with outlying areas. Author Alberto Capatti observed, "The railway in 1891 connected all the gastronomic stops cited in *Scienza in cucina* and delimited the regions known by [Artusi]."[8] Although not representative of every region, the resulting book was a compilation of dishes, each with its own culinary style determined by environment, resources, and traditions, as well as by cultural exchanges with neighbors.[9] Pasta is given considerable attention in Artusi's cookbook, which includes a number of recipes for spaghetti, in particular.[10] Although the culture of pasta is not exclusive to Italy, nor did it originate there,[11] what *was* distinctly Italian, according to Montanari, was the variety of shapes pasta assumed during the Middle Ages, based on the diverse gastronomic traditions of the peninsula.[12] As new technologies made pasta easier to produce, it increasingly became a part of Italian life. Later, at the turn of the twentieth century, Italian immigrants recreating the foods of their homeland in America subscribed to a comprehensive menu of "Italian" specialties—among them: pasta, tomato sauce, and pizza—which represented a singular Italian identity, eliminating regional differences.[13] Such adaptations highlight Sassatelli's assertion that food and foodways are more than a matter of sustenance; food, deeply intertwined with culture, becomes a "site of contamination and exchange, where social identities are constructed and realized, celebrated and challenged."[14]

Italian fashion, like the food culture that preceded it, also arose as a symbol of national pride and identity. In his forward to *Fashion, Italian Style*, which accompanied the 2003 exhibition at the Museum at FIT, Beniamino Quintieri, chairman of the Italian Trade Commission, noted the importance of fashion as a vehicle for disseminating the "Italian Lifestyle."[15] As prominent modes of cultural production and exchange, food and fashion are both mediums in which identities are constructed and celebrated. Like culinary practices, fashion is a cultural phenomenon—an aesthetic medium for the expression of ideas, desires, and beliefs prevalent in the society.[16] Italy's fashion industry emerged during the latter half of the twentieth century, developing rapidly thereafter and earning a cultural prestige that was distinctly Italian.

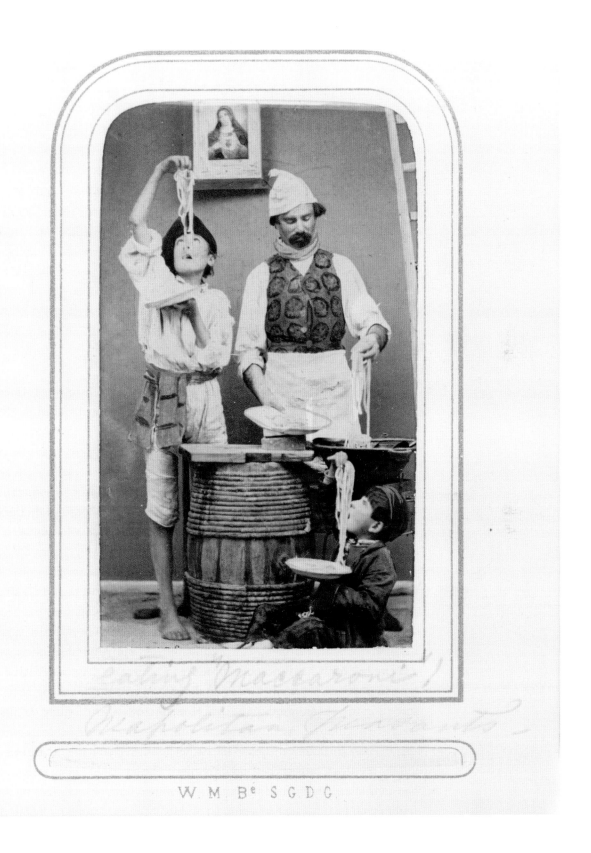

Post-war Italy heralded a period of rapid cultural and socioeconomic change, in which it sought to found a national identity through fashion that could be utilized as a form of soft power. A 1952 *Life* magazine article reported, "Just like the Chianti, Italy's fashions [are] becoming as well-known as its table wine."[17] Characterized by high-level craftsmanship, exquisite tailoring, and a relaxed elegance, Italian fashion became a stylistically independent industry by the 1970s, and by the 1980s, it was recognized as one of the top three players on the international fashion stage, along with Paris and New York.[18]

A 1985 *Vogue* feature that showcased designs by Valentino, Fendi, Missoni, and Armani paid tribute to Italian artistry and craftsmanship in fashion. Rife with food metaphors, the article compared Italian art, "the backbone of the international market," to Italy's artisanal food culture. Parallels were also drawn between Americans' consumption of handcrafted pastas, balsamic vinegar, and mozzarella and their rejuvenated embrace of Italian fashion, underscoring the prominence of the country's food and fashion as marketable examples of Italian cultural capital. This is emphasized by the author who juxtaposes these new accolades with earlier attitudes towards Italian products. The *Vogue* article states:

> Let's face it, ten years ago, maybe fifteen, the word *Italy* to most Americans conjured up nothing but the most banal connotations: red and white checked tablecloths, the smell of garlic, la dolce vita, Sophia Lauren and the *Mona Lisa*. . . . Mozzarella bought in New York was like something you'd use at the end of a pogo stick (if I remember correctly it even had a bouncy name); Italian fashion was some tiny silk shift by Pucci that could be rolled up into something the size of a tennis ball. But garlic is perhaps the best metaphor for Italy, the way it was perceived from this side of the Atlantic in those years: wholesome, hard to digest, hard to ignore, and fragrant like a hot August day in Naples.[19]

In addition to linking food and fashion with ideas of taste, the article also goes on to describe each as a culture of commerce and craftsmanship. Cultural geographers David Bell and Gill Valentine reason that taste—as a marker of "good" quality or of a high aesthetic standard—can "work to construct our cultural identity: we may be what we eat, but what we eat also produces who we are."[20] By referencing previous American attitudes towards the foodstuffs of Italy as a metaphor for America's attitudes towards Italian fashion, the article highlights Italy's carefully cultivated food and fashion cultures. Laden with sociocultural symbolism and intrinsic to national identity, they are intimately tied to the cachet associated with the "Made in Italy" label and the prestige it projects beyond its borders. The appeal of Italian fashion to American consumers, highlighted in *Vogue*, is consistent with observations by anthropologist Franco La Cecla about the model of Italian cuisine crafted by Italian American

immigrants during the twentieth century. "The creation of an Italian cuisine arose from a specific encounter between Italian domesticity, and the standardization model and the shop-window effect of a great expanding American market" wrote La Cecla. "It could be said that the Italians rode that model so masterfully that they made Italianness appealing and salable worldwide."[21]

Pasta and Pizza: Icons of Italy

A man's white linen vest with resin bow tie pasta buttons, designed in 1992 by Italian designer Franco Moschino, employs the designer's irreverent wit and love of the surreal to make explicit connections between food and national identity. The back of the vest features embroidered trompe l'oeil strands of spaghetti, a splash of tomato sauce, and a basil leaf, along with the words "Sorry. I'm Italian!" Here, Moschino creates a visual pun that operates twofold: on the one hand, it celebrates food and the act of eating as a source of Italian pride, and, on the other, it challenges stereotypes of Italians as "macaroni-eaters," a derogative label dating back to the seventeenth century when shortages of meat and vegetables led to pasta becoming a "food of the people."[22] For Moschino, humor is a mechanism that enables him to disrupt and reinforce the very social conventions that he ridicules, while expanding the boundaries of the imagination.[23] As anthropologist Mary Douglas has noted, jokes confront one accepted pattern with another, provoking a creative reinterpretation of social relationships.[24] In this case, a spatter of pasta and sauce against a white background may elicit images of a food-stained shirt or tablecloth, both remnants of a bountiful meal; however, the color scheme of red, white, and green is that of the Italian flag, reinforcing pride in Italian culture. Moschino's tongue-in-cheek design also fortifies notions of ease and conviviality often associated with Italy's food and fashion cultures.

Originating as a street food in Naples, pizza is now among the most popular foods worldwide. Its iconic status, however, was born of a unique iteration of this food by immigrant Italians in America—many who hailed from southern Italy—who were limited to using those products available in their new country. Historian Aliza Wong writes, "Pizza as a national icon is one that has been created by immigration, interpretation, exportation and re-importation."[25] Italian folklore posits the margherita pizza specifically as a national symbol. As legend has it, Queen Margherita, monarch of the newly unified Italy, visited Naples in the desire to break the monotony of French cooking. Pizza maker Raffaele Esposito honored her with a pizza that represented the three colors of the Italian flag: red in tomato sauce, white in the mozzarella, and green in fresh basil.

Drawing on this legacy, a 1980s Moschino Jeans shift dress, with an allover pattern of pizza, chianti in a traditional straw *fiasco*,[26] and Italian flags and streamers, employs food imagery to reinforce cultural pride and the prestige of the "Made in Italy" label.

Figure 9.3 (overleaf)
"Fashion Menu: Pasta," editorial by Anna Piaggi, *Vogue Italia*, May 1991, p.144–145. Realized by Bruno Rinaldi, Alfa Castaldi and Anna Piaggi

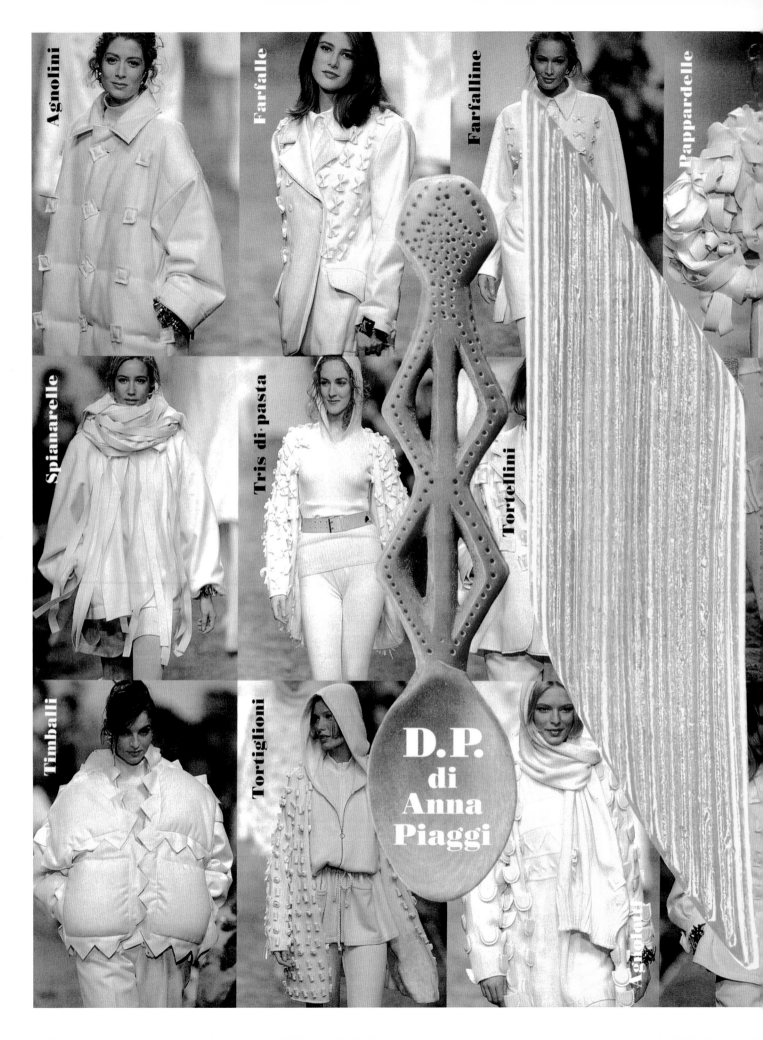

Agnolini

Farfalle

Farfalline

Pappardelle

Spianarelle

Tris di·pasta

Tortellini

Timballi

Tortiglioni

**D.P.
di
Anna
Piaggi**

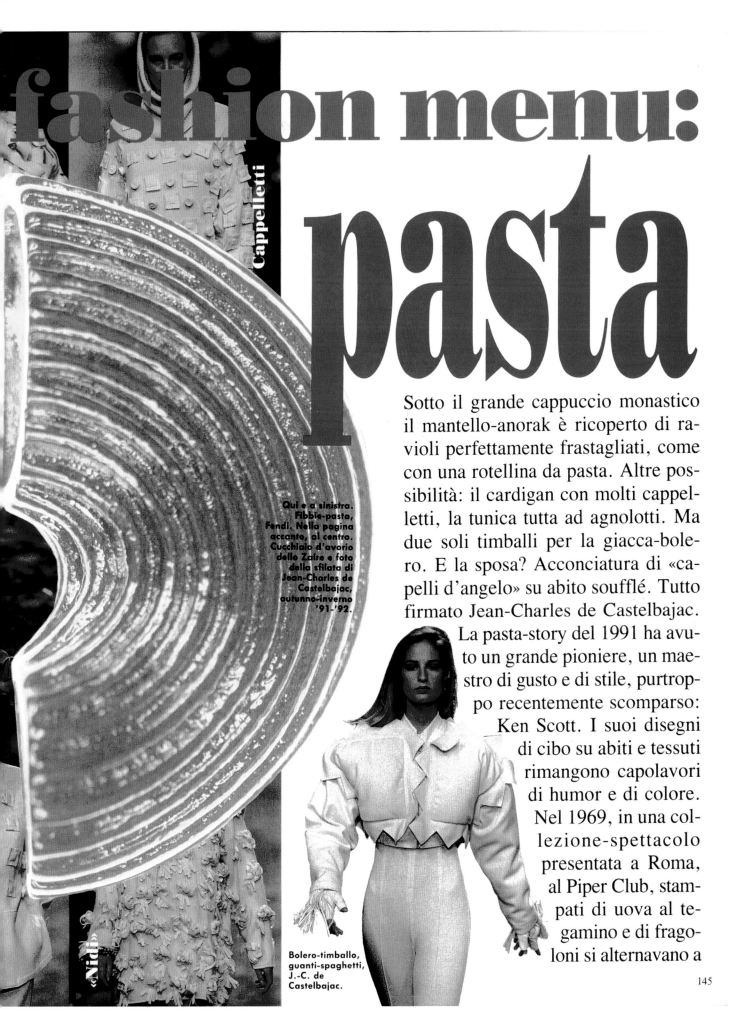

fashion menu: pasta

Cappelletti

Sotto il grande cappuccio monastico il mantello-anorak è ricoperto di ravioli perfettamente frastagliati, come con una rotellina da pasta. Altre possibilità: il cardigan con molti cappelletti, la tunica tutta ad agnolotti. Ma due soli timballi per la giacca-bolero. E la sposa? Acconciatura di «capelli d'angelo» su abito soufflé. Tutto firmato Jean-Charles de Castelbajac.

La pasta-story del 1991 ha avuto un grande pioniere, un maestro di gusto e di stile, purtroppo recentemente scomparso: Ken Scott. I suoi disegni di cibo su abiti e tessuti rimangono capolavori di humor e di colore. Nel 1969, in una collezione-spettacolo presentata a Roma, al Piper Club, stampati di uova al tegamino e di fragoloni si alternavano a

Qui e a sinistra. Fibbia-pasta, Fendi. Nella pagina accanto, al centro. Cucchiaio d'avorio dello Zaire e foto della sfilata di Jean-Charles de Castelbajac, autunno-inverno '91-'92.

Bolero-timballo, guanti-spaghetti, J.-C. de Castelbajac.

«Nidi»

Pizza and chianti are both inexpensive and accessible foodstuffs that are highly public symbols of Italianness to those on and off the peninsula. The same can be said of the Moschino Jeans label, which was a less expensive, "accessible" line of ready-to-wear that served as a symbol of Italianacity for the fashion-conscious consumer. For Moschino, who believed fashion should be fun and send a message, food references offered an outlet to express pleasures and beliefs and became a symbolic medium through which to reinforce stereotypes or undermine them.

Fashion editor and *grande gourmand* Anna Piaggi would bring together the worlds of food and fashion in "Doppie Pagine," the double-page editorial spreads that she created for *Vogue Italia*.[27] "Like a glam alchemist, she loved to link runway trends with a myriad of esoteric cultural and pop references from the Bloomsbury Circle to . . . food!" recalled Grazia d'Annunzio, former *Vogue Italia* editor.[28] In 1991, Piaggi served up a delectable homage to fashion and food in a feature titled "Fashion Menu: Pasta." "I still vividly remember how she came up [with] the pasta idea," recalled d'Annunzio. "During our regular phone meeting, after explaining the 'theme' of the May 1991 issue—the glamorous style of iconic stars such as Sophia Loren—and answering her questions, she said it loud: 'Let's make spaghetti!'"[29] For this feature, designs by Maurizio Galante and accessories by Fendi and Manolo Blahnik were interpreted through a culinary lens, while looks from Jean-Charles de Castelbajac's spring 1991 collection—the centerpiece of the editorial—were expressly classified as varieties of pasta.[30] D'Annunzio remembers "with a culinary twist she 'revisited' the details of the Jean-Charles de Castelbajac's white s/s '91 collection. Thin and thick fringe became angel hair and linguine; ruches were mafaldine, while quilted fabric . . . ravioli."[31] With an eye for detail and accuracy, Piaggi enlisted the help of a renowned Italian pasta maker to accurately identify the various types.[32] A veritable feast for the eyes, the resulting editorial was "a surreal, funny, unexpected gastro-feast."[33]

The variety in pasta shapes across Italy's regions is at once testament to the unity in diversity within Italian cuisine.[34] Such variety makes pasta a complex food with a multifaceted identity, a defining characteristic of fashion itself. The myriad variations in form and texture also bespeak the artistry involved in pasta-making, and parallels that of fashion, making it a fitting metaphor. Steeped in Italian heritage, the family-run luxury fashion house Fendi has also employed its artisan craftsmanship to produce pasta-themed gilt resin necklaces and bracelets, as well as leather handbags with gold pasta detailing. In his book *Pasta and Pizza*, La Cecla notes that it is through pasta, a food that takes on a great variety of textures and forms, that "Italians have found a theatre for their recent history."[35]

The aesthetics of Dolce & Gabbana are heavily influenced by designer Domenico Dolce's Sicilian roots. It embraces the romanticized Southern Italian sexpot look, inspired by legendary film stars like Sophia Lauren. Food motifs, however, have also featured prominently in Dolce & Gabbana's collections since the 1990s. Recently, the pair have shown dresses with allover produce prints (spring 2018), as well as pastas,

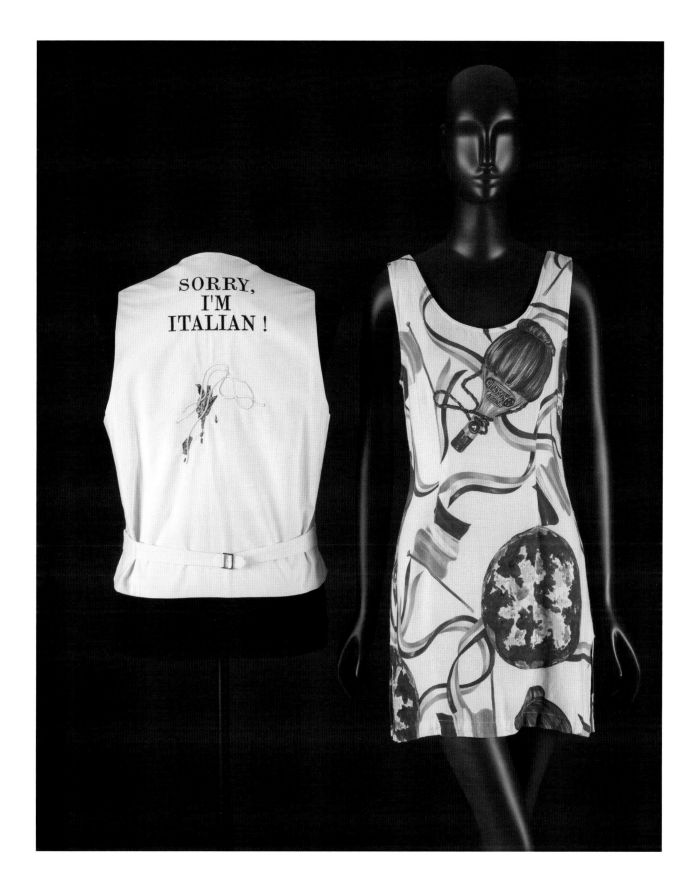

Figure 9.5
Dolce & Gabbana,
spring 2017 collection.
© IMAXtree.com

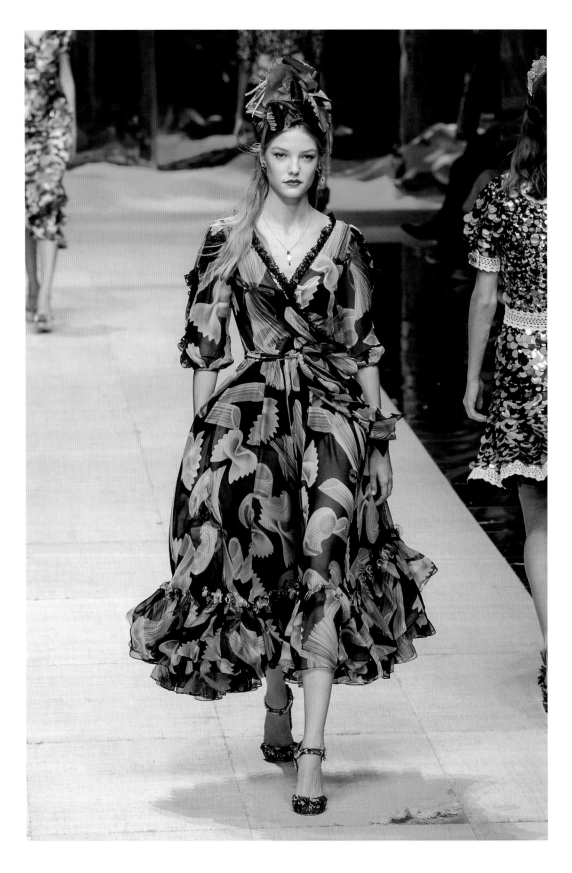

cans of tomato sauce, gelato, and cannoli patterns (spring 2017). These pop-infused food patterns are a playful tribute to iconic Italian foodstuffs, and celebrate their internationally recognized status. As Barthes has noted, advertising is a tool with which we can trace and analyze the signification of food; however, similar thinking applies to fashion.[36] Dolce & Gabbana's advertising campaigns often embrace cultural clichés, presenting Italian life through stylized, retro-meets-glamour compositions. They have included well-dressed men draped in bunches of garlic, glammed-up grandmothers serving pasta on majolica plates, and models posing in a farmers market or seated eating at a large family meal. These ads promote Italy as a paradise of pleasures, where food and fashion are intertwined as part of *la dolce vita*. In 2018, however, the designer pair courted controversy and a boycott of their products with three advertising campaign videos to promote their upcoming fashion show in Shanghai. The videos depicted Chinese model Zuo Ye awkwardly attempting to eat pizza, pasta, and a cannoli with chopsticks in a cartoonishly clumsy way, as Faith Cooper addresses in chapter eight. Dolce and Gabbana have never shied from examining Italian stereotypes, but with its play on the differences between Italian and Chinese cultures, these videos were received as culturally insensitive and racist.

Beginning in 2017, the pair partnered with the Italian pasta company Pastificio di Martino to create limited edition packaging for their product. The ongoing partnership is promoted on di Martino's website as "Two Made in Italy Excellences."[37] Pastificio di Martino has been producing dried pasta extruded through bronze dies since 1912. The luxe 2017 set included a vintage tin with four bags of pasta along with a custom designed Dolce & Gabbana apron. The redesigned packaging boasted illustrations of famous Italian landmarks such as the Colosseum, elaborate color tile motifs that evoked kitchen decor, and a hand-drawn illustration of an extended family sitting down to a pasta meal, with the slogan "*La Famiglia, La Pasta, e L'Italia!* xo, Dolce & Gabbana." Although this may seem to some a reductive depiction of Italian identity, these tropes nonetheless "unite foreign and local conceptions of what it means to be an Italian in a consumer society."[38]

In 2020, precluded from presenting a live show due to the COVID-19 pandemic, Fendi debuted its spring 2021 collection online and sent invitees packages of bespoke Rummo pasta molded in the shape of Fendi's signature double F logo. The "invitation" also included Fendi family photographs and the recipe for "Nonna's lemon pesto pasta."[39] Fendi's gastronomic care package underscored the domestic spirit and sense of nurturing that has become prevalent as millions of people were isolated in their homes during the pandemic. However, it also cultivates rich connections among family heritage, fashion, and food, presented as a taste of Italy. For Silvia Venturini Fendi, the bespoke pasta was a way to emphasize the "values behind fashion."[40] Rummo, another of Italy's storied pasta companies, shares with Fendi a similar commitment to family and craftsmanship, and their union again reminds audiences of the two Italian excellences, fashion and food.

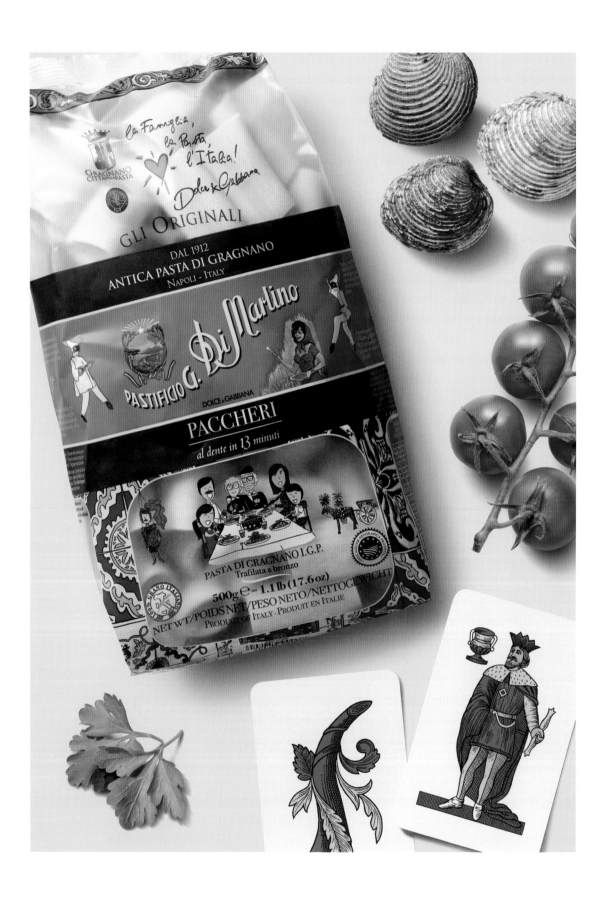

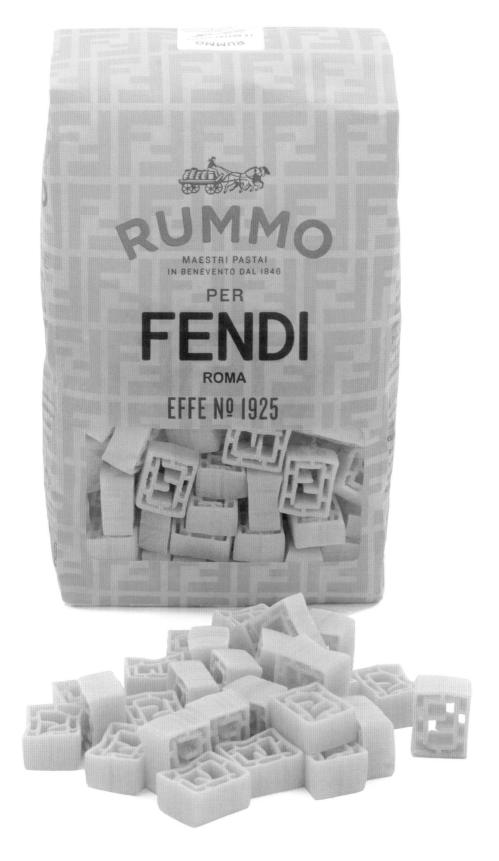

Figure 9.6 (left)
Pastificio Di Martino collaboration with Dolce & Gabbana. Photograph courtesy of Pastificio Di Martino

Figure 9.7
Fendi branded Rummo pasta sent to the invitees of the Fendi spring 2021 fashion show. Courtesy of FENDI

La Tavola

Traditionally, Italians have placed great value on home cooking. This is emphasized in countless cookbooks, in the value of jealously guarded family recipes passed down among generations, and even in the relaxed informal setting of the Italian model of the *trattoria* (as opposed to a restaurant), which embodies domestic customs.[41] In fact, among the highest forms of praise that one can bestow on a dish in Italian culture is that it tastes "homemade." Food is at the center of traditional family gatherings, and the table, *il tavolo*, holds an important place within domestic food traditions and is often emphasized in advertising, literature, and film. In his book *The Italians*, John Hopper demonstrates how the table as the center of tradition is even emphasized in Italian grammar:

> *Il tavolo* is the word for the physical object, whereas *la tavola,* the same word but in the feminine, is untranslatable into English. Its connotations encompass the meal and its preparation, quality and consumption, and—most importantly—the enjoyment of it [. . .] When, for example, Italians want to describe the joys of good eating and drinking, they talk of *i piaceri della tavola.*[42]

The significance of home cooking therefore extends beyond the mere preparation of a meal. It is the embodiment of fresh products, authentic flavors and the emotions that they elicit, and the conviviality of extended family. These notions are celebrated in the food-meets-fashion *Missoni Family Cookbook* (2018) by Francesco Maccapani Missoni, son of designer Angela Missoni and grandson to Rosita and Octavio Missoni, who are the founders of the storied fashion house. Missoni assembled a collection of his family's favorite recipes, thus sharing the culinary traditions of the family-run fashion brand. In his introduction, Missoni professes, "Food has always been a family affair to me."

The cookbook presents an assemblage of recipes, cooking notes, family anecdotes, and archival photographs of generations of Missonis preparing food or gathered around a table to enjoy a meal, and is presented as a reflection of the Missoni family values and lifestyle. Prepared dishes were photographed with the finesse employed in fashion photography; dishes boast an eclectic mix of color and texture that compliments the vibrant striped Missoni tableware on which they are served. The patterns on the multicolor tableware echo the iconic zig-zag knitwear that characterizes the Missoni fashion label and unite food and fashion under a unified aesthetic. "The more color you have, the better," Francesco Missoni insists, "both in food and in knits."[43] The book presents an intimate view of a prominent family and brand, one in which food traditions assume a prominent role in family heritage, and interweaves

Missoni traditions run deep. They bring us close and make us strong, and we always celebrate them with a home-cooked meal. My son, Francesco, loves traditions as much as he loves food, and with these family recipes, he's sharing the love. Buon appetito!

ANGELA MISSONI

Figure 9.8
Images from *The Missoni Family Cookbook* by Francesco Maccapani Missoni. © 2020 ASSOULINE

the cultures of food and fashion. In her study of the planning and execution of the Hotel Missoni Edinburgh, marketing scholar Alice Dallabona argues that the Missoni family creates an intimacy between the brand and its consumers by emphasizing their family domestic practices and lifestyle.[44] *The Missoni Family Cookbook* employs the same strategy, highlighting what Dallabona asserts are "the values of unpretentiousness, friendliness and informality that characterize the identity of the Missoni fashion label and, more broadly Italy."[45] The cookbook intertwines an informality and intimacy centered around home cooked family meals, with the domestic practices of the Missonis, in turn also highlighting the cultural value of heirloom family recipes in Italian culture.

Massimo Montanari has argued that once a recipe is published and ultimately codified, it leaves the domestic space. He also believes that "if the codification is proposed with humility, respectful of the differences and variants then the basic principle of home cooking is preserved."[46] Unlike most cookbooks, which dictate with authority, Missoni's book emphasizes elements of the Italian tradition such as selection of seasonal, locally sourced foods, and it includes suggestions for how to enhance main dishes with thoughtful sides and how to use leftovers inventively. These practices are typically part of orally transmitted customs and lend an authenticity to this celebration of Italian domesticity and *i piaceri della tavola*. "I decided to create this book to hand down our traditional Missoni way of life," Franco Missoni writes.[47]

Etro, another Italian family-run fashion brand, presented its spring 2015 menswear collection as a meditation on agriculture and food, focusing on its preparation and presentation. Titled "We are what we eat," the collection opened with a series of white looks woven from natural fibers derived from plants such as banana, hemp, and cereals, as well as from milk proteins.[48] The collection coincided with a 2015 world exposition in Milan, focused on food and sustainability.[49] In keeping with the theme of food and dining, suits of red and blue gingham evoked classic Italian tablecloth patterns. "What do we have in Italy? Tailors, design, fashion, and food!" Keane Etro remarked.[50]

As the locus of Italian family dinners, the table was a prominent element in Etro's collection. Elaborate patterns decorating suits and less formal athleisure were created by photographing tables with meticulously set food dishes, all of which were prepared by Etro himself and the Etro design team. Among them were spaghetti vongole with mussels—Etro's favorite—and risotto la Milanese, each "served" against a backdrop of elaborate paisley tablecloths.[51] Although founded in 1968, Etro is perhaps best known for its elaborate paisley patterns, introduced in 1981. In a 2014 interview with *GQ* magazine, Etro professed his love of food and cooking, saying, "I go home, I open the fridge, I start creating." He further noted that food is central to his family's business meetings. "A family like ours doesn't meet in a normal meeting room. A family like ours meets . . . having lunch in the kitchen."[52] Despite mixed critical reviews, the

spring 2015 collection was not only a celebration of Italian food culture, but also a meditation on the interconnectedness of food and fashion—its production and consumption—driving home that, in fact, we are what we eat.

Conclusion

Frank La Cela, writes that food, or "what Italians eat in order to *feel themselves Italian,*" has been as important to Italy as the Renaissance or Michelangelo. To this he adds, "Behind the apparent triviality of the culture of foodstuffs there lurks one of the most successful propaganda operations carried on by a people in recent world history."[53] A country exists through its cultural products: arts, literature, cuisine, and fashion. Culinary products such as pizza and pasta were integral to the creation of a coherent visage of Italy—one that became ever more pronounced the farther one got from the country.[54] It comes as no surprise, then, that a number of fashion brands, such Moschino, Fendi, Dolce & Gabbana, and Missoni, have all referenced Italian food culture to project the notion of "Italianness" to a global audience, reinforcing the prestigious "Made in Italy" label. Today, Italy's food and fashion remain powerful elements of national identity—one that is best understood as "an invention, the reinterpretation of scattered evidence from the past and the present organized as tradition."[55]

Notes

1. Roland Barthes, "Rhetoric of the Image" in *Image Music Text*, (New York: Hill and Wang, 1977), 48.

2. Roberta Sassatelli, "Food, Foodways and Italianicity," in *Italians and Food*, ed. R. Sassatelli, (New York: Palgrave Macmillan, 2019), 1.

3. Sassatelli, p. 1.

4. Simone Cinotto, *The Italian American Table: Food, Family and Community in New York City* (Urbana: University of Illinois Press, 2013), kindle edition, loc. 260.

5. Cinotto, *The Italian American Table*, loc. 266.

6. Massimo Montanari, *Italian Identity in the Kitchen, or, Food and the Nation* (New York: Columbia University Press, 2013), xv.

7. Charles Caramello. "Italian Identity in the Kitchen, or, Food and the Nation," book review in *Cooking & Food, Washington Independent Review of Books*, September 6, 2013, http://www.washingtonindependentreviewofbooks.com/index.php/bookreview/italian-identity-in-the-kitchen-or-food-and-the-nation.

8. Alberto Capatti, quoted in Montanari, *Italian Identity in the Kitchen*, 48.

9. Montanari, *Italian Identity in the Kitchen*, 47, 49. Artrusi continued to refine and elaborate on this text for the next twenty years.

10. Montanari, *Italian Identity in the Kitchen*, 50.

11. The origins of pasta are often debated. Although archaeologists credit central Asia to be the first area to have produced noodles, it is believed that nomadic Arabs are responsible for bringing early forms of pasta westward during the middle ages, introducing dried pasta to Sicily. See Montanari, *Italian Identity in the Kitchen*, 12–13.

12. Montanari, *Italian Identity in the Kitchen*, 12.

13. Maryann Tebben, "Semiotics of Sauce: Representing Italian American Identity through Pasta Sauces," in *Representing Italy though Food*, eds. P. Naccarato, Z. Nowak, and E.K. Eckert, (London: Bloomsbury, 2017), 183.

14. Sassatelli, p. 2.

15. Valerie Steele, *Fashion Italian Style* (New Haven: Yale University Press, 2003), ix.

16. Elizabeth Wilson, *Adorned in Dreams* (London: Virago, 1985), 9.

17. Quoted in Valerie Steele, *Fashion, Italian Style* (New Haven: Yale University Press, 2003), 23.

18. Nicola White, *Reconstructing Italian Fashion: America and the Development of the Italian Fashion Industry* (Oxford: Berg, 2000), 172.

19. Gini Alhadeff, "Fashion: Celebrating Italy: The Inspiration, in New York, for a Truly Grand Assortment of Italian Pleasures, Treasures, and More," *Vogue*, September 1, 1985, 693–695.

20. Quoted in "Consumption and Taste," in *Food and Cultural Studies* (London: Routledge, 2004), 59.

21. La Cecla, 65.

22. Montanari, *Italian Identity in the Kitchen*, 42.

23. Arie Sover and Orna Ben-Meir, "Humour, Food and Fashion: The Use of Humour and Food in Fashion Shows," *The European Journal of Humour Research* 5 (May 2017): 71.

24. Mary Douglas, "Jokes," in *Rethinking Popular Culture: Contemporary Perspectives in Cultural Studies*, eds. C. Mukerji and M. Scudson (Berkeley: Berkeley University Press, 1991), 304–306.

25. Aliza S. Wong, "Authenticity all'italiana: Food Discourses, Diasporas, and the Limits of Cuisine in Contemporary Italy," in *Representing Italy Through Food*, eds. Peter Naccarato, Zachary Nowak, and Elgin K. Eckert (London: Bloomsbury, 2017), 39.

26. Wine produced in the Chianti region of Tuscany was historically associated with a squat bottle enclosed in a straw basket called a fiasco.

27. Grazia d'Annunzio, email to author, June 28, 2020.

28. d'Annunzio, email to author, June 28, 2020.

29. d'Annunzio, email to author, June 28, 2020.

30. Anna Piaggi, "Fashion Menu: Pasta," *Vogue Italia* (May 1991): 144–149.

31. d'Annunzio, email to author, June 28, 2020.

32. d'Annunzio, email to author, June 28, 2020.

33. d'Annunzio, email to author, June 28, 2020.

34. La Cecla referenced in Roberta Sassatelli, "Introduction. Food, Foodways and Italianicity," in *Italians and Food*, 2019.

35. La Cecla, vi.

36. Nevana Stajcic, "Understanding Culture: Food as a Means of Communication," *Hemispheres* no. 28, 2013: 7.

37. See https://dimartinodolcegabbana.com/en/home/

38. Emilia Morano-Williams, "Dolce & Gabbana Dresses Up Pasta Packaging in Retro Italian Glam," *MOLD*, November 8, 2017, https://thisismold.com/visual/packaging/dolce-gabbana-dresses-up -pasta-packaging-in-retro-italian-glam#.Xt1W4zpKg2x.

39. Rudy Sanchez, "Fendi's Invitation to Its Latest Fashion Show Includes a Box of Fancy Pasta," *Dieline*, September 25, 2020, https://thedieline.com/blog/2020/9/25/fendis-invitation-to-its -latest-fashion-show-includes-a-box-of-fancy-pasta.

40. Sanchez, "Fendi's Invitation."

41. Montanari, *Italian Identity in the Kitchen*, 61.

42. John Hopper, *The Italians* (Milton Keynes: Penguin, 2016), 94. Quoted in Roberta Sassatelli, "Introduction. Food, Foodways and Italianicity," in *Italians and Food*, 2019.

43. Naomi Rogeau, "The Missoni Family Cookbook Celebrates La (Extremely) Bella Vita," *Elle*, April 25, 2018, https://www.elle.com/default/a19706900/francesco-maccapani-missoni-cook book-recipes/.

44. Alice Dallabona, "At Home with the Missoni Family: Narratives of Domesticity within Hotel Missoni Edinburgh," in *Home Cultures: The Journal of Architecture, Design and Domestic Space*, 3:1, (2016): 1–33. DOI: 10.1080/17406315.2016.1122965

45. Dallabona, p.8.

46. Montanari, *Italian Identity in the Kitchen*, 77.

47. Francesco Maccapani Missoni, "Introduction," *The Missoni Family Cookbook* (New York: Assouline, 2018), p.11.

48. Interview with Etro Keane, *GQ magazine*, online video, https://www.gq.com/video/watch/kean -etro-on-his-spring-2015-menswear-line [no longer available online].

49. Matthew Schneier, "At Fendi, Reveling in Real Clothes," *New York Times* (June 24, 2014). https:// www.nytimes.com/2014/06/25/fashion/fendi-etro-mens-milan-fashion-week-review.html.

50. Interview with Etro Keane, *GQ*.

51. Interview with Etro Keane, *GQ*.

52. "Keane Etro on Cooking and Fashion as a Family Affair," *GQ magazine*, online video, posted October 14, 2014.

53. La Cecla, iv.

54. Capatti and Montanari, xx.

55. La Cecla, *Pasta and Pizza*, iv

From Zen to Kitsch: Contemporary Japanese Food and Fashion

Patricia Mears

Contemporary Japanese creators had a seismic, course-altering impact on an array of creative fields during the second half of the twentieth century. Paralleling the nation's economic ascent in the post–World War II era, Japan's artists and designers gained global recognition in a wide range of disciplines such as film, architecture, and conceptual art. For the fashion world, this artistic wave was a tsunami that brought with it the most meaningful nonwestern source of change that contemporary western fashion has ever experienced. Much has been written about Japan's most celebrated fashion designers—Issey Miyake, Rei Kawakubo, and Yohji Yamamoto—and how they spearheaded profound aesthetic ideas that permeated many aspects of this worldwide industry. I was among a group of western curators who came to understand that these dark, "deconstructed," oversized, and body-obfuscating silhouettes, made from some of the most innovative textiles in the world were, in part and despite the designers' protests, contemporary manifestations of ancient philosophical principles. One of the concepts I explored was that although Japanese artistic endeavors may have gained international renown relatively recently, their aesthetics—considered by some to be the most refined in the world—are ancient and deeply rooted in many aspects of Japanese life. Japan has also had tremendous influence on counterculture trends. Embracing kitsch and novelty, some of the most inspirational Japanese fashions are boisterous and cartoonish. They reflect a love of pop culture and range from mind-blowing, female-led street styles, such as "Gothic Lolitas," to historicized, cartoon-inspired cosplay (short for *costume play* and pronounced *kosupure* in Japanese). Included in the vibrant mix are Brooks Brothers–loving, "Ivy Style" devotees, denim aficionados, and the cult of kimono-wearing by both the avant garde and the most traditional women in Japanese society.

Figure 10.1
Issey Miyake, Pleats Please "bento box" of accessories, 2018, Japan.
© The Museum at FIT

Figure 10.2
Yohji Yamamoto, gray
wool tweed suit, fall/winter
1997, private collection.
Photograph by William
Palmer

Figure 10.3
Japanese woman dressed
in the Gothic Lolita style,
Harajuku, Tokyo. Malcolm
Fairman/Alamy Stock
Photo

Such diversity is also evident in Japan's rich food culture. Japan is simultaneously celebrated for its refined kaiseki-ryōri (Japan's version of haute cuisine), as well as its small, family-run restaurants specializing in dishes such as noodles or tofu. Like its fashions, Japanese food is a global phenomenon. For example, sushi (whether prepared at high-end restaurants by skilled artisans or mass-produced for office workers) and ramen noodles (either those made by hand in small batches or cheap versions sold by the box in grocery stores) are accessible to consumers at every price point and in nearly every country in the world. In her essay, "Understanding Culture: Food as a Means of Communication," food scholar Nevana Stajcic writes, "Globalization has not necessarily homogenized all cultural differences nor erased the salience of cultural labels. Quite the contrary; it grows the franchise. In the global economy of consumption, the brand equity of [Japanese foods such as] sushi as Japanese cultural property adds to the prestige of both the country and the cuisine. Certainly, the presentation and ingredients or forms of sushi vary from country to country, but it is still seen as something very distinctive."[1] The same might be said of the distinctive styles created by Japanese designers and street style trendsetters. What two quotidian entities represent both sides of Japan's rich culture better than food and fashion? This chapter will focus on a small selection of cultural traditions and developments that have helped define Japan's post–World War II output and influence, specifically its cuisine and clothing. This selection is informed by leading connoisseurs and critics, as well as firsthand observations from my own travels to Japan.

Reflections on Experiencing Japanese Food in Its Homeland

During more than one dozen trips to Japan, beginning in the 1980s, I had the good fortune to experience its fashion and food firsthand. Observing the fashion industry and vibrant street styles was eye-opening and enriching. But eating Japanese food in Japan was more immersive and memorable. Although a nation's fashionable clothing can be readily exported, its indigenous cuisine cannot be so easily duplicated abroad. Perhaps that is why, decades later, I can still vividly recall meals such as a kaiseki feast filled with many courses, each exquisitely crafted with the freshest ingredients and almost too beautiful to eat. More impactful was a tofu meal served on the grounds of the Ryōan-ji Zen Buddhist temple, famed for its sublime rock garden, in Kyoto. I ate simple dishes as I gazed out at distant plum blossoms while snowflakes gently wafted by the large windows of a tatami mat–covered room. Another memorable Kyoto experience was a stop at Kasagi-ya, a small, traditional restaurant specializing in dishes made with adzuki beans. A simple soup and sweet bun were the rewards for climbing to the mountain-top temple, Kiyomizu-dera. These experiences reflect Stajcic's statement that "Japanese cuisine is unique in its attitude toward food. This ritual, presentational cuisine, which so insists upon freshness and naturalness, rests upon a

set of assumptions concerning food and its place in life. Eventually, the cuisine itself depends upon the Japanese attitude toward the environment, toward nature itself. Authenticity is detected in presentation and in flavor."[2]

Even shopping for food in Japan was a memorable experience—whether buying an inexpensive but exquisitely wrapped bento box lunch in a department store or traversing the vast Tsukiji fish and seafood market in Tokyo, the largest in the world. Before parts of it were closed to tourists, one could wander around its eerie, misty halls, filled with hundreds of gigantic frozen tunas, each slowly emitting water vapor as they thawed. Afterwards, the freshest sashimi was prepared as dawn broke—the perfect meal for jet-lagged visitors. Equally delicious were low-key meals at neighborhood restaurants that catered to locals. One such restaurant, specializing in Osaka-style fried fish balls, was populated by its usual gaggle of college students, most of whom were male. These cash-poor regulars were there to take advantage of the restaurant's unique sales gimmick: a speed eating version of "all-you-can eat." Done successfully, the diner could earn his meal at no cost. I watched in amazement as several young patrons successfully downed an astonishing quantity of food in just a few minutes.

The Foundations of Japanese Craftsmanship and Aesthetics

My samplings of Japanese cuisine illuminated a number of key traits that it shares with aspects of Japanese fashion. These speak to centuries-long traditions in Japan that deeply value craftsmanship and aesthetics. Even though Japan is one of the most technologically advanced nations in the world, it strongly embraces craft. Today, the training of some food and clothing makers is similar to that of the medieval guild system: young people begin working as apprentices under an established master for several years, slowly honing their craft before becoming a skilled professional. The cultural value placed on craftsmanship extends to Japanese customers, who are often discerning consumers of food and fashion.

Also important in the creation of contemporary Japanese food and fashion is the embrace of nature. For millennia, classicism, or Apollonian ideals of symmetry and balance and its strong-armed dominance over the natural world, has been at the root of western artistic output. By contrast, the Japanese created concepts such as wabi-sabi, a philosophical, intellectual, and cultural term with deep and profound meaning. Although complex, a few key elements of wabi-sabi include the appreciation of things that show their age or have an inherent patina and character, objects that are seemingly imperfect although beautifully and painstakingly crafted, and an embrace of impermanence and the ephemeral.[3]

Another important difference between European and Japanese aesthetics that inform food and fashion are the values placed on specific fields of creativity. In the West, the fine arts (primarily painting but also sculpture) are assumed to reign

supreme over the minor or decorative arts. In turn, there is a similar hierarchy in which furniture, ceramics, and metal work outrank other applied arts such as textiles, fashion, and the domestic arts, including cuisine. Japanese craftspeople and connoisseurs have traditionally understood that seemingly insignificant objects can be imbued with high levels of intellectual and spiritual importance. Ceramics, textiles, and paper, therefore, are objects worthy of deep and enduring reverence when created by masters. Japan's more democratic respect for all creative endeavors is evident to the observant foreigner. For example, in a 2002 article, fashion journalist Amy Spindler convincingly argues that Tokyo is now the international center of fashion, not Paris or New York:

> Being the capital of fashion isn't about who has the boutiques or the runways shows or the fashion magazines, although Tokyo has plenty of those. To be the true capital of fashion, fashion must dominate everything. It must be the passion of the masses and the connoisseurs. It must be the primary mode of expression beyond art, film, music. It must be a place where fashion is treated like a necessity, not a luxury. . . . It's the only city in the world where creating fashion is treated as an intellectual pastime. Ask who is the greatest living artist in Tokyo and a surprising number of people won't name a writer or painter; they'll name Rei Kawakubo. Or Junya Watanabe.[4]

How to Wrap Five More Eggs

Even Japanese traditional food packaging can become works of art, as vibrantly illustrated in Hideyuki Oka's publication *How to Wrap Five More Eggs*. His book is filled with images of humble organic materials, such as straw, that have been woven into ingenious packages to transport delicate and perishable food items, including dumplings, rice cakes, pickled plums, and, of course, eggs. Oka argued that what makes Japan's traditional food packaging so successful is not only his nation's embrace of nature and craft, but a spiritual commitment to the creation of such products. He wrote:

Figure 10.4
How to Wrap 5 More Eggs by Hideyuki Oka (book cover). Photograph by William Palmer. Reproduced with the permission of Shambhala Publications, Inc., www.shambhala.com. Photography on original book cover by Michikazu Sakai

> In no way self-conscious or assertive, these wrappings have an artless and obedient air that greatly moves the modern viewer. They are whispered evidence of the Japanese ability to create beauty from the simplest of products of nature. They also teach us that wisdom and feeling are especially important in packaging because these qualities, or the lack of them, are almost immediately apparent. What is the use of a package if it shows no feeling.[5]

Such emotional outpouring, Oka contended, resulted in packaging that became "works of art" as the end results were "products that often had more charm and more value than the actual contents of the package."[6] He claimed that it "is not the manual dexterity of the Japanese: it is rather the feeling of love and consideration of others that motivates them to do this handiwork."[7] This combination of craft, the embrace of nature and spirituality, and love was, in Oka's view, what he called the "aesthetic consciousness of propriety." For him, "wrapping and packaging as sort of a sacred ritual" also emerged from function and the importance of practices such as cleanliness. Oka wrote that the act of packaging becomes "a ritual of purification, of distinguishing the contents of the package from all similar objects that have not been purified. Traditional packaging is thus a reflection of Japanese psychology, which doubtless accounts for much of its orderliness and tidiness."[8]

The Unknown Craftsman: A Japanese Insight into Beauty

Like other Japanese writers who describe the crafts of their nation, Oka also addressed how hierarchy of art versus craft is decidedly different from other cultures. Prior to Europe's renaissance, the notion of a singular, creative genius did not exist; creators were anonymous artisans. This idea remained viable in modern Japan until the early twentieth century. Publications such as Soetsu Yanagi's *The Unknown Craftsman: A Japanese Insight into Beauty*, with its focus on what some derisively refer to as folk art or craft, is actually more of a primer on aesthetics, philosophy, and spirituality. A number of specialized crafts, such as roof ornaments, small pieces of furniture, and textiles, are discussed, but its focus is ceramics. Entire chapters are devoted to food and tea bowls: "The Beauty of Irregularity," "The Buddhist Idea of Beauty," and two chapters titled "The Way of Tea" and "The Kizaemon Tea-bowl."

Based on these chapter titles, the connection to food, or really drink, might seem obvious. Yet, the latter two sections are much more about the evolution of visual aesthetics based on their connection to function and spiritual enlightenment. The opening lines of Yanagi's "The Way of Tea" begins by describing the masters of tea: "They saw; before all else, they saw. They were able to see. Ancient mysteries flew from this well-spring of seeing." Yanagi continued:

> But seeing was not the sole merit of the Tea masters [. . .] Seeing led them to using and using led to seeing still deeper. Without using there is no complete seeing, for nothing so emphasizes the beauty of things as their right application [. . .] We might say they comprehended beauty in action. Tea is not mere appreciation of beauty. To live beauty in our daily lives is the genuine Way of Tea.[9]

Yanagi contends that, for the Japanese, craft, function, spirituality, and philosophy are cohesively blended in the making of tea ceremony equipment and utensils. Yanagi's next chapter on the Kizaemon tea bowl is less esoteric, but he still devotes seven pages to the discussion of this single tea-bowl that connoisseurs "considered to be the finest in the world." It was "so simple, no more ordinary thing could be imagined [...] It is just a Korean food bowl, a bowl, moreover, that a poor man would use every day—commonest crockery."[10] Japanese aesthetics were not only refined, they were prescient. Their centuries-old ideas have come to influence cultures far beyond their borders. Until recently, such rustic and humble objects had no place in the arena of western high culture. Today, they take center stage. For example, the deconstruction introduced into high fashion by Japanese designers such as Rei Kawakubo during the 1980s has become an embedded and recurring aspect of fashion design on all levels, from haute couture to fast fashion.

In Praise of Shadows

Decades before Oka and Yanagi published their works, modern Japanese aesthetics were expounded upon by eminent novelist Jun'ichirō Tanizaki (1886–1965). Although best known for fictional books such as *Naomi* (1924) and *The Makioka Sisters* (1943–48), he also wrote an important essay on Japanese aesthetics titled "In Praise of Shadows." Originally published in a literary journal in late 1933 and early 1934, Tanizaki proved that he had a profound and scholarly interest in traditional Japanese culture. The author described how many traditional elements pervade everyday life—from architecture to clothing to food. Tanizaki wrote this work at a crucial time in modern Japanese history. Although the nation had been officially opened to the West only eighty years earlier, it had already undergone a dramatic transformation. By this time, during the late Taishō and early Shōwa periods, Japan was the most westernized nation in Asia, at least in terms of adapting new technologies. Tanizaki abandoned his early infatuation with western culture by the early 1930s, and instead immersed himself in what he perceived as the loss of aesthetic meaning in daily Japanese life. Much of what he wrote about was living silently and quietly in the shadows. Thus, the title of his essay—"In Praise of Shadows"—was both a literal and metaphorical description of hidden domestic life and creativity. Tanizaki noted when describing food, "It is said of Japanese food that it is a cuisine to be looked at rather than eaten. I would go further and say that it is to be meditated upon, a kind of silent music evoked by the combination of lacquerware and the light of a candle flickering in the dark."[11] Tanizaki went on to describe a variety of foods and how they evoked the senses far beyond taste. For him, *yokan* (bean jelly)

possessed a "cloudy translucence, like that of jade" and a "faint, dreamlike glow." Miso soup was "infinitely more appetizing" when served in a "black lacquer bowl beneath the faint light of a candle." And the condiment soy sauce, served in an environment "rich in shadows" beautifully "blends into the darkness."[12] Rice and other white foods "lose much of their beauty in a bright room. [. . .] A glistening black lacquer rice cask set off in a dark corner is both beautiful to behold and a powerful stimulus to the appetite. [. . .] In this setting every grain [of rice] gleaming like a pearl."[13] Food presented in such darkness not only captured the essence of the ephemeral but also shielded the consumer from the harsh and gaudy. For Tanizaki, darkness was crucial to appreciating food because it "is an indispensable element of the beauty of lacquer-ware . . . decorated in gold [lacquerware] is not something to be seen in a brilliant light to be taken in at a single glance; it should be left in the dark, a part here and a part there picked up by a faint light."[14] Tanizaki also muses about how the darkness affects the way in which a woman's body is seen, or not seen. Within such visual quietude, Tanizaki described Japanese women in detail—specifically, how their dress erased their corporeal presence, as only their heads, necks, and hands could be seen. Despite the fact that the writer published his essay before designers Kawakubo and Yamamoto were born, there is an arguably viable similarity between his assessment of women in their kimonos and those who don avant-garde Japanese fashion.

Contemporary Food and Traditional Fan Making

One of the most unique fusions of food and fashion, tradition, and modernity I have ever experienced occurred in the summer of 2002. While on a research trip in Kyoto, Japan's ancient capital, I met with the celebrated chef Hyakumizon. She had recently closed her famous Tokyo-based restaurant in order to take over her family's multi-generational fan-making business. Her small store sold an array of traditionally crafted fans ornamented in decidedly contemporary ways, such as abstract brush strokes painted in silver against a black background. Each fan was sold with a handmade silk case crafted from old kimonos. While the fans alone were marvelous, the shopping experience was heightened thanks to small dishes prepared by Hyakumizon. In her shop, which was described as a "culinary vegetable atelier," I was presented with handmade lacquer bowls filled with a mélange of tiny melon and rice balls, mixed together with a light and refreshing nectar. Delicate and colorful, the food was the culinary manifestation of her family's long artisanal history and her contemporary life. Hyakumizon's transition from making food to fans appeared to be seamless, possibly easing her dramatic career change through her connection to traditional Japanese aesthetics.

Figure 10.5
Tea Bowl with Crescent Moon, Clouds, and Blossoming Plums, 17th century, Japan. Metropolitan Museum of Art. Gift of Mr. and Mrs. Samuel Colman, 1893

Figure 10.6
Hyakumizon fans, private
collection. © The Museum at FIT

Kitsch in Contemporary Japanese Food and Fashion

On the opposite end of the Japanese creative spectrum is an enthusiasm for pop culture and kitsch. Foreigners based in Japan, such as the American film critic Donald Richie, noted that "Japan is a kingdom of kitsch and Tokyo is its capital. Here the food in the windows, more mouthwatering than real, is plastic."[15] Richie goes on to write that kitsch has been a part of Japanese culture for centuries and so ubiquitous that there is no word for it. It is so prevalent "because in this most pragmatic of nations everything must be for immediate use." He argues that fusing architectural styles, rather than keeping each isolated and thus pure, is much more practical and pushes "more information in less space. Thus, Tokyo is a glorious architectural confusion of plastic tile and fake wood, of Corinthian columns and chromium pylons, dormer windows and polarized glass, half-timber and plain redbrick paste-on fronting, sheet steel, translucent paper, textured Lucite." There may be no single, definable term for this mélange of materials and styles, but such fusion of disparate design elements is also, according to Richie, "diverting, disarming, and even, if you squint, witty. Also it is resolutely modern."[16]

Increasingly respectable around the world, kitsch has become a vital component of contemporary Japanese fashion. For example, youth cultures in Tokyo are well documented by both contemporary Japanese fashion media and fashion scholars, such as Yuniya Kawamura and Masafumi Monden, for their array of unique, bizarre, and innovative street styles.[17] Even established members of the fashion system have felt its impact, spurring on their creation of looks that channel kitsch's visual playfulness and profound symbolism. One example is a faux bento box created under Issey Miyake's Pleats Please label and filled with small bags and belts made to look like pieces of sushi (see frontispiece). A novelty item with limited production, it was made to celebrate the twentieth anniversary of Miyake's Soho store in New York City. The small wooden box contained accessories that, when stored, resembled faux maki rolls and individual pieces of unagi (eel) and fish roe. Instead of seeking inspiration from real food, Miyake's bento was likely a riff on the molded plastic objects made to look like prepared dishes that are prominently placed in restaurant windows throughout Japan.

Known as sampuru (or the Japanese version of the English word *sample*), the making of fake food began in the early years of the twentieth century. Numerous sources state that fake food production ramped up during the early 1930s thanks to artisan Takizo Iwasaki. Legend has it that he made an amazingly realistic omelet out of wax

that was indistinguishable from the real thing. Sampuru was later made from PVC but continued to be crafted by hand. It eventually became an increasingly important part of Japan's plastic manufacturing industry, thanks in part to the influx of American military personnel stationed in Japan after World War II who had to eat, but were unable to read restaurant menus. Today, the sampuru industry grosses nearly one hundred million dollars per year. One reason for its continued profitability is that restaurants are no longer the sole buyers of sampuru. These items have also become collectables, adored by kitsch lovers around the world.

Another designer who dabbled in playful food ideas is Junya Watanabe. Considered by some to be the most brilliant technician working in fashion today, he began as a master pattern maker for Rei Kawakubo's Comme des Garçons company. Kawakubo went on to help Watanabe launch his eponymous line, providing crucial financial and marketing support. Although he is best known for masterfully constructed, three-dimensional marvels, Watanabe has also designed seemingly lighter fare. An important example, dating to the spring/summer 2001 season, was a collection of garments printed with assorted dessert imagery. Created a year after his tour de force spring/summer 2000 collection, which one critic described as "birthday cakes of tulle, exquisite in their architecture," Watanabe "turned to simple lines and approached the idea of woman as confection more ironically. He printed layered shirts and short dresses with photographs of dessert [sic]: a berry tart, a strawberry-chocolate cake."[18] Ginia Bellafante's article for *The New York Times* was one of the few western critical reviews of Watanabe's 2001 collection, perhaps because it lacked readily decipherable technical pyrotechnics. However, these dessert-printed garments are filled with layers of meaning, specifically when viewed through the lens of Japan's potent "girl culture." Many of the most interesting looks that dominate the Japanese youth culture street scene are created by girls and young women. This is also true in the wildly popular *shoujo* manga, or girls' comics, where western style sweets are a potent, recurring leitmotif. A growing number of scholars, both in Japan and abroad, recognize that "parfaits, cookies, cakes, and chocolate perform a crucial role in shaping the narratives and aesthetics of Japanese girls' culture."[19] Serial stories glorified female characters' obsession with western sweets. In the same publications, the *Ancien Regime,* classical ballet, and haute couture, all famous examples of French baroque and rococo culture with strong feminine connotations, were likewise embraced.

Watanabe must have understood how his playful reworking of feminized French sweets (à la *shoujo* manga) could be viewed as both fantasy and escapism to a young Japanese viewer. It is likely he also knew that the sugary side of this relationship could symbolize vacuous nutrition and gluttony. And, finally, as one of the savviest designers in Japan, Watanabe may well have understood, like a growing number of feminist scholars, that *shoujo* manga heroines lived sugar-laden lives that were anything but sweet. In her analysis of "sweetness, power, and gender" in Japan, Grace En-Yi Ting

Figure 10.7
Junya Watanbe for Comme des Garçons, white printed nylon and plastic pearl dress, spring 2001, Japan.
© The Museum at FIT

concluded that "there is real, considerable violence in the essentialization of girls and women in terms of decoration, indulgence, excess, and emptiness."[20] Watanabe reinforced the duality of sweet desserts by accessorizing a number of his printed dresses with pearls, the ultimate, mid-century, ladylike accessory. Some were "studded neatly at the neckline." Others were "twisted so the back became a strangled, beautifully articulated mess,"[21] thus making a powerful comment on visually delicious imagery that had a bit of evilness and rot at its core.

Conclusion

Japanese culture, both traditional and modern, continues to inspire the way the world eats and dresses. While most western designers tap the kimono or street styles for inspiration, a few have looked beyond the obvious. One example is the cerebral and celebrated American couturier Ralph Rucci. He named his company Chado, after the rigorous and contemplative tea ceremony famous for its requisite 331 steps. (Rucci would later shutter Chado and name his new company RR331.) He also chose more obscure Japanese objects to ornament his work: knotted silk cords, basketry, and calligraphy. One of his best Japanese inspired works was an organza caftan embroidered with tiny matchstick-sized twigs. Evocative of cherry blossoms and chrysanthemum petals cascading down the length of a pictorial surface, Rucci brilliantly captured a Japanese-inspired view of nature's fleeting beauty in a decidedly commercial medium. It remains an extraordinary phenomenon that Japan has, in a relatively brief time, repeatedly influenced so many fields of western creativity since its opening to the west, first during the 1850s, and again after World War II. The ideas and objects discussed here are mere morsels of the many Japanese foods and fashions that have and continue to impact our contemporary world.

Figure 10.8
Ralph Rucci, embroidered silk
organza caftan, fall/winter
2005. Photograph by William
Palmer

Notes

1. Nevana Stajcic, "Understanding Culture: Food as a Means of Communication," *Hemispheres*, no. 28 (2013): 5–14, 12.

2. Stajcic, "Understanding Culture."

3. See Kishino Haga, "The Wabi Aesthetic through the Ages," in Nancy G. Hume, ed., *Japanese Aesthetics and Culture* (Albany: State University of New York Press, 1995) and Roger J. Davies and Osamu Ikeno, eds., *The Japanese Mind: Understanding Contemporary Japanese Culture* (Tokyo, Rutland, Vermont, Singapore: Tuttle Publishing, 2002).

4. Amy Spinder, "Do You Otaku?," *The New York Times Magazine*, spring 2002, 134.

5. Hideyuki Oka, *How to Wrap Five More Eggs: Traditional Japanese Packaging* (New York and Tokyo: Weatherhill, 1989), 9.

6. Oka, *How to Wrap Five More Eggs*, 10.

7. Oka, *How to Wrap Five More Eggs*, 12.

8. Oka, *How to Wrap Five More Eggs*, 12.

9. Soetsu Yanagi, *The Unknown Craftsman: A Japanese Insight into Beauty* (New York: Kodnsha USA, 2013), 178–179.

10. Yanagi, *The Unknown Craftsman*, 190–191. Korean ceramics had a profound influence on the Japanese. This bowl, created in the sixteenth century during the Yi Dynasty, represents centuries of Japanese collecting and recreating aesthetic ideals pioneered by the Koreans.

11. Jun'ichiro Tanizaki, *In Praise of Shadows*, translated by Thomas J. Harper and Edward Seidensticker (New Haven: Leete's Island Books, 1977), 15.

12. Tanizaki, *In Praise of Shadows*, 16.

13. Tanizaki, *In Praise of Shadows*, 16–17.

14. Tanizaki, *In Praise of Shadows*, 13–14.

15. Donald Richie, *A Lateral View: Essays on Culture and Style in Contemporary Japan* (Berkley: Stone Bridge Press: 1992), 62–63.

16. Richie, *A Lateral View*, 62–63.

17. See Yuniya Kawamura, *Fashioning Japanese Subcultures* (London: Berg, 2012) and Masafumi Monden, *Japanese Fashion Cultures: Dress and Gender in Contemporary Japan* (London: Bloomsbury, 2015).

18. Ginia Bellafonte, "Paris Query: Just What Is a Woman," *The New York Times*, October 10, 2000, B11.

19. Grace En-Yi Ting, "The Desire and Disgust of Sweets: Consuming Femininities through Shojo Manga," *U.S.-Japan Women's Journal*, Volume 54, 2018: 52–74.

20. Ting, "The Desire and Disgust of Sweets," 55.

21. Bellafonte, "Paris Query."

Without Maize There Is No Mexico: Fashion and Corn

Tanya Melendez-Escalante

A young man dressed in denim stares at the camera seductively. In his hand, he holds a corn on the cob smothered in mayonnaise, chili, and cheese. A photograph by Dorian Ulises López Macías, this portrait of a young, urban-cool Mexican is an image intended to incite your desire for clothes. This photograph was part of H&M's campaign to mark the opening of its Madero Street store in Mexico City with great fanfare. López Macías created an emblematic celebration of the country through fashion. Corn was front and center—unequivocally Mexican.

Mexico is a global creative powerhouse. Its cultural life and arts are influential and vibrant. The country's cuisine has increasingly entrenched itself in cities around the world, while a refined food culture has flourished locally. Similarly, Mexican fashion has exponentially grown in the twenty-first century. Today, fashion and food are markers of national heritage in Mexico. Designers and chefs view their practices as intrinsically intertwined with Mexican cultural roots that date to pre-Columbian times. Corn stands as emblematic of this vision, a grain domesticated by local settlers in Mexican territory more than seven thousand years ago. Within food and fashion, a dialectic tension between tradition and modernity exists. Designers, stylists, artists, chefs, and many other tastemakers use corn in their work to highlight narratives about the role of this heritage food in Mexican contemporary life.

In Mexican fashion, as in other forms of cultural production, there has been debate about the relevance of national identity to creative endeavors. In 1949, fashion designers Ramón Valdiosera, Armando Valdés Peza, and Henri de Châtillon clashed during a radio interview over cultural heritage in fashion. Valdés Peza and de Châtillon expressed that there was little to learn from indigenous costumes "unless you want to dress everyone as Indians (*inditos*)." Valdiosera contested that studying the

Figure 11.1
"H&M Loves Madero" campaign, 2017. Direction and photography: Dorian Ulises López Macías, Creative Production: In The Park Productions, Model: Emiliano CJ, AD: Viviana Zúñiga, Photo and lighting assistant: Alexis Rayas, Fashion styling: Bárbara Sanchez Kane and Nayeli de Alba, Makeup: Ana G. de V., Hair: Erich Clemenz and Carlos Arriola, Art Direction: Discipline Studio, Executive Producer: Claudia del Bosque

elegance and refinement of the mosaic of pre-Columbian cultures could be a source of inspiration for Mexican fashion.[1] This debate is illustrative of colonial impulses that have been a source of tension in the country's fashionable circles for decades.

Conversely, fashion designers agree in considering corn central to the life and culture of Mexico. Bárbara Sánchez-Kane explains, "Corn is the basis of our nutrition and gastronomy. I create my collections based on what I see. Literally when I was designing my 2020 collection, I turned around and there it was, a street vendor of *esquites* (corn in a cup). And it became part of my fashion show."[2]

Corn and Culture in Mexico

According to anthropologist George Armelagos, Mexican cuisine has one of the largest flavor principles in the world, with its great variety in the themes and combinations of ingredients—case in point: corn.[3] When it comes to foods made with corn, there are obviously tortillas but also main dishes, soups, candies, snacks, and drinks. Additionally, there are dishes featuring huitlacoche (fungi that grow in corn), corn husk–enveloped tamales, and desserts that include flavors extracted from corn silk. Corn is truly everywhere in Mexican fare.

For its symbolic and economic importance, corn has been called the Latin American gold. Maize is one of Mexico's main contributions to the world. It is one of the most important crops globally, central to many economies,[4] and it quickly became a staple in Asia and Africa during the Columbian Exchange.[5]

In the pre-Columbian Americas, beyond being their main sustenance, corn was the basis for how people understood the world. The *Nueva Historia Minima de Mexico* explains that "the construction of Mesoamerican civilization started with the domestication of corn and other plants" 5000 years BCE. Early pre-Columbian cultures, such as the Olmecs, venerated a maize god and,[6] centuries later, Nahua societies, including the Aztecs, grew corn and incorporated maize in rituals associated with war.[7] Foods such as tortillas and practices like corn nixtamalization (cooking the grain in calcium hydroxide)[8] were developed in this era and are still part of Mexican cooking. Beyond these facts, corn was at the center of Mesoamericans' cosmovisions of duality and cyclical creation and destruction. Many pre-Hispanic civilizations believed that man was made of corn—that corn was flesh and blood. Calendars and rituals were created in response to corn's timeframes.[9] As Octavio Paz argues, "All these myths are culinary metaphors, but in turn, cuisine is a metaphor of culture."[10]

The Spanish Conquest brought new ingredients and gastronomic innovations that became part of contemporary cuisine in Mexico. This was a time when three very different cultures collided: the indigenous peoples of the Americas, the European conquerors, and the African slaves.[11] In the era of Spanish domination, the introduction of pork would have a special impact in the use of corn in Mexican cuisine. The lard from

Figure 11.2
Colectivo Amasijo's milpa greens salad, rabbit mixiote, and corn tamal. Photographer: Pablo Arguelles. © The Museum at FIT

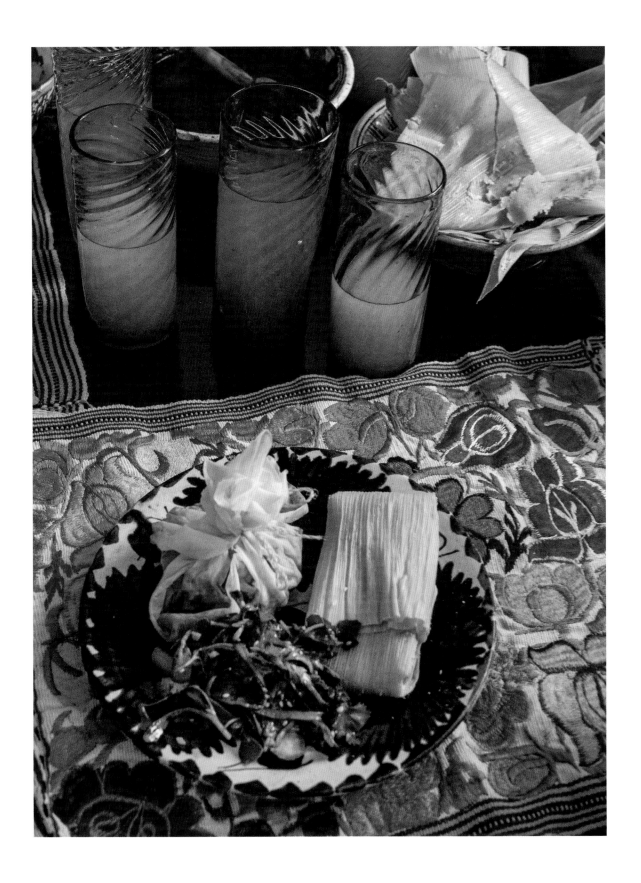

these animals opened up the possibility of frying corn foods.[12] Additionally, Spaniards introduced European gastronomic dynamics, which fused with Mesoamerican food culture.[13] New Spain's fashionable dress and food culture developed a distinct identity concurrently, around 1650 to 1715. Despite the abuses of the Spanish crown and the rampant social inequities that favored Spanish-born individuals to the detriment of local populations, the eighteenth century was an era of cultural and economic splendor in New Spain. The blend of indigenous, European, and African influences created local styles and dishes clearly different from those of other countries.[14] This cultural miscegenation is at the heart of the twentieth and twenty-first century narratives of national identity in Mexico.

By the nineteenth century, Mexico had become an independent country. French nationals became active players in luxury, textiles, beauty, retail, and banking, among other industries. As the century progressed, France would become Mexico's model in gastronomy and fashionable dress.[15] Even through this Francophile period, Mexicans retained their love for corn, as attested by Frances Calderón de la Barca, who mused in her memories that tortillas were considered unfashionable but could be found "in some of the best old houses."[16] In her memoirs, tortillas are mentioned tens of times, and she references other corn-based foods, including gorditas and atole, which are enjoyed in Mexico to this day.[17]

In Mexico, controlling corn is controlling power. This national grain is the focus of heated debates over its relation to mores, politics, economy, and farming. Because of its strong symbolic significance, maize has been an inspiration for fashion. What follows are instances in Mexican fashion where corn was used to shed light on inequity, the effects of industrialization, misogyny, and other contemporary issues.

Carla Fernández: The Politics of Corn

A milpa is the place where corn, beans, and pumpkins have been grown since pre-Hispanic times. These three plants create an environmental and nutritional balance. The species coexist, share resources, and nurture each other, protecting Mexican biodiversity. Additionally, the three foods are "an important part of Mexican cuisine and continue to be the basis of food sovereignty in many regions of Mexico."[18] Thus, the philosophy of Carla Fernández's "Milpa" collection was that "Man takes care of Earth and Earth takes care of Man."[19] The garments in "Milpa" were inspired by the clothes of field workers. This points to how Fernández's concerns with ecology are intertwined with the well-being of field workers and artisans. She believes that being respectful of workers and the environment are two faces of the same coin.

"In true luxury, there's no oppression!" was one of the chants in Fernández's "Fashion in Motion" presentation at the Victoria and Albert Museum in 2018. Feminist Audre Lorde argues that "for women, the need and desire to nurture each other is

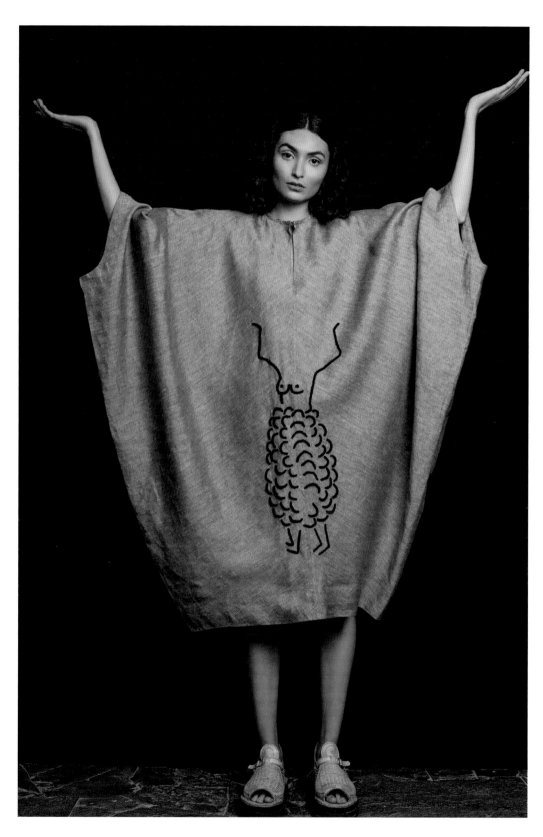

Figure 11.3
Carla Fernández, "Milpa" collection "Mariposa" tunic, spring/summer 2019. Photographer: Ana Hop; Model: Xiomara Moreno. Courtesy of Carla Fernández

not pathological but redemptive, and it is within that knowledge that our real power is rediscovered."[20] By collaborating with other women throughout Mexico, Carla Fernández creates a network in which design, shared experiences, and love of the land and its products provide all of them with means to sustain themselves.

The Mariposa tunic by Carla Fernández brings together ecology, ethical fashion, and political activism. In recent decades in Mexico, transgenic and industrially produced cornmeal has dramatically replaced heirloom nixtamalized corn. Nixtamalization chemically transforms vitamins and minerals in corn, allowing the human body to absorb them, and adds calcium to them, making maize even more nutritious. The switch to industrialized corn has not only adversely affected the nutritional value of a staple food in the Mexican diet, but also has put enormous strain on small corn farmers. The increased economic disparity and the detriment to Mexican diets were central preoccupations of Fernández's "Milpa" collection.

The Mariposa tunic was embroidered by women in the cooperative "Flor de Margarita" in Chenalhó, Chiapas. In this Mexican region, agriculture is the main axis of its inhabitants. In harvest ceremonies, corn is the most celebrated crop. The embroidery of the dress is a woman who is wearing corn as her skirt. Her outfit is that of how some women still clean and shell corn in parts of the country. To Fernández, fashion is political, and so is food. The designer is not willing to ignore the political implications in the sourcing, manufacturing, and consumption of fashion.

Pink Magnolia: Corn Paradise

The Tlacolula open air market in Oaxaca, Mexico, inspired Pink Magnolia's spring/summer 2019 *Paraiso* (Paradise) collection. To Paola Wong, creative director, the market is a paradise where she relished in the foods, traditions, color scheme, and the women who walk about dressed in traditional clothes. Tlacolula offers an array of prepared foods, ingredients for cooking, and cooking utensils, among many other products. Wong selected emblematic objects like corn on the cob and colorful tacos and had them embroidered onto the garments.[21] Sisters Paola and Pamela Wong, the team behind Pink Magnolia, described the collection on Facebook as a "colorful Mexican fiesta filled of [sic] vibrant details."[22] In appearance, the collection is urban and festive, but it is substantially handcrafted, incorporating natural dyes, artisanal embroidery, and waist loom-woven fabrics.

Unlike other designers, the Wong sisters do not shy away from sombreros, burro piñatas, and traditional dolls—images familiar to foreign eyes. In one particular garment, the *Arcoíris* shirt, they featured a taco filled with glitter. The shape of this food is reminiscent of hard shell tacos, an American food that is barely known in Mexico. But to Paola Wong, these glitter tacos are her homage to Tlacolula, where you can

Figure 11.4
Pink Magnolia, *Glitter Taco* shirt, spring/summer 2019. Photographer: Zac Stone, Model: Mexican model Karime Bribiesca. Photography courtesy of Pavo Wong/PINK MAGNOLIA

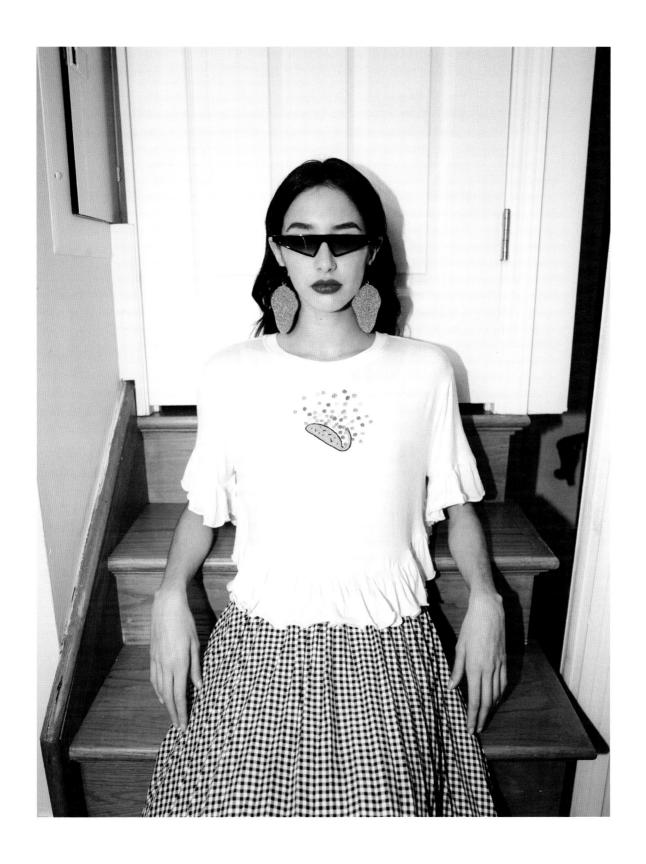

buy your own steak, grill it, and make tacos with "the soft corn *tortillitas*, with the delicious colors that characterize our culture."[23] The back of their pink *Mole* jacket is emblazoned by an embroidered corn on the cob covered in mayonnaise and chili. Again, this is a snack found in the market that inspired the collection, but it is also known globally as classic Mexican street food. The Wong sisters reconfigure power structures by stripping stereotypical representations of Mexico of any violence associated with the exoticizing gaze. In the Pink Magnolia paradise, Mexican female consumers lightheartedly wear these images that are inspired by real Mexico while being easily identified as Mexican to foreigners.

Alma: Beautiful Maize

Berke Gold established the accessories brand Alma in 2017. In its early stages, Alma was a home goods brand in which Gold designed in tandem with women artisans from Guerrero, a state on Mexico's Pacific coast. The processes proved extremely laborious and the end product outrageously expensive. During a brainstorming session to address the brand's issues, the artisans proposed selling their woven palm-leaf taco bags. The women had named them for their shape, which is that of a tortilla folded in half. The bags proved to be extremely popular, and thus, Alma became a brand that focuses on food. Over time, jewelry artisans and leatherers have joined the team. Other corn-based foods that have been featured in the brand's collections are silver tostada rings and flauta taco bags. Those at Alma share the vision that tradition and innovation are strongly linked. For Gold, Mexican food is complex, full of delicate qualities that he wishes to infuse in his designs. Made with two emblematic materials from Guerrero—silver and palm leaves—Alma's accessories are sophisticated and functional.

Alma's approach to fashion is whimsical and celebratory. The designer's lust for life is reflected in the brand. Inherited from Gold's background in product design, there is a focus on lifestyle and a strong emphasis on honing functionality. He continually prototypes and redesigns. Even the signature taco bag has gone through different variations. Food has proven a rich source for Alma; products such as market shopping bags are now turned into leather goods. In 2019, Alma and the store Ikal created a window design that featured fruit baskets, oranges, and taco handbags. The display highlighted the bags' gastronomic origins. "The taco. A shape we admire in Mexico. There is nothing more beautiful than a simple form that responds directly to its function: carrying something inside."[24]

Figure 11.5
Alma, "Taco" bag, 2019. Photographers: José Miguel Ramírez and Berke Gold. Courtesy of Berke Gold © 2020, ALMA

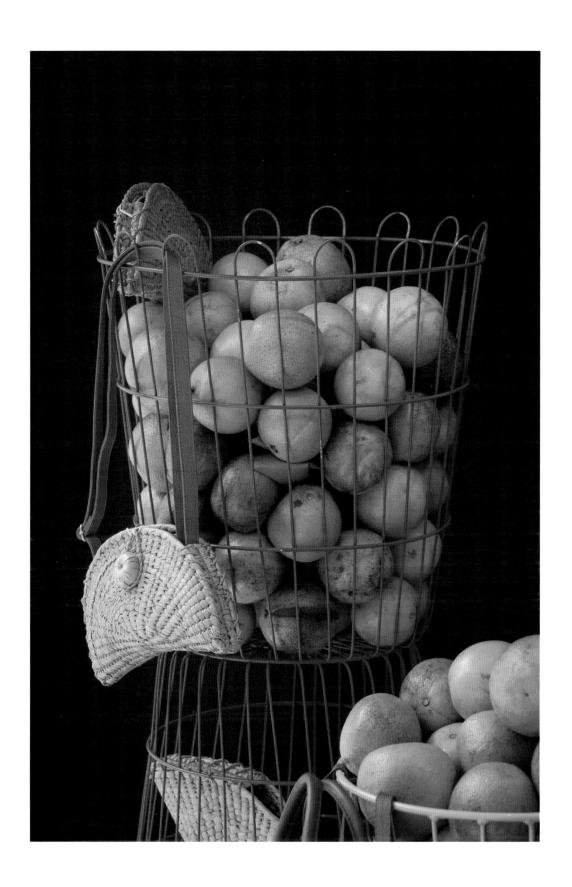

Orly Anan: Glam Corn

In 2017, artist Orly Anan directed a fashion editorial for the now defunct New York *Bullet Magazine*. Anan was born in Colombia and is based in Mexico City. For Anan as a foreigner, corn is the basis of Mexican culture; she cites that in the Mayan text *Popol Vuh*, man and corn are indissolubly linked. The focus of her editorial was to present a contemporary view of Mexico—one that is glamorous but full of contradictions.

The aesthetic of excess in most of Orly Anan's work pays homage to the natural world. She favors bright colors and smooth textures. Her compositions frequently depict stylized altars that incorporate food, tropical foliage, and man-made objects. Her image for the editorial includes a stack of tortillas at the center, surrounded by fruit, roses, ornaments, and a fifty pesos bill. "To me, corn is abundance and fertility, the most beautiful face of Mexico,"[25] explains the art director. Additionally, the photograph alludes to the social significance of tortillas. The word *Glam* is written with crystals and displayed over the tortillas. This juxtaposition points to the irony that although corn tortillas are the great equalizer in Mexico, they have always been considered poor people's food, with wheat bread being more prestigious. When New Spain's colonial institutions were established, "food was a separating factor between the European elite and the poorer Indigenous population . . . wheat and corn. . . . This culinary separation persists still today in parts of the Americas."[26] Anan's rendition of tortillas, while poetic, underscores Mexico's colonial past and its persistent culture of discrimination.

Sánchez-Kane: Gender and Taste

The slogan of menswear brand Sánchez-Kane is *La casa del macho sentimental* (The House of the Sentimental Macho). Unapologetically, it is a comment on chauvinism and masculinity in Mexico. Designer and founder Bárbara Sánchez-Kane is a lesbian working and living in a conservative country. She oftentimes dresses in male attire, "decentering and deconstructing dominant paradigms of masculinity."[27] Sánchez-Kane continually plays with words, creating visual puns that highlight the views of the designer on Mexico's mores. Through her fashions, she voices women's widespread frustrations over patriarchal structures, homophobia, and misogyny, all entrenched in Mexican culture.

Sánchez-Kane has used corn as a vehicle to express her perceptions regarding gender and stifling social norms in Mexico. Taste in terms of flavors, but also what is appropriate, is central to this brand. For that reason, the designer frequently includes

Figure 11.6
Orly Anan for Sánchez-Kane,
Tortilla Glam, 2017. Photographer:
Felipe Hoyos Montoya. Courtesy of
Orly Anan

Figure 11.7
Sánchez Kane, jumpsuit, spring/
summer menswear, 2018.
Photographer: Felipe Hoyos
Montoya. Courtesy of Barbara
Sánchez-Kane

food and tools such as cheese graters and Oaxaca cheese in her fashion shows and performances. Sánchez-Kane favors corn, which she has used in different presentations: on the cob as a phallic stand in, as tattooed tortillas in a performance, and in her showroom as a sculpture made of corn husks. To her, corn is Mexican, ubiquitous, and phallic. In slang, a *tortillera* (a woman who makes tortillas) is a lesbian, and Sánchez-Kane relishes in that play of words. Her use of corn tends to be accompanied by shock value and an iconoclastic spirit. This is an attempt to counterbalance societal impulses to cloak lesbians "in invisibility,"[28] and is indebted to queer theory, which proposes an "embodiment in practice of transgression and subversion."[29]

For her spring/summer 2018 "Men Without Fear" collection, Sánchez-Kane co-styled an editorial with fashion stylist Nayeli de Alba, which also was featured in *Bullet Magazine*. It was full of androgynous images that used maize to underline the seditious attitude of Sánchez-Kane. In one photograph, model Daniel Furlong stands on two tortilla stacks, wearing a jumpsuit inspired by cowboy chaps and fastened by multiple belts. Over the jumpsuit, a chainmail bra and two Maverick car logos are worn as ornaments, while the model holds a corn cob with its husk open, an edible phallus.

Ricardo Seco: Mexico's Soul Is Made of Corn

Ricardo Seco is a Mexican designer based in New York City. His collections have focused on his bi-national experiences. Seco has positioned himself as a proud immigrant during a very contentious time in American politics. A gay designer, he is heir to queer fashion history in his use of t-shirts to shed light on political issues. As scholar Jonathan Katz explains, the rise of the activist political queer t-shirt was "predicated on the development of a new historical identity, one that embraced the forthright declaration of visible difference as a strategic political advantage."[30] Seco's politics of visibility bring light to policies and discrimination affecting migrants. He addresses controversial topics in his t-shirts while infusing them with a nonchalant attitude.

Seco's spring 2021 collection centered on corn. The collection's t-shirts were white with bold slogans that use phrases such as "Mexico's Soul Is Made of Corn." Mexico and corn came first in his design. Wearers could express their alliance or admiration for the country by wearing the garment. These were celebratory shirts that underlined that corn is, above everything else, Mexican. The collection also featured oversized pre-Columbian gods of corn, boldly colored to make the clothes statement pieces. Seco explained, "I selected these deities because of their duality. Like our current dual national identity as Mexican Americans. There were Mayans and Aztecs, different societies with their own corn gods. I want to show how there has always been duality."[31]

Figure 11.8
Ricardo Seco, 2020. Photographer:
Uriel Santana. Styling: Blancopop.
Courtesy of Ricardo Seco

Maria Fernanda Sela: Eating Fashionably

For its tenth anniversary, the Mexican magazine *192* devoted its forty-fifth issue to the theme of hunger and explored its metaphorical meaning among some of Mexico's most prominent creative minds. The artists, architects, and designers shared their instinctive desire to create through a series of interviews, editorials, and articles. In a feature titled "*Mesa*" (Table), María Fernanda Sela, deputy director of *Elle Mexico*, interviewed prominent Mexican cultural figures, including fashion designer Carla Fernández and her husband artist Pedro Reyes; Maggie Galton, co-owner of the artisanal lifestyle brand Onora Casa; and photographer Diego Berruecos. Sela framed her interviews on the idea that table settings are "absolutely personal," and they reveal "the taste and personality" of hosts.[32] In this instance, the magazine serves as an aspirational gatekeeper of the tastes of Mexico's upper class.

Figure 11.9
The table of Carla Fernández and
Pedro Reyes as it appeared in the
interview "Mesa," *192* magazine.
Photograph by Ana Lorenzana.
© 192, courtesy of *192 Magazine*

Corn was part of the Fernández-Reyes table setting, exemplifying those of fashion elites in Mexico for whom it is a sign of refinement to serve Mexican cuisine in traditional dishware. The couple once treated the author to a dinner where the centerpiece was made of fresh corn and husks, and they served a soup garnished with white corn poured into artisanal bowls. For Fernández and Reyes, there is a pride and a pleasure in sharing Mexican traditions with their guests. Moreover, it makes for great conversation. In the interview, the couple explained that it is while entertaining their friends and colleagues that projects are resolved.[33]

The couple's stylish table setting is intrinsically linked with Mexico's cultural roots. They are heirs to iconic hosts such as Miguel and Rosa Covarrubias who brought together the likes of the Rockefellers and the Riveras in mid-twentieth century Mexico. American-born Rosa devoted years of her life to learning Mexican traditional recipes. The couple collected traditional crafts and pre-Hispanic art that decorated their home. In Ana Lorenzana's photograph of the Fernández-Reyes table, traditional barro bowls with cream of beans, fried corn strips, avocado, huauzontles, and salsa verde are on display. They represent an ultimate example of the sophistication and delicacy of fashionable, cultured Mexicans. From their rarified lifestyle, the couple infuse peasant dishes with their cultural capital. Despite their humble origins, simple food and tableware become desirable when associated with power.

Sin maíz no hay país (Without Maize There Is No Mexico)

All of the previously mentioned designers, although cosmopolitan, are very grounded in their experience in Mexico. Central to their creative practices is honoring the duality of Mesoamerican cosmovision. They are agents of modernity and progress, and heralds of their ancestral heritage. Like other postcolonial societies, Mexico romanticizes its past and its indigenous cultures to differentiate itself from other cultures. However, the question remains: Is Mexican fashion western fashion? Or are Mexicans the exoticized "Other"? Are those ideas mutually exclusive?

In the intricacy of its garments, photographs, and fashion media, Mexican fashion appears cultured and layered—even progressive. There is as much depth in the fashion of Mexico as in the country's food culture. They both lend themselves to questioning the politics and ethics of field work and manufacturing, the effects of gender inequality, and preconceived notions about what we eat and wear, and how they relate to taste and power. The food and fashion cultures of Mexico are complex and fascinating, profoundly imbued with meaning. When we eat, food becomes one with us. In these fashions, corn is the internal self and clothes envelop it. It is a communion between what nourishes our bodies and what becomes our skin.

Notes

1. Ramon Valdiosera, *3000 años de moda mexicana* (Mexico City: EDAMEX-Cámara Nacional de la Industria del Vestido, 1992), 222.

2. Bárbara Sánchez-Kane, conversation with the author, July 2020.

3. George Armelagos, "Cultura y contacto: El choque de dos cocinas mundiales," in *Conquista y Comida: Consecuencias del encuentro de dos mundos*, ed. Janet Long Coord. (Mexico City: Universidad Nacional Autónoma de México, 2018), 118.

4. Virginia Garcia Acosta, "El pan de maíz y el pan de trigo: una lucha por el dominio del panorama alimentario urbano colonial," in *Conquista y Comida: Consecuencias del encuentro de dos mundos*, ed. Janet Long Coord. (Mexico City: Universidad Nacional Autónoma de México, 2018), 267.

5. Stanley Brandes, "El misterio del maíz," in *Conquista y Comida: Consecuencias del encuentro de dos mundos*, ed. Janet Long Coord (Mexico City: Universidad Nacional Autónoma de México, 2018), 256.

6. Pablo Escalante Gonzalbo, "El México Antiguo" in *Nueva Historia Minima de México* (Mexico City: El Colegio de México, 2004), 12–13.

7. Inga Clendinnnen, "The Cost of Courage in Aztec Society," in *The Mexico Reader: History, Culture, Politics*, eds. Gilbert M. Joseph and Timothy J. Hendersons (Durham and London: Duke University Press, 2002), 67.

8. Amanda Galvez, "The Wisdom of Tradition," in *Nixtamal: A Guide to Masa Preparation in the United States* (Los Angeles and Mexico: Masienda/Mini Super Studio: 2017), 14.

9. Margarita de Orellana, "Maíz Místico," *Artes de México*, June 2006, 7.

10. Octavio Paz quoted in Debra A. Castillo, "Octavio Paz's Bread and Mole," *Hispanófila*, no. 178 (2016): 153–66.

11. Leticia Casillas and Luis Alberto Vargas, "El encuentro de dos cocinas: México en el siglo XVI," in *Conquista y Comida: Consecuencias del encuentro de dos mundos*, ed. Janet Long Coord (Mexico City: Universidad Nacional Autónoma de México, 2018), 155.

12. Casillas and Vargas, "El encuentro de dos cocinas," 159.

13. Janet Long, "Prólogo," in *Conquista y Comida: Consecuencias del encuentro de dos mundos*, ed. Janet Long Coord (Mexico City: Universidad Nacional Autónoma de México, 2018), 11.

14. Bernardo Garcia Martinez, "La época colonial hasta 1760," in *Nueva Historia Minima de México* (Mexico City: El Colegio de México, 2004), 95.

15. Andrea Ancira et al., *Moda y política: Encuentros místicos en la Ciudad de México* (Mexico City: Taller Fashion Development Project, 2015), 11.

16. Frances Calderón de la Barca, Life in *Mexico: During a Residence of Two Years in That Country* (Sydney: Wentworth Press: 2016), 117.

17. Calderón de la Barca, *Life in Mexico*, 52, 198, 323, 347.

18. Luis A. Venutra Martinez, "A Mexican legacy: La milpa," the birthplace of maize," Cornell Alliance for Science, Cornell University, October 12, 2007, https://allianceforscience.cornell.edu/blog/2017/10/a-mexican-legacy-la-milpa-the-birthplace-of-maize/#:~:text=One%20of%20the%20main%20advantages,fixation%20provided%20by%20the%20beans.

19. Carla Fernández, *Lookbook*, Spring/Summer 2019, 34.

20. Audre Lorde, "The Master's Tools Will Never Dismantle the Master's House," in *Feminist Postcolonial Theory: A Reader*, eds. Reina Lewis and Sara Mills (New York/London: Routledge Taylor & Francis Group, 2003), 26.

21. Pink Magnolia, interview with Ana Elena Mallet, Madame Mallet by Puentes, podcast audio, April 26, 2016, https://mytuner-radio.com/podcast/madame-mallet-puentes-1258270047.

22. Pink Magnolia's Facebook page, https://www.facebook.com/pinkmagnoliaofficial/.

23. Paola Wong, conversation with the author, July 2020.

24. Alma, *Lookbook*, Fall/Winter 2020/21, 1.

25. Orly Anan, conversation with the author, April 2020.

26. Nina M. Scott, "La comida como signo: Los encuentros culinarios de América," in *Conquista y Comida: Consecuencias del encuentro de dos mundos*, ed. Janet Long Coord. (Mexico City: Universidad Nacional Autónoma de México, 2018), 153.

27. Vicki Karaminas, "Born This Way: Lesbian Style Since the Eighties," in *A Queer History of Fashion: From the Closet to the Catwalk* (New Heaven/London: Yale University Press, 2013), 206.

28. Elizabeth Wilson, "What Does a Lesbian Look Like?" in *A Queer History of Fashion: From the Closet to the Catwalk* (New Heaven/London: Yale University Press, 2013), 167.

29. Wilson, "What Does a Lesbian Look Like?" 188.

30. Jonathan D. Katz, "Queer Activist Fashion," in *A Queer History of Fashion: From the Closet to the Catwalk* (New Heaven/London: Yale University Press, 2013), 222.

31. Ricardo Seco, conversation with the author, July 2020.

32. María Fernanda Sela, "Mesa" in *192*, September 2017–February 2018, 171.

33. Sela, "Mesa," 173.

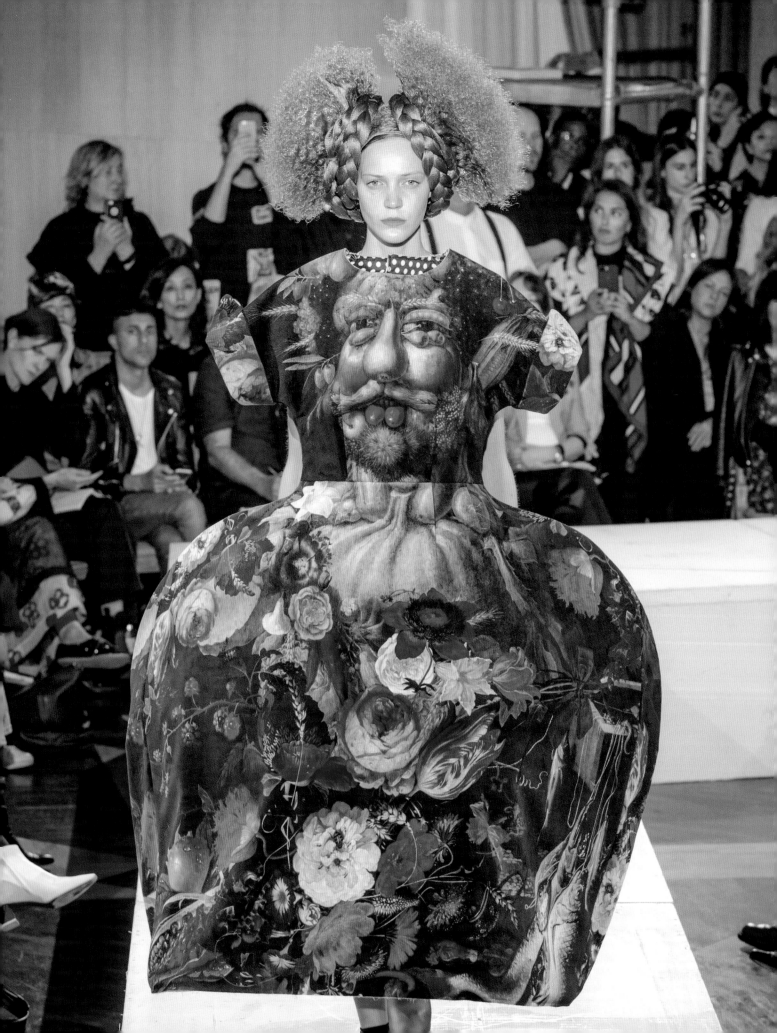

The Eye Has to Eat: Food, Fashion, and Art's Enduring Intersects

Madeleine Luckel

During the first quarter of the sixteenth century, Venetian painter Lorenzo Lotto completed a portrait of a noblewoman named Lucina Brembati.[1] The painting, with its emphasis on rich textiles and valuable jewelry, is not dissimilar from other depictions of members of the Italian aristocracy during the High Renaissance period.[2] But for those interested in the frequent intersections between visual culture and food, it contains a particularly alluring—if cryptic—detail. Suspended from a long gold chain and topped by a single pearl is what appears to be a hook- or horn-shaped pendant. The ornament is, in fact, a finely crafted toothpick, which was not an uncommon luxury accessory during the 1500s.[3] While at least one writer decried this trend at the time, associating such necklaces with bad manners, the painting evidences just how inextricably linked fashion, food, and art so often are.[4]

For as long as humankind has been creating art, food has been making constant, if at times subtle, appearances. The French caves at Lascaux, which date back to the Paleolithic period, show images of animals associated with the hunt.[5,6] A trompe l'oeil mosaic floor from an ancient Roman dining room contains scattered bits of food waiting to be swept up.[7] Later, food was featured in Japanese *ukiyo-e* woodblock prints, Iranian illuminated manuscripts, and Leonardo Da Vinci's *The Last Supper*.[8] Renderings of dining experiences can hint at how fluidly food and fashion can fit together within a composition and in daily life. During the late nineteenth century, French artists illuminated this in new ways, documenting Parisian café society as they and their peers experienced it. The results were vivacious and marked a significant departure from the more formal subject matters deemed worthy and appropriate in Europe during past eras. Paintings such Renoir's *Luncheon of the Boating Party* testified to

Figure 12.1
Comme des Garçons, spring 2018 collection. © IMAXtree.com

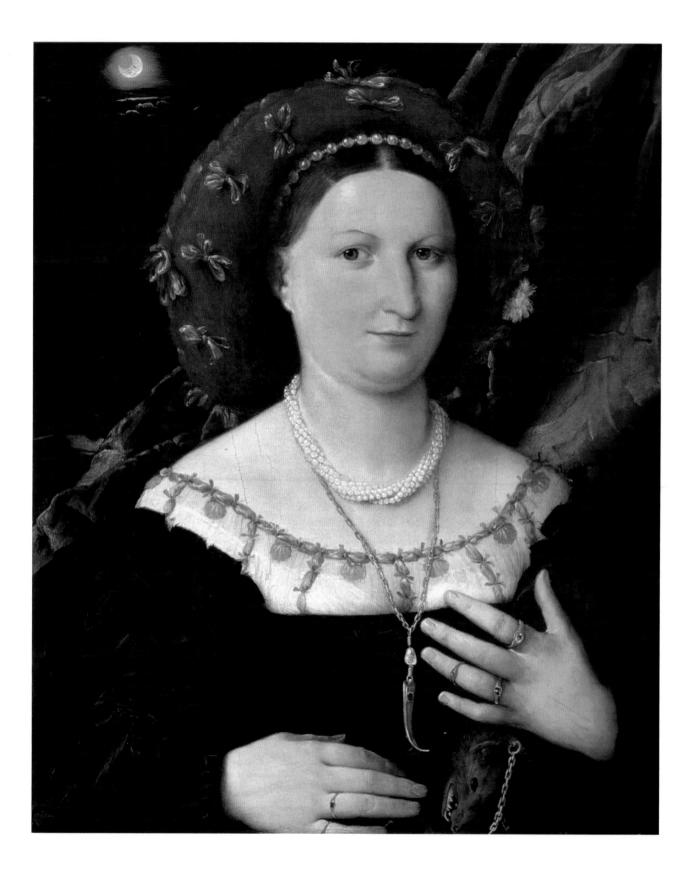

Figure 12.2 (opposite)
Lorenzo Lotto, *Portrait of Lucina Brembati*, c. 1518–23, oil on wood panel, Accademia Carrara, Bergamo, Purchased from the Countess Degnamerita Grumelli Albani of Bergamo, 1882

Figure 12.3
Pierre-Auguste Renoir, *Luncheon of the Boating Party*, 1880–1881, oil paint, The Phillips Collection, Washington DC

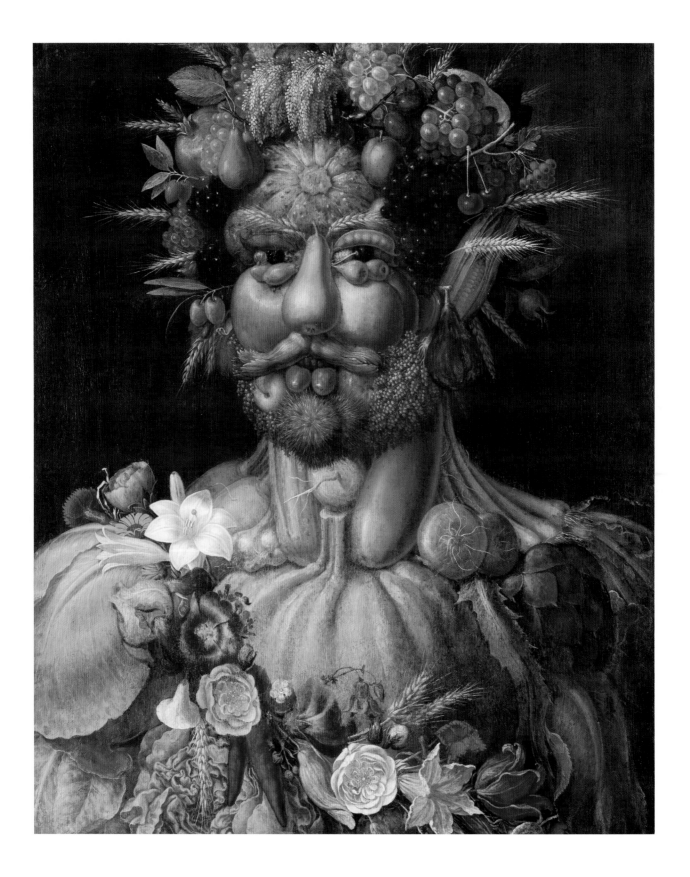

prevailing dress silhouettes, what exactly the individuals who wore these garments ate and drank, as well as wider shifts in class, custom, manners, and mores taking place then beyond the canvas's frame.[9]

It is tempting, at this point, to plunge headlong into the purview of twentieth and twenty-first century art, and to where this story reaches its crescendo, but to do so would overlook some of the most creatively nourishing works within art history, which dispel the overly simplistic narrative that the relationship between food, fashion, and art only became complicatedly interesting in the relatively recent past. Subtleties, a seemingly ironic name given to highly elaborate sugar sculptures made to crown tables during the medieval and Renaissance periods, were closely tethered to the art of setting an impressive and fashionable table.[10,11] Giuseppe Arcimboldo, an Italian artist active in the Habsburg court during the sixteenth century, painted distinct portraits that were often made up entirely of fruits and vegetables—from the subjects' facial features to their clothes.[12] Fantastical and highly imaginative, they were devised before still lifes were considered to be their own distinct genre, and continue to influence art and advertisements today.[13,14]

It is artworks such as these, which engage with questions of food and fashion in complex and, at times, ambiguous ways, that are the principal concern of this chapter. In the first section, the surrealist art movement—in particular, the work of couturier Elsa Schiaparelli—is examined, as is food photography. Later on, the commercial translation of Andy Warhol's *Campbell's Soup Cans* into a paper dress buttresses an investigation of Schiaparelli's Salvador Dalí lobster gown. Although conceptual artists are referenced, contemporary art is primarily addressed in the subsequent section, with an emphasis on pieces that contain performative elements or that grapple with issues of waste. The chapter ends with a discussion of the unique and more recent history of food photography in *Vogue*. In that way, the subgenre's relationship with fashion receives its own bookend, while allowing for a consideration of how social media is currently shifting the nature of and engagement with such images. Ultimately, by examining a multitude of disparate yet harmonious examples, the story of food, fashion, and art is brought into sharper focus as a topic brimming with endless avenues of interest. When the three fields meet and merge, seemingly ordinary necessities of life are often elevated. And in this way, an attuned viewer can learn to see each element in a new and more substantial light.

Figure 12.4

Giuseppe Arcimboldo, *Vertumnus*, 1590–1591, oil on panel, Skokloster Castle, Sweden

You Wear It, You Buy It:
Commercial Tendencies in Twentieth Century
Collaborations, Photography, and Art

In January 2017, the house of Schiaparelli sent a cream-colored gown down its spring couture runway.[15] The dress, which took 250 hours to create, featured a boldly embroidered lobster emblem.[16] As fashion industry observers pointed out, the garment was not so much an original concept as an homage to one of its namesake founder's most famous designs.[17] Unlike her interwar couturier peers, Elsa Schiaparelli believed vehemently that fashion was a form of art.[18] She helped facilitate an exhibition for surrealist artists (many of whom she knew personally), worked with Méret Oppenheim after an encounter at Paris's Café de Flore, and was inspired by Magritte's pipe-emblazoned *The Treachery of Images* when designing the bottle for a 1940 perfume.[19] Famously, she collaborated with Salvador Dalí on works such as her 1937 lobster dinner dress.[20] Purchased by the Duchess of Windsor as part of her trousseau, the dress included a phallic illustration of a lobster by the Spanish artist.[21] Although Schiaparelli apparently refused Dalí's request to spread mayonnaise on the garment, a Cecil Beaton *Vogue* image of the Duchess wearing the gown helped cement its fame.[22] In many instances, Schiaparelli's incorporation of food added a dose of subversive humor to designs created during the Depression and the reign of the Vichy government in France.[23] However, her collaborations with Dalí were more than that. As curator Dilys Blum states, that pairing helped alter the very nature of fashion by elevating what exactly a piece of clothing could be.[24]

For Dalí, Schiaparelli was just one course in an enduring fashion-and-food-focused meal with monetary potential. Like his contemporaries, Dalí went on to frequently contribute illustrations to magazines such as *Vogue* and *Harper's Bazaar*.[25] He also penned a surrealist cookbook, *Les dîners de gala* (1973), which has served as a source of inspiration for contemporary photographer Lucia Fainzilber.[26,27] Nonetheless, Dalí is far from the only artist to create his own cookbook, as recent publications by the likes of Studio Olafur Eliasson prove.[28] In 2016, Aperture published a long-forgotten project, titled *The Photographer's Cookbook*. First compiled by a George Eastman Museum employee named Deborah Barsel during the 1970s, it includes recipes, colorful introductions, and missives from some of the twentieth century's most acclaimed photographers, including Brassaï, Horst P. Horst, and Richard Avedon.[29,30]

Figure 12.5
Cecil Beaton, *Portrait of Wallis Simpson*, *Vogue*, 1937. Cecil Beaton, Vogue © Conde Nast

The first instances in which food can be found in photographs dates back to the late nineteenth century.[31] During this era, images of food started to appear in cookbooks such as *Le livre de cuisine* (1867) by Jules Gouffe.[32] By the mid-twentieth century, food companies were producing color-saturated cookbooklets such as the 1950 *Betty Crocker Picture Cookbook.*[33] But even prior to that, fine art photographers were exploring food as a fruitful avenue for paid commercial work.[34] Notably, the sugar cubes Edward Steichen shot for Stehli Silk were intended as a fabric design.[35,36] Later on, conceptual artists like Ed Ruscha found inspiration challenging the very nature of the commercialized food industry and its imagery, with photographs such as his still life of Sun-Maid raisins.[37]

Andy Warhol deftly triangulated similar themes. Warhol's *Campbell's Soup Cans* are some of the artist's most famous and widely recognizable works of art. His enduring interest in food has been well documented—from a cookbook that he illustrated to the banana he devised to anoint The Velvet Underground's 1967 album cover.[38,39] In 1964, Warhol was included in a Bianchini Gallery exhibition titled *The American Supermarket,* while his film *Eat* showed Robert Indiana eating a mushroom.[40,41] Fashion figured into Warhol's creative engagement with food, too. A 1972 *Vogue* feature titled "Andy Warhol Turns Gold into Food" recounts the artist's enchanting efforts to decorate a cake with gold leaf and Hershey chocolate kisses, while his iconic *Campbell's Soup Cans* ultimately appeared on a paper dress.[42,43]

Warhol stated that he began to paint cans of soup in 1962 simply because they were his usual source of lunch.[44,45] Like his peers, Warhol's interest in food as a subject can be traced back to its link to commercialism.[46] Thematically, that interest, as well as its associations with the nature of making art and questions of originality, related to Warhol's penchant for producing silk screen prints, which remove standard traces of the artist's hand.[47,48] In the late 1960s, recognizing the ascendance of pop art, Campbell's Soup Company capitalized on Warhol's serendipitous choice of subject matter by manufacturing paper dresses patterned with his art.[49] At the time, paper dresses were a trendy fashion item.[50] Interested customers could acquire a dress by sending the company one dollar, as well as two Campbell's soup labels, thereby further incentivizing the sale of Campbell's soup.[51] In this way, the garments perfectly married food, fashion, and art, while serving as their own form of Warholian advertising. The design epitomized impersonal mass production and capitalism in action, while functioning as a walking advertisement. In yet another sense, the frocks could be interpreted as creating an accidental form of performance art, by disseminating Warhol's vision to a random smattering of American streets.

Figure 12.6
Edward J. Steichen, *Sugar Cubes: Design for Stehli Silk Corporation,* 1920s, gelatin silver print. The Metropolitan Museum of Art, Ford Motor Company Collection, Gift of Ford Motor Company and John C. Waddell, 1987. © 2020 The Estate of Edward Steichen/Artists Rights Society (ARS), New York. © The Metropolitan Museum of Art. Image source: Art Resource, NY

Figure 12.7
Campbell's Soup Company, "The Souper Dress," 1966–67, USA.
© The Museum at FIT

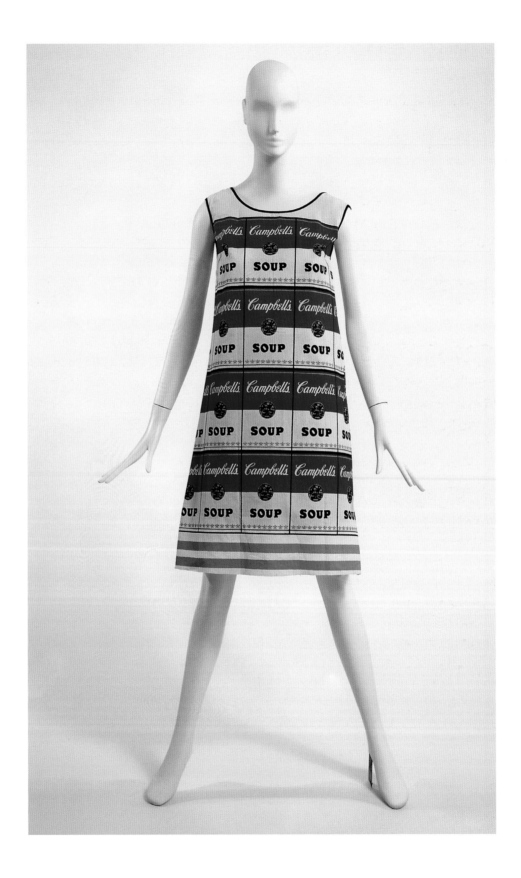

On and Off the Makeshift Runway: Issues of Performance and Waste

Peter Fischli and David Weiss created their *Fashion Show (Modenschau)* photograph in 1979.[52,53] The image, which features a parade of playfully assembled sausage meats making their way down a miniature and makeshift runway, is indicative of the duo's often humorous approach to art.[54,55] It also hints at how closely tethered the fashion industry is to performance and spectacle. Although a continuous litany of presentations, dinners, and events makes this fact clear year after year, it is the fashion show that exists in a stratosphere of its own—serving as a potent means of communication and even as an inspiration to artists.

Robert Kushner first showed his food costumes, which were constructed out of fresh produce, in 1972.[56] At the Jack Glenn Gallery in Corona del Mar, nearly nude individuals modeled scantily appointed and crochet-backed garments.[57] As Kushner later recounted, "True to California at that time, three or four audience members spontaneously stripped and tried on some of the costumes after the models had finished. At the end of the evening, I was pleased to see that a goodly amount of the food had actually been eaten."[58] Not long after, Kushner moved to New York, where he planned to stage the same piece.[59] The *Village Voice* announced the upcoming performance by referring to it as a fashion show and helped foment an uptick in audience attendance.[60] The results on the East Coast were very different: "The eating part of the performance in California had been celebratory and communal," Kushner later reflected.[61] "By contrast, with our advance publicity and confinement in a crowded SoHo loft, audience participation in New York took on a slightly carnal edge, and many of the performers beat a hasty retreat to the dressing room. During the performance a lot of food fell to the floor and was wasted. This degree of profligacy disturbed me, and I decided there should be a more responsible endgame for my next food performance. . . . In reality, I never did such a large performance again. I began looking for ways to continue making food costumes, but not on such a grandiose scale."[62]

Although Kushner is today best known as a member of the pattern and decoration movement, his food and fashion efforts did not end after these two performances.[63] While living in New York, he worked at SoHo's artist-run Food restaurant.[64] He pondered staging a restaurant-set runway show that would culminate in the consumption of a communal soup, while a smaller 1974 show ended with a strawberry- and banana-appointed bridal look in homage to the classic couturier practice.[65] Later on, Kushner was commissioned to create a high tea–themed display for Wanamaker's department store in Philadelphia, and fashioned a pumpkin- and collard greens–clad costume for a midnight fashion show at a 1994 Webster Hall Dada Ball.[66] Finally,

Figure 12.8
Fischli and Weiss, *Fashion Show (Modenschau)*, 1979, Chromogenic color print. The Abramson Collection. Gift of Stephen and Sandra Abramson. Museum of Modern Art, New York, NY, USA. ©Peter Fischli and David Weiss, Courtesy Matthew Marks Gallery. Digital Image © The Museum of Modern Art/Licensed by SCALA / Art Resource, NY

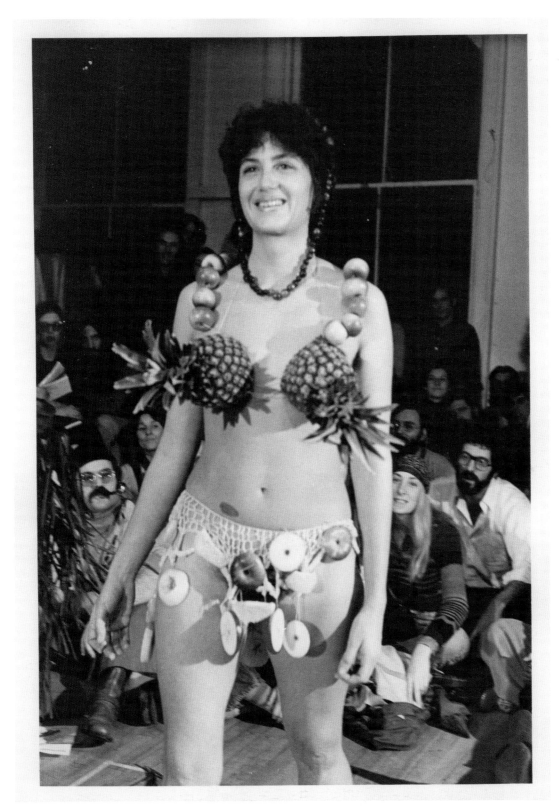

Figure 12.9
"Pineapple Falsies,"
*Robert Kushner and
Friends Eat Their
Clothes*, New York,
1972. Courtesy
Robert Kushner

Figure 12.10
Lady Gaga poses at the 2010
MTV Video Music Awards
at NOKIA Theatre on
September 12, 2010, in Los
Angeles, California. Photo
by Frederick M. Brown/
Getty Images

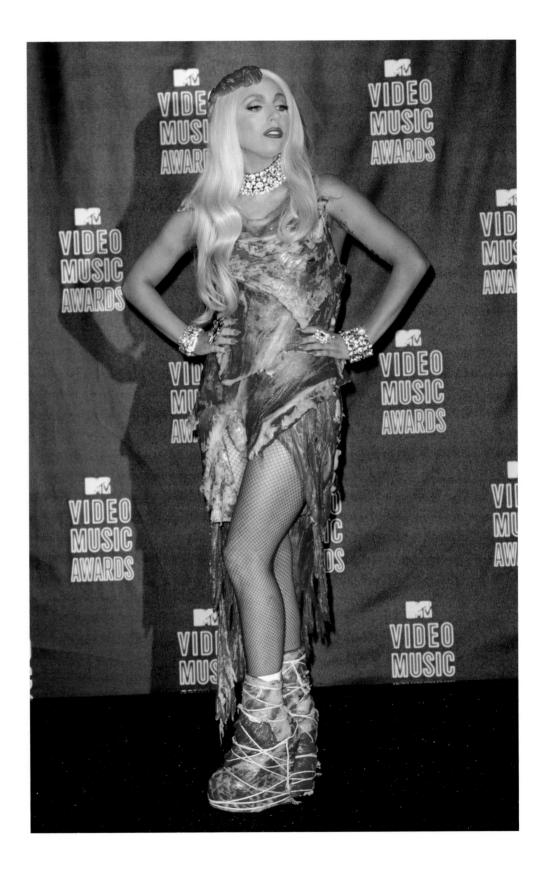

in 2010, he restaged his famous early 1970s performance art piece.[67] Coincidently, it was the same year that Nicola Formichetti dressed Lady Gaga in a memorable Franc Fernandez meat dress, a piece which was undoubtedly in line with the tradition of Kushner's own oeuvre.[68]

Clearly, other artists have engaged with real produce and other food to create pieces that hinge upon firsthand viewer experience. In early 2020, the Whitney Museum of American Art staged an installation by artist Darren Bader.[69] The untitled piece consisted of raw fruits and vegetables on pedestals. Every so often, Whitney staff members would take the ingredients, chop them up, and serve somewhat odd, or even bad, salads to visitors—as fashion-focused outlet *The Cut* reported.[70,71,72] Artist Antoni Miralda co-founded Food Cultura, a Barcelona-set nonprofit foundation, to help rethink food culture.[73] Miralda's focus is rooted in an anthropological approach, as opposed to an art historical approach, and has at times encompassed fashion.[74] In the early 1980s, Miralda helped stage a dinner in honor of Willi Smith's American Fashion Critics' Coty Award win for women's fashion.[75,76] As *People* magazine later recounted, "On top of three tables shaped like a jumpsuit, T-shirt and pair of pants, Miralda slathered gallons of mayonnaise, mustard and ketchup, dotted each table with little mirrors and watched as the chic guests, as he puts it, 'dressed themselves' while they downed asparagus tips and shrimp they had dipped into the brightly colored goo. As big a hit as most of these fantasies are, some have also produced bellyaches."[77] Miralda himself emphasizes today, "My sources of inspiration come more from popular environments, popular aesthetics, and connections to traditions."[78]

Although not based on any form of experiential events, Gretchen Röehrs's illustrations possess their own clear parallels to the work of Kushner. Röehrs, who is now art director at sustainable shoe company Rothy's, began creating whimsical fashion sketches of clothing made up of food during Instagram's nascent years.[79] After she gained online traction, Rizzoli published a book of her works in 2018.[80] The clothes she devised were not merely extensions of her drawings, but were instead fruits and vegetables sourced directly from farmers markets. In making her shopping selections, which were usually later repurposed for her own meals, Röehrs was able to put her values into creative practice, while challenging herself to eat items she might have ordinarily avoided.[81] "I think the first step in reducing food waste is acknowledging that you have food waste," Röehrs says, adding that, "I do think that certainly made me more aware of the parts of the fruits and the vegetables that maybe I didn't need to be throwing away."[82]

Figure 12.11
Gretchen Röehrs, *Le Banane*
fashion illustration from the
"Edible Ensembles" series, ©2018–
2020 GRETCHEN RÖEHRS

Today, the issues of waste and worth within fast fashion, and the increasing importance of sustainability, have become widespread topics of discussion. But the potential for consumption to be riddled with excess relates to the luxury market as well. Artist Tom Sachs has skewered this very dynamic in his *Value Meal* pieces.[83] The works, which reconstruct McDonald's packaging with shocking verisimilitude, recast the fast food chain's own branding in favor of recognizable logos. The first piece Sachs created in this series centered on Hermès, while subsequent iterations have been Prada-, Tiffany-, or Chanel-branded.[84] In a moderated interview with Sachs, Amy Cappellazzo, the current chairperson of the fine art division of Sotheby's, complimented the bricolage works, by noting how they unite "two distinct corners of reality."[85] She added, "I knew that Tom was looking at this and how it might look in 15 or 20 years, knowing that this meal on a tray would be its own relic. It was fascinating."[86]

Figure 12.12
Tom Sachs, *Hermés Value Meal*, 1997. Image courtesy Tom Sachs

Fashionably Formed: Food Photography in *Vogue* and Beyond

In a sense, the food photography that has been featured in *Vogue* throughout the years could be perceived as bringing together two seemingly distinct corners of reality. To many, the juxtaposition of food and fashion—specifically, food and *Vogue*—might seem contradictory.[87] But in reality, *Vogue*'s efforts to cover food have yielded some of the magazine's most intoxicating, whimsical, and artistic editorials—from striking still life photographs to the articles that they accompany. This trove is, by and large, separate from the work of photographers such as Helmut Newton, Guy Bourdin, and Tim Walker—whose fashion images tend to incorporate food primarily as props.[88,89,90,91] Taylor Antrim, the *Vogue* editor who currently oversees the magazine's food-related articles, notes that the pairing of text and image is "a huge part of the thinking" when selecting any feature's topic.[92] Of *Vogue*'s food coverage in general, Antrim adds, "Nestling a food image among fashion isn't one you immediately think of. It's somewhat unexpected and something of a privilege. . . . It brings with it some responsibility. You have to find the right tone, but there are no rules—it's an editorial journey."[93] Clearly, in terms of potential connections forged, the space for interpretation of this art extends broadly.

For years, Irving Penn created these photographs, producing cerebral and highly sculptural images of frozen foods and monumental cheeses. *Vogue*'s subsequent food photographs have been built upon his formidable foundation, shifting and transforming it along the way. Eric Boman's images indisputably centered on still lifes, while more recent contributions by notable artists such as Maurizio Cattelan have diverged more markedly in terms of topic and form.[94] Nevertheless, when asked which images he remembers being particularly surprised by or taken with, Antrim cites two Boman photographs.[95] One, which shows a dead duck hanging upside down, was published in the February 2014 issue and recalled art historical still lifes.[96] The other, which featured a stuffed rabbit climbing into a Le Creuset pot, yielded some reader complaints.[97] The images by Boman, like those of Penn, contrast with both the more lyrical fashion images included in the rest of the magazine and the food articles' prose, which tends to recount idiosyncratic quests and meditations on burgeoning culinary trends.[98]

Figure 12.13
Photograph by Irving Penn,
Small Cuttings of Bananas, New
York, 2008 © The Irving Penn
Foundation. Published in *Vogue*,
August 2009

Tamar Adler, who writes many of *Vogue*'s most whimsical food features, is a clear fan of Penn's and Boman's images.[99] "I loved the pairings of Eric Boman's photographs," she says of her own stories.[100] "I felt like his artistic lens was so wonderful and really, really added to the piece. It was a whole other dynamic that I couldn't have written in. . . . For a long time, I had a regular correspondence with him, and we would write to each other often, once a week about food, gardening, whatever. . . . There was a kind of relationship that was able to inform the art."[101] Clearly, collaboration is a strong creative current for Adler, yet both Antrim and Adler are highly cognizant of how food photography has changed in recent years with the advent of Instagram.[102]

For her own part, Adler laments this fact to a certain extent.[103] As she notes, "I think one of the things I really don't like about how widespread food photography is is that it seems to detract from the three experiences of food, which are the joy of making it, the joy of serving it, and the joy of eating it. It's not to say that food isn't beautiful. . . . It's just that I wonder about the cost to everything else, and the benefit."[104] Adler adds that the rise of food photography on Instagram is part of the reason she is so partial to paintings and illustrations that depict edible content.[105] "The artist clearly processed [his or her subject] and is making a whole new statement," she explains of such works.[106] "You know it has taken a long time and the point was never to eat the onions, right?" Adler offers as an example. "The point was to paint the onions."[107]

Nevertheless, the food images published in *Vogue* regularly reaffirm the subgenre's importance. "The trick about doing something interesting on food images in *Vogue* is to not be literal," Antrim says.[108] "Often what you see on Instagram is the dish or a prized table at a restaurant. Much of what we've been doing in *Vogue* is meant to provide some commentary, and that I don't see so much [on social media] or in other food magazines. [It's more,] 'Here's the dish you're going to want to cook.'"[109] In their most basic forms, food and fashion are both bare necessities, but when served with a side of such careful consideration and forethought, as is clearly the case with *Vogue*'s food photographs, artistic merit becomes difficult to discount.

Beyond *Vogue*'s pages, other contemporary photographers continue to grapple with similar themes, as well as the challenges posed by social media. Lucia Fainzilber, whose work often involves food and fashion, is one such artist. Overall, Fainzilber believes that the increase in accessibility that Instagram provides is a positive development.[110] "I feel like also with food, and with all the beautiful things, we are constantly receiving information, [as to] what's good and what's bad," she says, citing the ebb and flow of information as it relates to popular diets.[111] "We're overloaded with information. . . . And, it's not only about what we eat, it's about how we think."[112]

Figure 12.14
Lucia Fainzilber, *TDC 03*, 2015. This photograph is part of the "Three Course Dinner" series in which Fainzilber collaborated with art director Lara Crawshaw to combine elements of food and fashion in a Surrealist tableau. © Lucia Fanzilber

Conclusion

Food, fashion, and art are all part of the ongoing development of our collective creative culture. Naturally, the intersections between these fields are bound to continue. But even the stories that have already been told are ripe for further investigation. In 2014, artist Kara Walker debuted her monumental work, *A Subtlety, or the Marvelous Sugar Baby*.[113] The sphinx's head tie, a garment historically associated with enslaved and Black women, was just one of multiple ways it importantly drew attention to the history of American slavery. It also referenced the artistic tradition of subtleties in its name and medium.[114] Andy Warhol and his cohort may have been in part consumed by manufacturing, but around the same time, Wayne Thiebaud investigated elements of handcraft with his cake slice paintings after having been influenced by the Bay Area's then-nascent food scene.[115] And crustacean redo aside, the House of Schiaparelli dabbled with china plates and cutlery in a couture collection the year prior.[116] More recently, in 2020 Edward Hopper's *Nighthawks* has been recast in cartoon form for the socially distant era, as issues related to food colonialism have rightly extended far beyond the work of Julia Child to examine the nature of food and food media today.[117,118] Clearly, this tripartite story is set to become an increasingly relevant one, and part of a broader intellectual feast.

Notes

1. Lorenzo Lotto, Portrait of Lucina Brembati, ca. 1518-23, oil on wood panel, in "Renaissance: 15th and 16th Century Italian Paintings from the Accademia Carrara, Bergamo," National Gallery of Australia, https://nga.gov.au/exhibition/renaissance/default.cfm?IRN=202398&BioArtistIRN=11297&MnuID=ARTISTS&ArtistIRN=11297&ViewID=2.

2. Lotto, *Portrait of Lucina Brembati*.

3. Silvia Malaguzzi, *Food and Feasting in Art* (Los Angeles: Getty Publications, 2008), 342–343.

4. Malaguzzi, *Food and Feasting in Art*, 342.

5. Kevin West, "Will Work with Food," *Surface*, December 2017, 136.

6. Laura Anne Tedesco, "Lascaux (ca. 15,000 B.C.)," The Met Heilbrunn Timeline of Art History, https://www.metmuseum.org/toah/hd/lasc/hd_lasc.htm.

7. Mary Kisler, "Abstinence and Plentitude: Food and the Gaze in Renaissance and Baroque Art," in *Art and Food*, ed. Peter Stupples (Newcastle, England: Cambridge Scholars Publishing, 2014), 14.

8. Ajinomoto Foundation For Dietary Culture, "Food in Ukiyo-e: The Japanese Summer Feast," Google Arts & Culture, https://artsandculture.google.com/story/food-in-ukiyo-e-the-japanese-summer-feast/MAKioNL48PaxIg; Attributed to Sultan Muhammad, *"The Feast of Sada," Folio 22v from the Shahnama (Book of Kings) of Shah Tahmasp*, ca. 1525, opaque watercolor, ink, silver, and gold on paper, https://www.metmuseum.org/art/collection/search/452111; Leonardo da Vinci, *The Last Supper*, 1495–1498, tempera and gesso on plaster, Santa Maria delle Grazie, Milan.

9. Pierre-Auguste Renoir, *Luncheon of the Boating Party*, 1880–1881, oil paint, The Phillips Collection, Washington DC.

10. West, "Will Work with Food," 136–137.

11. Monica Lausch, "From the Wunderkammer to the Tavola: On Style, Sustenance and the Role of Curiosities at Princely Feasts," in *Art and Food*, ed. Peter Stupples (Newcastle, England: Cambridge Scholars Publishing, 2014), 26.

12. Lausch, "From the Wunderkammer to the Tavola," 27–28.

13. Malaguzzi, *Food and Feasting in Art*, 52.

14. Lausch, "From the Wunderkammer to the Tavola," 39.

15. Emily Farra, "80 Years Later, Schiaparelli Brings Back Elsa's Famous Lobster Dress," *Vogue*, January 24, 2017, https://www.vogue.com/article/schiaparelli-behind-the-scenes-details-lobster -embroidered-dress-inspiration.

16. Farra, "80 Years Later."

17. Farra, "80 Years Later."

18. Dilys E. Blum, *Shocking! The Art and Fashion of Elsa Schiaparelli* (Philadelphia: Philadelphia Museum of Art; New Haven: Yale University Press, 2003), 10.

19. Blum, *Shocking! The Art and Fashion of Elsa Schiaparelli*, 7, 121–123, 142, 147.

20. Blum, *Shocking! The Art and Fashion of Elsa Schiaparelli*, 121–123, 135.

21. Blum, *Shocking! The Art and Fashion of Elsa Schiaparelli*, 123, 135.

22. Blum, *Shocking! The Art and Fashion of Elsa Schiaparelli*, 135.

23. Blum, *Shocking! The Art and Fashion of Elsa Schiaparelli*, 244–245.

24. Blum, *Shocking! The Art and Fashion of Elsa Schiaparelli*, 121.

25. Kelsey Hallbeck, "Dalí: Magazine Covers & Ads," The Dali Museum, St. Petersburg, FL, April 2020, https://thedali.org/exhibit/dali-magazines-ads/.

26. Salvador Dalí, *Les dîners de gala* (New York: Felicie Inc, 1973; Cologne, Germany: Taschen, 2016).

27. Lucia Fainzilber, conversation with the author, June 2020.

28. Olafur Eliasson, *Studio Olafur Eliasson: The Kitchen* (New York: Phaidon Press, 2016).

29. Lisa Hostetler, "Introduction," in *The Photographer's Cookbook*, ed. Deborah Barsel (New York, Aperture: 2016), 8–11.

30. Barsel, *The Photographer's Cookbook*, 16–17, 62, 84.

31. Susan Bright, *Feast for the Eyes: The Story of Food in Photography* (New York, Aperture: 2017), 24–36.

32. Bright, *Feast for the Eyes*, 38.

33. Bright, *Feast for the Eyes*, 119.

34. Bright, *Feast for the Eyes*, 56, 64, 119.

35. Bright, *Feast for the Eyes*, 56.

36. Edward J. Steichen, *Sugar Cubes: Design for Stehli Silk Corporation*, 1920s, gelatin silver print, Metropolitan Museum of Art, New York, https://www.metmuseum.org/art/collection/ search/265263.

37. Bright, *Feast for the Eyes*, 129.

38. Maxime McKendry, "Andy Warhol Turns Gold into Food," in *Food in Vogue*, ed. Taylor Antrim (New York: Abrams, 2017), 96.

39. "The Story Behind the Velvet Underground's Most Iconic Album Cover," *Huffington Post*, October 28, 2013, https://www.huffpost.com/entry/velvet-underground-banana_n_4170126.

40. Sarah Kelly Oehler, "Convenience: Pop, Production, and the Making of Art in the 1960s," in *Art and Appetite: American Painting, Culture, and Cuisine*, ed. Judith A. Barter (Chicago: Art Institute of Chicago; New Haven: Yale University Press, 2013), 205.

41. McKendry, "Andy Warhol Turns Gold into Food," 96.

42. McKendry, "Andy Warhol Turns Gold into Food," 96.

43. "The Souper Dress," 1966–67, paper, The Met Collection, https://www.metmuseum.org/art/collection/search/79778.

44. Oehler, "Convenience," 206.

45. "The Souper Dress," 1966–67.

46. Judith A. Barter, "Introduction: Food for Thought: American Art and Eating," in *Art and Appetite: American Painting, Culture, and Cuisine*, ed. Judith A. Barter (Chicago: Art Institute of Chicago; New Haven: Yale University Press, 2013), 17.

47. Barter, "Introduction: Food for Thought," 17.

48. Oehler, "Convenience," 208.

49. Andy Warhol, "The Souper Dress," 1966–67, cellulose and cotton, Kirkland Museum, Denver, CO, https://www.kirklandmuseum.org/collections/work/souper-dress/.

50. Warhol, "The Souper Dress."

51. Warhol, "The Souper Dress."

52. Bright, *Feast for the Eyes*, 182.

53. Peter Fischli and David Weiss, *Fashion Show (Modenschau)*, 1979, chromogenic color print, Museum of Modern Art, https://www.moma.org/collection/works/192170.

54. Bright, *Feast for the Eyes*, 182.

55. Fischli and Weiss, *Fashion Show (Modenschau)*.

56. Robert Kushner, "Food + Clothing =," *Gastronomica* 4, no.1 (Winter 2004),158.

57. Robert Kushner, *Robert Kushner and Friends Eat Their Clothes*, June 28, 1972, Jack Glenn Gallery, Corona del Mar, California, https://www.robertkushnerstudio.com/robert-kushner-and-friends-eat-their-clothes-corona-del-mar-1972.

58. Kushner, "Food + Clothing =," 162.

59. Kushner, "Food + Clothing =," 162.

60. Kushner, "Food + Clothing =," 164–165.

61. Kushner, "Food + Clothing =," 165.

62. Kushner, "Food + Clothing =," 165.

63. "Robert Kushner," DC Moore Gallery, New York, http://www.dcmooregallery.com/artists/robert-kushner.

64. Kushner, "Food + Clothing =," 162.

65. Kushner, "Food + Clothing =," 165, 167.

66. Kushner, "Food + Clothing =," 167–168.

67. "Robert Kushner and Friends Eat Their Clothes," Robert Kushner, Astor Center, New York, February 2010, https://www.robertkushnerstudio.com/robert-kushner-and-friends-eat-their-clothes-nyc-2010.

68. "Everything You Wanted to Know About Lady Gaga's VMA Meat Dress!" *MTV News*, September 13, 2010, http://www.mtv.com/news/2513136/2010-vmas-lady-gaga-meat-dress-real/.

69. Darren Bader, "Fruits, Vegetables; Fruit and Vegetable Salad," Whitney Museum of American Art, 2020, https://whitney.org/exhibitions/fruits-vegetables.

70. Bader, "Fruits, Vegetables."

71. Andrea K. Scott, "Darren Bader," *The New Yorker*, n.d., https://www.newyorker.com/goings-on-about-town/art/darren-bader-whitney.

72. Cassidy George, "I Ate the Worst Salad of My Life in the Name of Art," *The Cut*, January 21, 2020, https://www.thecut.com/2020/01/i-ate-the-worst-salad-of-my-life-in-the-name-of-art.html.

73. "About," Food Cultura, http://www.foodcultura.org/en/about/.

74. Antoni Miralda, discussion with the author, June 2020.

75. Harriet Shapiro, "Visions of 200-Foot Bread Walls Dance in the Head of Antoni Miralda, Who Creates Food for Thought," *People*, June 23, 1986, https://people.com/archive/visions-of-200-foot-bread-walls-dance-in-the-head-of-antoni-miralda-who-creates-food-for-thought-vol-25-no-25/.

76. John Duka, "Coty Winners: Smith and Flusser," *The New York Times*, September 30, 1983, https://www.nytimes.com/1983/09/30/style/cotty-winners-smith-and-flusser.html.

77. Shapiro, "Visions of 200-Foot Bread Walls."

78. Miralda, discussion.

79. Tamar Adler, discussion with the author, June 2020.

80. Madeleine Luckel, "Art Is Everywhere: How One Artist Turns Banana Peels and Radish Slices into Fashion," Living, Vogue.com, February 8, 2018, https://www.vogue.com/article/food-fashion-illustrations-art-gretchen-roehrs-book.

81. Adler, discussion.

82. Adler, discussion.

83. Tom Sachs, "Hermés Value Meal," 1997, mixed media, https://www.artsy.net/artwork/tom-sachs-hermes-value-meal-1.

84. Sachs, "Hermés Value Meal."

85. Tom Sachs, "Art and Brands with Artist Tom Sachs," interview by Charlotte Burns, In Other Words, Art Agency Partners, March 30, 2017, https://www.artagencypartners.com/episode-1-transcript-art-and-brands-with-artist-tom-sachs/.

86. Sachs, "Art and Brands with Artist Tom Sachs."

87. Adler, discussion.

88. Helmut Newton, *Jerry Hall Holding Raw Meat*, October 1974, Condé Nast Archive, https://artsandculture.google.com/culturalinstitute/beta/exhibit/helmut-newton-early-years%C2%A0-conde-nast-archive/RQKiI_3cFDIuLg?hl=en.

89. Helmut Newton, *Chicken in Heels*, in Antrim, *Food in Vogue*, 128–129.

90. Guy Bourdain, *Charles Jourdan*, in Bright, *Feast for the Eyes*, 186–187.

91. Tim Walker, *Self-Portrait with Eighty Cakes*, in Bright, *Feast for the Eyes*, 272–273.

92. Taylor Antrim, discussion with the author, June 2020.

93. Antrim, discussion.

94. Maurizio Cattelan and Pierpaolo Ferrari, Untitled, August 2017, *Vogue*, https://www.vogue.com /article/around-the-world-in-condiments.

95. Antrim, discussion.

96. Antrim, discussion.

97. Antrim, discussion.

98. Adler, discussion.

99. Adler, discussion.

100. Adler, discussion.

101. Adler, discussion.

102. Adler, discussion; Antrim, discussion.

103. Adler, discussion.

104. Adler, discussion.

105. Adler, discussion.

106. Adler, discussion.

107. Adler, discussion.

108. Antrim, discussion.

109. Antrim, discussion.

110. Fainzilber, discussion.

111. Fainzilber, discussion.

112. Fainzilber, discussion.

113. "Creative Time Presents Kara Walker," *Creative Time*, spring 2014, https://creativetime.org/ projects/karawalker/.

114. Hilton Als, "The Sugar Sphinx," *The New Yorker*, May 8, 2014, https://www.newyorker.com/ culture/culture-desk/the-sugar-sphinx.

115. Oehler, "Convenience," 216–217.

116. Madeleine Luckel, "The Latest Spring 2016 Couture Trend? Fine Dining," *Homes, Living*, Vogue.com, January 25, 2016, https://www.vogue.com/article/shop-the-look-schiaparelli -spring-2016-couture.

117. The New Yorker Cartoons (@newyorkercartoons), "@j.a.k._ recently reimagined Edward Hopper's iconic painting 'Nighthawks' for the coronavirus era. Hopper was born on this day in 1882," Instagram cartoon, July 22, 2020, https://www.instagram.com/p/CC8vr14j9-g/.

118. Bright, *Feast for the Eyes*, 140.

Avocado Toast and Blonde Salad: Critical Perspectives on Fashion and Food on Instagram

Monica Titton

The Convergence of Online Persona Construction in Fashion and Digital Food Cultures

Since its launch in 2010, the photo-sharing app Instagram has shaped new social practices, changed the use of visuality in various forms of communication, and reshaped people's perceptions of themselves and the world. Both the fashion industry and the food industry have been transformed through the rise of the Facebook-owned social media platform. Instagram has become the digital version of a shop window, marketplace, showroom, and broadcasting and media outlet for the fashion industry, and fashion influencers (formerly known as fashion bloggers) have emerged as key figures in the new fashion media and marketing landscape.[1] In recent years, Instagram has come to increasingly replace fashion blogs. Although some fashion bloggers/influencers keep their blogs active in addition to their Instagram accounts and use their blogs as a kind of "repository" for their digital content, many rising "fashion influencers" are active exclusively on Instagram.

Over the first two decades of the twenty-first century, the role of digital fashion content creators has shifted from semi-outsiders and independent commentators[2] to powerful and highly visible agents in the dissemination of fashion.[3] The ever-changing fashion industry saw a reorganization of its economic and symbolic power structures.[4] Print fashion magazines have lost their significance for millennial and Gen Z fashion consumers, who rely on Instagram as their primary source of fashion information and content.[5] The collective imaginary of fashion has been changed by the digitalization of

Figure 13.1

Photograph from Chiara Ferragni's (aka The Blonde Salad) collaboration with Ladurée, September 2016. Image courtesy of TBS crew srl and Ladurée

its media: the mass circulation of self-made fashion photographs on fashion[6] and street style blogs[7] established a new aesthetic of the real in fashion photography that was successfully transferred from blogs to Instagram, fashion's favorite media platform.[8] Fashion in digital media (first on blogs and later on Instagram) is represented as rooted in everyday life, most often in stylized domestic settings, familiar urban landscapes, or mainstream travel destinations.[9] The visual language of fashion photography on Instagram revolves around the depiction of fashion and fashionable identities embedded in a lifestyle that encloses interior decoration, work, travel, health, relationships, and food. Due to their role as "intermediaries between fashion producers and their target market,"[10] fashion influencers create a homogenous visual discourse in fashion photography, that, as Karen de Perthius and Rosie Findlay critically assess, "often remediated the rhetoric and ideology of mainstream fashion photography rather than revolutionizing it."[11] Eating, cooking, nutrition, and all sorts of activities and consumption habits related to food are among the topics that are regularly featured in the feeds and stories of Instagram influencers.

When fashion consumers began to take photos of their outfits and to share these images on the internet, diners began to take their own pictures too, elevating the brightened, sharpened overhead shot— minimally propped and in natural light—to "the new currency of the food world," as Tim Hayward wrote in *The Guardian*.[12] The practice of sharing pictures of meals via social media is a central social practice for foodies, and Isabelle de Solier emphasizes that foodies construct their sense of self around food and "form a moral self not only through the consumption of material cultures of food, but also their production."[13] The proliferation of social and digital media also saw the emergence of amateur food bloggers becoming prominent figures in the new foodie culture, and seizing the "discursive territory previously occupied by a small number of elite professional food critics."[14]

Digital and social media have fostered new projects of identity construction and new professional roles in the fashion industry and in food culture alike. Instagram is the site where fashion and food meet and intersect. Influencers have contributed to the glamorization of food through posting photos and videos of what they eat, and visual representations of influencers eating, cooking, and dining have entered the collective visual imaginary of fashion. The preparation and consumption of food belong to the selected spheres of life that feed the construction of the online identities of fashion influencers, or "fashionable personas."

I have developed the concept of "fashionable persona" as a theoretical model of authorship that describes how collective fashion narratives become interwoven in processes of self-creation and identity construction on blogs and on social media.[15] Influencers like Bryan Grey Yambao (known as "Bryanboy"), Chiara Ferragni (known

as "The Blonde Salad"), Susie Lau (known as "Susie Bubble"), Aimee Song (known as "Song of Style"), to name but a few, access knowledge about fictional subjectivities in fashion when constructing their own fashion and style narratives.[16] Through the adoption of a fashionable persona and a stable and predictable personal brand identity, they integrate autobiographical elements with idealized, fictionalized identity fragments about gendered identities as depicted in pop and celebrity culture.[17] By turning to their everyday experiences and daily lives as picture motifs for their Instagram feeds and Instagram stories, and by adding short descriptions, hashtags, and emojis with a consistent tone to their posts, fashion influencers constantly actualize and re-inform their presentation of self and engage in the construction and enactment of a branded, online version of themselves—their fashionable persona. The predictability and stability of an influencer's fashionable persona as communicated throughout their various social media channels is paramount. It is the key to their success in signing deals with fashion brands and advertising partners, which is the main source of revenue for professional fashion influencers.[18] What influencers wear, but also what they eat, how they pose for pictures, where they like to travel, how they exercise, whom they date, and where they live—almost every aspect of an influencers' life is molded into the shape of their fashionable persona—can thus be potentially monetized. Food is often used instrumentally by a fashion influencer as an index of their persona's authenticity. Nothing signals real-life credibility like the very human and universal need to eat, and on social media, nothing engages followers like an enticing photograph of a meal.

However, long before the rise of digital and social media transformed the landscape of the fashion media industry and forged a new connection between fashion and food, recipes, nutrition tips, and articles preoccupied with weight loss were a fixture in fashion and women's magazines.[19] Cooking and matters related to food, as assumed female responsibilities,[20] have always belonged to the spectrum of idealized female life depicted in the media, along with sections on beauty, love and relationship advice, travel, and interior decoration. The ways in which fashion and women's magazines aggregate all these life spheres into a multilayered, contradictory, and unattainable ideal of femininity revolving around the perfect wardrobe, body, home, family, job, vacation, partner, and meal have been at the heart of persistent feminist critique against the fashion industry since the 1960s. More recently, Angela McRobbie has argued that the fashion industry is one of the key institutions that promotes female individualization, which generates bodily dissatisfaction and thus encourages young women to "embark on a new regime of self-perfectibility (i.e., self-completion)," within which "the fearful terrain of male approval fades away and is replaced instead with a new horizon of self-imposed feminine cultural norms."[21]

Food appeared in fashion and women's magazines via recipes, diets, and nutrition advice, but food has also always been a part of the fictional scenarios enacted by fashion models in fashion editorials. When food and fashion are portrayed in the same frame in fashion photography, these images "explore women's consumption as metaphorical of sexual appetite," Jess Berry writes in her examination of contemporary fashion editorials by Miles Aldridge, Ellen von Unwerth, Terry Richardson, and Sarah Bahbah, respectively.[22] Berry argues that food is portrayed as "either seduction or revulsion" in the works of these photographers. (Emma McClendon addresses this in more detail in chapter six of this volume.) She proposes a feminist re-reading of both visual tropes as expressions of burlesque humor and grotesque transgression that challenge the perfect body usually depicted in fashion magazines.[23]

Food and Eating as Normative Lifestyle Attributes for Digital Branded Identities

On Instagram, on the other hand, food and fashion are portrayed as the attributes to a healthy, happy, and exciting life. Breakfast, brunch, lunch, or dinner are occasions for photo shoots and videos that center on the influencers' affirmation of their fashionable persona and the life-sphere which they performatively inhabit. The literacy with nutritional fads and food trends, and the documentation of their own food habits, testifies to the readiness of influencers to adhere to mainstream practices of self-care and healthy living. From a feminist perspective, fashion influencers as social media celebrities, pop cultural icons, and entrepreneurs recall McRobbie's description of the production of girlhood in postfeminist discourses.[24] McRobbie argues that liberal feminist principles of the 1960s and 1970s were integrated in neoliberal narratives of female self-realization and that in this postfeminist culture, the young woman has become "an intensively managed subject of postfeminist, gender-aware biopolitical practices of new governmentality."[25] On Instagram, activities connected to food—sharing recipes, buying groceries, cooking, organizing food in the pantry— are presented as an integral part of modern and fashionable femininity. Influencers integrate food in the narrative of their fashionable persona, and their food choices are represented as coherent with the rest of their online universe.

Aimee Song's Instagram feed (@aimeesong) is a paradigmatic example for the contemporary fashion influencer aesthetic. Author of the best-selling book *Capture Your Style: Transform Your Instagram Photos, Showcase Your Life, and Build the Ultimate Platform* (2016), Song is an indisputable expert in the field of creating a coherent "fashionable persona" across several platforms. She dedicated a whole section of her book to food photography because recipes, aerial meal shots, and photographs of Song eating are a fixture in her Instagram feed, but are also a stalwart feature of her brand's website "Song of Style," where the subsection "food and recipes" is dedicated

to restaurant tips and recipes with catchy titles such as "5 Vegan Ice Cream Dessert Recipes to Try This Summer" or "Everything You Need for a Perfect Picnic."[26] In her canonical guide to food photography for Instagrammers, Song writes:

> If you follow me on Instagram, you already know that I seriously love to eat. Tacos, avocado toast, ice cream—all of it (the working-out part isn't half the fun). So it's only fitting that food is one of my favorite things to photograph. But I don't do it because I genuinely think people care about what I'm eating; rather, I take food photos because meals are normally a highlight of my day, and they are often beautifully presented and thoughtfully prepared.[27]

In Song's advice, the convergence between foodie culture and fashion influencer-content culminates in the simple principle that food is part of a (fashionable) lifestyle and, if it looks pretty, it will be photographed. Food is a reliable content-resource for fashion influencers. It is documented as a signifier of hominess in domestic life. It is often portrayed as the center of socializing events, but also as the highlight of travel experiences. The way in which food is presented on Instagram is adapted to each influencer's fashionable persona. For some, food and cooking are subordinated into

Figure 13.2 (left)
Influencer Aimee Song posing in front of fruits arranged at a farmers market, wearing an outfit from her clothing line "Song of Style." The image was posted on her Instagram feed @aimeesong on May 6, 2019. Photographer: Maggie Xue, Apparel: Song of Style top and bottom, By Far sandals, Cult Gaia handbag

Figure 13.3 (right)
Aerial shot of Aimee Song holding a bowl of fruits and seeds. The image was posted on her Instagram feed @aimeesong on March 31, 2018. Photographer: Aimee Song, Apparel: Celine sandals

the regime of a new domesticity; for others, food is part of a strict but ostentatiously happy regime of body discipline. Yet for others, food and restaurants are part of a life lived in public and the ultimate manifestation of cosmopolitan sophistication. In any of these ways, food on Instagram is presented as a genuine, stable part of an influencer's lifestyle—a lifestyle that, through the prism of branded online identities, comes into view as an all-encompassing, normative, and homogenizing conduct of behavior that regulates their consumption, desires, identities, bodies, and their psychological well-being.

Chicken Nuggets and Champagne: Bryanboy's Parody of "Influencer Realness"

One of Bryanboy's (aka Bryan Grey Yambao) most viewed posts on the video-sharing app TikTok is a twenty-two-second video in which he eats chicken nuggets on the terrace of a McDonald's in his hometown in Sweden.[28] In a quick sequence of fourteen frames, Bryanboy documents his experience at the fast-food restaurant dressed in a fashion-forward Dior Homme outfit, completed by a grey Hermès Kelly bag, a face mask, and a pair of rectangular black sunglasses. In the voiceover to the video, Bryanboy comments:

> Today I went to McDonald's fine dining. My ex-husband cut me off, and I don't have any money. I sold my Louis Vuitton bags to a man outside. My friend told me "People are dying, Bryan," so I said, "Let me eat first and worry about them later." I enveloped my seat with a Dior blanket, the chicken nuggets came on these golden plates, and I drank Cartier champagne. I love elevating everyday experiences. I live for the simple things in life. Yay![29]

With its provocative hyperbole, Bryanboy's video is a parody to a particular genre of ostentatious, reality TV-style videos posted on Instagram and TikTok by fashion influencers and Instagram celebrities, who flaunt their privileged and unattainable way of life while trying to appear down-to-earth by sharing their mundane everyday habits with their followers. The video was published in August 2020, at a time when the COVID-19-pandemic had disrupted life on a hitherto unknown global scale and when demonstrations for racial justice and against police violence ensuing the deaths of Ahmaud Arbery, George Floyd, and Breonna Taylor had erupted not only in the United States but all over the globe. Fashion brands and fashion publications that have historically excluded and marginalized Black people were quick to share messages of solidarity with the Black Lives Matters movement on Instagram, the industry's most important platform. Bryanboy, who is Filipino, has been an outspoken advocate for more racial diversity on the runways for years and has persistently voiced

Figure 13.4
Influencer BryanBoy eating chicken nuggets al fresco at a McDonald's restaurant. The image was posted on his Instagram feed @bryanboy on August 13, 2020. Courtesy of BryanBoy

his solidarity with the Black Lives Matter movement. Yet as an influencer, he, like his Instagram peers, had to keep posting fashion-related content despite the pandemic and its destabilizing effect on the fashion industry with its invisible but wide-reaching global interdependencies between labor and consumption. Bryanboy's McDonald's video can thus be read as a caustic commentary to the enormous distance between the privileged life of influencers and the lived experiences of the majority of people—especially the lives of working class and poor racial and ethnic minorities, for whom eating affordable, energy-dense fast food is not a lifestyle choice but a necessity.[30] In the small, prosperous luxury-bubble inhabited by fashion influencers, however, the act of going to a fast-food restaurant carries the must-have qualities of "realness" and "authenticity" that they constantly need to demonstrate in order to maintain their credibility as "one of us" ("us" being their Instagram followers).[31] Bryanboy satirizes the inherent contradiction of this "influencer realness" by adding "extra" elements, such as a designer blanket, designer champagne, and gold-rimmed porcelain that "elevate" the everyday experiences of eating chicken nuggets. The location of the video represents the antithesis to the refined and trendy restaurants and eateries usually frequented by fashion influencers. Bryanboy makes fun of the way in which fashion influencers try to partake in a reality that they are no longer part of and unveils how they contribute to the contradicting food discourse perpetuated by fashion magazines, where food is loaded with guilt and self-castigation, but also at the same time eroticized as pleasure and excess.[32]

In conclusion, Bryanboy's video can be read as a swan song to the short era of the fashion influencers and to their many pretenses. As one of the first fashion bloggers to be invited to sit front row at fashion weeks in Paris, New York, Milan, and London over a decade ago, Bryanboy's venture into TikTok was accompanied by the adoption of a new persona that refers to the trope of "rich white lady" frequently used in the contemporary queer people of color drag scene.[33] Bryanboy's new fashionable persona is expressed in his drag performance of a white, rich, divorced fashion influencer, who flies to fashion shows and "elevates her everyday life experiences" to entertain her followers and herself. With his new drag persona, Bryanboy combines parts of his fashion influencer self with elements borrowed from queer people of color drag performers (such as Joanne the Scammer) and the white supremacist, self-entitled, anti-vaxxer "Karen" figure that has dominated anti-racist meme culture in 2020.[34] During a year in which the fashion industry was forced to reckon with its racist, exploitative, and imperialist structures and practices, digital pioneer Bryanboy employs the Warholian gesture of eating at a fast-food restaurant to find new meaning and new fun in creating fashion content on the Internet.

Notes

1. Karen de Perthius and Rosie Findlay, "How Fashion Travels: The Fashionable Ideal in the Age of Instagram," *Fashion Theory* vol. 23, no. 2 (2019): 1–24.

2. Agnès Rocamora, "Hypertextuality and Remediation in the Fashion Media," *Journalism Practice* vol. 6, issue 1 (2012): 92–106.

3. Marco Pedroni, "Stumbling on the Heels of My Blog: Career, Forms of Capital, and Strategies in the (Sub)Field of Fashion Blogging," *Fashion Theory* vol. 19, issue 2 (2015): 179–199.

4. Minh-Ha T. Pham, "Susie Bubble Is a Sign of the Times: The Embodiment of Success in the Web 2.0 Economy," *Feminist Media Studies* vol. 13, issue 2 (2013): 245–267.

5. De Perthius and Findlay, "How Fashion Travels."

6. Monica Titton, "Fashionable Personae: Self-identity and Enactments of Fashion Narratives in Fashion Blogs," *Fashion Theory*, vol. 19, issue 2 (2015): 201–220.

7. Monica Titton, "Fashion in the City: Street Style Blogs and the Limits of Fashion's Democratization," *Texte zur Kunst* vol. 20, issue 78 (2010): 133–138.

8. Rocamora, "Hypertextuality and Remediation in the Fashion Media," 102.

9. Monica Titton, "Blogging the Female Self: Authorship, Self-Performance and Identity Politics in Fashion Blogs," in *Female Agency and Documentary Strategies: Subjectivities, Identities and Activism*, eds. Boel Ulfsdotter and Anna Backman Rogers (Edinburgh: Edinburgh University Press, 2018), 38–56.

10. De Perthius and Findlay, *How Fashion Travels*, 7.

11. De Perthius and Findlay, *How Fashion Travels*, 3.

12. Tim Hayward, "From Avocados to Instagram: The Decade in Food," *The Guardian*, December 9, 2019, https://www.theguardian.com/food/2019/dec/09/tim-hayward-decade-of-food-supper-clubs-avocados-instagram.

13. Isabelle de Solier, "Making the Self in a Material World: Food and Moralities of Consumption," *Cultural Studies Review*, vol. 19, issue 1 (March 2013): 9.

14. Morag Kobez, "A Seat at the Table: Amateur restaurant review bloggers and the gastronomic field," in *Digital Food Cultures*, eds. Deborah Lupton and Zeena Feldman (New York and London: Routledge, 2020), 64.

15. Titton, *Fashionable Personae*.

16. Despite the shift from blogs to Instagram, the social mechanisms of a branded online identity construction have remained the same across different social media sites and platforms, and the codes of the visual language developed on fashion blogs find their continuation on Instagram.

17. Titton, *Blogging the Female Self*, 39.

18. De Perthius and Findlay, *How Fashion Travels*, 10.

19. Ellen McCracken, *Decoding Women's Magazines: From Mademoiselle to Ms.* (Houndsmill and London: Palgrave MacMillan, 1993).

20. McCracken, *Decoding Women's Magazines*, 193.

21. Angela McRobbie, *The Aftermath of Feminism. Gender, Culture and Social Change* (London/Thousand Oaks/New Delhi/Singapore: Sage, 2009), 62.

22. Jess Berry, "Gluttonous Glamour: Gastro-Porn and the Grotesque in Contemporary Fashion Photography," in *Fashion and Contemporaneity: Realms of the Visible*, ed. Laur Petican (Leiden/Boston: Brill, 2019), 114.

23. Berry, *Gluttonous Glamour*, 115

24. McRobbie, *The Aftermath of Feminism*.

25. McRobbie, *The Aftermath of Feminism*, 60.

26. https://songofstyle.com/category/lifestyle/food-and-recipe/.

27. Aimee Song, *Capture your Style: Transform Your Instagram Photos, Showcase Your Life, and Build the Ultimate Platform* (San Francisco: Abrams & Chronicle Books, 2016), 206.

28. https://www.tiktok.com/@bryanboy/video/6860552640468618501.

29. https://www.tiktok.com/@bryanboy/video/6860552640468618501.

30. Hilda E. Kurtz, "Linking Food Deserts and Racial Segregation: Challenges and Limitations," in *Geographies of Race and Food: Fields, Bodies, Markets*, eds. Rachel Slocum and Arun Saldanha (London and New York: Routledge, 2016), 252.

31. Rosie Findlay, "Trust Us, We're You: Aspirational Realness in the Digital Communication of Contemporary Fashion and Beauty Brands," *Communication, Culture & Critique*, issue 1 (2019): 1–17.

32. Berry, *Gluttonous Glamour*, 117.

33. Madison Moore, *Fabulous: The Rise of the Beautiful Eccentric* (New Haven, CT: Yale University Press, 2018), 192.

34. Aja Romano, "How 'Karen' Became a Symbol of Racism," *Vox*, July 21, 2020, https://www.vox.com/21317728/karen-meaning-meme-racist-coronavirus.

Image List

Franco Moschino, black wool suit
with metal cutlery embellishment,
fall 1989, Italy. © The Museum
at FIT

1.6 Christian Dior, *Bon Bon* dress, autumn/winter 1947. Christian Dior Museum-Granville. © Laziz Hamani

1.7 Angie Mar, owner and chef of the Beatrice Inn, posing in front of her word web concept maps. Photograph by Johnny Miller/Edge Reps

1.8 Photo from *Butcher + Beast: Mastering the Art of Meat: A Cookbook* by Angie Mar with Jamie Feldmar. Photography by Johnny Miller. New York: Clarkson Potter/Publishers (2019). Photograph by Johnny Miller/Edge Reps

1.9 "Supermarket" runway show, Chanel, fall 2014. PATRICK KOVARIK/AFP via Getty Images

1.10 Andreas Gursky, *99 Cent 1999*. Chromogenic print mounted on Plexiglas in artist's frame. AM 2000-96. Repro-photo: Philippe Migeat. Musee National d'Art Moderne, Centre Georges Pompidou, Paris, France. Andreas Gursky, Artists Rights Society (ARS), New York/VG Blind-Kunst, Bonn. © Andreas Gursky/Courtesy Sprüth Magers/Artists Rights Society (ARS), New York © CNAC/MNAM, Dist. RMN-Grand Palais/Art Resource, NY

1.11 Jeremy Scott for Moschino, ensemble, fall 2014, Italy. Gift of Moschino. © The Museum at FIT

1.12 Demna Gvasalia for Vetements, spring 2020 fashion show. Photo by Victor VIRGILE/Gamma-Rapho via Getty Images

1.13 Stan Herman, McDonald's uniform, 1975, USA. Gift of Stan Herman. © The Museum at FIT

1.14 Telfar Clemens with White Castle employees wearing two versions of his uniform shirt. Photograph courtesy of White Castle Management Co.

1.15 Telfar x White Castle capsule collection, spring/summer 2017. Photograph by Jason Nocito

1.16 Jeremy Scott for Moschino, junk food dress, fall 2014. Courtesy of Moschino

2.1 Jeremy Scott for Moschino, fall 2020. Courtesy of Moschino

2.2 Silk damask *robe à l'anglaise*, circa 1765, England. © The Museum at FIT

2.3 Illustration from *Le cannameliste français, ou, Nouvelle instruction pour ceux qui desirent d'apprendre l'office* by Joseph Gilliers, 1751. A cannameliste is defined as one who "takes care of candied fruit, sugar works, refreshing liquors, pastilles, etc." Houghton Library

2.4 Vivienne Westwood, "La Cocotte" collection cotton t-shirt, fall/winter 1995/1996, England. Gift of Timothy Reukauf, Stylist. © The Museum at FIT

2.5 Vivienne Westwood, "La Cocotte" collection, fall/winter 1995/1996. © FirstVIEW/IMAXtree.com

2.6 Still from *Marie Antoinette*, directed by Sophia Coppola, 2006. Courtesy of Photofest

2.7 Jeremy Scott for Moschino, fall 2020. Courtesy of Moschino

2.8 *Louis le Grand l'Amour et les Délices de son Peuple . . . les Actions de grâce, les festes et les Réjouissances pour le parfait rétablissement de la santé du Roy en 1687*, engraving of a dinner for Louis XIV at the Hotel de Ville de Paris, January 30, 1687. Unknown author, Public domain, via Wikimedia Commons

2.9 Abraham Bosse, *Le Patisserie* (*The Pastry Cook's Shop*), engraving, 17th century. Yale University Art Gallery

2.10 Antoine Trouvain, *Quatrième chambre des apartemens*, etching of the Duke of Chartres and Mademoiselle with noble women at the palace of Versailles, circa 1696. © The Trustees of the British Museum

2.11 French women led European fashion throughout the eighteenth century. Jean François de Troy, *The Declaration of Love*, oil on canvas, circa 1724. The Metropolitan Museum of Art, Bequest of Mrs. Charles Wrightsman, 2019

4.4 Liberty & Co. Ltd., smocked dress, England, c.1893–1894. British, pongee silk with smocking and machine-made lace. © Victoria and Albert Museum, London

4.5 Hippie woman picking beets on a farm in Vermont, c. 1970. Photo by Rebecca Lepkoff, courtesy of Vermont Historical Society

4.6 A t-shirt from Levi's "Fresh Produce" line, 1970s. Courtesy Levi Strauss & Co. Archives

4.7 Looks from Mimi Prober's spring 2021 collection naturally dyed with avocado and pomegranate to produce dusty rose and soft yellow hues. Photo: Patrik Andersson

4.8 Isoude, hand-painted organic silk and cotton dress, spring/summer 2009, USA. Gift of Katie Brierley. © The Museum at FIT

4.9 *What if your food could improve the field it came from?* From the Ellen MacArthur Foundation food initiative campaign, 2019. © Ellen MacArthur Foundation, 2020

4.10 A scarf from the Ferragamo Orange Fiber collection, spring/summer 2017. Photo courtesy of Ferragamo and Orange Fiber

4.11 Bolt Threads™ mycelium mats grown by scientists and expert mushroom farmers in a European warehouse once used to produce specialty mushrooms for the gourmet food market. Image courtesy of Bolt Threads

4.12 Marina Hoermanseder, strap skirt made from Piñatex, a vegan leather made from cellulose fibers extracted from pineapple leaves, fall 2020. Photo © Stefan Kraul. Image courtesy of Marina Hoermanseder

5.1 The Rick Owens spring/summer 2020 collection *Tecuatl* prominently featured the United Farmer Workers (UFW) Union Eagle Mark logo. Courtesy of OWENSCORP

5.2 Dolores Huerta wears an example of protest fashion: a screen-printed image of the slogan, "There's blood on those grapes. Don't Buy Gallo Wine" on a white t-shirt. Chris Sánchez, gelatin silver print, 1973. Walter P. Reuther Library, Archives of Labor and Urban Affairs, Wayne State University. Courtesy of Clara Productions, LLC

5.3 The UFW Eagle Mark symbol was widely adapted onto clothing, as seen on this homemade jacket patch during a 1966 Sacramento strike. Jon Lewis photograph, courtesy of LeRoy Chatfield, © Yale University. All rights reserved.

5.4 Huerta was the first Latina to be included in the *One Life* series at the Smithsonian National Portrait Gallery. During the exhibition's inauguration in 2016, which coincided with the fiftieth anniversary of the 1965 Delano grape strike and boycott, a poem was recited specifically citing the symbolism of Huerta's Eagle Mark vest: "The difference is your red knit vest, small enough to be a child's, with the black eagle soaring across the room toward us." Dolores Huerta, portrait, c. 1970s, Photographer unknown. Walter P. Reuther Library, Archives of Labor and Urban Affairs, Wayne State University. Courtesy of Clara Productions, LLC

5.5 César Chávez's black satin bomber jacket was one of several made for UFW officers and high-ranking members, prominently featuring the UFW Eagle Mark flag. Division of Political and Military History, National Museum of American History, Smithsonian Institution. Donated by Helen Chávez. Smithsonian's National Museum of American History.

5.6 #WeFeedYou masks, designed by Justin Watkins, Project Manager of the UFW's Marketing Department. I Am Essential is the intellectual property of the UFW and is used with permission of the United Farm Workers of America, www.ufw.org.

6.1 Crystal Renn shot by Terry Richardson for *Vogue Paris*, October 2010. Terry Richardson/Art Partner

6.2 Charcot, *Attitudes passionnelles – extase*, 1878, from *Iconographie photographique de la Salpêtrière*, vol. 2. The J. Paul Getty Museum, Los Angeles

6.3 Miles Aldridge, *A Dazzling Beauty #4*, shot for *Vogue Italia*, March 2008, p. 226–227. Miles Aldridge/Trunk Archive

6.4 Everlane underwear ad, 2018. Courtesy of Everlane

6.5 Ashley Graham at the 14th Annual CFDA Vogue Fashion Fund Gala, 2017 John Palmer/ Media Punch/Alamy Live News

6.6 Lizzo at the 2020 BRIT Awards wearing Moschino's chocolate bar dress by Jeremy Scott. Karwai Tang/WireImage/Getty

7.1 Stella Jean, fall 2015. Daniele Oberrauch/IMAXtree.com

7.2 Stella Jean, cotton dress and socks, fall 2015, Italy. Gift of Stella Jean. © The Museum at FIT

7.3 Stella Jean, spring 2015. Daniele Oberrauch/IMAXtree.com

7.4 Stella Jean, spring 2015. Daniele Oberrauch/IMAXtree.com

7.5 Patrick Kelly, spring 1988 runway show, Paris. Photo by PL Gould/IMAGES/Getty Images

7.6 *Life* cover, August 9, 1937, photograph by Al P. Burgert, Adel, Georgia. Photograph courtesy of Al Burgert's loving family. From the pages of LIFE. © 1937 The Picture Collection Inc. All rights reserved. Reprinted/Translated from LIFE and published with permission of The Picture Collection Inc. LIFE and the LIFE logo are registered trademarks of TI Gotham Inc. used under license.

7.7 Patrick Kelly, ensemble, spring/summer 1988. Philadelphia Museum of Art: Gift of Bjorn Guil Amelan and Bill T. Jones in honor of Monica Brown, 2014, 2014-207-1a-e

7.8 Patrick Kelly, cotton denim overalls dress, fall 1987, France. Gift of Bjorn G. Amelan and Bill T. Jones. © The Museum at FIT

8.1 *Eating the Other* is a performance piece created by Betty Liu and Claire Myers, 2018. Photograph by Ruby Jurecka

8.2 Advertisement for Rough on Rats pesticide and insecticide, 1880s. It was printed by the Boston-based firm Forbes. Transcendental Graphics/Getty Images

8.3 Postcard of the interior of a New York Chinese Restaurant, 1907–1918. The Miriam and Ira D. Wallach Division of Art, Prints and Photographs, The New York Public Library Digital Collections.

8.4 Sandy Liang spring/summer 2019 presentation at Congee Village. Amy Sussman/WWD, Courtesy of Fairchild Archive

8.5 Snow Xue Gao spring/summer 2019 presentation at Jing Fong. Photograph by Akiko Ichikawa

8.6 Image from *More Than Our Bellies* by Phillip Lim and Viviane Sassen. Photo by Viviane Sassen

8.7 Sonia Fenxia in Gucci's "Roman Rhapsody" Cruise 2018 campaign. Photo by Mick Rock for Gucci. Creative Director: Alessandro Michele, Art Director: Christopher Simmonds, Hair Stylist: Paul Hanlon, Makeup Artist: Yadim Carranza

9.1 Advertising image from Dolce & Gabbana's collaboration with the Italian pasta company Pastificio Di Martino, 2017. Courtesy of Dolce & Gabbana with photography by Davide Gallizio and model Chiara Scelsi

9.2 Neapolitan peasants eating macaroni, 1869. Photographer Conrad Georgio, Library of Congress Prints and Photographs Division Washington, D.C. 20540 USA

9.3 "Fashion Menu: Pasta," editorial by Anna Piaggi, *Vogue Italia*, May 1991, p.144–145. Realized by Bruno Rinaldi, Alfa Castaldi and Anna Piaggi

9.4 Cheap & Chic by Moschino, embroidered man's vest, circa 1992 and Moschino Jeans, pizza and Chianti dress, 1983–1989, Italy. Vest: Gift of Michael H. Harrell. © The Museum at FIT

9.5 Dolce & Gabbana, spring 2017 collection. © IMAXtree.com

9.6 Pastificio Di Martino collaboration with Dolce & Gabbana. Photograph courtesy of Pastificio Di Martino

9.7 Fendi branded Rummo pasta sent to the invitees of the Fendi spring 2021 fashion show. Courtesy of FENDI

9.8 Images from *The Missoni Family Cookbook* by Francesco Maccapani Missoni. © 2020 ASSOULINE

9.9 Etro, spring 2015 menswear. Photo by Stefania D'Alessandro/Getty Images

10.1 Issey Miyake, Pleats Please "bento box" of accessories, 2018, Japan. © The Museum at FIT

10.2 Yohji Yamamoto, gray wool tweed suit, fall/winter 1997, private collection. Photograph by William Palmer

10.3 Japanese woman dressed in the Gothic Lolita style, Harajuku, Tokyo. Malcolm Fairman/Alamy Stock Photo

10.4 *How to Wrap 5 More Eggs* by Hideyuki Oka (book cover). Photograph by William Palmer. Reproduced with the permission of Shambhala Publications, Inc., www.shambhala.com. Photography on original book cover by Michikazu Sakai.

10.5 Tea Bowl with Crescent Moon, Clouds, and Blossoming Plums, 17th century, Japan. Metropolitan Museum of Art. Gift of Mr. and Mrs. Samuel Colman, 1893

10.6 Hyakumizon fans, private collection. © The Museum at FIT

10.7 Junya Watanbe for Comme des Garçons, white printed nylon and plastic pearl dress, spring 2001, Japan. © The Museum at FIT

10.8 Ralph Rucci, embroidered silk organza caftan, fall/winter 2005. Photograph by William Palmer

11.1 "H&M Loves Madero" campaign, 2017. Direction and photography: Dorian Ulises López Macías, Creative Production: In The Park Productions, Model: Emiliano CJ, AD: Viviana Zúñiga, Photo and lighting assistant: Alexis Rayas, Fashion styling: Bárbara Sanchez Kane and Nayeli de Alba, Makeup: Ana G. de V., Hair: Erich Clemenz and Carlos Arriola, Art Direction: Discipline Studio, Executive Producer: Claudia del Bosque

11.2 Colectivo Amasijo's milpa greens salad, rabbit mixiote, and corn tamal. Photographer: Pablo Arguelles. © The Museum at FIT

11.3 Carla Fernández, "Milpa" collection "Mariposa" tunic, spring/summer 2019. Photographer: Ana Hop; Model: Xiomara Moreno. Courtesy of Carla Fernández

11.4 Pink Magnolia, *Glitter Taco* shirt, spring/summer 2019. Photographer: Zac Stone, Model: Mexican model Karime Bribiesca. Photography courtesy of Pavo Wong/PINK MAGNOLIA

11.5 Alma, "Taco" bag, 2019. Photographers: José Miguel Ramírez and Berke Gold. Courtesy of Berke Gold © 2020, ALMA

11.6 Orly Anan for Sánchez-Kane, *Tortilla Glam*, 2017. Photographer: Felipe Hoyos Montoya. Courtesy of Orly Anan

11.7 Sánchez-Kane, jumpsuit, spring/summer menswear, 2018. Photographer: Felipe Hoyos Montoya. Courtesy of Barbara Sánchez Kane

11.8 Ricardo Seco, 2020. Photographer: Uriel Santana. Styling: Blancopop. Courtesy of Ricardo Seco

11.9 The table of Carla Fernández and Pedro Reyes as it appeared in the interview "Mesa," *192* magazine. Photograph by Ana Lorenzana. © 192, courtesy of *192 Magazine*

12.1 Comme des Garçons, spring 2018 collection. © IMAXtree.com

12.2 Lorenzo Lotto, *Portrait of Lucina Brembati*, c. 1518–23, oil on wood panel, Accademia Carrara, Bergamo, Purchased from the Countess Degnamerita Grumelli Albani of Bergamo, 1882

12.3 Pierre-Auguste Renoir, *Luncheon of the Boating Party*, 1880–1881, oil paint, The Phillips Collection, Washington DC

12.4 Giuseppe Arcimboldo, *Vertumnus*, 1590–1591, oil on panel, Skokloster Castle, Sweden

12.5 Cecil Beaton, Portrait of Wallis Simpson, *Vogue*, 1937. Cecil Beaton, Vogue © Conde Nast

12.6 Edward J. Steichen, *Sugar Cubes: Design for Stehli Silk Corporation*, 1920s, gelatin silver print. The Metropolitan Museum of Art, Ford Motor Company Collection, Gift of Ford Motor Company and John C. Waddell, 1987. © 2020 The Estate of Edward Steichen/Artists Rights Society (ARS), New York. © The Metropolitan Museum of Art. Image source: Art Resource, NY

12.7 Campbell's Soup Company, "The Souper Dress," 1966–67, USA. © The Museum at FIT

12.8 Fischli and Weiss, *Fashion Show (Modenschau)*, 1979, Chromogenic color print. The Abramson Collection. Gift of Stephen and Sandra Abramson. Museum of Modern Art, New York, NY, USA. © Peter Fischli and David Weiss, Courtesy Matthew Marks Gallery. Digital Image © The Museum of Modern Art/Licensed by SCALA / Art Resource, NY

12.9 "Pineapple Falsies," *Robert Kushner and Friends Eat Their Clothes*, New York, 1972. Courtesy Robert Kushner

12.10 Lady Gaga poses at the 2010 MTV Video Music Awards at NOKIA Theatre on September 12, 2010, in Los Angeles, California. Photo by Frederick M. Brown/Getty Images

12.11 Gretchen Röehrs, *Le Banane* fashion illustration from the "Edible Ensembles" series, © 2018–2020 GRETCHEN RÖEHRS

12.12 Tom Sachs, *Hermés Value Meal*, 1997. Image courtesy Tom Sachs

12.13 Photograph by Irving Penn, *Small Cuttings of Bananas*, New York, 2008 © The Irving Penn Foundation. Published in *Vogue*, August 2009

12.14 Lucia Fainzilber, *TDC 03*, 2015. This photograph is part of the "Three Course Dinner" series in which Fainzilber collaborated with art director Lara Crawshaw to combine elements of food and fashion in a Surrealist tableau. © Lucia Fanzilber

13.1 Photograph from Chiara Ferragni's (aka The Blonde Salad) collaboration with Ladurée, September 2016. Image courtesy of TBS crew srl and Ladurée

13.2 Influencer Aimee Song posing in front of fruits arranged at a farmers market, wearing an outfit from her clothing line "Song of Style." The image was posted on her Instagram feed @ aimeesong on May 6, 2019. Photographer: Maggie Xue, Apparel: Song of Style top and bottom, By Far sandals, Cult Gaia handbag

13.3 Aerial shot of Aimee Song holding a bowl of fruits and seeds. The image was posted on her Instagram feed @aimeesong on March 31, 2018. Photographer: Aimee Song, Apparel: Celine sandals

13.4 Influencer BryanBoy eating chicken nuggets al fresco at a McDonald's restaurant. The image was posted on his Instagram feed @bryanboy on August 13, 2020. Courtesy of BryanBoy

Notes on Contributors

Melissa Marra-Alvarez is Curator of Education and Research at The Museum at the Fashion Institute of Technology, New York. She curated the exhibitions *Minimalism/Maximalism* (2019) and *Force of Nature* (2017) and co-curated *Head to Toe* (2021) and *Fashion & Politics* (2009). Her research interests include the intersections between fashion, the natural sciences, and sustainability, as well as new perspectives in the study of fashion as visual culture. She holds an MA in Museum Studies: Fashion and Textile History from The Fashion Institute of Technology.

Elizabeth Way is Associate Curator of Costume at The Museum at the Fashion Institute of Technology, New York. She co-curated the exhibitions *Global Fashion Capitals* (2015), *Black Fashion Designers* (2016), and *Head to Toe* (2021) and curated *Fabric In Fashion* (2018). Way's personal research focuses on the intersection of African American culture and fashion. Way holds an MA in Costume Studies from New York University.

Faith Cooper previously worked in the education department at The Museum at the Fashion Institute of Technology. Her work experiences include *Vogue*, the Metropolitan Museum of Art, Condé Nast International, the Smithsonian Cooper-Hewitt Museum, and Christie's. She holds a bachelor's degree in Art History and Museum Professions and a master's degree in Fashion and Textile Studies, both from the Fashion Institute of Technology. She currently serves on the Associate Board for Apex for Youth, a nonprofit that delivers possibilities to underserved Asian and immigrant youth from low-income families in New York.

Madeleine Luckel is an editor at *Architectural Digest*, where she covers national and international design news for online. Previously, Luckel worked at *Vogue* and *Vogue.com*, where she wrote about a variety of design-related topics. Madeleine holds a Master of Arts in Costume Studies from NYU and a Bachelor of Arts in Classics from Brown University. She is originally from Berkeley, California.

Emma McClendon is a fashion historian, curator, and author. While at The Museum at FIT from 2011 to 2020, she curated numerous exhibitions, including *Power Mode: The Force of Fashion* (2019) and *The Body: Fashion and Physique* (2018). She currently teaches in the MA Fashion Studies program at Parsons School of Design and is completing her PhD at the Bard Graduate Center for decorative arts, design history, and material culture in New York City.

Michelle McVicker is the Collections and Education Assistant at The Museum at The Fashion Institute of Technology. She previously worked as a collections management assistant at The Costume Institute and was a Smithsonian Cultural Heritage Fellow at The National Museum of American History. She received her Master's in Fashion Studies from Parsons The New School, New York. Her research interests include how material culture, specifically clothing, embodies ever-evolving Latinx representations in the United States.

Patricia Mears is Deputy Director of The Museum at The Fashion Institute of Technology. Prior to that, she was the assistant curator of costume at the Brooklyn Museum. During her 30-year-long career, Mears has organized or contributed to more than two dozen exhibitions and written the accompanying books and essays, including *Madame Gres: Sphinx of Fashion* (2008), *American Beauty: Aesthetics and Innovation in Fashion* (2009), *Expedition: Fashion from the Extreme* (2017), and *Ballerina: Fashion's Modern Muse* (2020).

Tanya Melendez-Escalante is Senior Curator of Education and Public Programs at The Museum at The Fashion Institute of Technology. She has organized more than 100 programs for diverse audiences. A Fulbright scholar from 2002 to 2004, she is a contributing author to the books *La comedia y el melodrama en el audiovisual iberoamericano contemporáneo* and *Pink: The History of a Punk, Pretty, Powerful Color.*

Dr. Monica Titton is a sociologist, fashion theorist, and culture critic. She currently works as a Senior Scientist at the Fashion Department of the University of Applied Arts Vienna, Austria. Her work develops a critical, sociological perspective at the intersections of fashion, politics, art, and identity. Her research is guided by an effort to expand and develop theoretical frameworks for critical analyses of fashion, and is informed by the traditions of poststructuralism, Marxism, feminism, and postcolonialism.

Index

Acknowledgments

Funnily enough, the idea for an exhibition on food and fashion was born over lunch at an Indian restaurant near FIT. From there—thanks to the support and encouragement of our colleagues at the Museum at FIT (MFIT) and at Bloomsbury—the idea was encouraged, nurtured, and ultimately grew to encompass a major museum exhibition and the book you see here. There are many people to thank. Firstly, thank you to Dr. Joyce Brown, President of the Fashion Institute of Technology, for her continued support of the museum, which permits us to produce original and scholarly exhibitions. This book would not have been possible without the encouragement and guidance of our director, Dr. Valerie Steele, who gave us the opportunity to explore this topic, curate an exhibition, and present this volume to you. For this, we are extremely grateful. We also would like to give special thanks to MFIT's deputy director Patricia Mears, senior curator Fred Dennis, and curator of costume and accessories Colleen Hill, who encouraged and believed in the merit of this topic in its infant stages.

We are grateful to the members of the Couture Council of The Museum at FIT, who make it possible for us to mount world-class exhibitions and public programs. Thanks also to FIT's department of external relations, especially Loretta Lawrence Keane, Beth Mitchell, Alexandra Mann, Ivana Cepeda, and Steven Bibb. Thank you also to Lucia DeRespinis, Executive Director of FIT's Office of Grants & Sponsored Programs.

This book has several contributors, among them Valerie Steele and Fabio Parasecoli, who wrote forewords and who have provided much enthusiasm and support throughout this whole process. We are most grateful for your involvement and contributions. We are also grateful to Faith Cooper, Madeleine Luckel, Emma McClendon, Michelle McVicker, Patricia Mears, Tanya Melendez-Escalante, and Monica Titton, who wrote original essays; your efforts and participation have made this work possible.

Special thanks must be given to MFIT photographer Eileen Costa, who took many of the beautiful photographs, and to Thomas Synnamon for his styling. Thank you also to Nateer Cirino for all of her administrative organization and support. Since this book accompanies an exhibition, we also want to extend special thanks to our colleagues at MFIT: Alison Castaneda, Ann Coppinger, Sonia Dingilian, Laura Gawron, Michael

Judith Leiber, pavé rhinestones and
gold metal minaudière, 1994, USA,
Gift of Judith Leiber, Inc. © The
Museum at FIT

Goitia, Jill Hemingway, Gabrielle Lauricella, Lynn Sallaberry, Ellen Shanley, Glendene Small, Gladys Rathod, Vanessa Vasquez, Ken Wiesinger, Ryan Wolfe, and Tamsen Young. Several interns worked on this project along the way, and we are grateful for their contributions—heartfelt thanks are owed to Sarah Brennan-Martin, as well as Caroline Elenowitz, Marie Olivier, Lara Rössig (Fulbright scholar), and Anita Spadoni.

There were many photographers and organizations who generously contributed images to this book, for which we are grateful. Thanks are also due to those who shared their knowledge and provided assistance along the way, including Pablo Arguelles, Grazia d'Annunzio, Daniel Grushnik, Jussara Lee, Tracey Panek at Levi Strauss & Co. Archives, Stefano Piaggi, and Mimi Prober, among many others. We are particularly grateful to Mimi Sheraton for the early discussions and brainstorming sessions on the connections between food and fashion.

Thanks to the Bloomsbury team, especially Frances Arnold and Rebecca Hamilton.

Last, but not least, this achievement would not have been possible without the love, support, and advice of our friends and family.